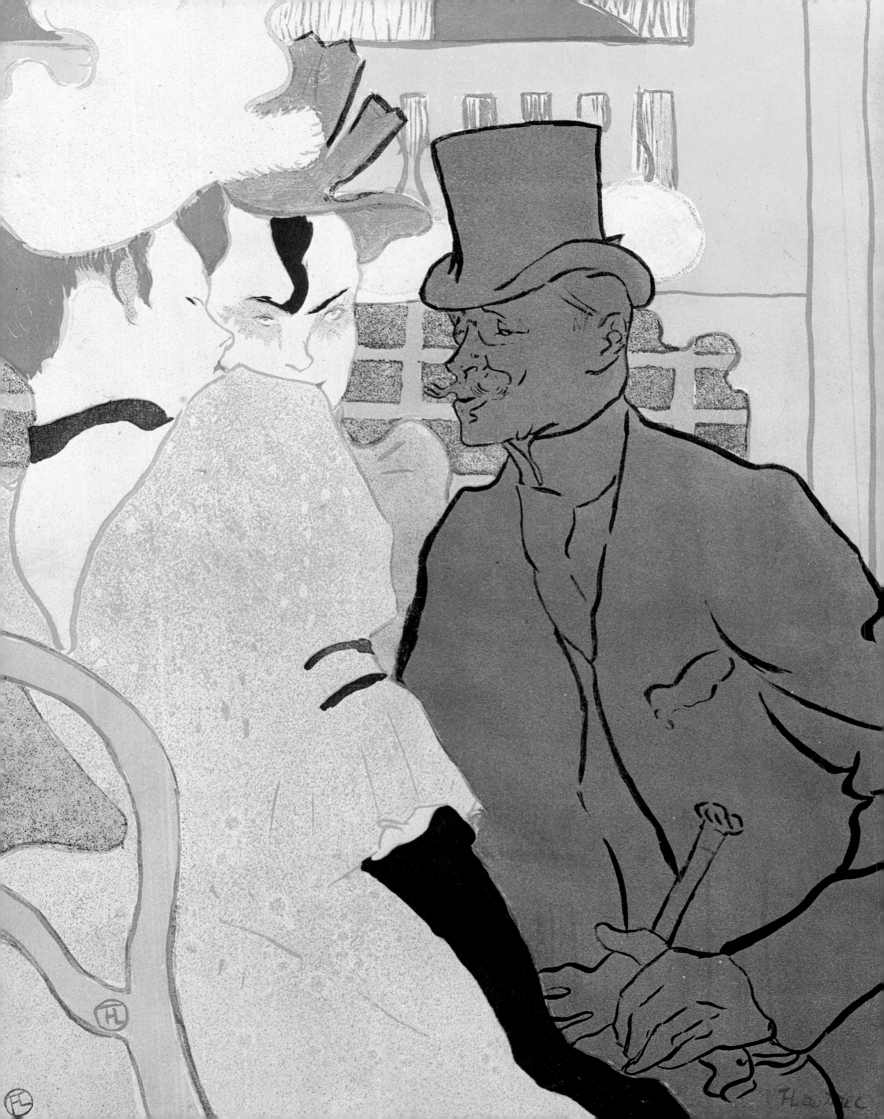

LITHOGRAPHY
200 YEARS OF ART, HISTORY & TECHNIQUE
DOMENICO PORZIO, GENERAL EDITOR

With the Collaboration of Rosalba
and Marcello Tabanelli
Essays by Jean Adhémar, Jacqueline Armingeat,
Michel Melot, Fernand Mourlot, Domenico Porzio, and Alain Weill

Translated from the Italian by Geoffrey Culverwell

Harry N. Abrams, Inc., Publishers, New York

Library of Congress Cataloging in Publication Data

Litografia. English.
 Lithography: 200 years of art, history, and
technique.

 Translation of: La litografia.
 Bibliography: p.
 Includes indexes.
 1. Lithography. I. Porzio, Domenico, 1921–
II. Tabanelli, Rosalba. III. Tabanelli, M. R.
IV. Adhémar, Jean. V. Title.
NE2425.L5713 1983 763 83-3691
ISBN 0-8109-1282-1

Frontispiece: Henri de Toulouse-Lautrec. *The
Englishman Warener at the Moulin Rouge (L'anglais
Warener au Moulin Rouge),* 1892

CONTENTS

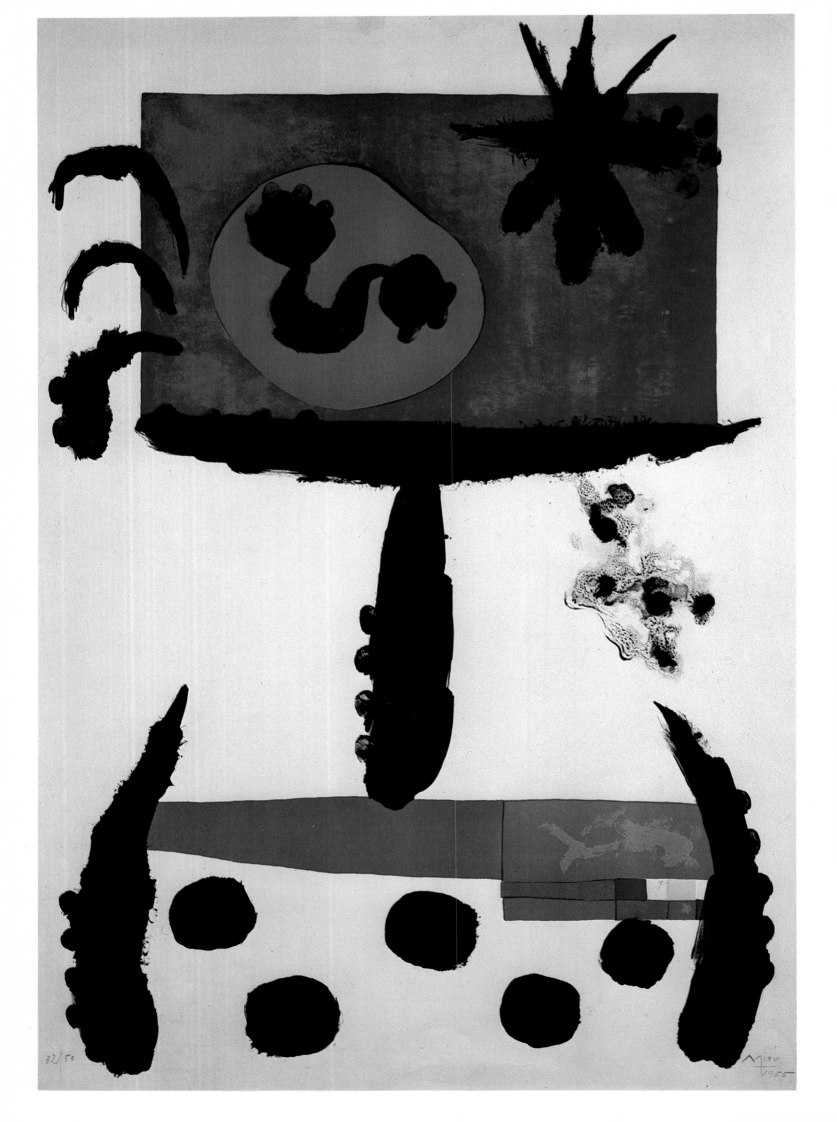

PREFACE

Lithography was not born to serve art. Senefelder's invention merely provided a new method of printing which, by means of a limestone block, allowed for the rapid and large-scale reproduction of documents and pictures. Napoleon was interested in the process because he saw it as a way to ensure the speedy diffusion, during military campaigns, of facsimiles of orders and communiqués. It was, therefore, first and foremost, a technical and commercial proposition linked to a surprising innovation in the field of graphic reproduction.

Only later did artists discover lithography, when, in the early years of the nineteenth century, they realized that the newly invented process could, unlike etching, capture and transfer onto paper their ''touch'' and personality without calling for complicated artifice and endless patience. The evidence of this intimate relationship between the hand of the artist and the finished product is fundamental to our appreciation of the emotional content of lithographic prints and to our recognition of their value as collectors' items: it is the essential quality that enables us to define them as ''original'' works of art.

It is the intention of this book to provide a profile both of the technical evolution of the medium and of the actual history of lithographic art. Although it is true that the history of lithography runs parallel to that of the figurative arts, it excludes, of necessity, many of the latter's protagonists. Some of the greatest painters and sculptors, ranging from Modigliani to Brancusi, Constable, Böcklin, and Morandi, are absent from the pages of this book simply because they did not practice lithography, or else because their infrequent and indeterminate ventures into the field did nothing to contribute toward lithography as an art form. On the other hand, the book does include the names of artists who revealed their talents to a greater extent in lithography than in painting. Equally, there are artists such as Cézanne, for example, whose few prints are among the greatest achievements of lithography. What we, therefore, have tried to highlight in this book is the qualitative aspect of the individual contributions made to the development of lithography as an original art form, and it is this criterion that has guided the different authors in making their selections.

The Golden Age of the expressive medium discovered by Senefelder is, quite clearly, the hundred years that stretch between Goya and the protagonists of the European historical avant-garde. It was an age that enjoyed its greatest moments in France, where, more than anywhere else, lithography attracted the attention of artists, printers, and collectors alike. It is for this reason that we have called upon French scholars and art historians to assist us in casting light on specific and essential aspects of the world of lithography.

During recent decades, as is pointed out in the chapter devoted to the history of lithography, the relationship between artists and the medium has become confused and complicated by the development and perfection of mechanical printing techniques that allow for a gradual diminution of actual physical participation in the process. This dilution of the artist's active role and of the immediacy of his manual creativity, even though it produces what are undeniably graphic works, is nevertheless a betrayal of the lithographic ideal since it deprives lithography of its essentially expressive role. Opinions are divided on the subject: the debate remains open, with no prospect of a verdict. However, for those who, like me, believe that lithography is not one of the lesser arts, it is clear that a technique is important not for its intrinsic potential but for the artistic quality of the hand that uses it and claims it for its own. It is the aim of this book to demonstrate this fact in simple and strictly defined terms.

Domenico Porzio

Opposite: Joan Miró, *Palotin Giron*, 1955

7

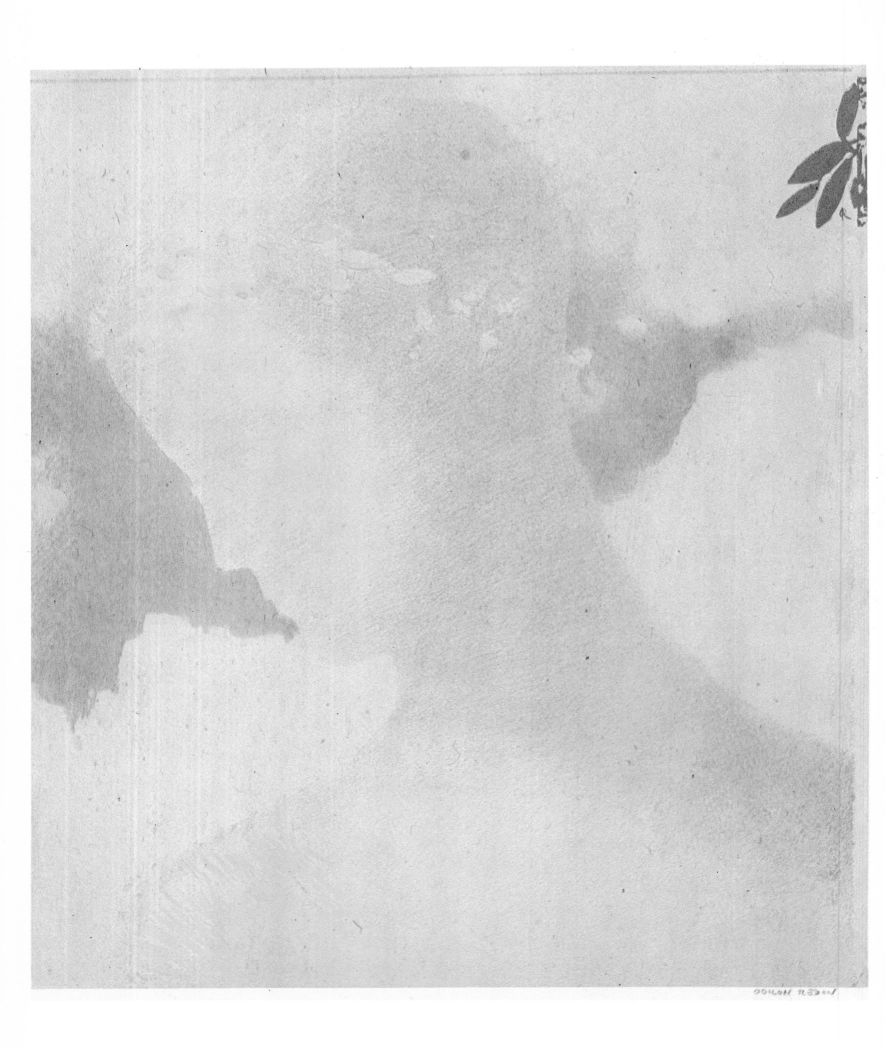

IN PRAISE OF LITHOGRAPHY

by Jean Adhémar

It is not possible to talk about lithography without quoting these words of Degas, which are both a tribute and an expression of regret: "If only Rembrandt had been familiar with lithography, what he would have achieved!"

This remark, reported by Paul Valéry, on whom it had made a deep impression, is a good summing-up of what can be expected from lithography, which is, above all, an art form of the painter, the painter-engraver. Rembrandt "invented" etching; Goya "invented" lithography. It is also an art form that has been widely practiced since the end of the eighteenth century, but that, as we shall see shortly, enjoyed its greatest flowering in France, at least during the nineteenth century.

Lithography exercises, and has always exercised, a particular fascination for poets, but it has also attracted an ever-increasing number of enthusiasts among the general public. This poetic affinity was sensed, among others, by Mallarmé and Valéry, who very successfully defined it; the public, on the other hand, tends to see lithography as a cheap form of wall decoration, a substitute for painting, as well as a spur to creating drawings (a sort of "do-it-yourself" art) because of its deceptively easy means of execution.

In reality, lithography, like any other form of printing, is, however one looks at it, both an "art" and a "craft." As a craft, it presupposes, in addition to the master artist, who performs a vital function, the presence of a skilled craftsman, namely the printer (and Fernand Mourlot provides ample proof of this phenomenon). This collaboration has existed from the very beginning: it is noted on the stone from the start of the nineteenth century, in what is known as the "letter." At the base of a lithograph by Delacroix, for example, we read *Delacroix del, lith de Motte*, meaning "Drawn by Delacroix, lithographed by Motte," which clearly indicates the role played by the printer in executing the work. In color lithography, the part played by the printer is even more important, given the fact that very few artists know exactly how any particular color or shade is going to turn out in the final print, which is why they work in close contact with the printer.

The attempts made by Senefelder, by the English artists interested in lithography (*Specimens of Polyautography*, 1803, by Henry Fuseli and Benjamin West), and by the early French Romantics would never have succeeded in advancing lithography beyond the pleasant, documentary, "craft" stage. However, on the day that Goya, in the workshop of an unknown printer in Bordeaux, drew his bullfighting scenes on stone, a new

Opposite: Odilon Redon, *Beatrice*, 1897

art form was born. This event took place between 1824 and 1825. Gassier has drawn attention to the fact that the artist had gone to Paris to see "his friend Cardano," former director of the lithographic printing works in Madrid, who had emigrated to France. It was he who introduced Goya to Horace Vernet. From Cardano and from the Bordeaux printer Gaulon, Goya learned only the rudiments of lithography, and the story goes that, when confronted by their works and the works of others, he exclaimed: "That's not it!" On the other hand, the brutal poetry, the violent contrasts of light, and the freedom of line of his *Bulls of Bordeaux* make them true masterpieces. Gassier compares them to an album of Goya's drawings which reveal the same "robust density" and were, in all probability, also destined to be turned into lithographs; however, their subject matter (madmen, bizarre means of transport) was not of the type most conducive to the commercial success of the prints, which is the most likely reason for their never having been published as lithographs. His bullfighting lithographs, by contrast, were well known in France: Delacroix spent many years trying to find proof copies of them, and in 1847 he still speaks of "those famous Goyas that I long for." There were two examples in the sale of Delacroix's collection, as well as the portrait of Gaulon that he must have bought in 1847, and from 1840 onward there are clear signs of the influence that these Goya lithographs had on his art.

The lithographs of Géricault, dating from about 1817 to 1823, are earlier than those of Goya, but Delacroix accords them the same admiration. They do, in fact, have similar qualities of strength, a similar use of shading, and similar contrasts (Géricault often asked the printer to "strengthen the shadows"). His *Boxers*, which dates from 1818, and, above all, his *English Suite (Suite anglaise)* from 1821, are undoubtedly the work of a true master (we should note the importance of his relationship with a London lithograph printer: "Géricault, one of the glories of the Hullmandel firm," writes K. Beall).

Delacroix (1798–1863) notes in 1824 in his diary: "Tried some lithography. Superb ideas for that subject. Caricatures in Goya's manner." Up until then he had produced only mediocre lithographs but some fine etchings after Goya and Géricault. The latter was to be his master, along with the exceptional lithograph printer called Motte, who was brother-in-law of the painter Achille Devéria and was once characterized as too much of an artist to be a tradesman. Mention should be made of Delacroix's *Faust* (1828), studied herein by J. Armingeat, as well as his *Frightened Wild Horse*, one of his finest plates (which was reused for *L'Artiste* magazine in 1865); his *Hamlet* dates from 1834–44. It should also be recalled that in 1826 Delacroix had experimented with a curious lithographlike effect in his portrait of a friend, Baron Schwiter.

In the Romantic era, lithography enjoyed a considerable success, similar, in certain ways, to the modern-day vogue for photography. Everybody produced lithographs, everybody bought lithographs, and the specialist firm of Lemercier in Paris became renowned for its lithographic reproductions. Lemercier's assistants were able to improve on even the clumsiest lithographic attempts brought in from all over the world. These works, often the fruit of modest talents, can be classified under a number of different headings: caricatures and scenes of social life, which will be examined at greater length later; illustrated books and albums; landscapes and genre scenes.

The landscapes are of interest in that they show us a now-vanished preindustrial world, complete with medieval churches and turreted castles, as well as the lush vegetation of virgin forests and the colonial-style houses

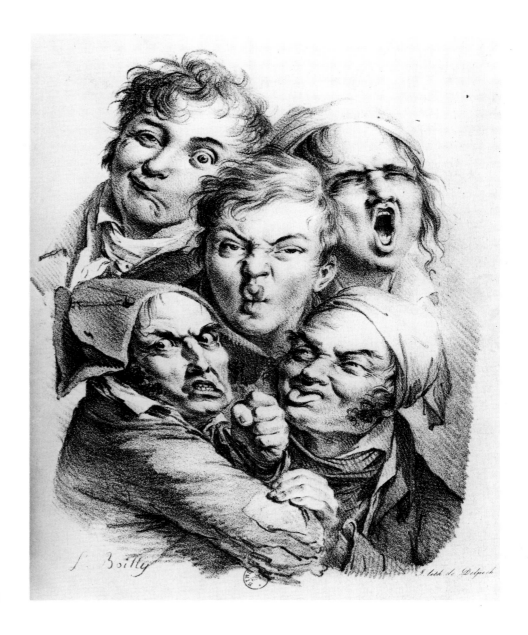

Louis-Léopold Boilly, *Grimaces*, 1823

of America. These landscapes, which were drawn from life, were almost invariably sent from France, Italy, and America to the firm of Lemercier, whose lithographers, as we have already said, added the finishing touches; they gave them a poetic, dreamlike mood in the English manner that was to find scant favor with the next generation, which had by then grown used to photography. The most adventurous undertaking was that of Taylor and Nodier's *Voyages pittoresques et romantiques dans l'ancienne France*, which consisted of two thousand lithographs published between 1820 and 1878; although sponsored by the French government, these *Voyages* proved less and less popular with the public, partly because almost eight hundred albums or local series had already provided detailed portrayals of the various landscapes.

Genre scenes were another speciality of Romantic lithographers, as Beatrice Farwell has pointed out. The world of *grisettes*, *lorettes*, and later of *cocottes* and *petites dames* provided inspiration for the thousands of former students who had become notaries or merchants in the provinces and were happy to rediscover in these prints the customs, attitudes, and witticisms of their youth. Boating parties, bathing in the Seine, and idyllic picnics in the countryside were other favorite subjects—themes that were to greet the arrival of Impressionism.

11

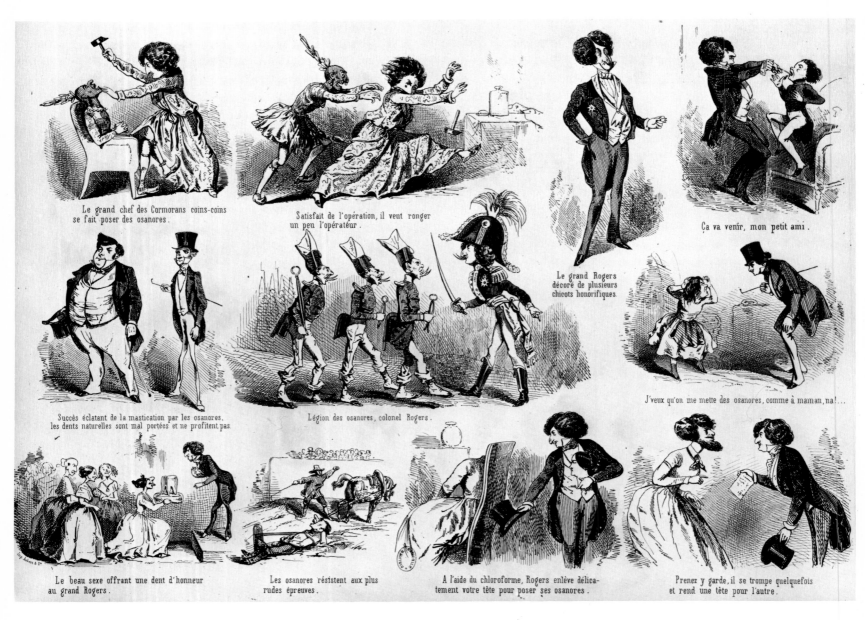

Le grand chef des Cormorans coins-coins se fait poser des osanores.

Satisfait de l'opération, il veut ronger un peu l'opérateur.

Ça va venir, mon petit ami.

Succès éclatant de la mastication par les osanores, les dents naturelles sont mal portées et ne profitent pas.

Légion des osanores, colonel Rogers.

Le grand Rogers décore de plusieurs chicots honorifiques.

J'veux qu'on me mette des osanores, comme à maman, na!...

Le beau sexe offrant une dent d'honneur au grand Rogers.

Les osanores résistent aux plus rudes épreuves.

A l'aide du chloroforme, Rogers enlève délicatement votre tête pour poser ses osanores.

Prenez y garde, il se trompe quelquefois et rend une tête pour l'autre.

Gustave Doré, *Hosannah! Voici les osanores!*, 1849

These genre lithographs marked a reawakening of interest in the "stories through pictures" that had been such a feature of the fifteenth and sixteenth centuries. The strip cartoons of Rodolphe Toepffer are, in fact, lithographs executed with a pen, especially the *Histoire de M. Jabot*, published in Geneva in 1833, which brought laughter to the whole of Europe and was imitated not only by Toepffer himself but by numerous other artists. The "nobility" of this means of expression was explained as follows by Toepffer: "Stories can be written by means of lines and words: this is literature in the true sense. Stories can be written by means of a succession of scenes portrayed graphically: this is literature in prints." There was also a vogue for portraits—official portraits, portraits of literary figures, portraits of women that can also be regarded as fashion plates—as well as for devotional images to be hung on the wall.

In the midst of this flood of lithographs, which became ever more mediocre and commercial as time went by and were soon treated with disdain (before being collected by modern-day historians of nineteenth- and early-twentieth-century life), some true artists did emerge. Let us concentrate on two of these: Paul Gavarni and Honoré Daumier. That Paul Gavarni (1804–1866) has yet to gain the recognition he deserves is the fault of the Goncourts, who sought to turn him into a deep "thinker." In

fact, Gavarni started off by being an excellent fashion designer, and it was only fairly late in life that he decided to make pictures to amuse the bourgeoisie. The Goncourts maintain that his works possess no artistic merit until 1843, but the best examples of his oeuvre were created prior to that date, when his much-admired fashion lithographs inspired the comment that he knew clothes better than he knew the human body. It is even said that one tailor suggested that he would personally "launch" Gavarni's clothes by being the first to actually wear them.

Daumier, who until 1900 was regarded as being inferior to Gavarni, is of a completely different calibre. "What a marvelous sculptor," Antoine Bourdelle said of him, and this opinion was shared by his sculptor friends Préault and Feuchère. The sculptural attraction of the lithographs Daumier created around 1830, their strength, their robust design, and the way in which their figures seem to leap out from the background invest this disciple of Goya's with the status of a truly great master. Michel Melot has also, elsewhere herein, quite rightly pointed to his role as a pamphleteer.

After 1848, when his sight was beginning to fail, Daumier "discovered" Impressionism, of which he is the true initiator and which his contemporaries were not to understand until much later. In fact, his "Impressionist" works of 1848–49 were not accepted until 1860 by the journal for which he worked, and they continued to create great controversy, being the cause of his expulsion from *Charivari*, much to the anger of Baudelaire and his friends. Finally, Daumier's lithographs, which became increasingly daring, were also rejected by purist collectors because they were not worked on stone, but were instead *gillotages* (from the name of the inventor of a process that gave birth to "zincography," Firmin Gillot).

Although black and white was the only thing that mattered to Daumier, his editor and the public did not share his view, with the result that during his lifetime there were colored versions of his work for sale at higher prices than the black-and-white originals.

The public wanted colored lithographs, whereas artists did not care for them. In England, Hullmandel (Géricault's printer) launched the "lithotint"; in France, Lemercier launched the "chromo" (chromolithograph). G. von Groschwitz has discovered a "chromo" dated 1837, by Bouquet and Lessou, bearing the annotation "curious experiment in colored lithography"; Delécluze spoke of it in *L'Artiste* in 1839; the publisher Curmer experimented with it; the printing firm of Lemercier produced examples, but without ever succeeding, because of the lack of artists, in raising its results above the mediocre.

In America, from 1835 onwards, Currier & Ives used color lithography (for such popular pictures as *The Ruins of the New York Stock Exchange After the Fire of 1835*), and the same applies to Miranda in Spain; Winslow Homer and David Claypoole Johnston used it for their caricatures. It was also around 1835 that the famous *images d'Epinal* began to be produced lithographically rather than from woodcuts.

During the Romantic era, artistic lithography found no real favor among the general public, with Daumier and Gavarni being regarded solely as *amuseurs* and Delacroix remaining unknown. Only one collector, the little-known Parguez, had the sense and discernment to quietly amass a collection of some 760 lithographic masterpieces, and the sale of his collection in 1861 created a sensation. In fact, it released onto the market 700 magnificent lithographs of the works of two hundred Romantic painters; in the sale, "the public preferred the colorists," especially Géricault. The critics, including the most articulate of their number, Philippe Burty, then

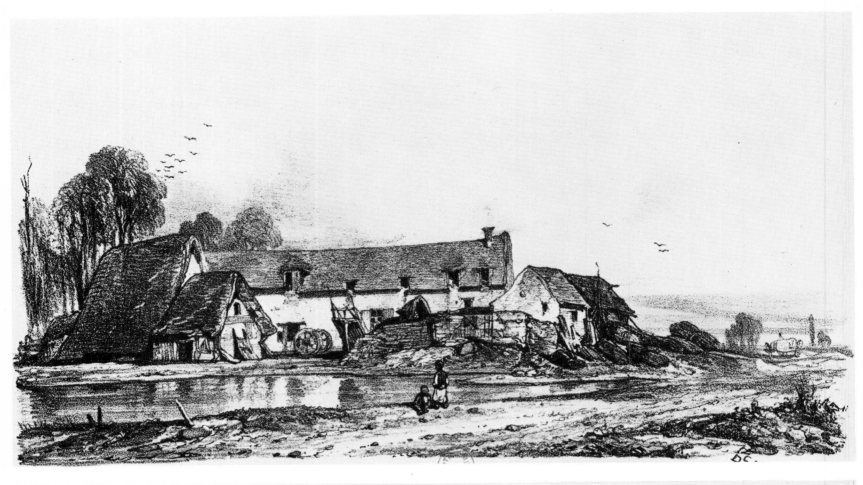

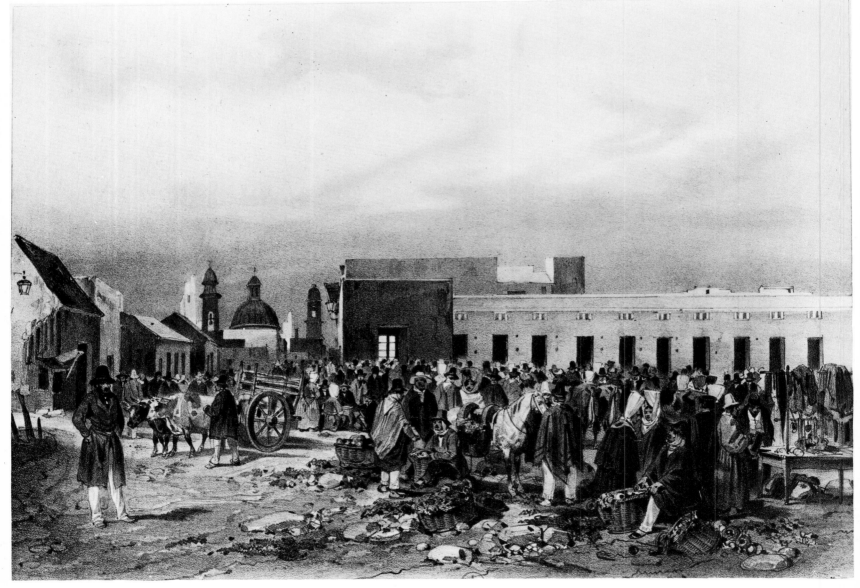

became convinced that only painters could bring lithography alive. Nor was it mere coincidence that another important auction took place during the same period as the Parguez sale: that of the Arozarena collection, which released hundreds of etchings by different artists onto the market.

One draftsman whose activities as a lithographer have gone unnoticed, another *amuseur*, is the young Gustave Doré, born in 1832; posterity has made the mistake of ignoring his almost three hundred lithographs, reproduced by the printers Aubert-Philipon and by a number of illustrated journals between 1845 and 1855. The lithographs of the young Doré are matched by at least as many woodcuts, and it was the latter technique which, from 1855 on, took the place of lithography, since the artist for some reason found it an easier medium.

In the same way as engraving and etching have undergone periodical declines, so lithography has had its ups and downs. In 1865, a certain Monsieur de Saint-Saintin wrote in the *Gazette des Beaux-Arts* that "litho has been forsaken, struck down by a mortal illness" and that very able practitioners had reduced it to the level of a simple "craft." And yet, the year before, Manet had created *The Races*, the first "modern" lithograph, which was to have formed part of an album planned by the publisher Cadart but was abandoned, it is thought, as the result of a lack of public interest.

That Manet remained a great lithographer is shown by his illustrations for *The Raven* by Edgar Allan Poe. He also designed one of the first art exhibition posters, the one announcing, with great expressive simplicity, Champfleury's *Les Chats*, and also created his own color lithograph *Punchinello*.

Before Manet, in 1861, another lithograph by a painter was published: Rodolphe Bresdin's *The Good Samaritan*, a great Symbolist work, as poetic and strange as its author, a solitary figure who lived in Toulouse in a "room furnished with dreams and birdcages." Starting in 1854, Bresdin created lithographs along with his etchings. This *Good Samaritan*, undoubtedly his greatest work, was the product (according to Van Gelder) of "twenty years of passions and dreams." Although unconventional, the work was accepted by the official Salon, and its author was widely respected in both Toulouse and Paris, being rightly admired as a great artist. Victor Hugo, Théophile Gautier, Courbet, Théodore de Banville, the critic Burty, Odilon Redon, and Huysmans were among his greatest supporters. Only the specialists (Béraldi, Delteil) held back, for reasons that Baudelaire well understood: "He has no talent," he remarked, "he has genius."

After 1870, lithographs signed by artists vanished for almost ten years, being revived in 1879 by Redon. He did not initially regard lithography as an art, but as a means of reproducing and circulating his charcoal sketches. "Fantin gave me the excellent advice to reproduce them with the help of a wax crayon. I therefore did my first lithograph in order to *multiply my drawings*" (Roseline Bacou, *Odilon Redon*, 1956). The technique of lithography was admirably suited to the needs of this dreamer, this seer who wanted to produce, in black and white, "a kind of diffuse and dominant attraction toward the dark world of the indeterminate." Redon also executed a number of masterpieces that were unrecognized because the public did not understand that he had made far-reaching modifications to the technique of lithography, seeking and obtaining effects similar to those achieved in charcoal sketches.

At the same time as Redon, around 1879, Degas created *The Song of the Dog*. This work, however, has nothing in common with the *Noirs* of

Opposite, above: Alexandre-Gabriel Decamps, *Landscape*, 1830; below: Adolphe Bayot, *Montevideo Market* (after Lauvergne), 1839–40 (from the series *Voyage de la Bonite*)

Redon, for which Degas nevertheless expressed great admiration. Here Degas, in his vision of the woman (Mademoiselle Bécat) singing with a coarse gesture and brightly lit from below, has stayed close to his own monotypes and to his own paintings, which he wanted to turn into lithographs for himself. The importance of this lithograph as a sort of "manifesto" is illustrated by the exceptionally high number of preparatory drawings for it—some twenty in all.

One gains a better idea of the revolutionary nature of the lithographs of Redon and Degas if one considers that, at the time, lithography was represented in most people's eyes by Chéret's color posters, whose monotony and facile appeal were not without a certain charm and attraction.

The revival of lithography as an art form in its own right probably began in England with Whistler, who in 1887, in London's Boussod-Valadon gallery, exhibited a number of Impressionist lithographs known as *Nocturnes*. Much to his fury, these views of the Thames, which he himself called *Notes*, were mistaken by the critics for straightforward facsimiles of drawings. He was assisted by Thomas Way and by Way's father, and the resultant lithographs bear a close resemblance to ones by Fantin-Latour. In the same spirit, in 1892, Whistler executed a famous autographed lithographic portrait of Mallarmé, which appears on the frontispiece of *Vers et prose* and which delighted the poet: "This portrait is a marvel, the only work ever to have really looked like me, and I love it."

The year 1891 saw the beginning of a revival in color lithography by artists when Bonnard published his poster entitled *France-Champagne*. This was followed by Toulouse-Lautrec's poster for the Moulin Rouge and in 1892 by the first Symbolist lithographs of Maurice Denis.

The great Parisian printer of the period was the internationally renowned Auguste Clot (1858–1936), who started work with Lemercier, but subsequently worked on his own for Redon and the Nabis. The Nabis entrusted him with pastels and drawings on transfer paper (as did Cézanne), and they came to work in his establishment. Like Groux, they were grateful for Clot's "invaluable collaboration in this diabolical craft," a collaboration stressed by the historian Mellerio, who states that the printer is an "élite practitioner whose task is to conduct research and experiments in order to complete the printing process."

Between 1893 and 1899 there was a notable increase in color lithography in Paris, fostered by a greater familiarity with Japanese prints (works by Utamaro and Hiroshige were exhibited at the Durand-Ruel gallery in 1893) as well as by the publication of *L'Estampe originale*, nine albums edited by André Marty, of which a hundred copies were printed, each consisting of sixty lithographs, with thirty-three in color. At the center of this publication, alongside the subtle Rivière and the mythical Dulac, stood Lautrec, who brought to lithography his inimitable sense of design, of simplification, and of irony.

In 1895–96, in Paris, Edvard Munch produced his portraits of Mallarmé and Strindberg (printed by Clot). But the Expressionists preferred woodcuts to lithographs, except for those artists working for the press, including the great Franco-Germans who worked for *Simplicissimus* from 1896. Also noteworthy was the publication in 1899 of an album of original lithographs by Meier-Graffe entitled *Germinal*.

During the final decade of the nineteenth century, the use of lithography by painters—which had produced so many beautiful works—came under attack from the purists. These critics had already refused to acknowledge Daumier's *gillotages* and had gone on to condemn the transfer

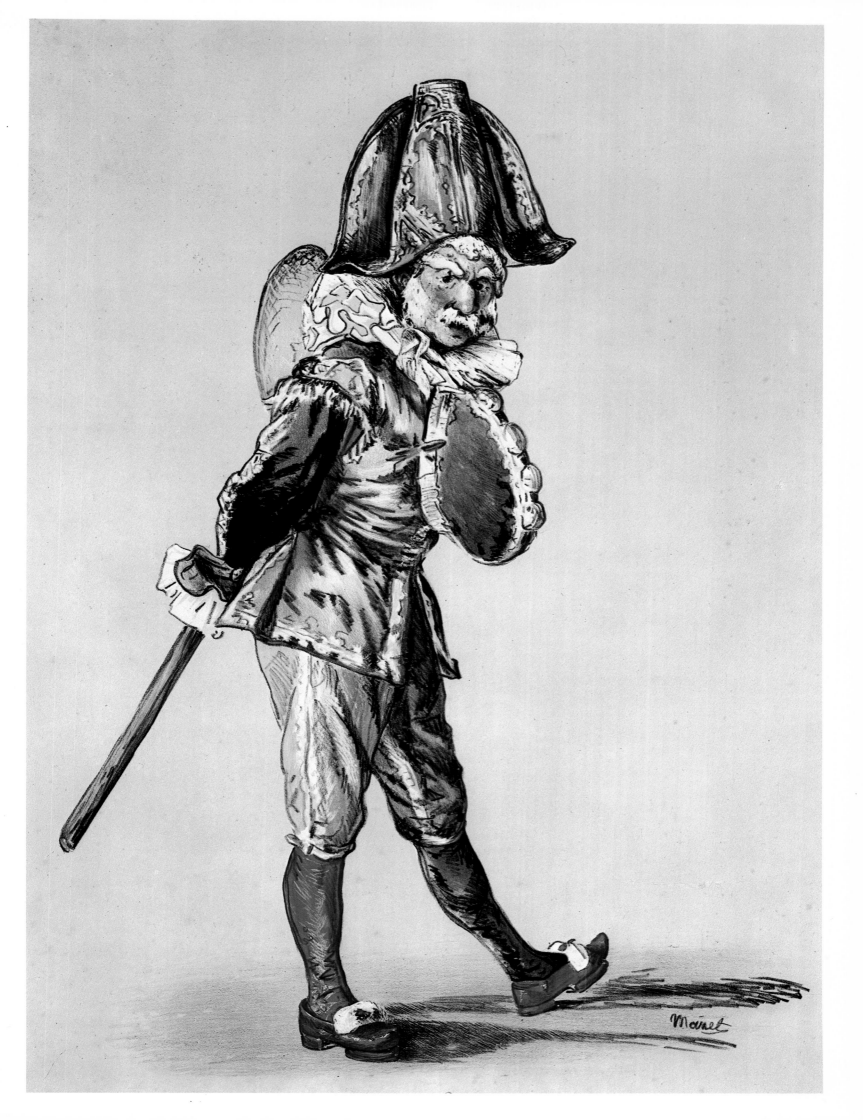

James Abbott McNeill Whistler, *Stéphane Mallarmé*, 1894 (above), and *The Steps*, 1893 (right)

paper on which Fantin-Latour and Redon traced their compositions before they were transferred onto stone. (In fact, one could apply the term "transfer paper," in a much earlier context, to what Géricault called "stone-papers" and to the "autographical paper" used by Senefelder as early as 1799.) Fantin's adviser was Belfond, who was in charge of proofs at Lemercier's printing works. In 1896, the Englishman Sickert launched a violent attack against Joseph Pennell, who made lithographs solely on autographical paper ("transfer lithography"), and he also attacked Whistler on the same grounds. A court case ensued, as a result of which Sickert had to pay 2,250 francs in defamatory damages; at the end of the proceedings the foreman of the jury offered his hand to Whistler in a gesture of congratulation. The use of transfer paper was deemed admissible in lithography by Colvin, keeper of prints at the British Museum, while Léonce Benedite, curator of the Musée du Luxembourg, wrote with a certain irony in 1889 that "all

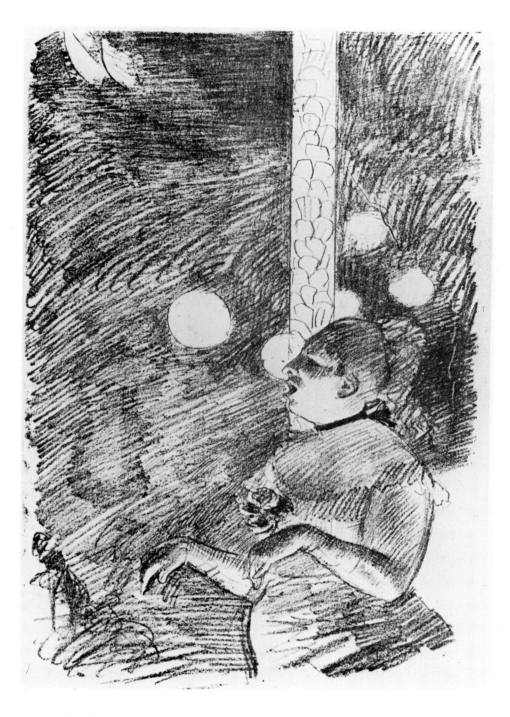

Edgar Degas, *The Song of the Dog*, c. 1879

those old disputes between people who were continually sniping at each other are now ancient history.''

Lithography once again went into a decline around 1900, despite the outstanding results achieved by the artists of the Secession and despite the efforts of art critics like Roger Marx, Mellerio, and Bouchot. However, this decline was also perhaps partly a result of the critics' excessive enthusiasm and lack of tact. Toulouse-Lautrec, for example, refused to show his works at the Universal Exhibition, saying, ''after books like Monsieur Bouchot's, I am forced to keep very much on my guard'' (letter of 1899).

Neither the Cubists, nor Villon, nor such important graphic artists of the post–World War I period as Segonzac ever devoted themselves wholeheartedly to lithography.

Between the wars, however, artists and publishers sporadically revived lithography. Käthe Kollwitz used lithographs to express her sympathy for

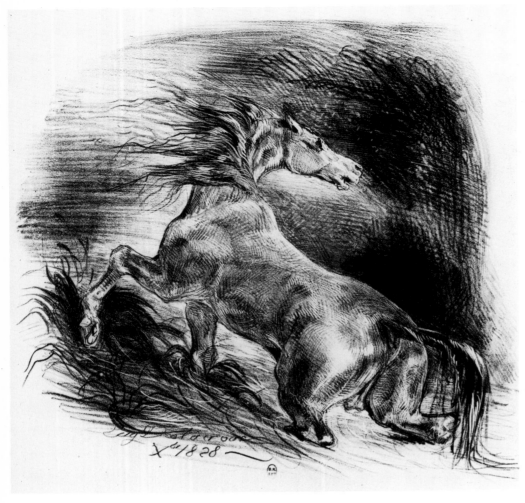

Left: Eugène Delacroix, *Wild Horse*, 1828. Below: Edouard Manet, *The Races*, 1864

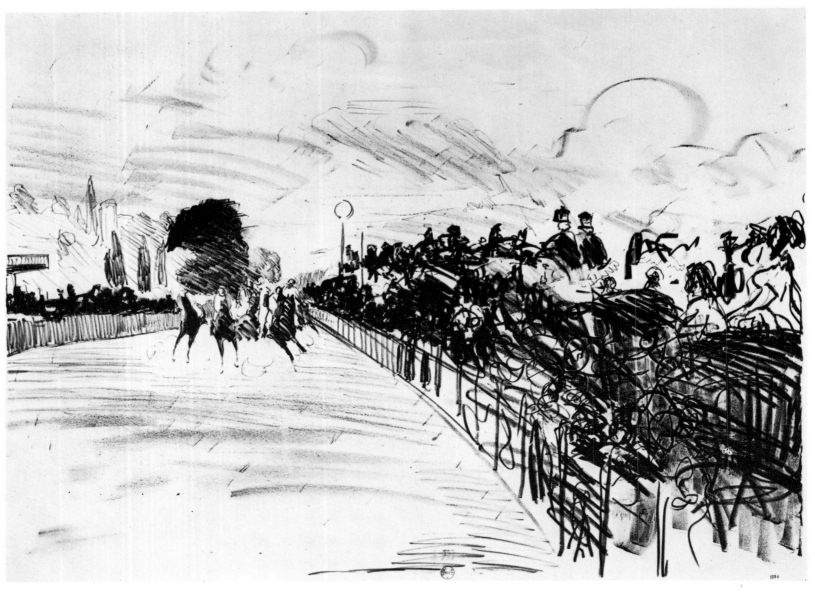

the poor and downtrodden. In America, George Bellows, Martin Lewis, John Morican, and Thomas Hart Benton employed the medium for their observations of daily life. During the twenties, in France, the publisher Daragnès and his friends Luc-Albert Moreau, Dignimont, and Boussingault made extensive use of lithography. The greatest figure of the period, however, was Max Ernst, who once proclaimed that "a lithographic frottage is a perfectly original lithograph." His lithographic oeuvre, produced over a number of years, was to make its mark on two generations of artists.

Around 1945—after Picasso had executed the masterpieces analyzed herein by his assistant Mourlot, using all the techniques known at the time and also inventing new ones (as Arp said, "Picasso is as important as Adam and Eve")—the Americans threw themselves wholeheartedly into lithography. Jasper Johns, Robert Rauschenberg, and Jackson Pollock were particularly notable among such artists. Lithography began to be taught in American universities and museums as a workshop course. Meanwhile, every now and then, what J. Laude calls a "symptomatic" work would emerge.

Later on, in what has come to be known as the Ecole de Paris, lithography was practiced under a number of different or analogous forms, such as silk screens and linocuts; artists as diverse as Chagall, Bissière, Moore, Bram van Velde, Miró, Bacon, Tamayo, Magnelli, Andy Warhol, and Roy Lichtenstein began to experiment with lithographic forms. Hartung explains the renewal of interest by saying "I have discovered in lithographic stones a substance that facilitates the portrayal of large masses and also, as a result of the grain of the stones, a marvelous transparency. . . . The practice of lithography has even led to a renewal of my painting." (For further information on this period, and particularly on the Italians, the reader should consult Domenico Porzio's essays in this book.)

Between 1945 and 1950, in France as elsewhere, it was the interior decorators who encouraged artists to practice lithography. This period, in fact, saw the birth of a building boom in which customers demanded fully furnished and decorated apartments. And large-scale lithographs, as part of the furnishings, provided suitable substitutes for original paintings by famous artists, which would have been too expensive.

However, to encourage people to buy lithographs, famous names were needed; as a result, painters were encouraged to return once again to color lithography. They did so with alacrity, Picasso, Braque, and Matisse being the most active. But the printers, indispensable collaborators of the painter-engravers, then began to assert their own importance in the eyes of the press and the public. They did this to such a degree that people were misled into thinking that the printers alone were responsible for producing lithographs, a belief that led to the public's forsaking the medium. Disputes broke out, with accusations that "honor was a thing of the past" and that "artists were unforgivable," but the final word belongs to Richard Field, who said that an artist's lithograph is one "that has been executed for the purpose of creating a work of graphic art."

Will lithography endure, like engraving and etching? The answer to that is definitely yes. We can take it for granted that it will appear under new guises, in experiments that link it with photography, but it will always be an art form providing a source of pleasure for many. There is still great contemporary relevance in the words of Adolphe Thiers (written in 1824 when he was an art critic), which echo the sentiments of his artist friends: "The triumph of lithography lies in the rough sketch, and how much genius there is in that rough sketch! Lithography has given full rein to the verve of our draftsmen; they have been more original and more realistic on stone than on many highly rated and very expensive canvases."

Jean Adhémar, honorary chief conservator of the Cabinet des Estampes in the Bibliothèque Nationale, Paris, and author of essays on Goya, Daumier, Toulouse-Lautrec, and other painter-engravers, is also editor-in-chief of the Gazette des Beaux-Arts.

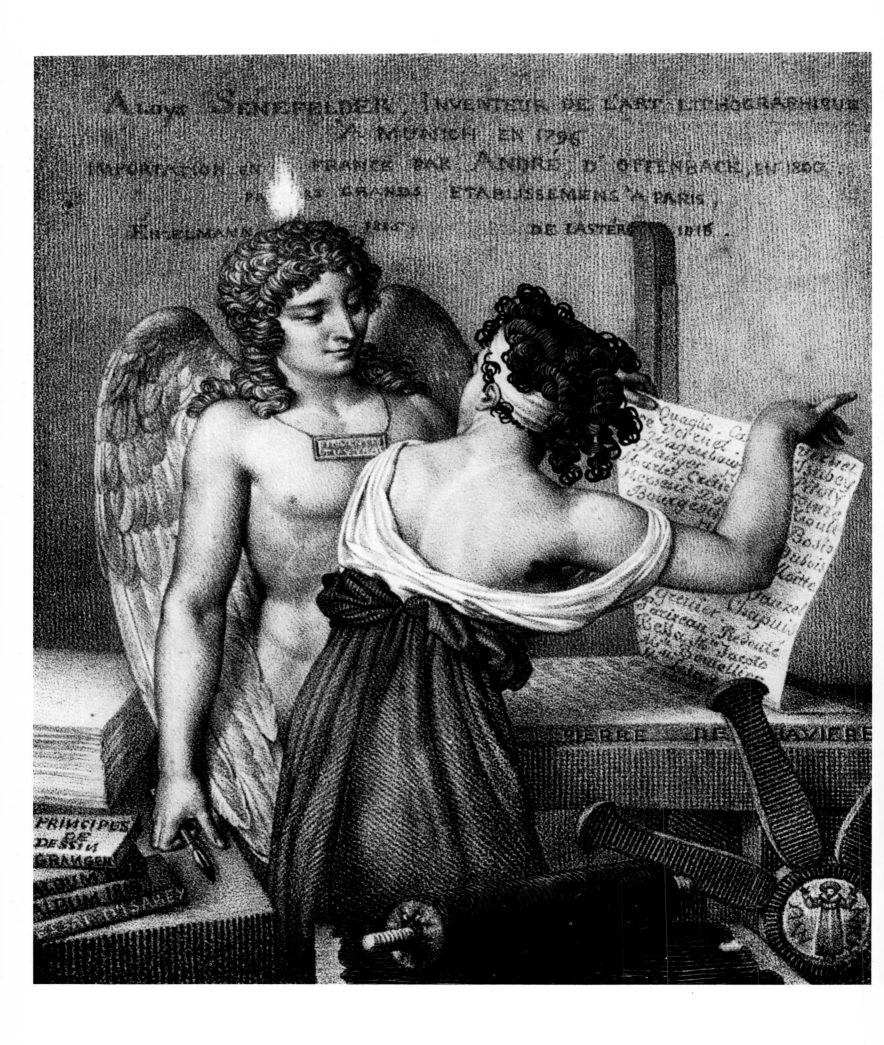

INVENTION AND TECHNICAL EVOLUTION

by Domenico Porzio

Lithography has remained true to its origins and to its etymological derivation (the Greek word "lithos" means "stone"), without having to pass through the labyrinth of technical advances that Senefelder's first surprising invention had to negotiate during its early years. Like any other art form, lithography is simply the result of a meeting between the necessary materials and the hand of the artist, who subjects them to his own personality. The purity of the limestone slab—and later of the zinc or aluminum sheet —the quality of the inks, the balance between the gum arabic solution and the acid used in preparing the stone, the quality of the paper and the press, and the precision of the color transfer are as important as the instruments (pencil, pen, brush, roller, pad, scraper, and such) at the artist's disposal. The spatial depth of a lithograph, the texture of its reliefs and its colors, the light that it absorbs and reflects, and the vital harmony of its composition all result from that accord between instrument and material sought by what Henri Focillon calls the "touch": the moment in which the artist, by means of his utensil, "wakens the shape in the material." The same critic adds, "Now the work of art regains its precious quality of life: it becomes a solid entity, composed overall of closely linked elements, with no sense of disjointedness." Naturally, it is necessary for the artist to be fully "in touch" with the whole array of different lithographical instruments at his disposal and to know how to control and combine them with a view to realizing the project he has in mind. And yet it is also true that, within the artistic context of this century and the preceding one (from the time of Senefelder's invention on), there have been painters who, although highly skilled in the use of brush and canvas and even in engraving techniques, have never felt the fascination of lithography. They have either rejected it or merely dabbled in it without any feeling of true involvement, finding themselves incapable of imparting any personal touch to it. Their lithographs are, therefore, of purely academic interest, contributing neither to the artistic career of the individual concerned nor to the historical development of lithography in general. On the other hand, there are artists who, although of little renown in the annals of painting, have succeeded in expressing the best of their imaginative and technical personalities almost exclusively through the medium of lithography. For this reason, the history of this fascinating and by no means secondary branch of graphics also involves a

Opposite: Allegorical lithograph in honor of Aloys Senefelder, drawn by Jacob in Paris in 1816; it was included in an album that appeared in 1819 as a supplement to Senefelder's *Complete Course of Lithography.*

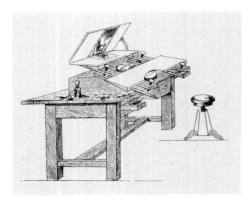

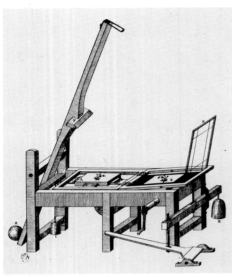

Top: A workbench for designing lithographs in accordance with the techniques practiced at the end of the nineteenth century. It had a sloping work surface, and the drawing to be transferred onto the stone was reflected in a mirror to enable the lithographer to reproduce it "in reverse," so that it would appear "the right way round" on the printing paper. The stone rested on a pivot for greater mobility. Above: One of the first manual presses proposed by Senefelder.

number of highly individualistic figures, often with unfamiliar names, who do not appear in dictionaries of painters and sculptors. It should thus be emphasized that the different styles and signatures encountered in lithography represent an independent world; they are not a lesser reflection of another, more powerful artistic activity. This autonomy is visibly articulated when lithography reveals the physical intervention of the artist and of his "touch," showing the metamorphosis of materials into an explicit formal and visual spirituality, an active, living expression of technique.

The collector of lithographs must become aware of their particular character. As has often been pointed out, he should not believe that the name of a great or at least "known" painter at the bottom of a lithograph is any guarantee of authenticity; it might be real, but again it might not be. He should not imagine that a color lithograph is either more important or more valuable than a black-and-white one. Nor should he pay too much attention to the size of the edition: a lithographic poster produced, because of its very function, in hundreds and hundreds of examples could well be more representative, and therefore more valuable, than some limited edition. At this point, the art historian could interject that Senefelder's invention was intended to facilitate the multiple diffusion of its product; he could say that lithography was intended solely as a means of spreading information and that it achieves its true goal only when produced in large numbers for wide circulation. In fact, this important social function has been passed on, through technical advances, to photo- and offset-lithography. The press and the stone (the zinc sheet and the printing paper) are still controlled by the manual dexterity of the artist, who is interested not in the quantitative but in the qualitative aspect of his work and whose overriding concern is the struggle to achieve the harmonious interaction between his own personality and the implements of lithography which takes place whenever he is confronted by the lithographer's stone. Shortly before his death as an exile in Bordeaux, Francisco Goya completed the four lithographs in his *Bulls of Bordeaux* series, regarded as an undisputed high point in the history of lithography. The old artist worked on them in his studio, resting the stone vertically on an easel and using the pencils and the scraper as though he were painting with brushes on canvas. Concentrating solely on what his hand could lay down and then draw from the stone, Goya produced only a hundred examples of the works. He was clearly unsure of their popularity, since he humbly sent a few examples to his friend Ferrer in Paris in December 1825, writing that if Ferrer found them worthy of being sold, he could send him more since he believed that it would be possible to "give them to a print dealer at a modest price, without mentioning my name."

Those particular prints found neither success nor buyers; yet there is nothing in the field of European graphics of the day to compare with them.

The modern-day expansion of artistic education, the spread of information concerning art, the growth in purchasing power among a wide range of social groups, the discovery of art as an investment commodity, and the ensuing commercial boom that it has enjoyed have together distorted and increased the private collector's market. There is a tendency now to collect not beautiful works but ones that happen to coincide with the vagaries of the market and of contemporary taste. People invest in signatures rather than in quality. Lithographs are bought as substitutes for oil paintings—as a means of getting one small step nearer to an artist's original canvas —and not because of their own intrinsic merits. And artists, in response to

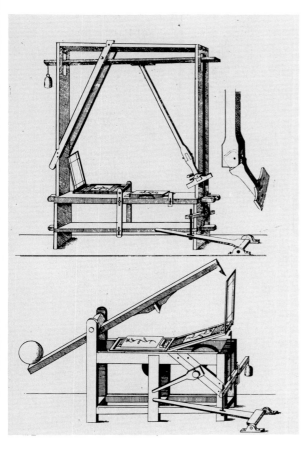

Two other presses suggested by Senefelder in his treatise. The inventor studied a series of devices (levers and counterbalances) to simplify the wooden presses and speed up the printing of lithographs; it was, in fact, the rapidity of the process that was of greatest commercial interest. One of the points on which Senefelder's publicity campaign insisted was the possibility of obtaining "copies of the most important despatches and documents, without the necessity of confiding in the fidelity of Secretaries or Clerks."

requests by gallery owners and in order to satisfy a by no means negligible market, often invent lithographs or compromise by producing photolithographs signed in the manner of original works. And the resultant mistakes and confusions are in no way settled by the surrounding conspiracy of silence. The most basic thing to be borne in mind is that lithography should never be regarded as the servant or poor relation of painting: the language of lithography is a language in its own right, not the lowly offshoot of some greater tongue. The trained collector, with an instinct and feeling for his subject, will easily learn how to distinguish what is appropriate and what is inappropriate to lithography. He will recognize the quality and condition of the paper, the freshness and accuracy of the impression, the characteristics of a particular artist's touch, the modulations of light and shade that result from extraordinary technical skill as well as from the quality of the stone and the inks used, the elegance of the composition, and the effectiveness of the result. He will learn to distinguish euphony from cacophony and inspiration from improvisation, and he will know how to differentiate between the lithographically valid and invalid, regardless of the signature or the size of the edition.

THE INVENTOR AND HIS INVENTION

In the world of prints, lithography is the one skill whose place, date, and means of invention are precisely known, because the man who discovered it, Aloys Senefelder, has himself left us a detailed account of the event in his *Complete Course of Lithography*, the most historically exciting passages of which are quoted in this book. Senefelder defined himself as the "inventor of the art of lithography and of chemical printing," but behind this art and this chemistry there lie, in fact, some very simple elements: a well-polished stone, grease, ink, water, and paper. These materials had been at man's disposal for centuries, and it is surprising that the process was not discovered in Europe until 1798. It is equally amazing that painters, engravers, and woodcut artists failed for centuries to discover, through intuition, a process that required neither complicated technical elaboration nor sophisticated materials. One tries to imagine the stone and the press in the hands of the great figures of the European Renaissance, and one thinks of the quality and quantity of the documents that could have come down to us, including the multiple copies of the studies of Leonardo or Raphael, Titian, Velázquez, Michelangelo, or Dürer. The stylistic information that would have eventually been spread in this way could have radically altered the whole course of Western culture. This consideration, however, was probably not in the mind of Senefelder the comedy writer when he experimented with inks and soaps on the Kelheim stone that he had bought in order to grind his colors. By contrast, the lithographer Ackermann, who translated and published the English version of the *Complete Course of Lithography*, wrote in the preface in 1819: "By means of it the Painter, the Sculptor, and the Architect, are enabled to hand down to posterity as many fac-similes of their original Sketches as they please. What a wide and beneficial field is here opened to the living artist and to future generations! The Collector is enabled to multiply his originals and the Amateur the fruits of his leisure hours. The Portrait Painter can gratify his Patron by supplying him with as many copies as he wishes to have of a successful likeness. Men in office can obtain copies of the most important despatches or documents, without the necessity of confiding in the fidelity of Secretaries or Clerks: the Merchant, and the Man of Business, to whom time is often of the most vital importance, can, in an instant, preserve what

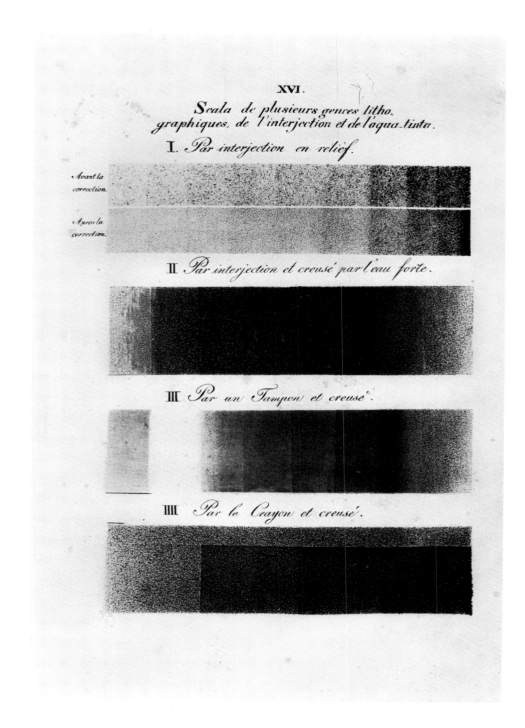

copies they may want of their accounts or tables. In short, there is scarcely any department of art or business, in which Lithography will not be found of the most extensive utility.''

The young Aloys Senefelder was, however, probably thinking in commercial rather than artistic terms—and most especially of his own business difficulties—when he began to experiment in Munich with stones, acids, and greasy inks. The forty-four-page entry on Lithography in the *Enciclopedia delle Arti e Industrie*, published in Turin in 1885 by the Unione Tipografico-Editrice Torinese and entrusted by the director, the Marchese Raffaele Pareto, to Signor Doyen Camillo, begins as follows: ''A result of chance stimulating an innovatory and reflective mind, lithography was born in Munich in the year 1798. Aloys Senefelder, first a student at Ingolstadt University, then an artist and dramatic writer, the sole sup-

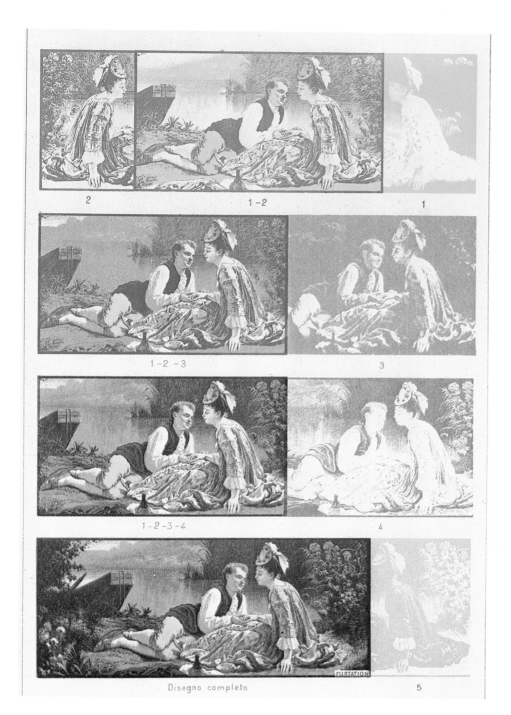

2 1-2 1

1-2-3 3

1-2-3-4 4

Disegno completo 5

The plate opposite, included in Senefelder's treatise, gives a practical indication of the range of results obtainable by the different lithographic modes and the possibilities of correction offered by resorting to several procedures. The plate on the right is taken from an edition of the *Enciclopedia delle Arti e Industrie*, published in Turin in 1885 by the Unione Tipografico-Editrice Torinese. It illustrates the superimposition, on the same print, of the impressions made by stones bearing four different basic colors, so as to obtain a color lithograph.

port of poor parents and numerous brothers, was its modest discoverer. The invention's origins lay in his having observed, during certain researches that he was conducting in a different field, the fact that a number of drops of oil adhered to a few words traced in greasy ink on a small sheet of paper smeared with a rubbery solution.'' Senefelder was born in Prague in November 1771 and was barely twenty-seven years old at the time of his momentous discovery. His father, Peter, born in Franconia, was an actor in the Royal Theatre in Munich, and his son would have followed the same career had his father not expressly forbidden it. With a heavy heart he therefore enrolled in the law faculty, although, driven by his passion for the theater, he occasionally took the opportunity of acting with small companies and also writing dramatic texts. In his own memoirs he says that his early years were dogged by misfortune: he lost his father in 1790, and for

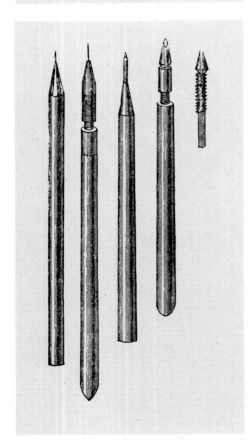

two years, despite the success of one of his comedies, he knocked in vain on the doors of a number of theater managers. Having decided to try his luck as a writer of theatrical pieces, he discovered that the printing of his works was costing him more than he could afford. In the meantime, he had been learning typesetting and had become so enthusiastic that he proposed to set up a small personal printing works, thereby becoming author, printer, and publisher of his works. Lack of funds forced him to abandon this ambitious project, however. It was at this point that Senefelder happened to come across the piece of limestone in his studio and discovered, quite by chance, how water and greasy inks behaved on its surface. When he sensed the possibility of a practical application of his discovery, he was not thinking in terms of graphic art but rather of music—in the use of his invention as a means of printing musical scores, which were in great demand at the time. His modest success in this field encouraged one of his customers, the Reverend Steiner, to suggest that he lithographically reproduce a number of images for a catechism to be used in schools. The first results were only mediocre, but the idea of lithographic printing, encouraged by its energetic inventor, began to gain followers.

Senefelder, mindful of lithography's commercial potential and of the competition already beginning to emerge, in 1799 obtained exclusive rights to the process from the Elector Maximilian Joseph of Bavaria; in the meantime he had also founded, with Gleissner, the first Lithographic Institute in Munich. He then began the process of perfecting his technical equipment and, in 1800, he lodged his *Complete Course of Lithography* with the Patent Office in London. The first and most far-reaching effect of the new process was felt in the field of music publishing, but what impressed and fascinated people most was the speed (about three hundred sheets per hour) and accuracy with which scores could be reproduced. The first major contract that Senefelder entered into was with the music publisher and seller Johann André, who had a printing house at Offenbach on the Main. Senefelder and Gleissner sold André the lithographic process for 2,000 florins and went to Offenbach to equip a printing press and train the workers. This joint venture was important both because the invention could be spread more easily into the other countries of Europe from Offenbach and also because the two groups (Senefelder, his brothers Theobald and Georg, and Gleissner, on the one hand, with André on the other) aimed to penetrate the markets of Paris, London, Berlin, and Vienna as part of a carefully conceived industrial plan. Although this overall scheme never passed beyond the planning stage, the indefatigable Senefelder did go to London, where he stayed for the whole of 1801. There, he was surprised to find that the English textile industry had already developed a lithographic process for the color-printing of materials similar to the one evolved at Offenbach. Having obtained a patent in London in 1801, Senefelder then traveled to Vienna, where he formed a limited company with Von Hartl, a representative of the imperial court, and where he suggested to his new associate that they should acquire the rights to the musical scores of certain composers, among them Beethoven. Essentially, however, Senefelder was more interested in applying his lithographic process to the textile industry than to either music or the figurative arts, since he foresaw greater profits in that sector. But his excessive optimism and rash commercial overexpansion led to the enterprise encountering severe difficulties. In Munich, around 1807, together with Baron von Aretin, Senefelder had opened a new printing works that ran into almost immediate competition from a state-run lithographic enterprise, and his entire venture began to waver.

Opposite, above: The first fossil bird (*Archaeopteryx*), found in the caves of Solnhofen in compacted limestone, the same stone that Senefelder used for the first lithographic experiments; center: a stone with a handle, formerly used to smooth lithographic stones by hand; below: burins with steel points or with chips of diamond embedded in their tips, used for the first outlining of the drawing on the stone. Top, from left to right: Steel pen, scissors to sharpen the nib, and two scrapers, all of a type in use during the nineteenth century. Above: Roller for delicate halftint work.

The rest of Senefelder's private and business life lies beyond the scope of this book. As an entrepreneur, he was perhaps somewhat lacking in level-headedness in that he proved unable to keep control over the process he had invented and developed. After many disappointments, he is recorded as having been given the royal appointment of Inspector of Lithography for Bavaria, but he soon forsook this post in order to go to Paris to find out what progress his invention had made in the artistic field, which he had so misguidedly neglected. In France, he attempted to revive his fortunes but was unsuccessful, and he subsequently returned to Munich, where he died on February 26, 1834. Chance and intuition had together presented him, at an early age, with a revolutionary discovery whose importance he suspected but did not properly understand. Among the bitter blows he had to endure was to see the originality of his invention disputed. In fact, before and during the years when he was perfecting his process, many experiments along the same lines were being carried out, both in Munich and elsewhere. Some journals of the day attributed the invention to Paris or London. It was partly for this reason that the director of the Munich Academy, Frederic von Schlichtegroll, asked Senefelder to write his treatise and course on lithography; it was, in fact, in his preface to the work that Von Schlichtegroll refers to the "rumors circulating, even in Munich, that attribute the invention to both Aloys Senefelder and also to Dean Simon Schmidt of Miesbach, formerly a professor in Munich." Schmidt, who was passionately interested in natural science, had indeed become involved in the engraving of writing on stone, as is verified by a letter written by him in 1810; in his memoirs, Johann Christian von Mannlich, director of the Royal Museum in Munich, credits Schmidt with the "discovery" and Senefelder with its "employment in printing music." Senefelder, however, stated that "although believing the word of Dean Schmidt, if he is able to maintain in all honesty that he printed on stone before July 1796, his printing process was, in fact, different from mine." The question of who was first became a subject of endless debate, and there were many who took Senefelder's part solely because the dean, a fine naturalist, had been preoccupied with the lithographic reproduction of drawings. In reality, it has to be admitted that neither Schmidt's capabilities nor his achievements bear comparison with those of Senefelder.

In the tangled accounts concerning the origins of lithography, other names have also been mentioned—Niedermayer, Reihl, Strohofer, Von Schlotheim, and the excellent Berlin lithographer Wilhelm Reuter—all of whom, almost at the same time as Senefelder, were involved in lithographic reproduction. It often happens (as in the case of the telephone and the radio) that an invention or, more precisely, an instinctive response to a pressing need for some better technical solution to a particular problem, will emerge at the same time in different places and in the workshops of different researchers; it is, however, the actual practical application of an idea that turns it into a useful invention. That Senefelder had solved the technical problems and found a worthwhile use for lithography can be deduced from his treatise, in which he affirms that he is able, with only three presses for printing music, to "print six thousand sheets per day." In the same work, he stresses what in his opinion is the true novelty of his lithographic process, which lies not so much in the engraving or in the working of the stone, but in the "chemical method" that allows for the print's execution: "Here it does not matter whether the lines be engraved or elevated; but the lines and points to be printed ought to be covered with a liquid, to which the ink, consisting of a homogenous substance, must adhere,

according to its chemical affinity and the laws of attraction, while, at the same time, all those places that are to remain blank, must possess the quality of repelling the color. These two conditions, of a purely chemical nature, are perfectly attained by the chemical process of printing.... Upon this experience rests the whole foundation of the new method of printing, which, in order to distinguish it from the mechanical methods, is justly called the chemical method; because the reason why the ink, prepared of a sebaceous matter, adheres only to the lines drawn on the plate, and is repelled from the rest of the wetted surface, depends entirely on the mutual chemical affinity, and not on mechanical contact alone.''

DEVELOPMENT AND PERFECTION OF TECHNIQUE

Those Parisians who in the mid-nineteenth century bought several thousand copies of the periodical *Le Charivari* from their local newsstands and scanned in amusement the satirical cartoons lithographed by Daumier were certainly not aware that they were holding works of art in their hands or that Daumier was raising lithography to unimagined heights.

Nor should it be imagined that they regarded as ''art'' the color posters, each bearing the signature of Toulouse-Lautrec, which a few decades later adorned the streets of the French capital. Lithography had, in fact, been invented in Munich for a completely different purpose. When, in 1809, Senefelder published and distributed, for promotional reasons, his *Highly Important Communication Regarding Lithography*, he gave twenty-four examples to illustrate the different ways in which his invention could be used and to show how many potential applications it had. ''We are,'' he declared, ''dealing with an art that can compete both with engraving on copper or wood and also with printing, and which in many cases has already surpassed them in beauty and purity of execution, as well as possessing all the advantages of speed and lower cost.'' An imitative and repeatable process, producing indisputably competitive results—this was Senefelder's commercial goal. ''And,'' he added, ''it will be of incalculable advantage in the textile industry. Thanks to this process, almost any design will be able to be transferred, in three days at the outside, onto plates and rollers ... in this way lithography will make patterning extraordinarily cheap.'' His suggestions produced a positive reaction, and the process was soon being used for printing programs for concerts and horse races, for documenting the latest news events, for maps and for botanical and archaeological illustrations, thereby inaugurating wide-scale popular illustration.

Color lithography

In 1732, more than sixty years before the invention of lithography, Jacques-Christophe Le Blond, clearly bearing in mind Newton's studies on the analysis of the colors of the solar spectrum, produced some fine three-color prints from copper engravings, employing a technique that involved the use of several plates and that was later perfected over succeeding years. From its start, lithography also tackled the problem of color because of the specific requirements of the market (programs, posters, printed textiles) at which it was aimed, but without any great artistic pretensions or, at the very most, with a concern for stereotyped, popular needs. Senefelder, in fact, promised copies of oil paintings ''which nobody will be able to say are prints.'' The demand for color prints was so widespread, and the potential for them so great, that while the processes of chromolithography were still

From its outset, lithography was used for the reproduction and dissemination of works from the art collections of major museums. Above: The frontispiece and a plate from an album of lithographs by Strixner, dedicated to Dürer. The first printers regarded lithography primarily as a means of printing for commercial and educational purposes; only later was it realized that the lithographic stone could be a means of artistic expression in its own right.

in the development stage and were slowly being perfected, thousands of black-and-white lithographs were being hand-colored. The technical lithographic difficulties were considerable; although it was relatively simple, using two stones, to link one shade with another, the process became more sophisticated if, along with the number of colors, the number of stones was also increased. Senefelder did, however, succeed in producing a lithograph with eleven stones, each of which printed a separate color; printing by means of the superimposition of three primary colors (yellow, red, and blue), which is the basic solution, seems to have been attempted with modest success by Franz Weishaupt in 1825, also in Munich.

It is the process of superimposition that makes chromolithography possible, and if one has to speak in terms of inventors and choose a single name from all of its many practitioners, then pride of place would have to go to Godefroy Engelmann, who in 1837 sought and obtained a patent for "Lithocolor printing or lithographs in color imitating painting," where mention is made for the first time of chromolithography. Engelmann was given an official prize in 1838 for his "discovery," having presented an album containing examples of chromolithographs produced entirely on a press (with no need for further retouching by hand); he said that he was convinced that he had opened "a new era" in lithography with his technically simple process, whereby any competent black-and-white lithographer would be able to produce prints in color. Setting aside the question of who discovered the technique first, which has been a subject of controversy among historians, the decisive fact is that Engelmann used the superimposition of the three primary colors as the basis for obtaining his other

colors, with the addition of a fourth stone for the color black. It is also worth noting that the prints were produced on dry paper. Like black-and-white lithography, chromolithography was geared toward commercial usage (posters, for example); it also attracted true artists, who molded it to their own personalities, their own "touch" (men such as Jules Chéret and Toulouse-Lautrec). It is clear that from the beginning chromolithography created a somewhat oleographic illusion, producing cheap reproductions for the mass market and yielding to the temptation of providing "artificial" substitutes for the real thing. To some extent it served merely to furnish copies of original works of art, thereby contributing, however unintentionally, to the spread of bad taste.

It was not until the time of the French Impressionists that any major development in the stylistic and aesthetic approach toward color lithography took place, and this reassessment gained even greater momentum following the advent of the Cubists, the Expressionists, and the Surrealists. Color lithography, which until around 1870 was used mainly for commercial purposes, could, like all other forms of lithography, also be produced on metal (zinc and aluminum) and transfer paper, as well as on stone. Obviously it is possible, when printing in a series of superimposed colors, to add to the number of stones (or plates) in order to achieve a wider range of shade and color, but the quality of a lithograph does not depend on its number of colors. Many nineteenth-century chromolithographs, despite the number of colors and stones used in their production, lack any real aesthetic personality for the simple reason that they are attempting to imitate either an oil painting or a watercolor. Quality, regardless of the range of colors used, depends solely on the precisely judged relationship between the artist's imagination and the color on which he relies. And this interaction depends of necessity on the artist's technical excellence and manual dexterity, which combine to produce clear evidence of a personal "touch." Since color lithography allows the artist to transcribe the whole range of his chromatic sensibilities, this explains why most artists prefer it. In fact, when compared to lithography, other processes do not permit the same variations of color—least of all silk-screen printing, which virtually ensures the abolition of any personal touch. It should, however, be added that the technical procedures involved in color lithography—the separation of the plates containing the different colors and the inevitable wait for their completion, the need to correct and modify them, the gaps between the different stages—can be difficult for the artist. It is during this progression, when the artist feels deprived of any sense of immediate contact between what he has set out to achieve and the final result, that the collaboration of the printmaker is of such importance.

Photolithography

During the first half of the nineteenth century, while lithography was being perfected, photography was born out of the work of Daguerre, Bayard, Talbot, and Goddard, with the latter being responsible for the introduction of silver bromide as a means of sensitizing the plate. It was impossible that the two discoveries, both of which were concerned with the multiple reproduction of images, should not find some point of convergence. This likelihood becomes even greater when one thinks that, at the beginning, it was a lithographer, Joseph Nicéphore Niépce, who tried to transfer an image onto a plate. In its very name, photolithography includes the presence of a lithographer's stone: its goal was to fix onto this stone the shapes drawn by the light on sensitized glass so as to be able to reproduce them in limitless

quantities. It would seem that the first successful attempt at the application of photography onto stone should be credited to Armand Séguier; however, in the use of greasy ink to print an image that had not been hand-drawn but obtained with the assistance of light, the most positive results were obtained by the Parisian lithographer Lemercier. His work was matched by that of Lerebours and Bareswil, but their solutions did not prove satisfactory until, in 1856, Poitevin discovered the reactive properties of certain materials (bichromate gelatin) when subjected to the action of natural or artificial light.

To be more precise, Poitevin's researches led to the printing process known as "collotype," but he himself called his idea of creating an impression on bichromate gelatin by means of greasy inks "photolithography." The collotype process first used copper plates as a vehicle for the gelatin, but these were later replaced by very thick glass sheets or ones made from zinc or aluminum. It should be pointed out that for those involved in photomechanical reproduction, collotype seemed, and in a certain sense still seems, to be one of the most attractive processes: the prints that it produces do not betray the presence of the reticle but display a grain so fine as to be visible only under a magnifying glass; the halftones are reproduced delicately and faithfully; the full tones can be as vibrant as those obtained from copper engravings; and three-color sheets produce excellent results. Photolithography, too, can make use of metal sheets as well as stone (nowadays aluminum ones are favored), and technical advances can provide for the fixing of the image from a negative onto a sensitized metal plate and also for the ensuing transfer of the image onto the lithographic stone. The fixing of the image, whether onto stone or metal, can be carried out either directly or by the transference of an image obtained previously on suitably sensitive paper (photolithographic paper). Once the transfer has been effected, the final operations are the same as in normal lithography. There are also many technical links between photography and lithography, but their lengthy discussion and enumeration lie beyond the scope of this book. There is, however, one substantial difference between the two processes: whereas in lithography the personality and actual "touch" of the artist are indispensable ingredients, photolithography is the result, however brilliant, of a chemical process, without the complicity of the artist-lithographer. Thus a painter can give the printer a drawing, a painting, or even a color slide of one of his works in order to have photolithographs produced. There can be no objections to this process if the resulting prints are marketed as photolithographs, but there are grounds for serious objection when these works, obtained either by photographic techniques or by other methods that bypass any direct contact between the artist and the plate (metal or stone) or the transfer paper, are offered, complete with signature and number, as though they were original lithographs.

The extraordinary technical advances made in the field of printing and the subsequent increase in quality of the photomechanical product have in recent years (often, regrettably, with the connivance of the artists) created impossible problems, even for dealers and art experts acting in good faith. This confusion is aggravated by the increasing demands of a market that is not only gullible but also clearly incapable of sophisticated and detailed analysis. Additionally, in cases where the artist, by adding his own signature, has authenticated the work, the purchaser has, in practice, no possibility of redress.

There is, finally, an ideological argument that the widespread propagation of artistic images leads to the cultural "conversion" of the uninitiated and so to the attainment of a laudable educational and social goal, making

Two famous documents. Below: Nadar, the noted pioneer of photography, with top hat and binoculars, in a picture taken by himself in the nacelle of a hot-air balloon in 1861. Shortly afterward, Daumier dedicated an ironic lithograph to Nadar bearing the legend: *Nadar raising photography to the level of art* (right).

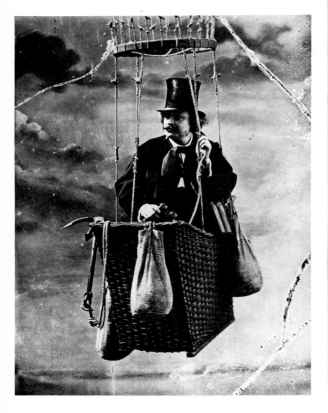

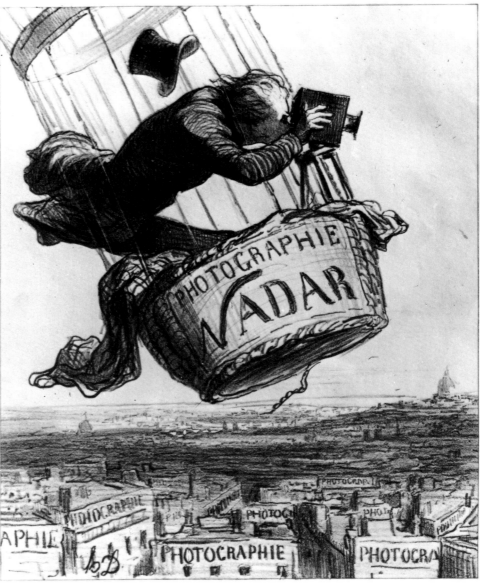

the work of art a source of popular enjoyment as well as a means of encouraging artistic appreciation. The annals of the twentieth century have, quite justifiably, already opened a separate chapter to deal with photography, since the camera lens is certainly able to fulfil a creative role; they will obviously also record the most important successes achieved by photolithography and its related techniques, and even more so when one considers that many artists have used photographic processes as a springboard for further expressions of their art. This book, however, does not deal with such developments, quite simply because it is concerned with lithography as a means of artistic expression. Nowadays, art photography and art lithography follow two separate courses, gearing themselves to different markets: the former, having been co-opted by the mass media and the advertising industry, now floods the visually obsessed world in which we live, while the latter remains the preserve of a few *aficionados*. In the nineteenth century the two techniques were, for a certain period, at daggers drawn. In 1861, the famous photographic pioneer Nadar (Gaspar-Félix Tournachon) photographed himself with top hat and binoculars in the nacelle of a hot-air balloon; shortly afterwards, Honoré Daumier translated this photograph into an ironic and very beautiful lithograph, which he entitled *Nadar raising pho-*

tography to the level of art. Seen in the context of today, Nadar's photograph is a historical document, whereas Daumier's print forms part of the history of lithography as an art form.

The offset process

In order to complete the historical evolution of lithography, mention should be made of the discovery of the offset process, which brings us to an industrial type of lithography. It is an indirect method of printing because the image, instead of being pressed directly onto the paper, is first transferred onto rolls made of an elastic substance against which the paper passes. The speed and therefore the economical nature of this technique have led to the complete industrialization of color and black-and-white lithography, with exceptional applications in publishing (books, magazines, catalogues, posters). The discovery of the practical potential of the rubber roller and of the quality of its results was a matter of pure chance. In 1904, Rubel, a lithographer in Nutley, New Jersey, discovered the principle of indirect printing while producing a collotype on his press. The roller with which he was working was covered in a layer of rubber, and one day one of his workers forgot to insert the sheet of paper destined to receive the print, so that the rubber received the impression instead, with the result that the next sheet was printed on both sides. Rubel noted that the impression from the rubber was, for his purposes, much more satisfactory than the one he had been obtaining, and from this he formed the idea of a rolling press, with a metal printing cylinder and a rubber transfer cylinder. The offset technique, with its system of indirect printing, in time spread beyond the United States into Europe (particularly Germany), with continual technical refinements and improvements being made. Although it has provided the printing industry with extraordinary scope, it has never been able, however, to make any worthwhile contribution to art lithography.

STONE, METAL, TRANSFER PAPER

The compacted limestone of Solnhofen in Bavaria, from whence the first lithographic stones were obtained, is the rock in which the first fossil bird, the *Archaeopteryx*, was discovered. It is a hard limestone (specific weight 2.8834), composed of calcium carbonate (97.22 percent), silica, alumina, and ferrous oxide. Calcium carbonate is easily found in the earth's crust, but it is rare to find it in the almost pure state in which it occurs in Bavaria (in Solnhofen and Kelheim, for instance). Good lithographic stones are also to be found in France, Italy, and elsewhere. Their suitability is determined by their ratio of width to thickness, their weight, and the homogeneity and uniformity of their color. The best ones absorb water at a slower rate than the others. As for color, the white stone is rather soft, which means that the print will tend to "flatten out" when a long run is involved; the yellow is generally good; the bluish gray is considered ideal because it is compact, easy to granulate, and stands up well to heavy pressure and long runs. The dark gray is also good, whereas the reddish type is regarded as poor. The most common defect found in stones is veining, with crystalline veins being particularly bad. Other defects are alterations in color, which can confuse the artist working on the stone, and unevenness in texture, due to small white spots of a softer, chalky substance, which leads to irregularities in the print. Less harmful are imperfections arising from stains, providing that they are only minor and not surrounded by a "halo." Lithographic stones vary in size and should have perfectly parallel surfaces that are carefully leveled before being polished and granulated.

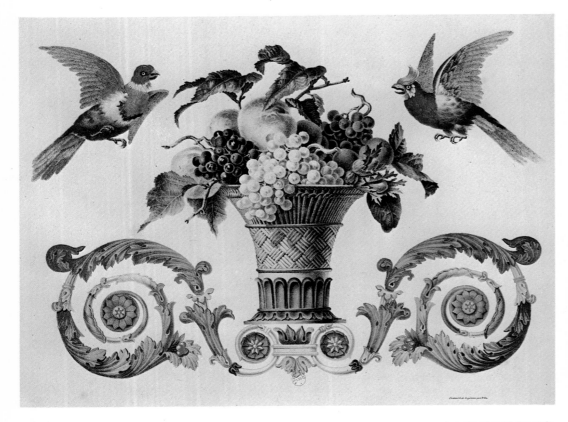

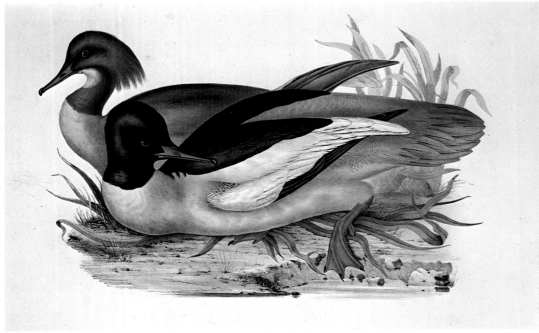

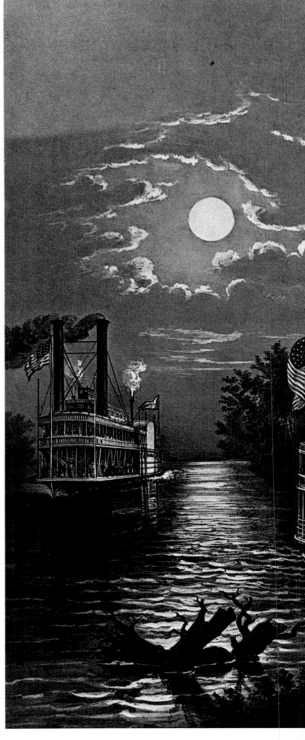

Top: *Bowl of Fruit with Two Birds*, by the French lithographer Godefroy Engelmann, who in 1836 patented a chromolithographic process. Above: *Goosander*, from the series *Birds of Europe* (1832–37) by John Gould. Opposite: *"Wooding up" on the Mississippi*, a hand-colored lithograph printed in 1863 by the publishers Currier & Ives, who during the closing decades of the nineteenth century produced thousands of popular prints portraying aspects of American life.

Because of their weight and unwieldiness, lithographic stones can be inconvenient, which is why they are often replaced by relatively thin zinc or aluminum plates that have been mechanically ground in order to render their surfaces porous. The use of zinc plates was suggested by Senefelder as early as 1818 and was soon adopted by lithographers in Germany, France, England, and Italy, whereas aluminum did not become widely used until 1891. Lithography using metal plates became commonplace only after the invention of the rotary offset press. The principles of metal lithography are similar to those of "true" lithography, but there are differences in the design process and the preparation of the plate and also in the end product.

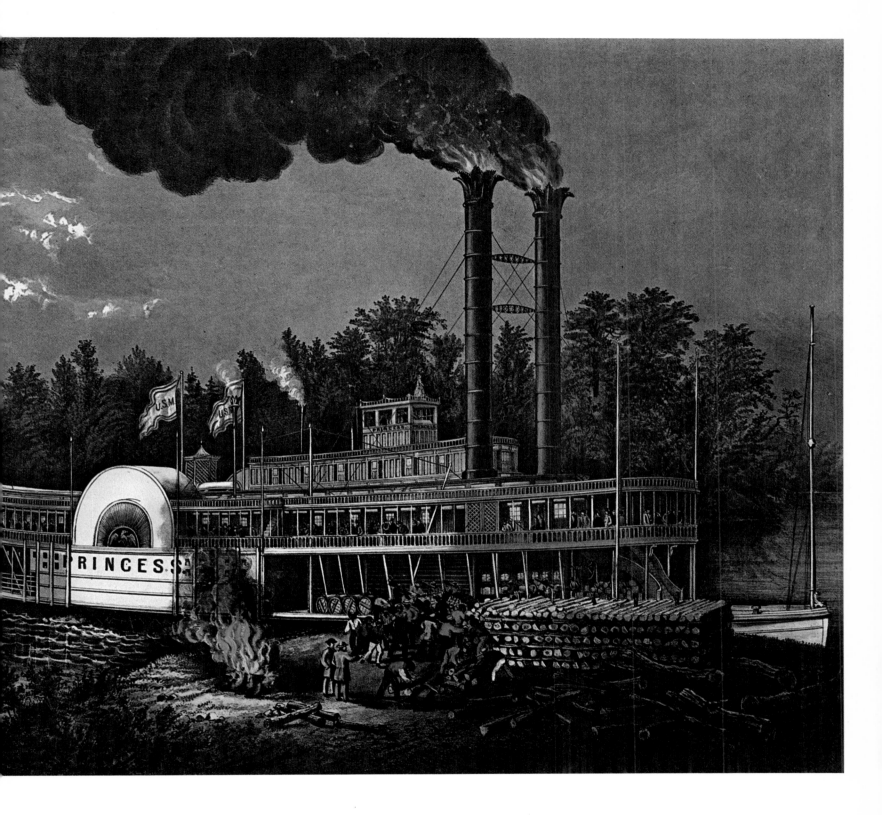

The drawing on metal, for example, is treated with solutions whose chemical components are different. Collectors of lithographs should be reminded that prints taken from metal vary slightly in graininess from those taken from stone. An artist may draw lithographically on metal plates made of either zinc or aluminum, with the preparation of the plate's surface being designed to enhance the absorption and retention of water and to give the final image greater stability. There are also plates prepared with a photosensitive surface for those intending to mix photographic techniques with drawing. Metal plates are lighter, more convenient, and less costly than ones made of stone, they allow for certain visual effects that are unobtain-

able with stone, and they are useful as an adjunct to stone in the printing of color lithography. The main difference between stone and metal, however, is that the latter lacks any natural porosity, which is provided to a certain extent by granulation; since the image drawn has consequently a lesser chemical penetration, the printing process requires a great deal of care to ensure the stability of the image. There are certain subtle differences between zinc and aluminum as regards the physical and chemical behavior of the plate; from the artist's point of view, aluminum has a paler surface, which makes it easier to see differences in shading, and drawings done on it bear a closer resemblance to those executed on stone. Similar conditions are not provided by zinc, which is darker in color.

Lithographic pencils and inks can be used to draw on paper as well as on stone and metal plates. When a lithograph is executed initially on one surface and then transposed onto a second in order to be printed, the process is known as "transfer lithography," with the paper that is used being called "transfer paper." It is a process that has been employed since the very start of lithography and one that has been continually improved upon over the years. It offers clear advantages in that the artist can avoid the manual difficulties posed by the stone and also work in his own studio. Transfer paper was often used—particularly in the early stages of lithography—by artists such as Fantin-Latour, Redon, and Toulouse-Lautrec, and it has been further refined and adapted by many modern artists, among them Picasso and Chagall, in order to achieve new and different results. Among the advantages offered by transfer paper, apart from greater naturalness and fluency, is the fact that an unsatisfactory or unsuccessful drawing can be redone on another sheet of paper, whereas a stone has to be cancelled and eventually subjected to another grinding-down process. Furthermore, the artist can see what he is drawing in the same way as it will appear on the final print: the image is not reversed, as happens when it is drawn directly onto the stone or metal plate. The same drawing can also be used to obtain a series of variations on a theme. It should, however, also be pointed out that some quality and shading are lost in lithographs obtained by the transfer process because of the necessary roughness of the original paper: the transposed image rarely possesses the softness of touch preserved by the technique of "direct" lithography. This loss of quality, however subtle, means that the final result is somewhat lacking in precision and also seems slightly less lively. The experienced eye can, on the basis of these differences, establish whether a lithograph has been produced on stone or on transfer paper. The process is not, therefore, a substitute for "direct" lithography but an extension of it. Transfer paper, either treated or untreated, occurs in many different forms, and in order to achieve the best results it is important to select the type specially prepared for one's purpose.

LITHOGRAPHIC PAPER

The paper used for printing lithographs is not just a minor detail in the final stage of the process: it plays an important part in determining the quality of the end product, since its characteristics can "make or break" a print. There are three basic qualities that the paper must possess: flexibility, a compact surface, and an ability to absorb ink correctly. Flexibility enables it to stick firmly and uniformly to the printing surface; compactness serves to prevent the lithographic ink, which is very sticky, from detaching particles of fiber that would stick to the printing plate. Correct absorption of ink is important for aesthetic reasons: the printed image ought to create

A *View of Stockholm* (1850) by C. J. Billmark. These "views," a genre in which numerous European artist-lithographers distinguished themselves, created a market among the better-off and also paved the way for mass-circulation images. Lithography began to assert itself as a valid art form when it replaced drawings "transferred" onto the stone with original, "directly drawn" pictures.

the illusion that it forms part of the paper and is not just resting on its surface. The paper also possesses expressive qualities through its color, its surface texture, its thickness, its tactile nature, and its reaction to light —qualities that combine with those of the actual lithographic process. The highest-quality paper is most frequently made by hand.

SIGNATURES AND NUMBERS

When, after several attempts, the artist and the printer are convinced that a lithograph has been perfected, it is customary for the artist to place a so-called *bon à tirer* onto the stone in its definitive state: all subsequent prints drawn from the stone are then compared with this in order to eliminate unsatisfactory versions. This prototype is generally kept at the printer's, and since it is unique and also, for obvious reasons, of optimum quality, it tends to have a greater commercial value than the prints from the rest of the run. The artist signs or initials the lithograph either in the margin or in the printed area, although he may sometimes sign it on the back. The prints are also numbered; if the run consists of a hundred prints, then they are numbered 1/100, 2/100, 3/100, and so on. These numbers have no qualitative significance, however, since each print should be identical to the *bon à tirer*. In fact, a lithograph bearing the number 1 cannot differ from another lithograph from the same edition bearing the number 100, and even a print numbered 1/100 is merely an indication that it forms part of an edition of a hundred. When a lithograph is colored, sequential numbering, even if it is done at the printer's, has no meaning because the prints are never produced in the same order when the colors are applied one on top of the other. Sometimes part of an edition of a lithograph is produced on

different, higher-quality paper, and these special editions are given Latin numerals, such as I/XXX or II/XXX. When the run has been completed, if there are prints of outstandingly good quality, then these may be signed "artist's proof" (*épreuve d'artiste*) or *hors commerce* (abbreviated to *h.c.*). These "proofs" are sometimes planned in advance and eventually printed on special paper. Prints taken before the *bon à tirer* are called "printer's proofs": they are of lesser quality solely in that the impression may be somewhat weak or there may be small errors in the inking. "Trial proof" is the name given to a print that records alterations made by the artist to the plate, whether stone or metal, but the term can also apply to one that shows the result of accidental changes made to the plate during the printing process. "Progressive proofs" refers to prints that document each individual color of a color lithograph, while "cancellation proofs" are printed after the entire edition has been completed and after the plate has been visibly and decisively altered. Many quality lithographs also carry, as a guarantee of authenticity, the stamp, the signature, or, even better, the punch mark of the printer.

THE ROLE OF THE PRINTER

Since the earliest beginnings of lithography, the printer has never been just a craftsman specializing in plates and presses: his experience and his enthusiasm in cooperating with the artist have contributed to the quality of lithographic prints in a way that can be historically documented. There have been artists who, having learned the necessary technique and obtained a press, plates, inks, and all the other relevant equipment, have become their own printers as well as lithographers. In this way they have solved the basic problem of the inconvenience caused by having to work in public, amid all the noise of a workshop and without the possibility of being able to concentrate fully. Yet if these obstacles are resolved by an intelligent attitude on the part of the printer and by his being on call when needed, the resultant partnership has always proved a very fruitful one. Lithography is, at heart, a simple process, but it also possesses some technical complexity, and numerous problems may arise during the undertaking of the work. It is in such emergencies that the printer's experience comes into play, and his advice can lead the artist to seek some different solution, even on an aesthetic level.

Patience and confidence on the part of the printer and artist, together with a feeling of resoluteness, have succeeded in producing results that plate and ink alone could not have achieved. The story of lithographic art is undoubtedly also the story of the printers, not just in the early, trailblazing years but right up until the present day as well (one thinks of the achievements made during recent decades in the ateliers of France).

THE PIONEERING YEARS

Within little more than twenty years of Aloys Senefelder's invention, lithographic workshops and presses had opened in all the major cities of Europe, and in 1818 the new skill crossed the Atlantic and reached America. Senefelder then became involved in intense promotional activity: after having set up lithographic printing works in Munich and Offenbach and having obtained exclusive rights to the process in Bavaria, he intended to obtain immediate patents in England, France, and Austria, his ambitions being, as we have already noted, clearly commercial rather than artistic. In this program of expansion he was greatly assisted by the family of Johann André, the music publisher from Offenbach with whom he had estab-

Above: Frontispiece of the lithographic album *Viaggio pittorico nel Regno delle Due Sicilie*, printed in Naples between 1828 and 1833 and dedicated to Francesco I. Right: *Forest Fire* (1829) by Cesare Benevello della Chiesa. These romantic ''journeys'' through the countryside proved very popular and, over a number of years, they involved the printers and draftsmen of Europe in lengthy publishing enterprises.

lished an agreement. In fact, when Senefelder went to London in 1800 he was accompanied by Johann's brother Philipp, who stayed in England to run a lithographic printing business. Another André, Frédéric, opened a workshop in Paris in 1801. The lithographs of these early pioneers were known as ''polyautographs,'' and the first ones to have any obviously artistic pretensions were printed in London by Philipp André, who in 1803 published his *Specimens of Polyautography*, which contained twelve lithographic prints by the same number of English artists. In the same year, in Paris, Frédéric André printed an original polyautograph by Pierre Bergeret. In Berlin, the following year (1804), Wilhelm Reuter exhibited a series of *Polyautographische Zeichnungen vorzüglich Berliner Künstler*. It was probably in that same year that the introduction of the pencil or crayon technique in place of pen and ink attracted a great number of artists to lithography, for the new method permitted subtle shading and transparency of light and shade, producing chiaroscuro effects that were particularly suited to Romantic expression. In his book entitled *La Gravure des origines à nos jours*, Jean Adhémar refers to the first lithographic experiments in Europe as ''christened somewhat pompously the incunabula of lithography,'' but nevertheless he sees them as worthy of consideration even though ''almost solely second-rate talents ventured into a still virgin territory that needed true innovators and not merely *dilettanti* to give life to the process.'' During the early years, undoubtedly, artists

felt little confidence in the lithographic stone; however, the passionate enthusiasm of these pioneers should be recalled because they succeeded, within a very short time, in advancing the course of this new art to an extraordinary degree.

THE FIRST LITHOGRAPHERS

In his *Histoire de la lithographie*, Weber records that it was a cousin of Johann André of Offenbach, called François Johannot, who sought to use lithography "as a new technique of graphic art" and in fact, in 1802, Johannot printed a *Landscape of Ruins in the Manner of Piranesi*. Yet it was the German painter Wilhelm Reuter (1768–1834) who was the first artist to make any notable contribution to lithography. In his album published in Berlin in 1804, there were, as well as some of his own lithographs, others signed by Schadow, Genelli, Baudoin, Bolt, Frisch, Schlotheim, and Müller. Another album, published in Munich in 1804 by Mitterer, had a primarily didactic aim and contained drawings by Simon Klotz (who did a portrait of Schelling and then a series of Italian landscapes, as well as an illustrated life of Christ) and by Johann Mayerhoffer. Among the most outstanding of the Munich lithographers were the Quaglio brothers, while mention should also be made of Joseph Anton Koch, an artist who lived for a long time in Rome, where he died in 1839, and who was the author of *Il monte Sabino con il monastero di Subiaco*. The development of German lithography was greatly assisted by Strixner's lithographic reproductions of some forty Dürer drawings, which were published by Senefelder in 1808. This beautifully executed series so pleased Goethe that he did his utmost to ensure that a lithographic institute and workshop were opened at Weimar as well. The realization that the new process could be used for the reproduction of great works of art meant that for a certain period of time German lithography stressed this kind of work. The director of the Munich Museum, Johann Christian von Mannlich, who had taken over the workshop granted to Baron von Aretin by Senefelder, published a series of drawings of Old Master paintings belonging to the royal Bavarian museums under the title of *Lithographic Works*. This edition, with drawings executed by Strixner and Piloty, enjoyed a great success and was reprinted on several occasions. Further series along similar lines featured other collections, and in 1820 many works from the Albertina in Vienna were also lithographed. This idea of Mannheim's—to use lithography as a means of granting universal access to artistic masterpieces—has remained one of the mainstays of art publishing, and even today, following the advances made in the field of color photolithography and the high quality of the results achieved, it continues to contribute to the widespread appreciation both of masterworks from past centuries and also those from modern times. Von Mannlich (1741–1822), as well as being a promoter of lithography (he had a lengthy correspondence with Goethe on the subject), was also himself a lithographer of some talent.

In London, as has already been mentioned, a lithographic workshop had been opened, under royal patent, by Philipp André. For his first sample album, André had obtained the collaboration of Henry Fuseli, Richard Cooper, and other artists. Horses, a constant subject for English graphic art at all levels, were lithographically portrayed for the first time by artists such as Konrad Gessner. His prints, like those produced in 1817 by the Frenchman Antoine-Jean Gros, presage to a certain extent the later equine masterpieces of Géricault. Also in London, Rudolf Ackermann, the En-

Opposite: Two Italian lithographs from the first half of the nineteenth century. Above: Lithographic version by Giuseppe Elena of a painting by Pelagio Palagi. Below: A lithograph by Michele Fanoli (*Remembrance*, 1833). The first lithographic patent in Italy was obtained in Milan in 1807 by De Werz, a printer from Munich. Evidence concerning the beginnings of Italian lithography is scarce because there was no legal obligation for lithographers to register with the authorities.

glish publisher of Senefelder's treatise (1819), published a *Repository of Arts* in forty volumes. Others among the early lithographers active in England were Richard Parkes Bonnington, who subsequently moved to Paris, and Charles Hullmandel, the son of a German living in London and author of *Twenty-four Views of Italy*, who perfected a method of faithfully reproducing watercolors by means of lithography.

Of the Viennese lithographers, Joseph Lanzedelly (1774–1832) was noteworthy in that he printed drawings of popular scenes of daily life, being among the first to introduce elements of caricature. Lanzedelly also at the same time studied the possibilites of color lithography. Ferdinand von Olivier was the author of several fine landscapes, while Josef Kriehuber was an indefatigable portraitist.

With lightning speed, and with great success both in capturing the attention of the commercial market and in attracting the interest of artists, lithography spread throughout Europe—Milan (1807), Rome and Prague (1810), Madrid and Barcelona (1811), St. Petersburg (1816), Moscow (1818)—and, in America, to Philadelphia and New York (1819).

LITHOGRAPHY IN FRANCE

Jean Adhémar, honorary chief conservator of the Cabinet des Estampes in Paris's Bibliothèque Nationale and author of such relevant works as *La Lithographie en France au XIX^e siècle*, who has also continued the alphabetical register of French engravings since 1800 (*L'Estampe*), begun in the 1930s by Jean Laran, has stated that "Napoleon is perhaps the first Frenchman to have understood all the possibilities offered by lithography." This scholar, however, in considering the overall lithographic production of France during the first fifteen years of the nineteenth century and the signed prints of Boilly, Bergeret, Lejeune, Lomet, Vivant Denon, and others, finds them "still very timid...lacking in that note of directness which we find some years later in those first-rate artists who, at the bidding of Engelmann or Lasteyrie, were to place their signatures beneath drawings that were no longer transferred, but inscribed directly onto the stone." Nevertheless, within the history of European lithography, not only during the last century but also throughout the first half of the present one, French lithography has been so far ahead of the rest of Europe, in both technical development and quality of results achieved, that it is vitally important to take a look at its origins. Wilhelm Weber in the already-mentioned *Histoire de la lithographie*, when speaking of the Napoleonic era and the interest expressed by the emperor in this new method of printing, notes that "it was very important that the true artistic adviser to the Emperor, Dominique Vivant Denon, director general of the museums in Paris, was not content just to encourage lithography, but was also a lithographer himself." Lithographic stones and the relevant processes were introduced into France by Germans: Frédéric André, brother of the Offenbach printer, in 1802 obtained a patent for the "new method of printing." André, who was twenty-two at the time, started by producing sheet music, but his workshop also played host to two draftsmen: Konrad Johann Theodor Susemihl and Pierre-Nolasque Bergeret, a pupil of the painter David, whose lithographs were, historically speaking, the first to be executed in France. Their commercial debut was, however, disastrous, and Frédéric André sold his small workshop to the widow of a paper manufacturer and, most important of all, handed over a number of lithographic stones to Charles Lasteyrie. While the young André was returning to

Susanna and the Elders (1821), a lithograph by the Milanese artist Giuseppe Longhi. Longhi, a professor at the Brera Academy, also executed a large, much-praised lithographic portrait, *Giovane donna di fronte*, which was printed by De Werz.

Offenbach, two other lithographic workshops were trying, without success, to establish themselves in Paris. The first was opened by the musical composer Pleyel, who attempted with the help of the lithographer Anton Niedermayer to become a music publisher, but it ceased activity in 1804. The second was opened in 1806 by André's cousin, François Johannot, but that lasted no longer than a year. In 1807 Frédéric André returned to Paris and opened a new workshop, the most memorable products of which were the prints drawn by Jomard, who together with Vivant Denon had taken part in the campaign in Egypt. Nevertheless, André's second enterprise also foundered, and he handed it over to two of Lasteyrie's friends.

During the same period it so happened that a number of French draftsmen in the retinue of Napoleon's army stopped at Munich and visited the lithographic workshops there. In 1806, Louis-François Lejeune, aide-de-camp to Marshal Berthier, executed a lithograph for Senefelder's press of his drawing entitled *The Cossack*, which many people believe was responsible for reawakening French interest in lithography. In November 1806, Senefelder's press received an outstanding visitor: Napoleon himself, accompanied by Vivant Denon who, as well as acting as artistic adviser to the emperor, was also an ardent draftsman. In 1799 he had drawn the illustrations for the campaign in Egypt and had gained Bonaparte's complete confidence, being put in charge of, among other things, the business of looting Europe of its works of art for transfer to the Louvre. In Munich, a city which he visited on several occasions, Vivant Denon got to know Von Mannlich, the director of the royal museums, and himself made a lithograph of the *Holy Family in Egypt*. It is probable that he was the man responsible for Von Mannlich's nomination in 1809 for honorary membership in the Institut de France. Lasteyrie also had contacts with Munich, and in 1810 the painter Gérard-Fontallard arrived in the city, where he completed two prints, *Portrait of an Official* and *Portrait of a Lady*. Gérard, one of David's pupils, was an artist of considerable talent, and he and Vivant Denon encouraged that fashion for "lithographic portraits" which, over the years, spread through England as well as France. In the meantime, after having worked for years to organize and foster the art of lithography

Above, left: *Magdalene* (1822) by Francesco Hayez; right: A portrait of a woman (1808) by Giuseppe Longhi. Other important lithographic portraitists in Italy were G. Lega and Giuseppe Molteni. Also active in Milan was Rosalpina Bernini, who is regarded as the "first lady" of Italian lithography.

in Paris, Lasteyrie became owner and manager of a printing shop of his own in 1816, shortly after Godefroy Engelmann had begun work as a lithographer in Mulhouse. Engelmann, an enthusiastic pioneer of the new processes, began to display an extraordinary genius for the different techniques of lithography. His prints on colored paper, using two stones, were highly acclaimed by the Society for the Encouragement of the Arts in Paris, and this accolade persuaded him in 1816 to open a printing works in the French capital, which soon attracted men such as Regnault, Mougin, Girodet, and Carle Vernet. These artists were later joined by Evariste Fragonard (grandson of the famous painter), Horace Vernet, and Joseph-Dionysius Odevaere. The roots of the great French lithographic tradition were now firmly established.

PROGRESS IN ITALY

The most complete study of the fortunes of Italian lithography is, in the author's opinion, Augusto Calabi's *Saggio sulla litografia* (Milan, 1958). It is to the information contained in that book that we will refer in the following brief section, especially since many of the useful facts contained in Calabi's book are often omitted from other historical accounts of European lithographic art. Calabi attributes to De Werz, who worked in Milan but originally came from Munich, the first patent obtained in Italy (1807) for the exploitation of Senefelder's invention. Other integrative and substitutive licenses, however, were obtained in 1816 by Giuseppe Elena in Milan and by Müller in Naples, in 1819 by G. B. Gervasoni in Genoa, and in 1820 by Felice Festa in Turin. All the early enterprises were in fact commercially oriented ventures, with the exception of the one started by the Florentine Marchese Cosimo Ridolfi. The earliest dated Italian lithographs (1807 and 1808) are a portrait of the Florentine artist Antonio Fedi and five sheets of scientific illustrations, as well as two landscapes, by Giuseppe

Levati and by Corneo, published by De Werz in Milan. The portrait and the two landscapes, signed by famous painters of the day, can, because of their quality and the deftness of their execution, be regarded as lithographic works of art. During the same years, lithographic prints were also produced by Signora Rosalpina Bernini, who was not without talent and who may well have been Italy's first female lithographer. Another contemporary venture was the Dell'Armi printing works in Rome, but examples of its prints cannot be dated before 1813. Calabi underlines the fact that whereas in France, from 1817 onward, lithographers were legally obliged to register with the authorities, thereby allowing scholars and historians to trace the gradual development of lithography, Italy had no such provision and thus a significant source of information has been denied to later generations. On the subject of landscapes, there is a fine print of a mountainous view signed by Giuseppe Levati in 1808, "a small work of art expressed lithographically," probably the first lithograph of its type in Europe. Giovanni Moja, a Milanese artist, executed a number of panoramic landscapes with considerable sensitivity around 1820; later on, in 1827, landscape was to dominate the historical lithographs produced in Milan by Francesco Hayez and then, shortly afterwards, by Massimo D'Azeglio. Other outstanding works are *Forest Fire* (1829) by the Piedmontese artist Cesare Della Chiesa and a fine view of Milan by the painter Friedrich Lose printed about 1810 by De Werz. Two Milanese views, from the same period, were drawn by Gaspar Gagliari and lithographed by his pupil Giovanni Migliara. The idea of assembling several prints under the heading of a "pictorial journey" arose in Italy following the publication in London in 1822 of Hullmandel's *Britannia delineata*. In Turin in 1822, a group of thirty-three lithographs entitled *Viaggio romantico pittorico nelle provincie occidentali dell'antica e moderna Italia* was printed by Felice Festa as the first of three volumes; in 1826 work began in Milan on *Viaggio romantico pittorico nel Regno Lombardo-Veneto*, drawn almost totally by G. Elena; and in Naples in 1828, the first part of Cuciniello and Bianchi's *Viaggio pittorico nel Regno delle Due Sicilie* was published, the final section appearing in 1833.

Portraiture, which had become popular in France and England, was one of the most sought-after forms of lithography in Italy, even though these works, few of which have survived, were not always of the highest quality. There is a very fine portrait of a child by Antonio Fedi from 1807, while about 1810 the Milanese Giuseppe Longhi produced a large lithographic portrait of a young woman that is considered to be among the most beautiful of the works printed in De Werz's workshop. G. Lega, Giuseppe Molteni, and Francesco Hayez were also lithographic portraitists. Group compositions (two or more figures in a setting) in imitation of oil paintings clearly called for particular technical skill: among those to experiment in this field were the Milanese Rosalpina Bernini, whom we have already mentioned; Valentini, who in 1818 lithographed Hayez's painting of *The Athlete*; Longhi, who created a very fine lithograph of *Susanna and the Elders* (1821); and Hayez, who executed two large lithographs entitled *Greek Costume* and *Mary Stuart on Her Way to the Gallows*. Mention should also be made of flowers as another lithographic subject that found a particularly fine exponent in the Roman painter and lithographer Giuseppe Canuti, as is shown by the fifty prints he made in 1826.

Domenico Porzio, the journalist and literary critic, is also a student of the problems of contemporary art. Among his writings are the monographs Conoscere Picasso *and* Conoscere De Chirico.

TWO CENTURIES
OF HISTORY
by Domenico Porzio

GOYA'S "BULLS OF BORDEAUX"

On May 30, 1824, the lord chamberlain of Ferdinand VII wrote to the
"pintor de cámara Don Francisco Goya" that His Majesty had agreed to
"give the royal assent to his going to Plombières in France in order to
take the waters and cure his ailments." Despite his weariness and his
deafness, the painter, who was seventy-nine years old at the time, was
thinking more of a change of atmosphere than of thermal cures: Ma-
drid was in the grip of the "white terror" of the Restoration, and even his
great reputation was not enough to shield him. He wanted to leave his
homeland, but with his papers in order and without cutting himself
completely off from Spain, where his son, his grandson, his belongings,
and his income all were. Bordeaux was the place where Leocadia Weiss
had sought refuge—Leocadia, the woman who had remained constantly
at his side since he had been widowed, affectionately and diligently look-
ing after his work and his health. She had also taken with her little Rosario,
the stepdaughter who occupied a special place in the heart and aspira-
tions of the old artist. Thus, Goya set out for Bordeaux in the summer of
1824, negotiating the rutted roads in a run-down carriage, without a
single domestic servant to accompany him. Scarcely had he arrived and
greeted Leocadia and her children when, after three days, he left for
Paris, to the consternation of those who feared that the journey would
prove fatal for him. He would not listen to their advice, however, for he
wanted to see the world, to see Paris. That his thirst for knowledge and
for discovery knew no bounds may be seen in one particular drawing he
completed during the months before: an old man, white-haired and
bearded, is shown walking with the aid of two staffs. The drawing is
inscribed *Aún aprendo* ("I am still learning"). That summer, the Paris
Salon was showing Géricault's *Raft of the "Medusa"* and Delacroix's *Mas-
sacre at Chios* and *Tasso in the Madhouse,* works that marked the immi-
nent arrival of Romanticism. We do not know whether Goya visited the
exhibition, but it is certain that very little of what he saw in Paris inter-
ested him; impatient to work, he painted the portraits of his Spanish
friend Ferrer and his wife in the house in which he was staying. The
great French capital, with its sunshine and crowds, did not stimulate him
but rather fired him with such nostalgia for Spain that he completed a
painting entitled *Bulls.* The memory of the arena and the *corrida,* that
carousel of life and death which condenses and sublimates the quality of
hispanidad, still accompanied him when he returned to Bordeaux. There
he painted portraits and began to regain his strength, although the city,

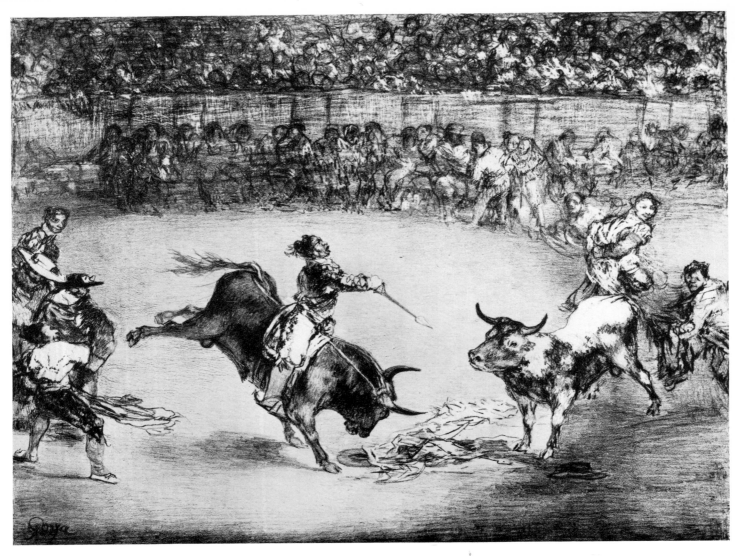

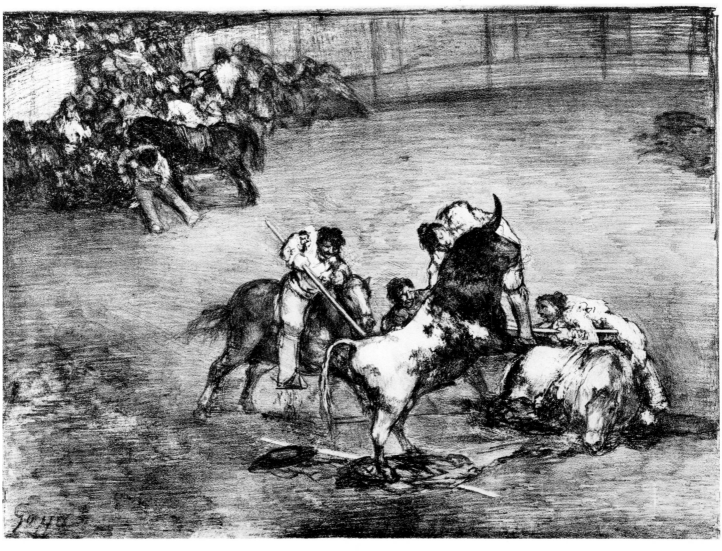

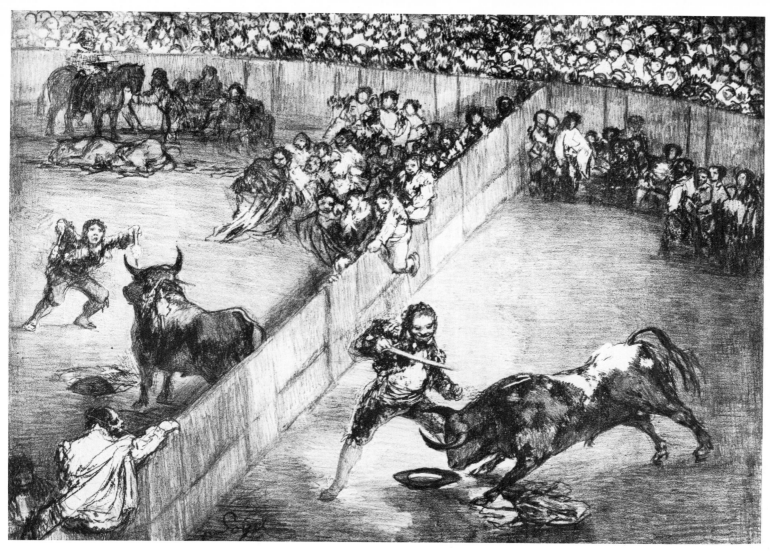

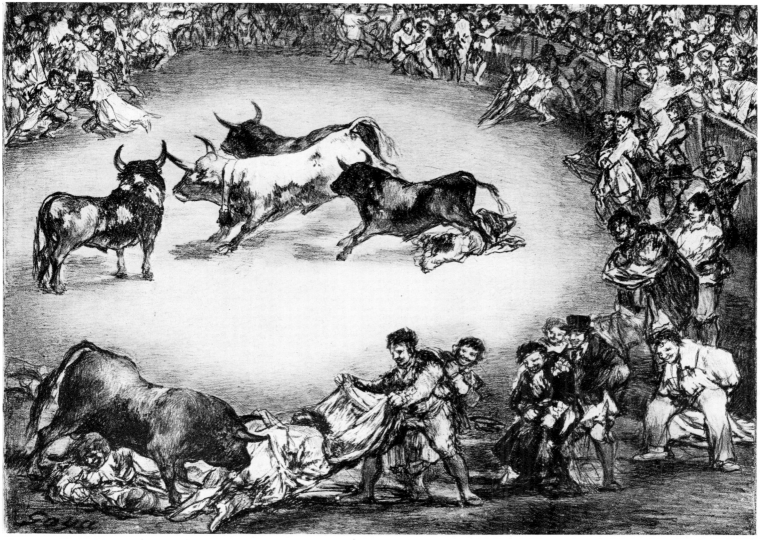

he wrote to his son in a letter advising him on the administration of his assets, "is not strong enough reason for abandoning my family and my homeland." In June 1825, Goya became so ill that his friend Moratín believed he was on the point of death, but the eighty year old was made of sterner stuff, and no sooner had he recovered than he resumed painting. His deafness worsened and his sight became so weak that he was forced to use a magnifying glass. It was during these months that he moved to a small house in the Rue de la Croix-Blanche which he bought and put in the name of little Rosario's mother, Doña Leocadia. Here, in a studio that opened onto a garden, he learned how to paint miniatures on ivory, in order to please the child, but he quite consciously distorted the new technique: "In certain aspects" he said later, "they resemble the brushwork of Velázquez and Mengs." Then, perhaps by chance, he returned once again to lithography, which he had already experimented with five years earlier in Madrid. Santiago Galos, a Spaniard living in Bordeaux, whose portrait Goya had painted and who acted as his banker, put him in touch with Gaulon, who owned a lithographic workshop.

His mind turned once more to the bulls of Spain, to the *corrida*, and he completed the stones for the four prints entitled *The Bulls of Bordeaux*, each of which had a run of a hundred. They were announced in the following terms: "Don Francisco Goya y Lucientes, Principal Painter to the King of Spain and Director of the Royal Academy of San Fernando, drew and lithographed these four prints in Bordeaux in 1826 at the age of 80." In fact, he had already begun work on them during the closing months of the preceding year, since in December 1825 he sent some of the prints to Paris to Ferrer for him to show to some dealer or other "without mentioning my name." It is recorded that, before starting work on these famous prints, Goya had already renewed contact with lithographic stones almost as though to steady his trembling hand ("I lack sight, strength, pen and ink; all I have is my will and that is not lacking...," he wrote to Ferrer). As we have already said, Goya used to place the stone on an easel, as though it were a canvas, and outline figures and animals with rapid strokes. Among his earliest efforts are the *Bull Beset by Dogs*, *The Dream*, and *Duello*, as well as the haughty dancer of *Andalusian Dance*, a very rare print of which ended up in Paris in the eager hands of Delacroix. Goya also produced a portrait of the printer Gaulon. As many of his earlier works amply prove, he was an expert on bulls and *corridas*, and he once confessed to his friend Moratín in Bordeaux "to having once entered into the arena and having feared nothing for as long as he had a sword in his hand." The *Bulls of Bordeaux* suite (*The Famous American, Mariano Ceballos*; *Brave Bull*; *The Divided Arena*; and *The Entertainment of Spain*) was executed with extraordinary mastery. At a distance of a century and a half, and despite the qualitative evolution of the medium at the hands of subsequent generations of artists, Goya almost makes one feel that he had both discovered and exhausted the possibilities offered by black-and-white lithography. A miraculous sense of immediacy runs through these prints, enhanced by a spareness of outline amid the dynamic action of the scenes. They are illuminated by a light that focuses, with a harsh and unhesitating emotionalism, on the animals and the crowds participating in the fierce spectacle. They exude both the feeling of danger that animates bullfighting and the ancient sacredness of this fearsome ritual; there is an underlying strain of anguish, a suspension of time that freezes the tumult of the arena. The whole scene is brought alive by the light which sanctifies the courage and dignity of the protagonists summoned to this inescapable contest: man and the

Opposite, above: Auguste Raffet, *The Retreat of the Battalion Sacré at Waterloo*, 1835; below: Nicolas-Toussaint Charlet, *The Grenadier of Waterloo*, 1818

Richard Parkes Bonington, *The Rue du Gros Horloge in Rouen*, 1824

bull at their moment of truth. There is a scent of life and death, a painful and pitiless reappearance of that "religious" understanding of any event and any human or earthly image that inspired Goya's brush and pencil. We see here a reemergence of the compassion and the dismay, the magical vibrations, the awareness of man's annihilation, and the metaphysical murmurings that formed an integral part of his artistic passion. The print dealers of Paris, however, saw little or none of this perfection in the *Bulls of Bordeaux*, and so Ferrer, in order to console him, suggested that perhaps he would like to return to the themes of his much-acclaimed *Caprichos*. Goya replied that this could not be done for he had handed over the prints to the king more than twenty years earlier and "today I have better ideas." Only time, as history so often records, was able to do

Above, left: Thomas Shotter Boys, *The Clock Tower in Paris*, 1847; right: Jean-Baptiste Isabey, *The Leaning Tower*, 1822

him full justice: the Bordeaux suite nowadays is not only regarded as one of the greatest achievements of Goya's whole graphic oeuvre, but it also marks one of the high points in the history of lithography, an artistic declaration that anticipated and demonstrated the hidden potential of Senefelder's discovery.

THE ROMANTIC IMPULSE

Amazement before the remnants of a lost past, recognition of the patrimony of past generations, nostalgia for a memory, civil or cultural, etched on a picturesque Arcadian landscape: these were the great themes that inspired Edward Gibbon's regretful, twenty-year-long study, *The History of the Decline and Fall of the Roman Empire*. They also provided a powerful catalyst for Romantic thought, which found in lithography a particularly potent means of expression. This longing for a vanished past was a thread that had run through Humanism and the Italian Renaissance, and was to come to full fruition in the literature of the German Romantic school. It was probably this cultural mood that inspired Baron Taylor to publish the *Voyages pittoresques et romantiques dans l'ancienne France*, a work that took from 1820 to 1878 to complete and comprised no fewer than twenty-five volumes containing prints by a host of draftsmen and lithographers. It also provided the inspiration for Millin's *Voyages dans les départements du midi de la France* and Burgoing's *Tableau de l'Espagne moderne*. While Burgoing had, of necessity, been forced to resort to engraving on copper (he was working in 1807), Taylor chose to make use of

Engelmann's lithographic printing works because he appreciated the potential and economy of the new process. Once embarked on his new enterprise, he realized that there were not enough lithographic artists available to bring it to a speedy conclusion, but his appeals for assistance attracted almost all the most famous names of the day. Among his first collaborators were Louis-Jacques Daguerre, future inventor of the daguerreotype, and the two Isabeys (Jean Baptiste and his son Eugène, who gained fame for his landscape watercolors); they were soon joined by Nicolas Chapuy, Louis Bichebois, Paul Huet, and, possibly the most skilful of all, Richard Parkes Bonington. All these names, from Chapuy to Isabey the elder, reappear in those other editions of "picturesque" travels dealing with the Danube, the Orient, Italy, and Lyons. Already by 1823 there had appeared a lithographic series entitled *Cathédrales de France* (Chapuy) and, shortly afterwards, a *Moyen Age pittoresque*, thereby completing the range of great Romantic subjects that were to flood the art market.

The lithographic excellence of the French, who were to maintain their artistic supremacy for several decades, was not rooted solely in their talent for picturesque views. Around the workshops of Lasteyrie and Engelmann there gravitated a number of artists who, in the years between 1815 and 1825, began to express themselves with increasing boldness through the medium of lithography. The enthusiastic dilettante Vivant Denon created lithographs, as did Antoine-Jean Gros (his *Desert Arab* of 1817 "is a presentiment of Géricault" according to Jean Adhémar, an authority on the history of engraving) and Pierre-Narcisse Guérin, the teacher of Géricault and Delacroix. Some remarkable horse studies were executed by Carle Vernet, whose son Horace is remembered for his scenes of military life. One particularly distinguished member of this avant-garde was Nicolas-Toussaint Charlet, a friend as well as the true precursor of Géricault. Charlet's vast output (more than a thousand prints), especially his scenes of military life, has a vibrant and highly personal lyricism combined with a strongly descriptive psychological quality. Delacroix once said admiringly of him, "He possesses the secret of marrying grandeur to naturalness." With Charlet, lithography tended to become more autonomous; this quality is to be found in the work of those, such as Hippolyte Bellangé, who modeled themselves on him and also of those who, with less sensitivity, branched out in different directions: Marlet, Boilly, Decamps, Eugène Lami, and Maurin. With Girodet and Aubry-Lecomte, these are just some of the multitude of artists, each with their own particular merits, who formed the lithographic avant-garde during the opening decades of the nineteenth century. As it reacted with the particular sensibilities and inclinations of the individual artists, lithography ended by creating different genres, with the result that it would be possible to draw up a history of lithography according to subject: portraits, military scenes, animals, landscapes, and such. Antoine-Louis Barye, for example, was an *animalier* of extraordinary talent, even though he created only a very few small prints. Of the landscapists and *vedutisti*, one of the most prestigious was Eugène Isabey, the teacher of Jongkind, who has already been mentioned in connection with Taylor's *Voyages pittoresques et romantiques dans l'ancienne France*. In his marine works, Isabey succeeded in capturing the mobile nature of water by means of wonderful effects of light and an intensity of line that have rarely been equaled elsewhere. Marine landscapes also interested Paul Huet, whose most notable and most original works, however, are his views of Versailles and who, in any case, displayed a greater mastery of etching. Louis-Adolphe

Opposite: Hyacinthe Aubry-Lecomte, *Danaë* (after Girodet), 1824

Hervier preferred views of old cities, which he saw through romantic eyes and captured with technical precision, while Jules Dupré concentrated on rolling plains and wide-open spaces with scattered vegetation and clouds.

GÉRICAULT AND DELACROIX

Within Théodore Géricault's brief lifespan (1791–1824), the period of lithographic activity was only a momentary interlude—the six years from 1817 to 1823. There are no more than a hundred prints by him, of which seventy-five are by his own hand, with the remainder being the fruit of his collaboration with other artists (Lami, Charlet, Lesaint). He was introduced to the technique by Carle Vernet, whose studio he frequented for two years (1808–10), but he also certainly learned some things in the atelier of Guérin, whose advice, we are told, he tried "respectfully to forget." While his enthusiasm for drawing on stone was inspired by the extraordinarily skillful prints by Charlt, Géricault expressed genius whereas Charlet had merely expressed ability. The mysterious and dramatic beauty of animal forms, and particularly that of the horse, was the theme that came most naturally to him: the horse seemed to symbolize a combination of elemental force and expressive innocence with which he was able to identify. Yet the adaptability and graphic control of this great and poetic painter allowed him to treat almost any other subject with the same revelatory intensity; according to his friend Delacroix, whatever he touched he instilled with new life. His first lithograph was inspired by the cowherds of Rome, his second one (*I Dream of Her*) by a theme that he was to return to in his final prints, when, gravely ill, he

Eugène Delacroix, *Royal Tiger*, 1829

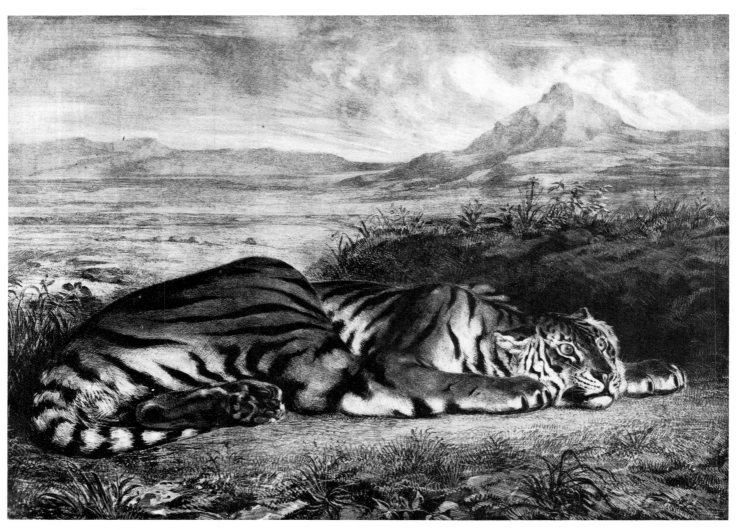

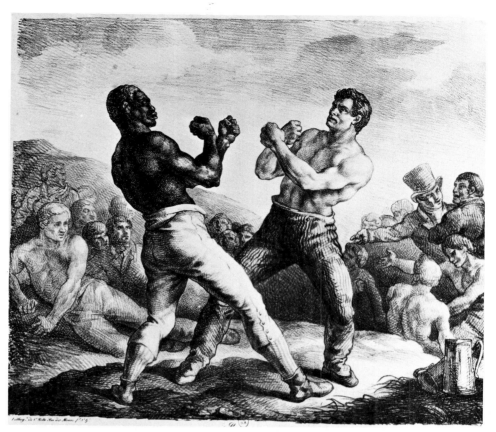

Théodore Géricault, *Boxers*, 1818 (right),
and *The Flemish Farrier*, 1821 (below)

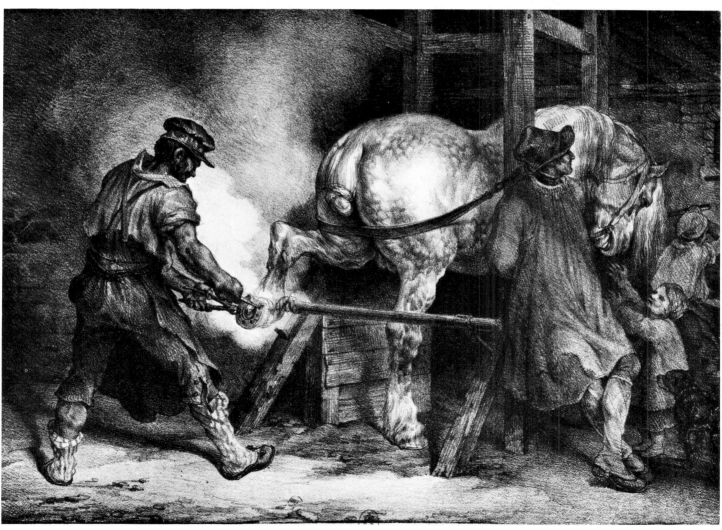

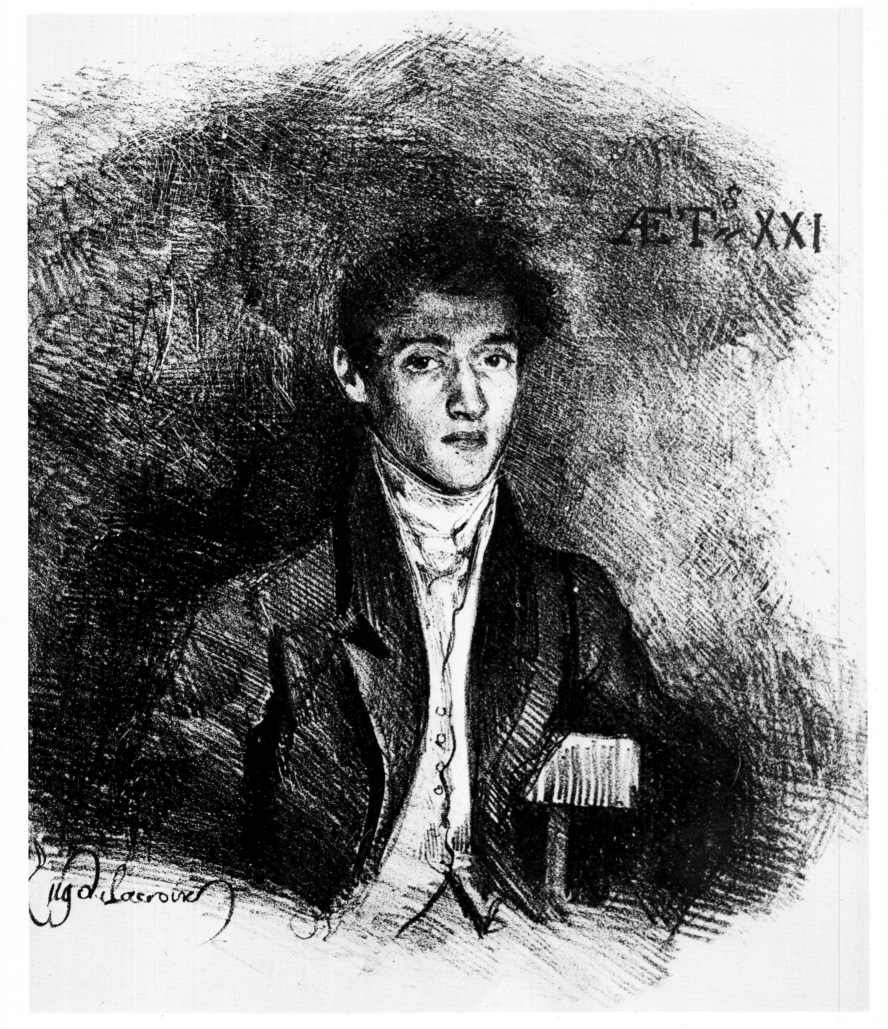
ÆT⋅ XXI

called on Eugène Lami for assistance in transferring onto stone the old, Romantic subjects inspired by Byron (*Mazeppa, Giaour, Lara*). Géricault's greatest works date mainly from 1818 and 1819, beginning with his *Boxers*, which rejected the neoclassical climate of the day. These were followed by prints that revealed, together with his disputatious nature, his ever-increasing technical mastery (*The Swiss Sentry at the Louvre, Two Gray Horses Fighting in a Stable, Horses Going to a Fair*), carefully conceived pictures in which there is no color because it would serve no purpose. In 1820 he traveled to London in the company of Charlet, with whom he had collaborated in the lithographic reproduction of the *Raft of the "Medusa"* for the exhibition of that great painting; there, moved by the hardship which he saw around him, he created a number of lithographs of beggars, old people, and cripples. The twelve prints of this series (*Various Subjects Drawn from Life on Stone by J. Géricault*) were published in 1821 by Hullmandel and brought him immediate fame in England.

When Géricault returned to Paris, ill and too tired to apply himself to the pictures that he had planned (*The Slave Trade*), lithography was the alternative means of expression to which he turned. Once again he celebrated the glory of Napoleon and also collaborated in *Voyages pittoresques*, while still remembering the horses that had provided him with one of his main themes (*Twelve Horses from Nature*). One of the most ardent and assiduous students of Géricault's graphics, the Italian art historian Giovanni Testori, states that it is with this artist that "in French art, lithography becomes an instrument of absolute dignity, fulfilling and, in a manner of speaking, extolling the virtues of its full potential." He goes on to say that "Géricault's passion for horses, which bordered on an obsession, led him to choose lithography because of that need of his, not so much for imitating as for an identifying with reality, with the skin and muscle of the animal." Géricault met this need with his clearly epic overtones and with that "immense energy for upheaval (and, therefore, dignity) that continually stimulates the lithographic prints of the great French master."

In the diary of Eugène Delacroix (1798–1863), we read of his visit to the Natural History Museum in Paris: "On entering this museum I had a feeling of happiness. As I gradually proceeded, this feeling increased.... What a prodigious variety of animals, and what variety of species, shapes, destinies.... Tigers, panthers, jaguars, lions.... Creation has nothing in common with our cities and with the works of man...." It was from this breathless admiration that the lions, tigers, and other animals that populate the artist's prints and paintings developed. A painter of great historical subjects and an amazing Romantic draftsman and illustrator, Delacroix was a close friend of Newton Fielding, the exceptional English lithographer of animal themes, but he himself approached lithography with considerable suspicion and disquiet. Worried by the inconvenience of drawing on stone, he preferred to work in his studio and rarely attended the printing of his lithographs in order to correct and rework them. Retouching, he maintained, "is impossible and always deprives the drawing of some of its freshness"; it is for this reason that there are very few artist's proofs of his lithographs. Delacroix admired the power of Géricault's lithographic works (he collected them and sometimes used them for inspiration in his own work) but did not possess the same deep passion for the technique, a fact that he justified on the grounds of not having "the time to devote himself to those little things." Yet, in fact, every time he did become involved, either as an *animalier* or, more especially, as an illustrator of books, the results were enough to class him as a "liberator" of the lithographic art. He became

Opposite: Eugène Delacroix, *Baron Schwiter*, 1826

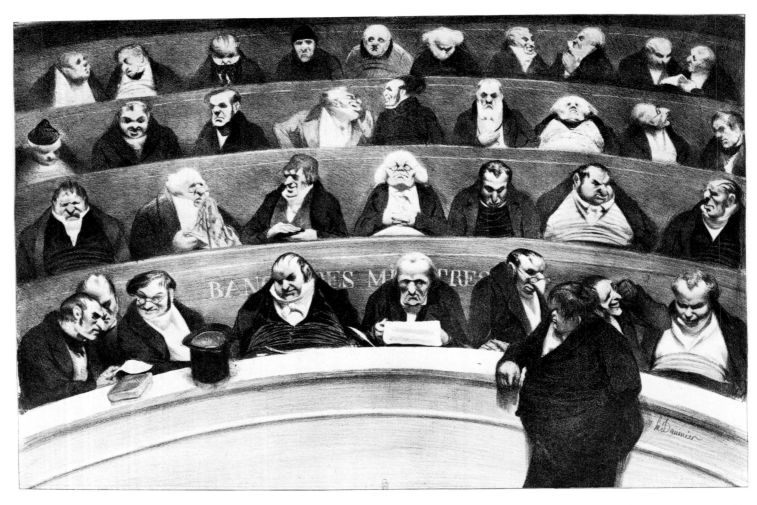

such a liberator because of his own originality, expressed especially through his skillful drawing, his use of shapes reverberating with a Romantic rhythm, and his masterly, unreal chiaroscuro effects. This excellence applies equally to those occasions when he appears to be limiting himself to the copying of ancient medals and the Parthenon metopes, as to the times when he draws inspiration from the pages of Shakespeare for such masterpieces as *Macbeth Consulting the Witches* (1825) and *Royal Tiger* (1829). Literature was a temptation to which Delacroix willingly yielded. He illustrated *Faust* after having seen a production of the play in London; later, in Weimar, when Goethe saw some of these lithographs (which were destined for the French edition of the poem), he wrote that Delacroix "had created prints that nobody else had been able to conceive." It is a strange fact that the painter did not find Goethe's poem very interesting, apart from the "romantic flavor" that he had emphasized in his lithographs. Delacroix also created illustrations for *Hamlet* and for works by Walter Scott and Byron, opening up a new field for lithography: the interpretation of literary works.

SOCIAL LITHOGRAPHY AND DAUMIER

Portraiture, one of the earliest paths taken by lithography and one which it was to pursue until its replacement by photography, immediately endowed it with a social function. Subsequently, as it acquired a polemical and critical accent, lithography developed into an instrument of satire and irony in the hands of certain artists. Its development in this direction was not, however, an exclusively French phenomenon. The imaginative caricatures of the Englishman Cruikshank certainly had an influence on Monnier, who focused his humor on popular scenes and characters (*Modes et ridicules,*

Esquisses parisiennes). Also revolving around Daumier's rising star was Grandville, with his timid and lyrical visions of the mundane, even though, as a satirical draftsman, he lacked Daumier's strength and powers of synthesis. Nevertheless, Grandville's *Grimaces* undoubtedly influenced the development of the young Daumier. The same can be said of Paul Gavarni (Sulpice Guillaume Chevalier), who in 1825 had already published his album of diabolical and phantasmagorical "recreations." The son of a glassmaker and poet in Marseilles, Honoré Daumier (1808–1879) had decided in his youth to be a painter, and all his family's attempts to dissuade him were in vain. Because his father, who had first moved to Paris alone and then sent for his wife and child, was busy pursuing dreams of literary greatness (without managing to achieve any sort of financial stability), the young Honoré had to set himself up in more than one trade: he was apprentice– errand boy and clerk in a bookshop in the Palais-Royal. He later succeeded in obtaining lessons from the painter Alexandre Lenoir, an adequate teacher who also taught him sculpture, and in 1825 he found work with Belliard, a lithographer and printer, where his specific job was to grind and prepare the stones. Daumier's first drawing appeared in the humorous journal *Silhouette*, and the revolution of July 1830 found him participating with such fervor that he received a wound on the forehead. Even when, at the invitation of Philipon, editor of the weekly *La Caricature* and the daily *Le Charivari*, Daumier began to contribute pointed and extremely popular political cartoons aimed at the government of Louis Philippe, he gave up neither his painting nor his sculpting: one series of portraits, displayed in the windows of the newspaper office in 1832, enjoyed immediate and wide-spread success. However, in that same year he was taken to court because of his antimonarchist cartoon entitled *Gargantua* and was sentenced to six months' imprisonment, part of which period he spent in a nursing home. It should be emphasized that, although Daumier was an exceptional painter, it would be incorrect to say that his painting was derived from his draw-ing: in fact, the reverse is true. For this reason, as Baudelaire noted, his black-and-white drawings were born "naturally colored." He made lengthy studies of the Flemish and Dutch masters in the Louvre and was also a great connoisseur of Rembrandt, Rubens, and Goya, particularly the latter's "black painting." It is true that in time enthusiasm for his paintings waned and people no longer echoed Paul Valéry's words that his oeuvre "recalls Michelangelo and Rembrandt: and quite rightly so," but this does not alter the fact that behind the inimitable social lithographer there was a painter and sculptor with an extraordinary ability for synthesis and for the revela-tory distortion of reality. As for the nature of his drawings, the comparison with Balzac, continually repeated by Zweig, Klossowski, and others, will always remain inevitable in view of the relentlessness and vehemence with which he attacked the *comédie humaine* of his day.

It is extraordinary, even incredible, that at the age of forty Daumier had already executed two thousand lithographs and that the catalogue of works drawn up after his death (he died in poverty, after two years of unbearable blindness, sustained only by the friendship and generosity of his friend Corot) included approximately four thousand. He executed his lithographs with an extraordinarily swift technique, relying on his prodigious memory for shapes; the strong outlines with which he deline-ated his figures were derived from his plastic experience as a sculptor and are even more evident in his paintings, which Van Gogh himself contem-plated with admiration ("he was a true pioneer"). Clearly the strength of his lithographic drawings derives from a highly developed sense of mor-

Opposite: Rodolphe Bresdin, *The Good Samaritan*, 1861

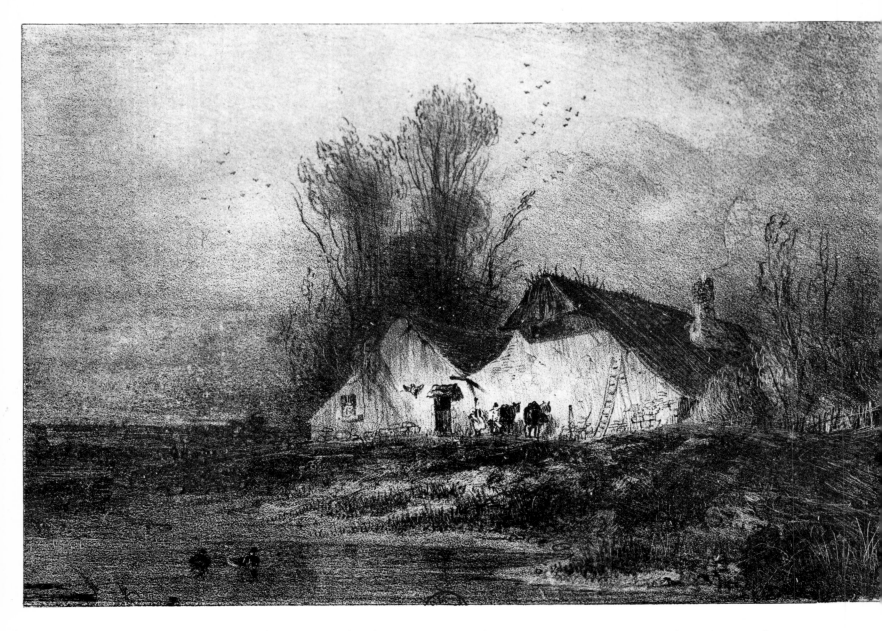

Paul Huet, *The Marshal's House*, 1829

ality, from a contempt for hypocrisy and worldly vanity. Although it may seem totally instinctive and improvised, the masterly skill with which Daumier controls light, scraping and isolating the patches of light and shade in his prints, is the result of an assiduous apprenticeship and later became second nature because of his talent and deep sense of involvement. It is useless to try and isolate, from a mass of four thousand lithographs, his best or most representative works: it is more revealing to underline the fact that, within his meticulous and pitiless recording of sins and vices, the tendency toward caricature and judgment diminishes in the face of a growing ability to strip away the human facade. It is this chilling talent that deprives his prints of any sense of being dated and lifts them above the level of mere cartoons. We feel stunned admiration for such series as *Types français*, *Les Plaisirs du jour*, *Robert Macaire*, *Les bohémiens de Paris*, *Les baigneurs*, and *Les physionomies tragi-comiques*, and many other equally famous ones whose profound truths have inspired countless artistic heirs, among them George Grosz, one of the founders of the Dada movement.

During Daumier's lifetime, lithography not only fulfilled a role of social criticism but also developed into a means of social documentation. The glowing portraits of Achille Devéria, portraying, for instance, Victor

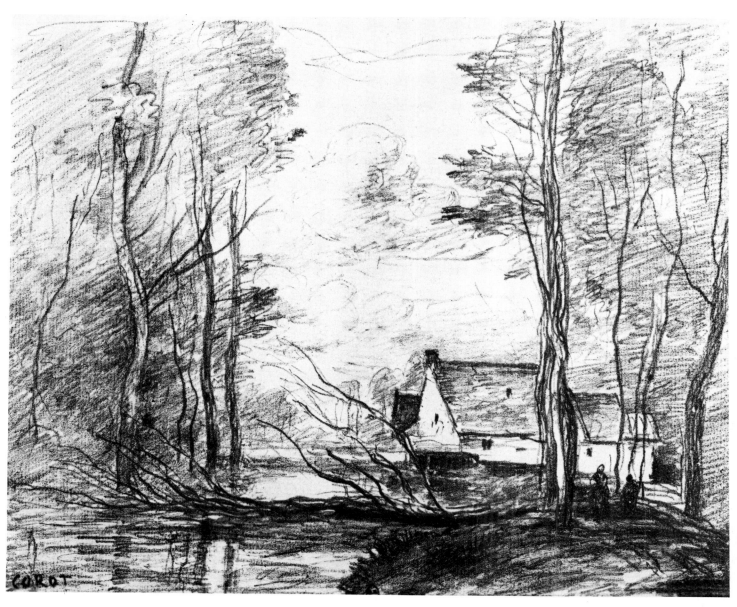

Above: Jean-Baptiste-Camille Corot,
Cuincy Mill, near Douai, 1871. Right:
Jules Dupré, *Views Taken at Alençon*,
1839

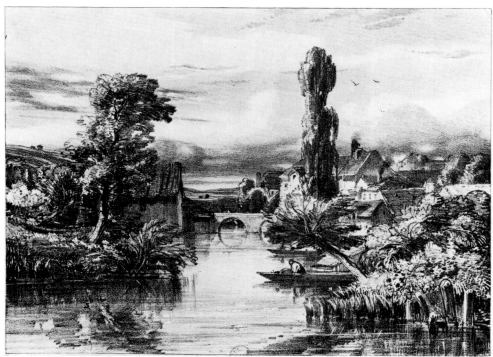

Edouard Manet, *The Barricade*, 1871

Hugo, Alfred de Vigny, Lamartine, and Alexandre Dumas, immortalized the faces of a whole cultural movement. Devéria was a virtuoso whose work rarely became mannered, and the same fresh quality also appears in the clear and accurate interiors of Gavarni, who was highly praised by the Goncourts for the romantic charm that he brought to a genre that could be quite worldly. Another member of the same generation was Auguste Raffet, a pupil of Gros and Charlet, who achieved a masterly control of chiaroscuro effects, often with unparalleled visionary qualities. His work appeared in *Album criméen* and in *Paysage romain*, but his talent can be most clearly seen in his prints depicting the Napoleonic saga, which he endows with a dreamlike aura (*La Grande Revue nocturne*). This sense of reverie achieved by an unreal softness of light was also sought by the etcher Théodore Chassériau, author of the splendid *Venus Anadiomène*. Louis Dupré is another portraitist who should also be remembered. The great period of French social lithography had echoes elsewhere—in the comic albums of the Swiss Rodolphe Toepffer and in the lithographic caricatures of the Germans Dörbeck and Hosemann, to name but three of the best names from a host of lesser European imitators.

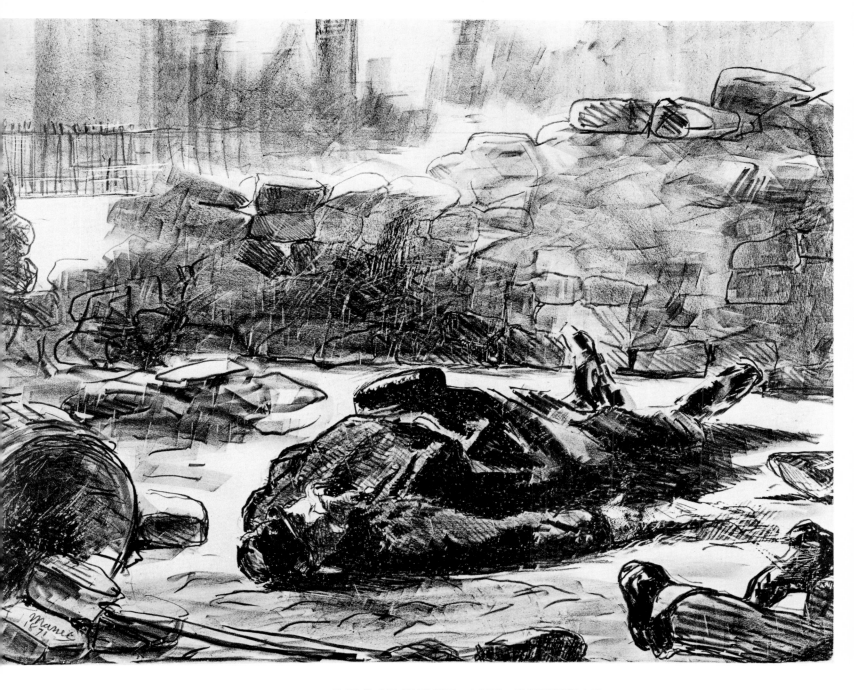

DECADENCE AND REVIVAL

Edouard Manet, *Civil War*, 1871

Paradoxically, during the same years as Daumier was producing his lithographic masterpieces for different journals and painting a series of canvases on the theme of print enthusiasts, graphic art (lithography and engraving) began to be supplanted in the public imagination by photography and other forms of reproduction. As it lost its popular appeal, the number of artists prepared to practice it also decreased. In an atmosphere of consternation for both artists and printers, the demand for lithographic prints collapsed so dramatically that many projects were abandoned. In addition, the technique of lithography had spread with such frenetic speed that a whole group of mediocre artists had been able to flood the market with their banal efforts, which had the effect of further increasing the disillusionment of serious collectors. Some of Manet's prints were produced in small numbers, but Théodore Fantin-Latour had his lithographic plates rejected by the publishers. There was throughout France a decline in good taste, in the number of purchasers, and in the production of quality prints. Nor was this state of affairs

in any way remedied by the activities of that reserved and secretive genius Corot, who, in his solitude, devoted himself to etching and to the creation of twelve splendid autographs. (The same can also be said of Rodolphe Bresdin, another isolated figure, a bizarre and visionary artist who invented in his engravings and lithographs a planet covered in incredible vegetation and inhabited by fantastical creatures.) It is surprising that Corot, a great friend of Daumier, whom, as we have already said, he sheltered during his final illness-stricken years, drew and lithographed as though he had never seen a single one of Daumier's prints. Corot's style was restrained, transparent, fluid, with no strong patches of darkness and shadow, steeped in an unreal, contemplative Arcadian glow, far removed from the fierce and clamorous resentment displayed by his friend.

IMPRESSIONISM AND ITS ECHOES

"It is sincerity," wrote Manet, "that endows works with a character that can seem like a protest, whereas in reality the painter has merely sought to express his own impression...he has simply wanted to be himself and not somebody else." In 1862, the publisher Cadart brought a lithographic stone to the thirty-year-old Edouard Manet (1832–1883), who was already working on his "scandalous" *Déjeuner sur l'herbe*, and asked him to draw on it whatever he wanted. Cadart certainly did not expect that the fresh and joyful lines of Manet's *Balloon*, traced with happy excitement by the painter, would make the workers in the Lemercier printing works laugh. It was this kind of pitiable skepticism, this failure to grasp such an unusual graphic style, that blocked Cadart's initiative and became a typical reaction as lithographic art moved in a new direction. Rejecting both the delicacy of Gavarni and the commonplace utterances of a worn-out pictorial and lithographic tradition, Manet had expressed, with "sincerity," his own "impression" of everyday life: a popular event, a Sunday fair with greased poles and bunting, a festive crowd clustering around a hot-air balloon about to rise up into a clear and cloudless sky. With rapid flicks of his pencil, he has transmitted the carefree mood of the gathering and reproduced the true-life impressions of men, women, and children who have caught his eye. Executed with effortless honesty, this print was for a long time underrated and the subject of controversy, like the whole of Manet's provocative oeuvre. He did not produce many lithographs: a dozen original prints, to which must be added a few book illustrations and one or two drawings made into lithographs. A lithograph taken from his painting *The Execution of the Emperor Maximilian* was banned by the censor and published only after his death. The authorities found Manet's antirhetorical approach unacceptable; that squad of soldiers shooting at the emperor and the other two condemned men with such total indifference (one is even testing the magazine of his rifle, which has jammed) in the face of this "historical tragedy," combined with those incurious faces looking over the surrounding wall, created a scandal. There is none of the heroic impetus or denunciatory quality of Goya's famous painting *The Third of May 1808*, from which Manet appears to have drawn inspiration, but there is an altogether new element: a reflection of the cold and mechanical way in which death was becoming a part of politics, together with the total rejection by the new mood in painting of any form of stereotyped academicism. This respect for the truth shines through all of Manet's other prints: *The Barricade, Civil War,* his splendid portraits of Berthe Morisot, *The Races* (1864), and his famous color print, *Punchinello*. No less important are the five highly original illustrations that he did for his friend

Opposite: Henri Fantin-Latour, *Sara the Bather*, 1892

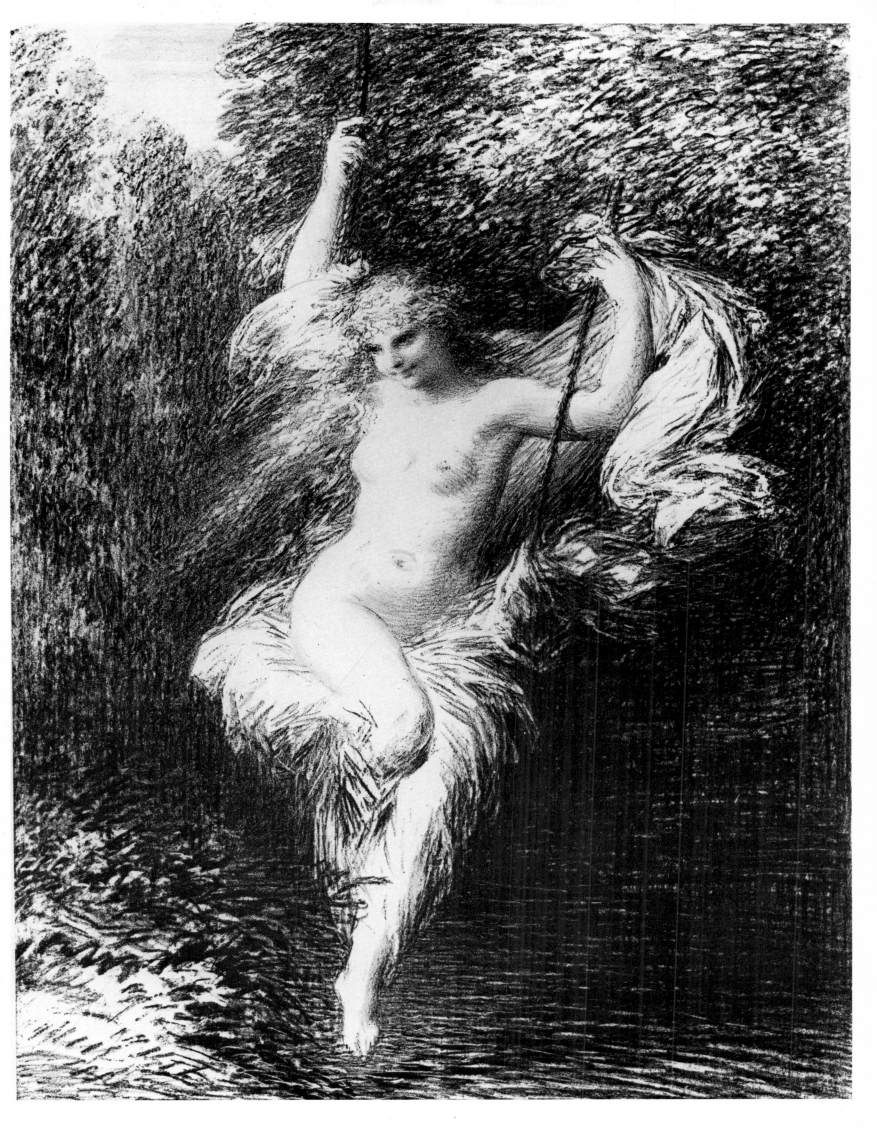

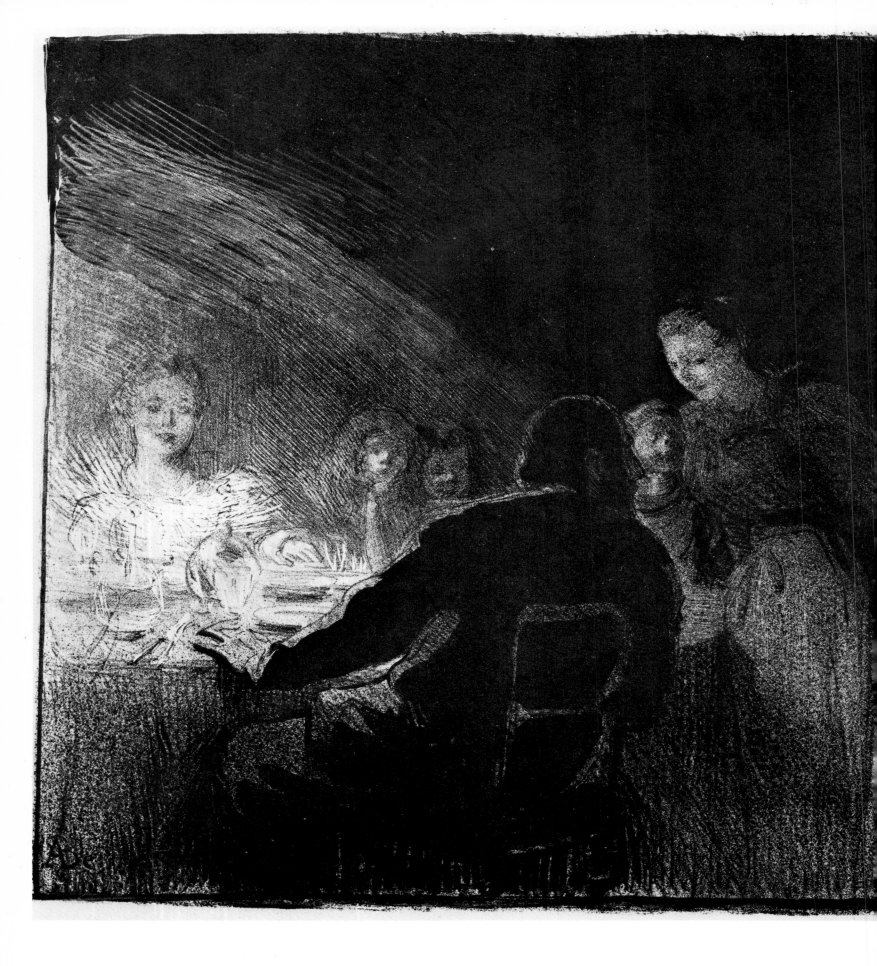

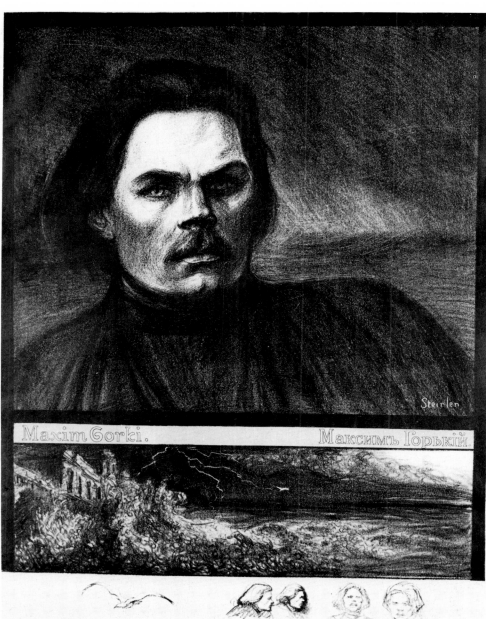

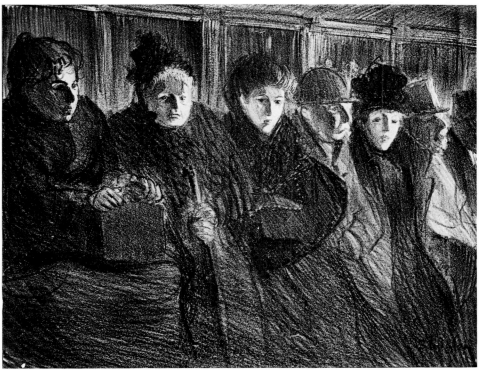

Above: Paul-Albert Besnard, *The Female Visitor*, 1893. Théophile-Alexandre Steinlen, *Full-face Portrait of Maxim Gorky*, 1905 (top), and *Tramway Interior*, 1896 (right)

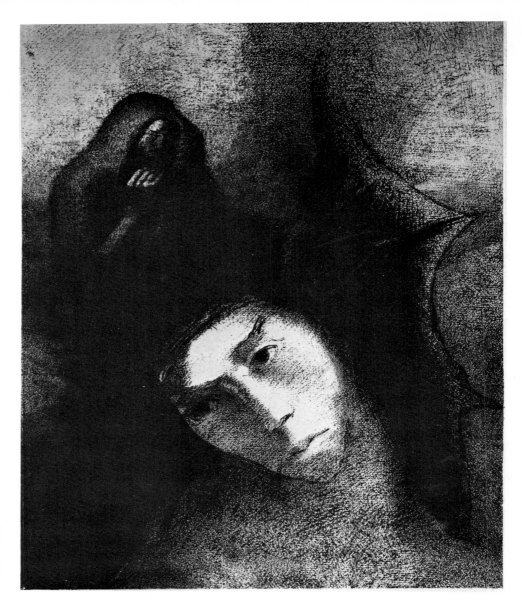

Mallarmé's translation of Edgar Allan Poe's *The Raven*. The *japoniste* simplicity and delicacy of these drawings were not understood by those used to the mannered realism of contemporary illustrators, and yet Manet's preference for suggestion rather than description led to a drastic reassessment of illustration techniques.

Edgar Degas (1834–1917), who, at Manet's funeral, had exclaimed "He was greater than we realized," was an Impressionist without all the usual qualifications—he did not like immersing himself in nature and he preferred interiors to the open air. For him, art had to be the conquest of truth, rooted in sensual reality but recomposed by poetic and stylistic invention; it was not made subject to spontaneity. Nevertheless, "he is the person," wrote Edmond de Goncourt, "whom I have seen best grasping, in the translation of modern life, the spirit of this life." Degas was an Impressionist by virtue of the practical way in which he contemplated reality without indulging in dreamlike distortions, without becoming intoxicated by its beauty, and without succumbing to romantic fantasies. His modernity, when compared to traditional art, lay in the precision with which he transferred the movement of the real world onto canvas and in the daring way in which he portrayed it in his graphics. When he laid down his brushes and took up the lithographer's pencil, his main concern was still stylistic. In his *baigneuses* (bathers), prints of which he repeated and modified on many occasions, it is not the spontaneity with which the bodies of the women are treated but their shading that makes them different and, at the same time, classic. Degas possessed a magical gift for reproducing a feeling of sensuality by means of delicate contrasts

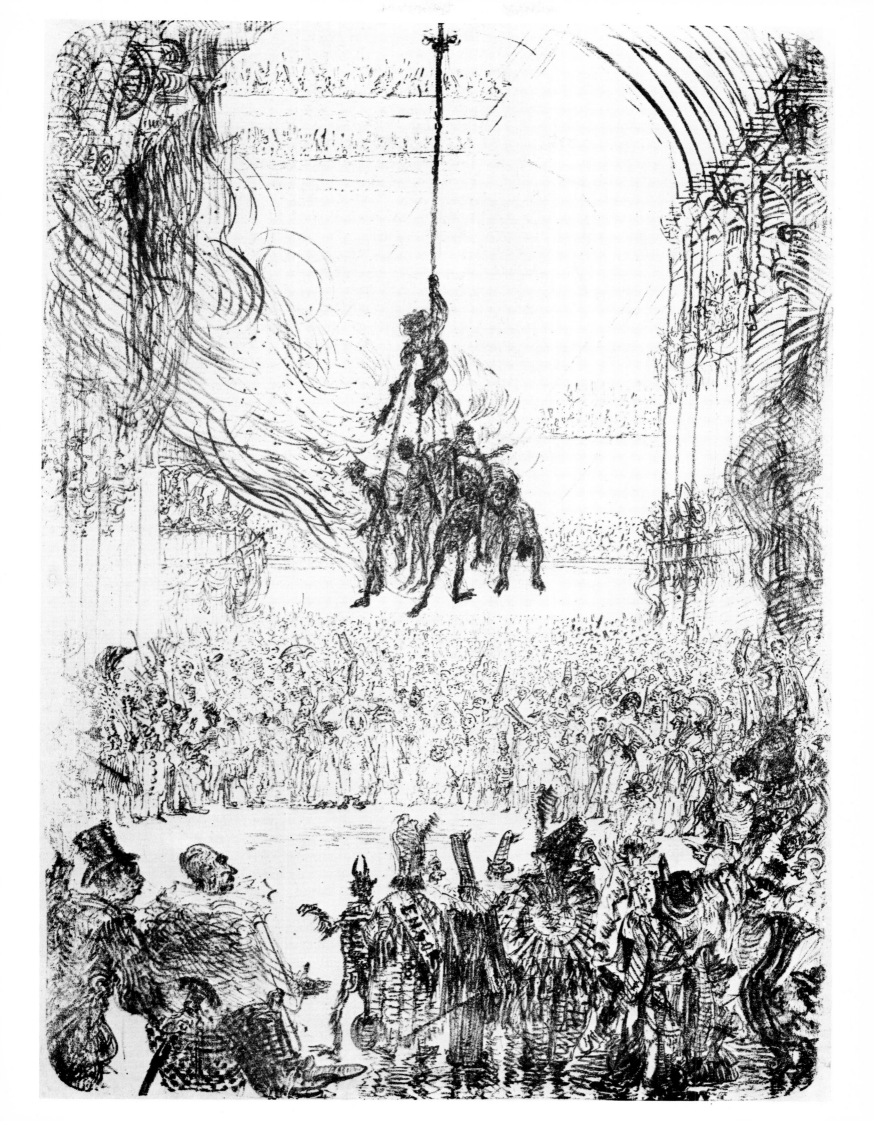

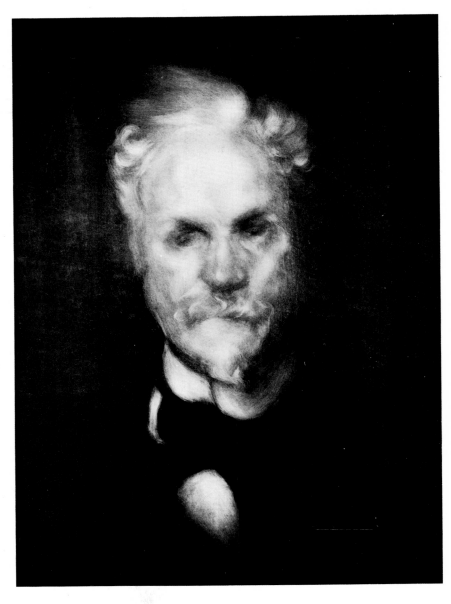

Eugène Carrière, *Henri Rochefort,* 1896

of black and white. He was also a forerunner of Toulouse-Lautrec and an artist whose representations of the naked body have made a lasting impression on painters over the years.

The annals of original lithography do not always reflect conventional art historical trends, nor do they always mirror the great contemporary movements in painting. Sometimes they fail to take account of certain very famous artists purely because the latter were never attracted to lithography, preferring other graphic techniques like engraving. In the case of Impressionism, for example, one of its greatest exponents, Claude Monet, never succumbed to the lure of lithography, unlike Auguste Renoir, whose *The Pinned Hat* is an exceptional lithographic work, and unlike Camille Pissarro, Mary Cassatt, Paul Signac, Alfred Sisley, and some of their lesser contemporaries. Except for certain groups outside the realm of conventional criticism, the embers of Romanticism continued to unite almost every type of artist (painters, poets, sculptors, writers) throughout the second half of the nineteenth century; Romanticism also fostered a lithographic renewal that manifested itself in original contributions by artists who shared a common contemporary interest, even though they differed in their individual approaches. During those decades, lithography enjoyed a revival at the hands of Odilon Redon, Henri Fantin-Latour, Théophile-Alexandre Steinlen, Maurice Denis, Eugène

Max Liebermann, *Portrait of Theodor Fontane*, 1896

Carrière, Pierre Puvis de Chavannes, Henri-Edmond Delacroix (known as Cross), Félix Vallotton, and, most notably of all, Paul Gauguin and Pierre Bonnard.

In our discussion of the different techniques, we have mentioned transfer lithography, which, as its name suggests, involves initially transferring a drawing from paper onto the lithographic stone. There have been lengthy discussions among historians of graphic art as to the legitimacy (nowadays completely accepted) of this technique, which artists use sometimes for convenience and sometimes in order to achieve a specific sfumato effect or a particular gradation of shading. This particular method of graphic reproduction was extensively exploited by Henri Fantin-Latour, and, in the opinion of the authoritative art historian Jean Adhémar, it was the source of ''both his charm and his limitations.'' But Adhémar nevertheless admits that *Bouquet of Roses* (1879), which the artist transferred from one of his paintings, is a true masterpiece. If one considers another memorable Fantin-Latour lithograph, *Eva*, it can be seen that the artist was using the technique precisely in order to exploit its inherent ''weakness'' and so create the required mood; this applies equally to his *Tannhäuser* prints, inspired by Wagner, of whom he was an ardent admirer, and also his *Sara the Bather*. Fantin-Latour is also remembered as an illustrator of books, particularly those by Jullien on Wagner and Berlioz, in whose pages he seems to

fluctuate stylistically between Seurat and the Symbolists. A completely different mood pervades the work of the Belgian Félicien Rops (1833–1898) who drew inspiration from Gavarni and Daumier: a lively feeling of irony, occasionally bitterly satirical, runs through his cartoons printed in the journal *Uylenspiegel*. Later, in Paris, where he worked during the 1860s, he developed a marked penchant for erotic drawings and was in great demand as an illustrator of erotic literature. In some of his prints, most notably his etchings, his pungent realism acquired a sharp edge that Baudelaire particularly admired. The Group of Twenty, founded in 1884 by Rops, Ensor, and other exponents of the avant-garde, was the first Belgian modernist movement. Among the most notable of Rops's prints displaying a sense of bitter social criticism are *The New Year's Gift* and *The Last Flemings*. Also working in the same vein was Jean-Louis Forain, whose satirical lithographs of Parisian life, with their strongly expressive element of caricature, have their antecedents in the work of Goya and Daumier.

SYMBOLIST WINDS OF CHANGE

Symbolism is a rather sweeping term used to describe several generations of painters and writers from the end of the nineteenth century. In art it is applied specifically to that group of artists, primarily French, who during the closing decades of the century rejected the concept of art as a mirror of nature, viewing art instead as the translation of a state of mind, with all its inherently private emotions, as a visual interpretation of the encounter between sensory perception and spiritual understanding. Historically, Symbolism is a byproduct of Romanticism, a reaction against

Below: Paul Gauguin, *Manao Tupapau*, 1894. Opposite: Eugène Grasset, *The Morphine Addict*, 1897

Application du Cercle Chromatique de M.^rCh.Henry.

P. Signac

Left: Cross, *The Walk*, 1897. Above and opposite: Paul Signac, *Application of Mr. Ch. Henry's Chromatic Circle*, 1888, and *Saint-Tropez: The Harbor*, 1897–98

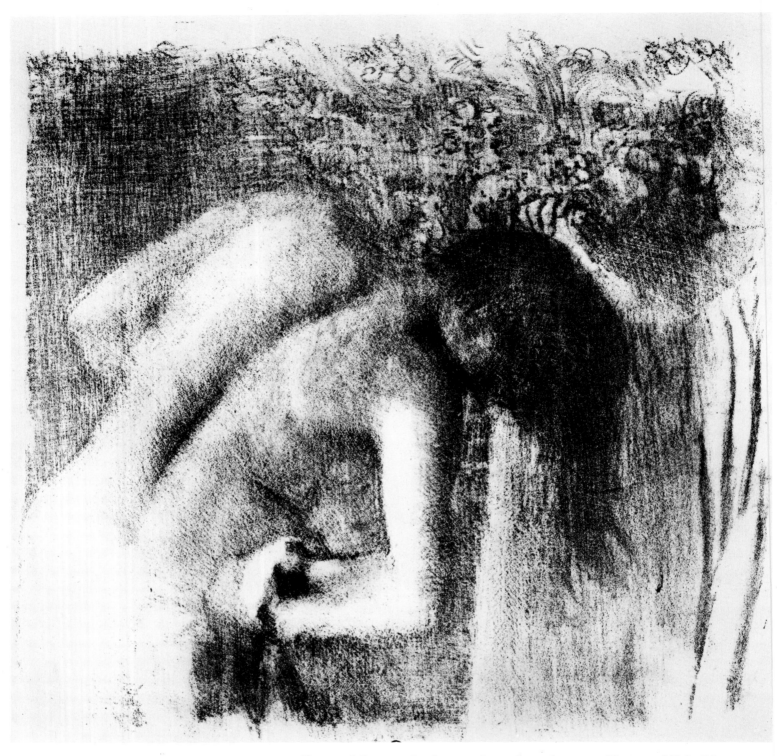

Edgar Degas, *Leaving the Bath,* large plate, c. 1891

naturalism and Impressionism, and was born in a manifesto published by the poet Jean Moréas in 1886. In the annals of art, schools and movements have no clearly defined boundaries, whether geographical or historical: the flight from nature, from the Aristotelian ideal and the claims made for it by Humanism, is merely part of the long and involved story of Mannerism, which, from Renaissance art through to the avant-garde movements of the twentieth century, has fostered—sometimes covertly and sometimes overtly—the advancement of the arts. The linking of the real world and the world of dreams in a synthesis of the visible and the invisible is a centuries-old ambition that Symbolism stressed, with particular vehemence, for a brief moment of time. The Neo-Impressionists (Seurat and Signac) had already turned their backs on naturalism, introducing a visionary element into their search for new optical effects; at the same time, the

writer J. K. Huysmans was theorizing the flight from "plein-air" realism, provoking a morbid and eccentric aestheticism and paving the way for the raising of *décadentisme* to a philosophy of life. The key figures of Symbolist art are normally regarded as being Gustave Moreau, Puvis de Chavannes, Rodolphe Bresdin, and Odilon Redon, but the movement also embraced the final mysticism of Félicien Rops, the alienated voice of Fernand Khnopff, the decorative exoticism of Paul Gauguin, and the painting "from memory" of Emile Bernard. Among the unsung ancestors of Symbolism was the Swiss-English artist Henry Fuseli, who a hundred years earlier had manneristically depicted the world of dreams and of the subconscious with a succinctness and splendor that would captivate the Expressionists. The vogue for Symbolism developed in more than one direction: it found expression, both explicit and implicit, in the work of the Nabis (Aristide Maillol, Pierre Bonnard, Maurice Denis), the mysticism of the Rosicrucians, the Flemish *décadentisme* of Ensor, and the dream imagery of the Surrealists. Art Nouveau and the many abstract movements of the twentieth century also owe an artistic debt to it.

ODILON REDON

Lithography was adopted by the Symbolists, some of whom brought a totally new approach to the medium, because, in the words of Odilon Redon, it allowed the artist to generate in the spectator an overwhelming attraction toward the "dark world of the indeterminate." Behind the graphic art of Redon (1840–1916) lies his fascination with the works of his teacher Bresdin, that solitary and eccentric draftsman with the sinister imagination, whom he had met in his native city of Bordeaux. But his art also betrays the influence of Blake, Moreau, Turner, and Flaubert's *La Tentation de Saint Antoine*.

The subjects of Redon's lithographs, and later of his paintings, derive from a tangled mass of literary, classical, and Oriental myths, taken from the writings of his favorite authors (Mallarmé and Huysmans, Baudelaire and Flaubert), whose works he illustrated. However, his iconography was also affected by the microscopic world revealed by the botanist Clavaud; since in his work the chimerical was intermingled with elements of the grotesque, Redon was, in a sense, one of the forerunners of Surrealism. He once made a statement that partly explains the Symbolists' interest in lithography: "I am amazed that artists have not become more deeply involved in this rich and docile art, which obeys the most subtle stimuli of sensibility." He also declared, "All my prints are the fruits of a restless analysis of the power pent up in the lithographer's greasy pencil, assisted by paper and stone." Redon began his lithography in 1879 with the album *Dans le rêve*, which was followed by his extraordinary prints *To Edgar Poe, Origins, Homage to Goya*, and, successively, his three illustrations for Flaubert's *La Tentation de Saint Antoine*. The high point of his visionary talent as a lithographer came with *Captive Pegasus, Beatrice*, and the *Songes* album. Apart from his evocative choice of subject matter, Redon displayed amazing skill in bringing out the expressive force of the medium and bending it to his own purposes, a fact that was recognized even by those of his colleagues who did not understand the meaning of his prints. Degas, for instance, said: "I do not understand much of what he is trying to say, but his blacks...his blacks, it would be impossible to print more beautiful ones."

PUVIS DE CHAVANNES, CARRIÈRE, ENSOR

Symbolism, which appeared under many, almost contradictory guises, united artists of very different temperaments. Pierre Puvis de Chavannes

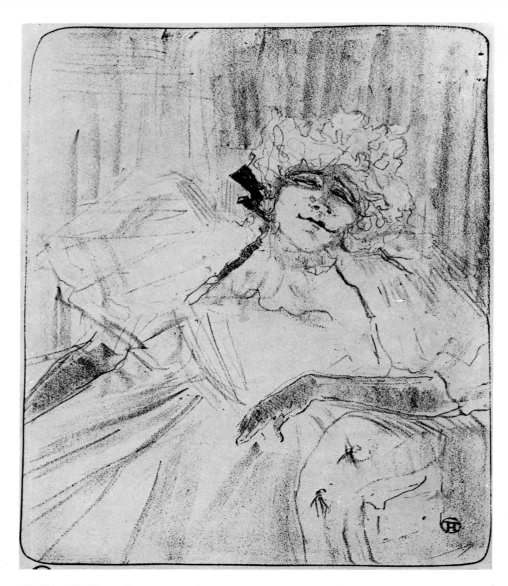

Henri de Toulouse-Lautrec, *An Old Song (Yvette Guilbert, English Suite)*, 1898 (right), and *Half-length Portrait of Lender Greeting an Acquaintance*, 1895 (opposite)

(1824–1898), a former engineer, seems to turn his back on both Moreau and Redon; his affinity with the Symbolists, whose love for his work was not reciprocated, was primarily temperamental. His basic mood was one of gray melancholy, and, despite its academic appearance, his work was decidedly antinaturalistic and abstract in character. Although it was not his intention, Puvis became part of the Symbolist group because he rejected the poetry of the Impressionists and used legendary and primitive themes. The enchantment of the mundane, suspended in time and dreamlike space in his lithographs (*The Poor Fisherman*), was adopted wholeheartedly by Gauguin and also partially by Picasso in his Blue and Pink periods. His youngest kindred spirit was Eugène Carrière (1849–1906), who with Puvis and Rodin promoted the Société Nationale des Beaux-Arts and who had as pupils at the Académie Carrière, which he had founded himself, Matisse and a number of Fauve painters. Carrière's style developed along Symbolist lines despite the fact that he showed no tendency toward abstractions of reality. An attentive observer of family life and especially of the mother and child theme, he said that he did not know whether the world of reality was different from the realms of the spirit since ''gestures are only the visible movement of the will; and I have always believed that they were linked.'' In his expressive technique, a veil like a thin mist envelopes the figures; it is a symbolic veil, a visible atmosphere that isolates and distances the physiological reality of the faces, placing them in another, allusive and spiritual, dimension. In his lithographic prints, this removal from reality is obtained through velvety grays of varying intensity, with pervasive sfumato rarely equaled by other lithographers; among his most outstanding portraits is the one of Henri Rochefort.

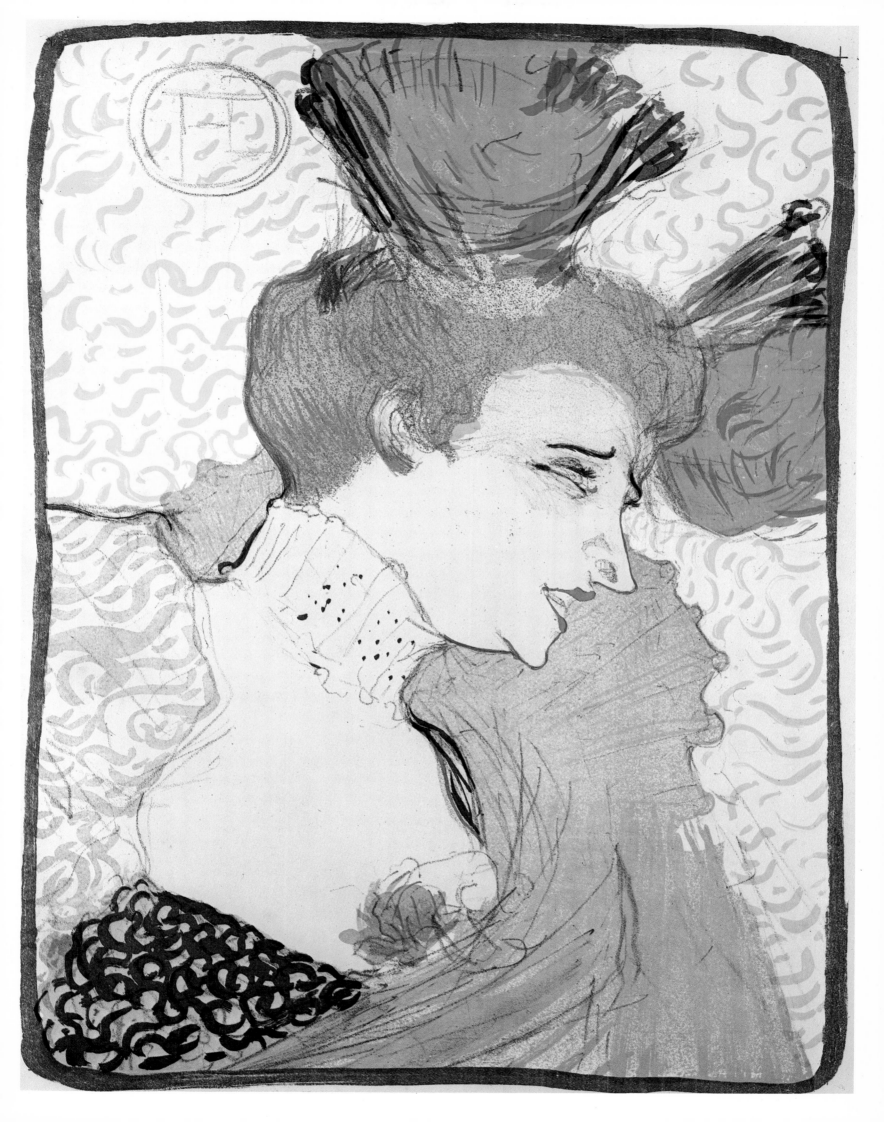

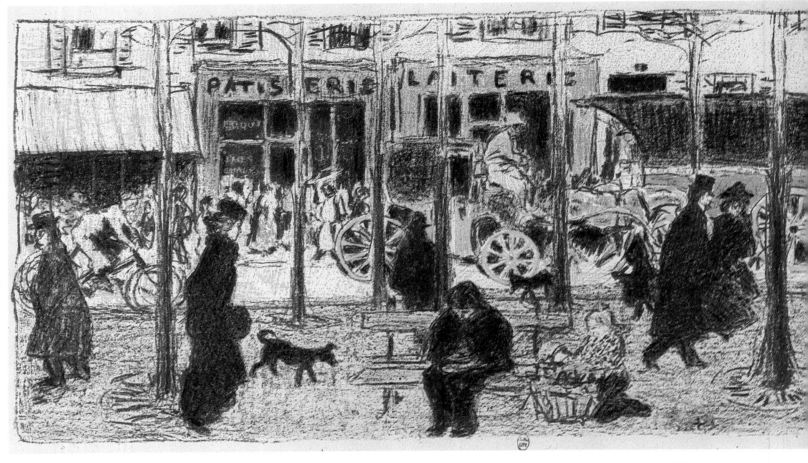

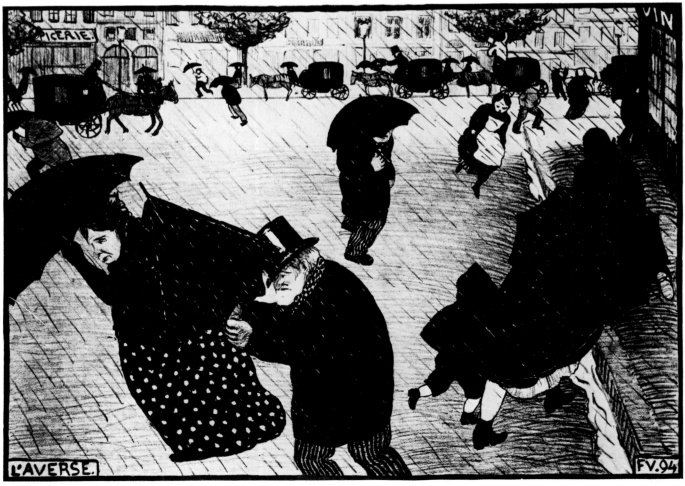

Above: Pierre Bonnard, *Boulevard*, 1899.
Opposite: Félix Vallotton, *The Downpour*
(from *Paris intense*, VII), 1894

James Ensor (1860–1949), born in Ostend, was eleven years younger than Carrière. Although he was active well into this century, his visionary and Symbolist roots developed during the final working years of his much older compatriot Félicien Rops, during that period of masks and skeletons nurtured by Rops's devoted religious mysticism. Ensor's sensibilities were completely different; he filled with magical life the same themes that Rops had treated with absent-minded conventionality. Although the iridescence of his visual effects and of his color owes much to the Impressionists, there is nothing naturalistic about his works: the monsters and the shocking, fantastical masks that crowd through his carefree and irreverent *danses macabres* (*The Vengeance of Hop Frog*, 1898) are in the same mysterious and symbolical vein as Redon's work. Ensor is one of the most literary exponents of Symbolism but also one of the most violent, for his masks are prophetic representations of contemporary alienation.

THE VERVE OF TOULOUSE-LAUTREC

The feeling of activity and life that permeates the paintings, lithographs, and posters of Henri de Toulouse-Lautrec (1864–1901) reflects the artistic trends contemporaneous with his work and, at the same time, is completely original. His work was born in Impressionism, paid passing homage to Degas, dabbled in Symbolism, launched Art Nouveau, and, without subscribing to it, inaugurated Expressionism, that style of painting which endows objects with subjective expression by means of line and color. Such were the achievements of this physically stunted aristocrat, who acknowledged only Van Gogh as his equal and who fed his thirst for life with the alcohol that drove him first into a mental hospital and then to an early death at the age of thirty-seven. The graphic explosion which he unleashed, and for which he is quite rightly acknowledged by historians of both lithography and poster art, brought him certain "fellow travelers" like Jules Chéret, but none succeeded in achieving anything like the same stature. Elegantly ironic hyperbole distinguished his graphic style, which is steeped in imagination and far removed from any naturalistic criteria, even when he took his easel into brothels. The often bitter mood of his lithographs is tinged with pessimism as it mirrors the animal side of society; behind the Japanese arabesques, the top hats, and the lace of the *belle époque* there lurks the spirit of Daumier. The miraculous spontaneity that appears in all his posters is merely an illusion: color and line seem to come together in a single moment of brilliance, but they have in fact undergone a long process of observation and thought. One has only to look at the way in which he skilfully rejects the use of chiaroscuro and shading to model his shapes, employing instead sharp blocks of color in the Japanese fashion and bold, carefully calculated photographic perspectives, whether in a glimpse of a music hall or of galloping racehorses. His genius was supported by a rigorous professionalism: after having drawn on the stone, he personally oversaw the color printing and the proofs, intervening until he was satisfied with the result, sometimes destroying the work and starting again from scratch.

Toulouse-Lautrec executed no fewer than three hundred and seventy prints, both color and black and white, including thirty-one posters, as well as illustrations, book covers, and theater programs. Among his best-known lithographs are the albums *Yvette Guilbert* and *Elles*, which immortalized the great figures of Parisian nightlife, but he also revealed his considerable talents as an *animalier* in his illustrations for Jules Renard's *Histoires naturelles*. In his large lithographs, which he designed for public display (*La Goulue, Aristide Bruant, The Englishman Warener at the*

Moulin Rouge, Jockey, At les Ambassadeurs, La passagère), his style stands revealed in the strong, precise outlines and clearly delineated blocks of color. The small-sized lithographs, destined for a more private audience, have more delicate, flickering outlines and colors, with multiple variations of tone that achieve great charm and precision (enforced by his own strict supervision of the printers). During the period when Toulouse-Lautrec was supplying drawings for the journal of his friend the singer-composer Aristide Bruant, he was assisted by the Swiss-born painter Théophile-Alexandre Steinlen, who had arrived in Paris from Lausanne in 1880 and was an excellent lithographic artist. After having illustrated two volumes of songs for Bruant, Steinlen began to collaborate on the weekly *Gil Blas illustré*, which lasted for a decade. Although a mediocre painter, he revealed considerable talent in his use of pencil and ink, proving himself in all the graphic skills, and produced posters as well. In his work as both draftsman and lithographer, Steinlen was attracted to portrayals of popular interiors and representations of the downtrodden and the lowliest members of society: he, too, was one of the heirs of Daumier.

THE EXOTICISM OF GAUGUIN AND "THE BATHERS" OF CÉZANNE

As a graphic artist, Paul Gauguin (1848–1903) made a greater contribution to wood engraving, which he endowed with a new and modern ex-

Edouard Vuillard, *The Avenue*, 1899 (below), and *The Pâtisserie*, 1899 (opposite)

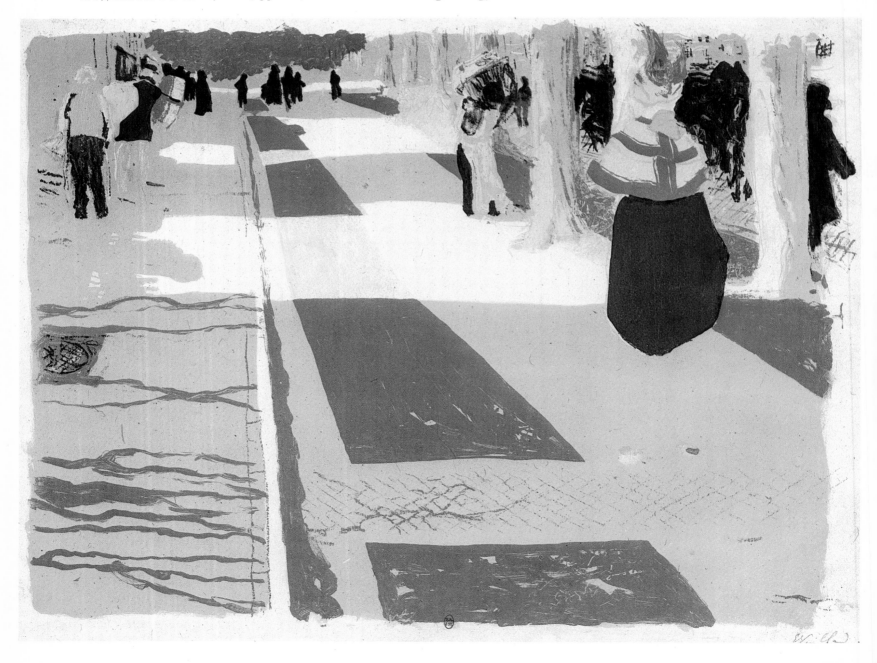

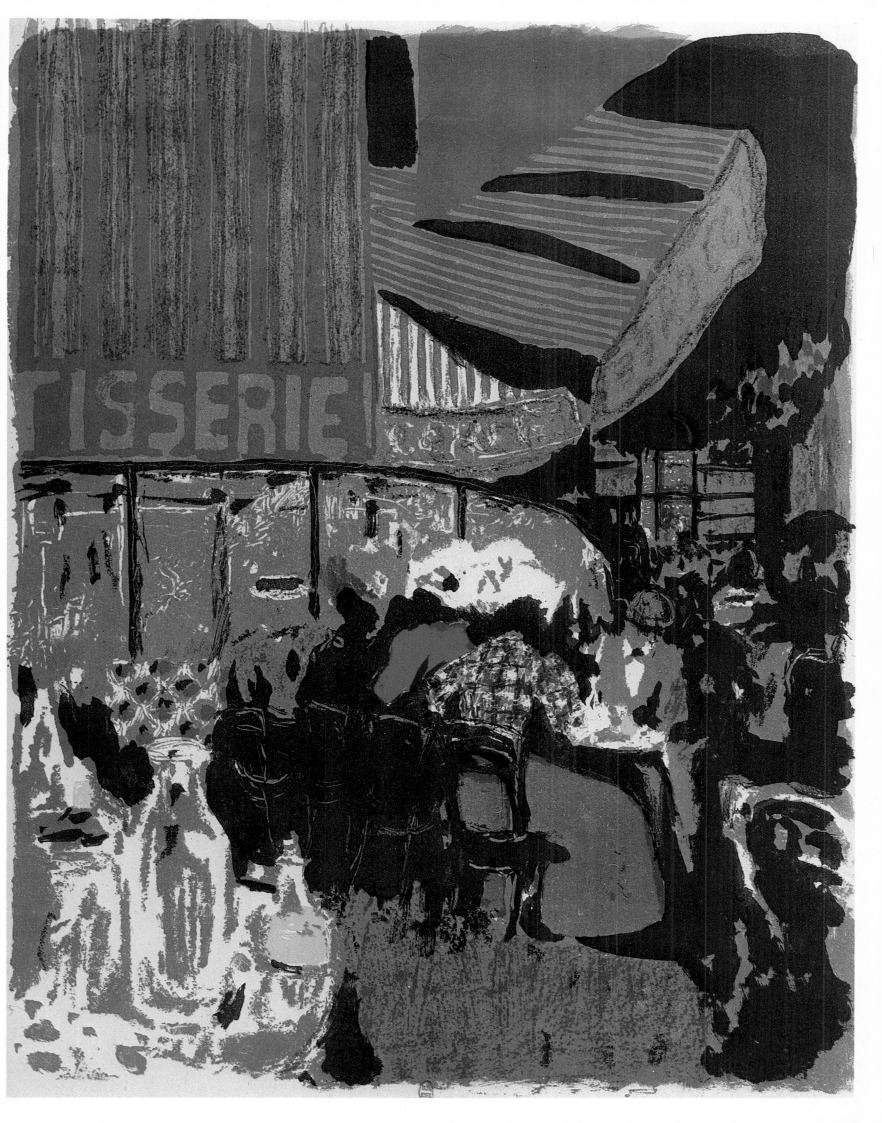

Pierre Bonnard, *The Little Laundress*,
1896 (below), and *Screen with Four
Leaves*, 1899 (opposite)

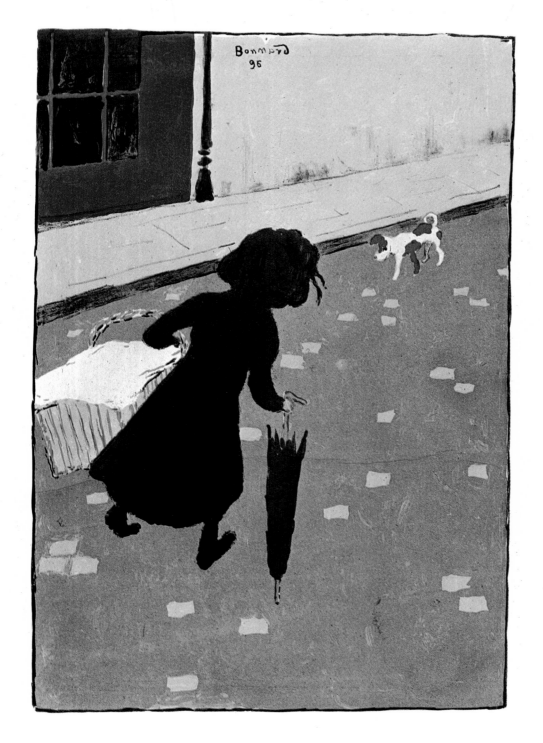

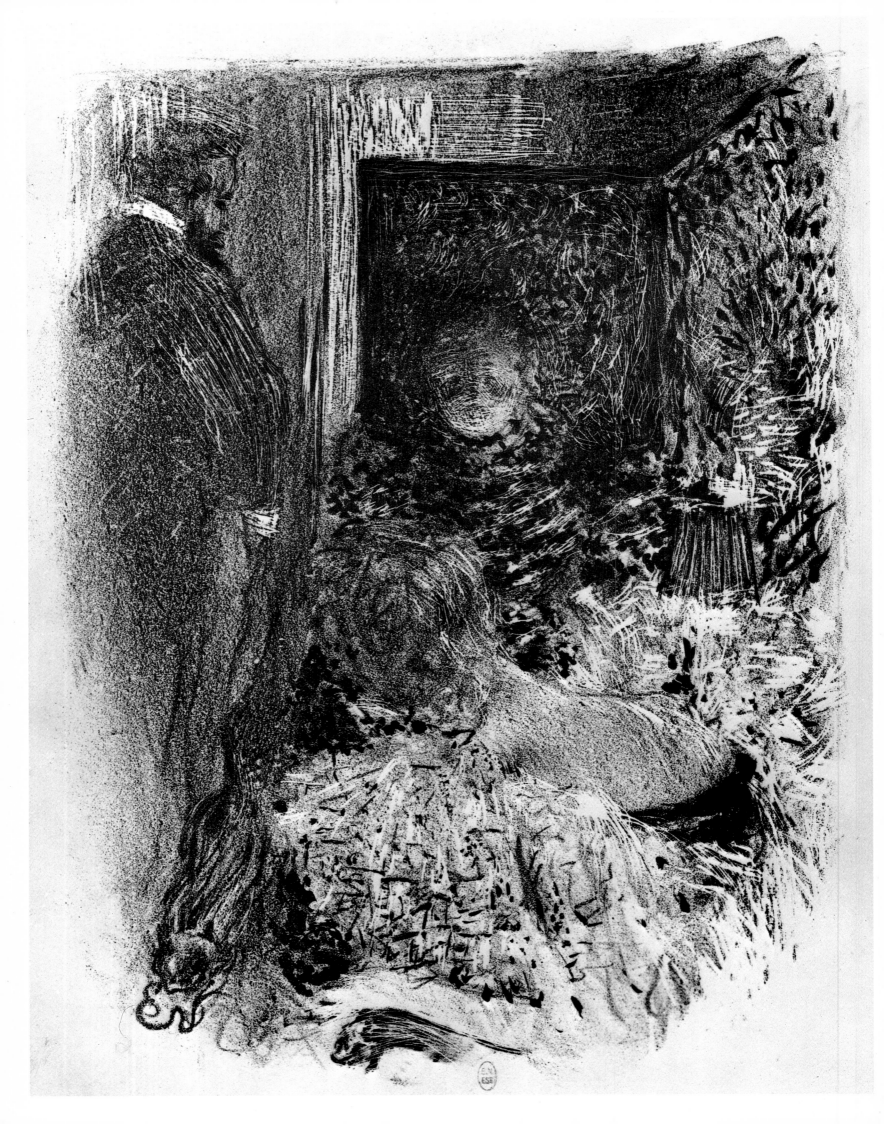

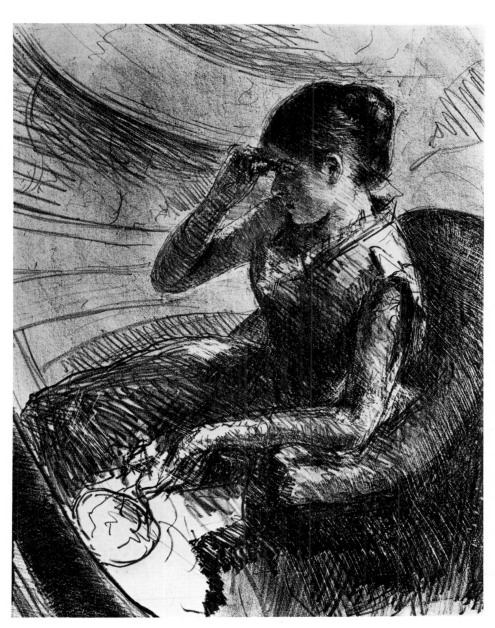

Right: Mary Cassatt, *Woman Seated in a Loge*, c. 1880. Opposite: Edouard Vuillard, *Intimacy*, c. 1895

pressive force, than to lithography. Nevertheless, the unique nature of his subject matter, in both his paintings and his prints, ensures him a special place in the history of lithography; and in particular that special brand of primitivism that he introduced into Europe from the South Seas frequently echoed in the works of succeeding generations. Gauguin's body of work is impossible to pigeonhole: the way in which it instinctively breaks up planes of perspective, visual images, and colors inspired the young Nabis, the Cubists, and the German Expressionists, and yet the critic Aurier defined it as Symbolist, because it is "synthetic, subjective and decorative." Gauguin's vague and misty poeticism (he was a confused and ingenuous theorist and an amateurish writer, despite the exotic allure of his travel journals) led him to form in Brittany, along with Emile Bernard, the Pont-Aven group of painters, later to be joined by Sérusier and Denis. They proclaimed a style known as Synthetism, which is characterized by broad patches of intense color, strongly outlined and arranged in a predominantly decorative manner, with shapes reduced to their barest essentials. They were, therefore, returning not only to the world of Japanese prints and to the popular art of the *images d'Epinal* but also to the realms of medieval stained glass (in fact, it must have been their artistic direction that inspired Rouault). Gauguin's work signified a flight, albeit somewhat remorseful, away from Impressionism and all forms of naturalism toward the frontiers of decorativism and the conse-

quent manifestations of Art Nouveau. This prophetic flight is even the subject of certain of his paintings: for example, *Futata te Miti (To the Sea)*. His development as a painter and graphic artist involved passing through a number of experimental stages. When he first started, Gauguin was influenced by Pissarro, whose style he interpreted with the taste and innocence of a Sunday painter. His artistic personality was buffeted by the different aesthetics he encountered and by the various artists he periodically admired (Degas, Van Gogh, Redon), but it acquired its stamp of originality only after his final escape to the South Pacific, as much of his graphic work shows (for example, *Manao Tupapau*, 1894).

Paul Cézanne (1839–1906) was a friend and pupil of Pissarro, who spent a great deal of time showing him how to exploit the full potential of color in an Impressionistic way and was also largely responsible for Cézanne's participation in the first Impressionist exhibition at Nadar's studio in 1874. Cézanne was the protagonist of another great escape: to the solitude of Provence, where he decided to "make of Impressionism something solid and lasting, like the art in museums." This great and undisputed father of modern painting was very active in the graphic arts and printed numerous lithographs, but perhaps the brightest star in his lithographic firmament is *The Bathers*. This restatement of the classical theme of the nude in a landscape possesses the unique difference that the figures and the landscape are inventions of the studio; it is an anti-naturalist abstraction, removed from any direct optical or perspective effects, whose formal lyricism springs from a deep and sincere inner truth. Cézanne's lithography provides essential documentation of how he married light, volume, and space and then combined them with total simplification and a synthetic approach to color and form. His formal

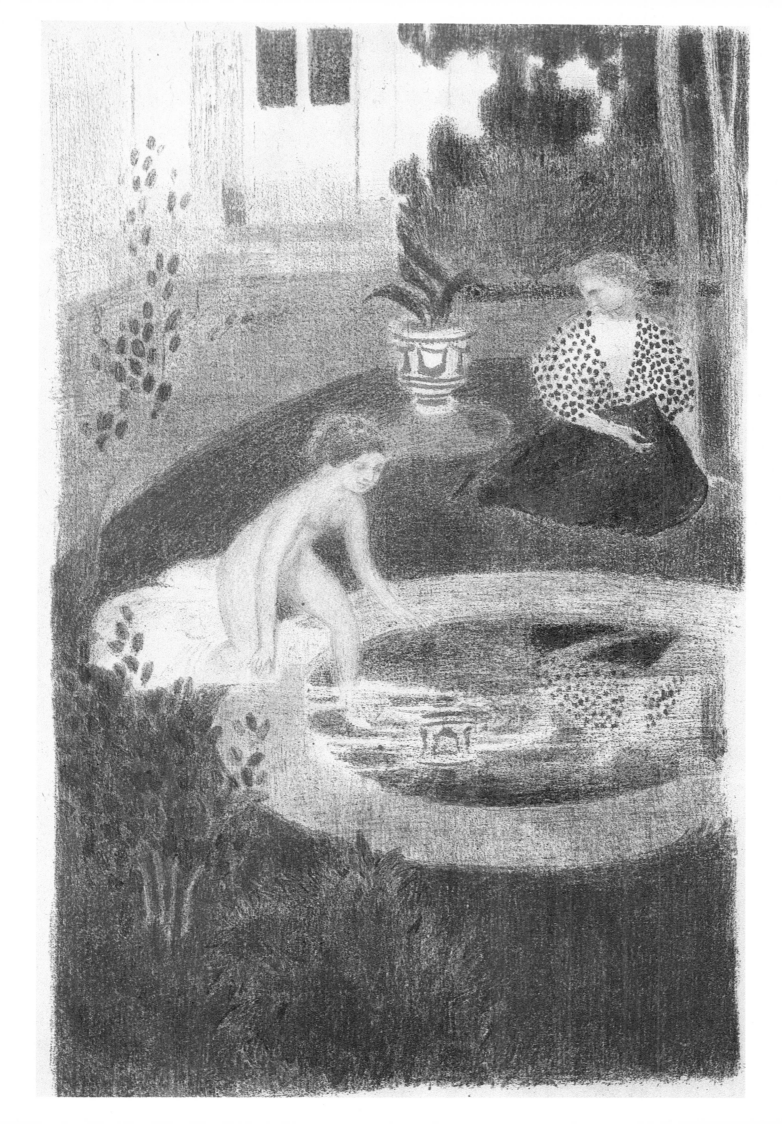

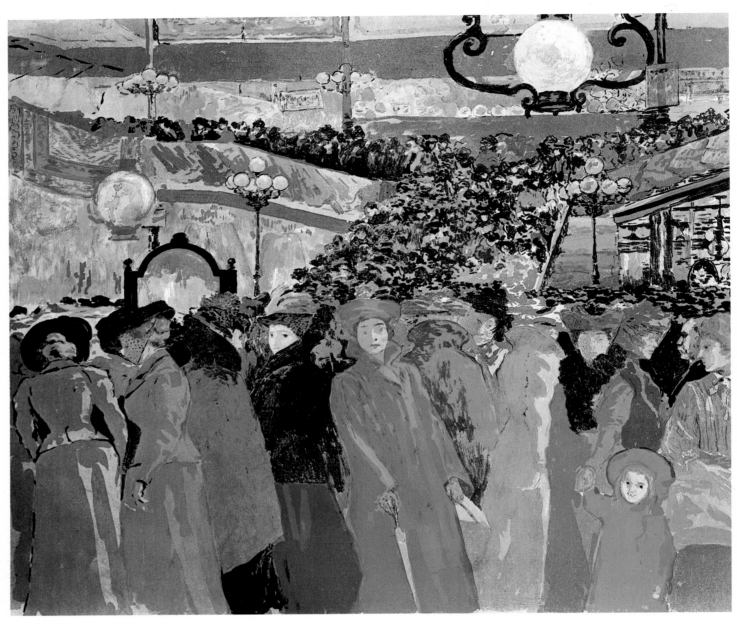

Above: Alexandre Lunois, *The Fancy-goods Store*, 1903. Opposite: Auguste Renoir, *The Pinned Hat* (Plate II), 1898

lyricism endowed objects, figures, and landscapes—particularly during the final period of his highly controversial career—with a quality of enduring realism, unrestricted by time or space, that lives on in our consciousness. Cézanne's sublimation and interiorization of reality are, perhaps, the final expressions of faith in nature by an art that was about to abandon itself to the heroic mannerisms of revolutionary avant-garde movements. The reality of Cézanne is a reality balanced between subjectivity and objectivity: it is self-contained and governed by laws that reject both naturalism and emotionalism. It is a reality that aspires to the eternity of form.

AMBROISE VOLLARD AND THE NABIS

After 1890, French lithography received an extraordinary boost from the activities of the great collector, dealer, and publisher Ambroise Vollard, who later recounted his involvement with modern art in a book entitled *Souvenirs d'un marchand de tableaux*. This fanatical (at the age of four he was already collecting shells and, shortly afterwards, stuffed animals) and intelligent Parisian, a frequent visitor to the Moulin Rouge, soon began to acquire drawings and prints; at the age of thirty, having branched out on his own following an apprenticeship at the Union Artistique, he organized the first exhibition of Cézanne's work. Vollard's premises be-

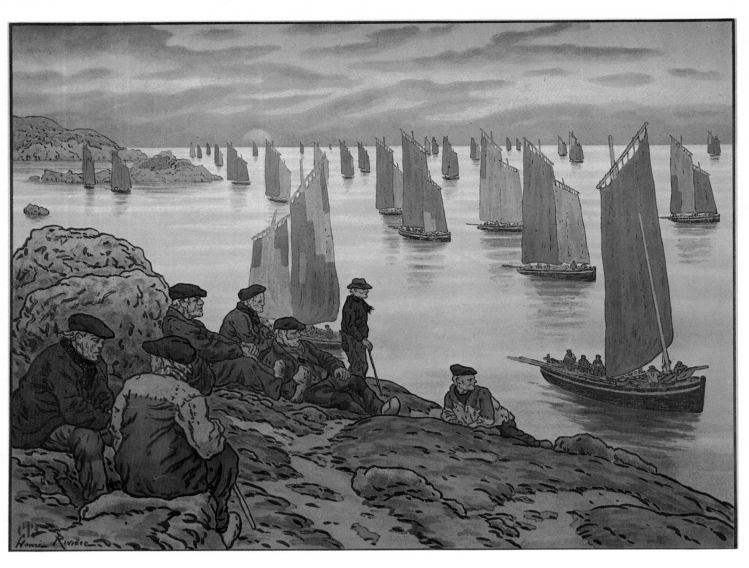

Above: Alfred Sisley, *The Riverside* or *The Geese*, 1897. Opposite, above: Henri Rivière, *In the Northwest Wind: The Old Men*, 1906–19; below: Camille Pissarro, *Women Carrying Kindling Wood*, 1896

came a vital landmark for new painters, particularly the Nabis, and later also for the Fauves. In 1901 he held an exhibition of Picasso's work and in 1904 one of Matisse's. In 1906, having sensed the merits of the new painting styles long before the critics, Vollard acquired in one fell swoop all the pictures that Vlaminck had in his studio. Rouault, Maillol, Rodin, and Renoir were all friends of his and all dedicated works to him. His activities as a publisher of graphics, and hence as a sponsor of new trends in lithography, began in 1895, the year in which he published a collection of lithographs by Bonnard (*Quelques aspects de la vie de Paris*). In 1897 he published his *Album d'estampes de la Galerie Vollard*, which contained lithographs by Toulouse-Lautrec, Bonnard, Denis, Signac, and others. In fact, he produced prints by almost all the most important painters of the time. In his preferences, his enthusiasm, and his critical appreciation, Vollard anticipated the taste of the public and the awareness of art historians by several decades.

During the final years of the nineteenth century, a number of artists —the most important were Maurice Denis, Pierre Bonnard, Edouard Vuillard, Aristide Maillol, Félix Vallotton, and Ker-Xavier Roussel—formed themselves into a group and declared themselves to be followers of Gauguin, taking the name of Nabis (the Hebrew word for "prophets"). Lacking any real stylistic homogeneity, they adopted as their artistic points of reference the works of certain Symbolists (Redon, Puvis de Chavannes), the primitivism of popular art, and the flatness of Japanese art and were interested mainly in the decorative qualities of art, in the arabesque, in symbols, and in expressive distortion. Historically, it is interesting to note that a new attention began to be paid to craftsmanship and to the

Right: Walter Crane, *Dancer,* 1894. Opposite: Henri Evenepoel, *In the Square,* 1897

applied arts, as revealed in items ranging from playing cards to puppets, stamps to posters, screens to wallpapers. Book illustrations also figured prominently in the aesthetic preoccupations of the Nabis. The movement as a whole was rather lacking in cohesion, because of the different inclinations of its protagonists, but its members did succeed in broaching new territory, which, under their influence, was further explored by Art Nouveau, Cubism, and Op Art.

Pierre Bonnard (1867–1947) was, like Vuillard, one of the artistic heirs of Toulouse-Lautrec. His first lithographed poster, *France-Champagne,* as has been pointed out, dates from 1891; a year later he executed *Family Scene* and some book covers for Vollard. From 1893 come the eighteen black-and-white illustrations of his *Petites scènes familières,* followed by a large number of posters, among them *La Revue blanche,* which dates from 1894. In 1898 Bonnard provided a color lithograph for the cover of André Mellerio's *Lithographie à couleurs,* while in the following year he created *Screen.* The most outstanding examples of his work as a lithographer are his prints for Paul Verlaine's *Parallèlement* and for *Daphnis et Chloé,* and his *Little*

Théo van Rysselberghe, *On the Jetty*,
1899

Laundress, *Boating*, and *Child by Lamplight*. Bonnard continued to create
lithographs almost up until his death: in fact, his series of twenty-four
lithographs for the *Crépuscule des nymphes* dates from 1946. The complete
catalogue of his works comprises eighty-three individual prints and approx-
imately three hundred book illustrations. Realism with a magical aura of
light and gentle shadows, and the vibrant spread of color in its purest state—
these are the hallmarks of Bonnard's lithographic art.

A mood of intimacy, intensified by glimmering lamps and decora-
tive richness, combined with a pervasive feeling of melancholy at the
passing of time, characterizes the art of that "painter of interiors," Edouard
Vuillard (1868–1940). Consistently faithful to his scenes of bourgeois
life and immune to the growing blandishments of the avant-garde, Vuillard
locked himself away in his own domestic world, which became more and
more resonant with decoration and warm, subdued lighting. His litho-
graphic work is not as intense as Bonnard's, and his earliest prints (*Inti-
macy*, 1895) were in black and white, with deep and luminous tonal
contrasts. Vuillard's first important color lithograph, *The Tuileries Gardens*,
dates from 1896; three years later Vollard published his album entitled
Paysages et intérieures, which contains the celebrated *Avenue*. He also exe-

cuted a considerable number of illustrations for avant-garde theater pro-
grams (*L'Oeuvre*). The most striking feature of Vuillard as a lithographer
is his moderation, his progressive simplification of light and surface.
Despite the limited number of his prints (roughly sixty), they introduced
an element of originality to lithography which is comparable, albeit on a
different level, to that of Toulouse-Lautrec.

Ker-Xavier Roussel, a friend of Vuillard, also completed an album
of colored lithographs for Vollard, but his main interest lay in the illustra-
tion of books, an activity that occupied him for more than twenty years.
Nymphs, satyrs, and fauns were the creatures whose portrayal Roussel
felt most at home with. Like Odilon Redon, he worked on the stone with
torturous attention, continually reworking his designs and sometimes
even destroying them and starting again from scratch. Acutely conscious
of the decorative potential of art, Roussel often indulged his own talent
for decoration; together with Vuillard, he was responsible for the panels
adorning the Palais des Nations in Geneva. One of the most indepen-
dent spirits in the Nabis group was Maurice Denis, whose greatest litho-
graphic achievements were his twelve prints in the *L'Amour* series, an
album published by Vollard in 1898. A lively critic and theorist (he was

Above: Jan Theodor Toorop, *The Lady of the Swans*, 1896. Left: Paul Berthon, *Sarah Bernhardt*, 1898. Opposite: Edmond-François Aman-Jean, *Beneath the Flowers*, 1897

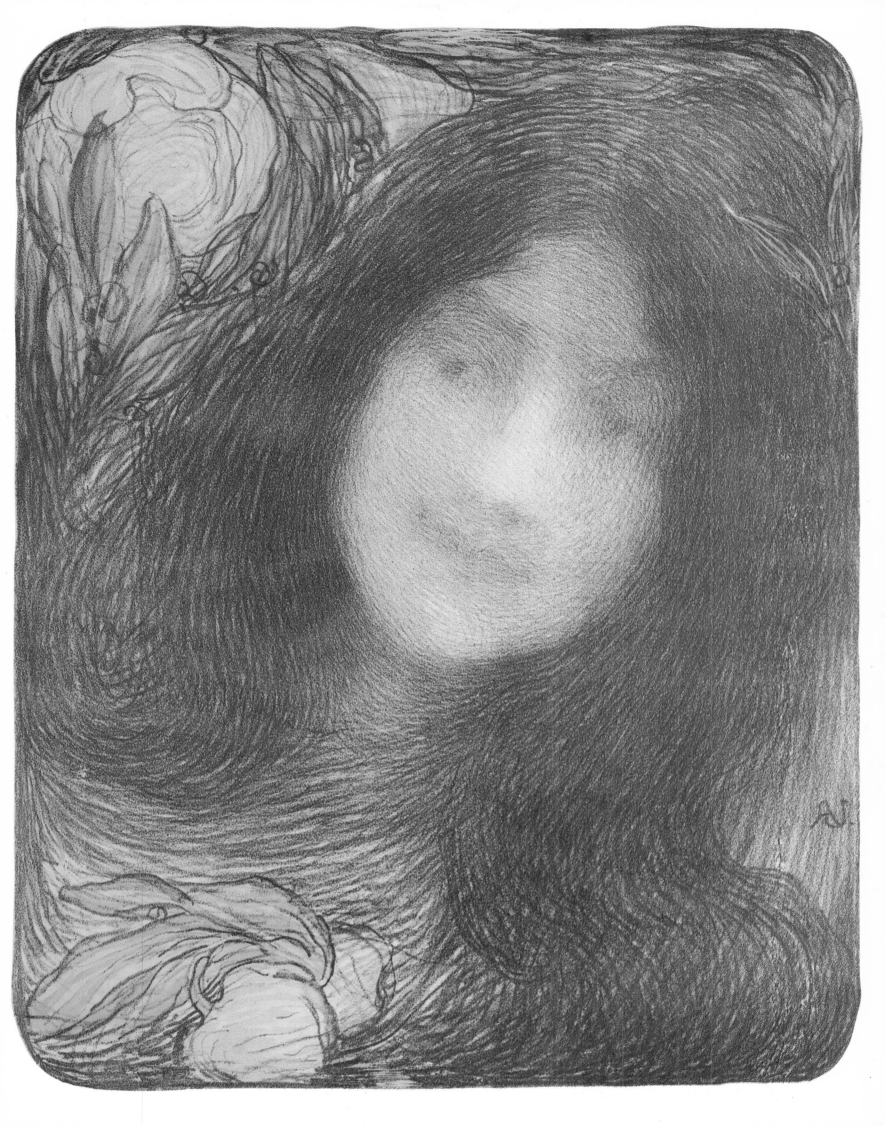

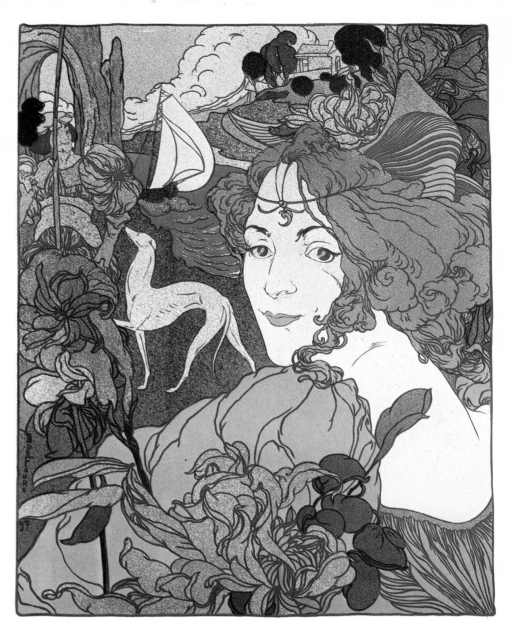

Right: Georges De Feure, *Return*, 1897.
Opposite: Paul Balluriau, *Dusk*, 1897.
Following pages (from left to right): Alphonse Mucha, *The Morning's Awakening*, *The Brightness of Day*, *The Evening's Reverie*, *The Night's Repose*, all 1899

among the first to understand Cézanne's work), Denis abandoned his intimist origins to arrive, via the Pre-Raphaelites and a superficial, literary vision of Catholicism, at a compositional style somewhat reminiscent of the Neo-Classicists. Félix Vallotton, another of the Nabis, arrived in Paris from Lausanne in 1882. Turning his back on any form of painting that relied on atmosphere, impression, or symbolic connotations, Vallotton looked instead to Henri Rousseau in his desire to portray the mundane and the episodic in the most linear and straightforward way, as in his *Paris intense* series. An admirer of Gauguin and Denis, the sculptor Aristide Maillol also participated, as an illustrator, in Vollard's publications. He was a highly skilled wood engraver and produced fine lithographs of nudes.

THE FORTUNES OF ART NOUVEAU

The Art Nouveau style, which spread rapidly and fairly uniformly throughout Europe (and thence across the Atlantic) during the closing years of the last century, was born of reactions against the eclecticism and imitativeness of past artistic styles and against the decline of craftsmanship in decorative objects and furnishings; it also reflected the preferences of the industrial middle classes, whose power at the end of the nineteenth century was firmly established. Its actual name varied from country to country: in Italy it was known as the *floreale* or ''Liberty'' style; in England it was called the Modern Style; in Spain *modernismo*; in Belgium

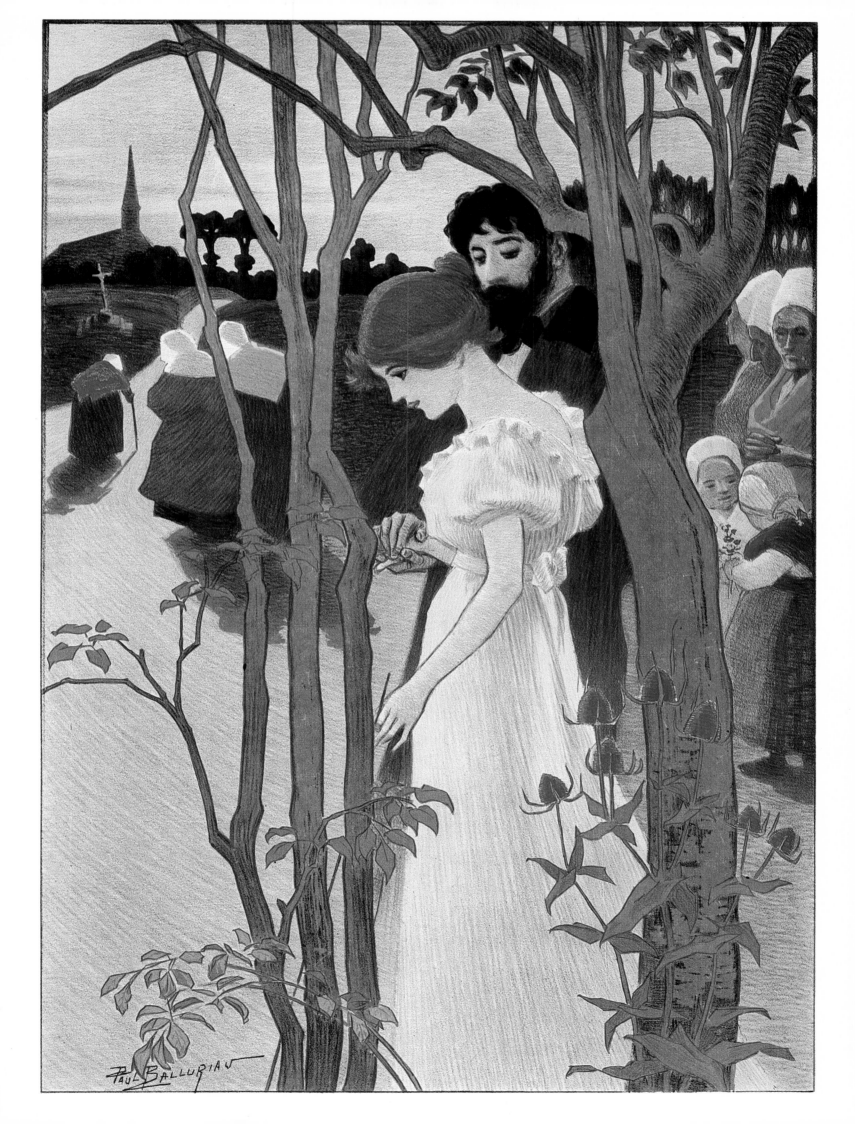

PAUL BALLURIAU

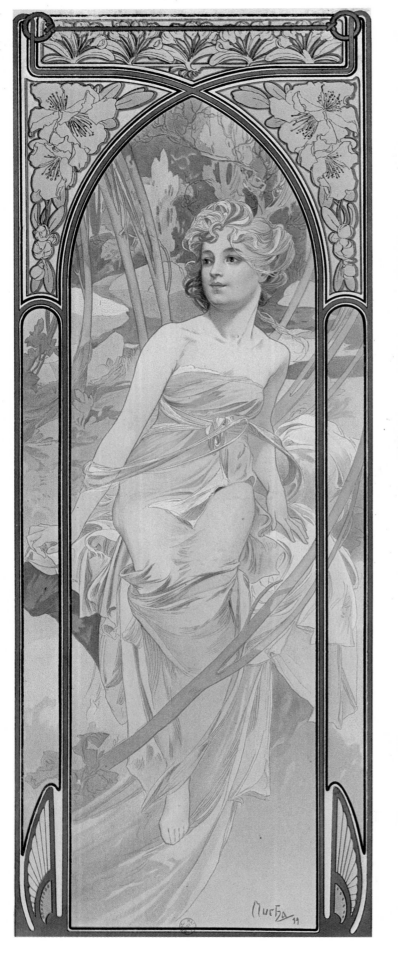
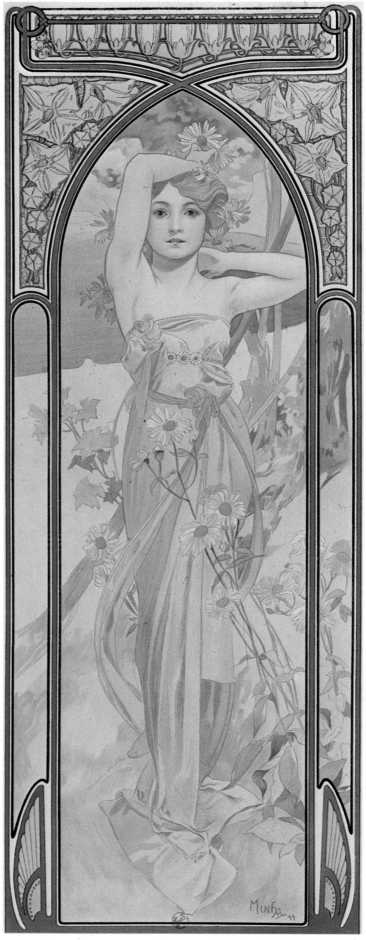

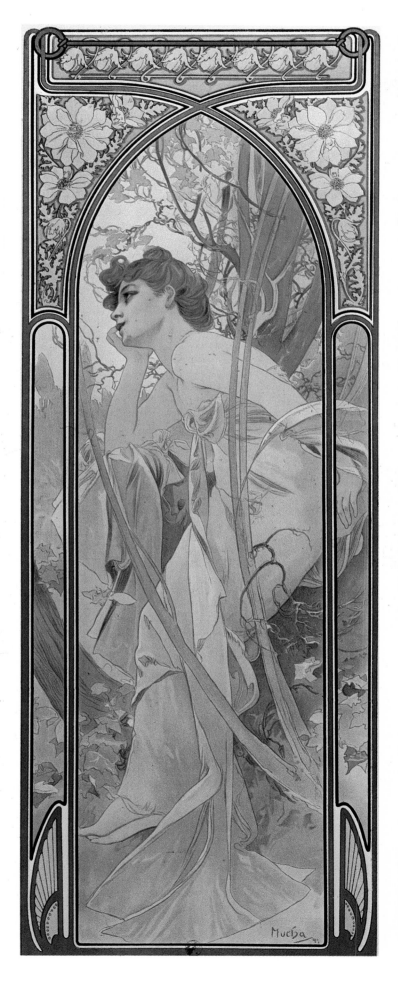
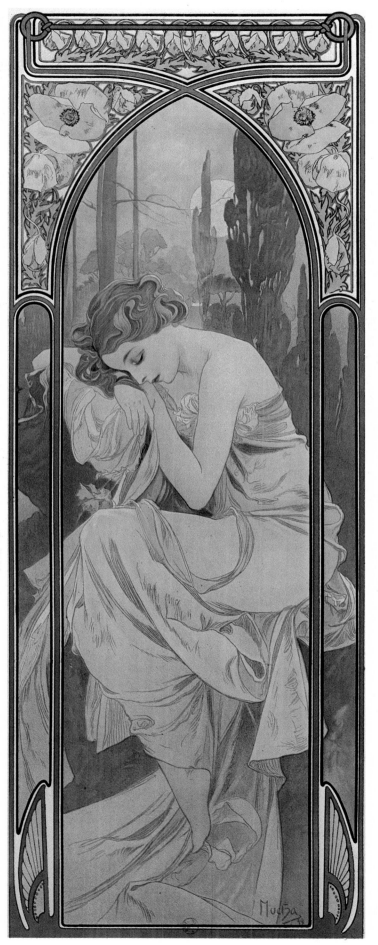

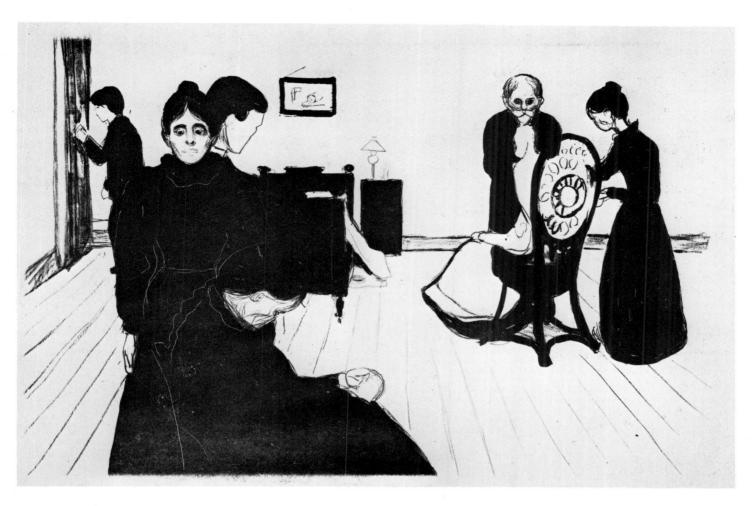

Edvard Munch, *The Sick Room*, 1896
(above), and *The Scream*, 1895 (opposite)

the Velde style; in Germany *Jugendstil*; and in Austria *Sezessionstil*. Although this process of renewal occurred mainly in the decorative and applied arts—in furnishings and then in architecture—it also had far-reaching effects in the figurative and graphic arts. Art Nouveau had a strong symbolic content, and its main contribution, its special character, lay in its linear symbolism, which it carried to extremes in all its manifestations.

In the figurative arts, Art Nouveau rejected the genre themes exploited by earlier movements in favor of conceits and ideas with literary connotations; it also introduced such themes into portraiture and sculpture, thereby running the risk of hyperbole. Sinuous and serpentine linear rhythms, based on references to foliar and floral cadences, identify Art Nouveau's romanticized and abstract vision of a flat, two-dimensional world. The main moving forces behind this successful new trend, which involved painters from otherwise different schools, included the Pre-Raphaelite Brotherhood in England (Ford Madox Brown, Dante Gabriel Rossetti, Edward Burne-Jones), out of which developed the refined erotic calligraphy of Aubrey Beardsley; the French Nabis (particularly the Renaissance-style art of Emile Bernard); the exoticism of Gustave Moreau; the dream imagery of Odilon Redon; the foliar abstractions of Van de Velde; and the linear accentuation of Edvard Munch, as yet untainted by any feeling of angst. The cult of "line," an almost Byzantine intricacy, and a great sensual joy ensure a special place for the elegant decorativism of Gustav Klimt (1862–1918), the greatest figure of the Vienna Secession. As has already been said, the movement gained followers in every country, making its mark on all aspects of graphic art, but in the field of lithography its most distinguished exponents included Alphonse Mucha, Paul

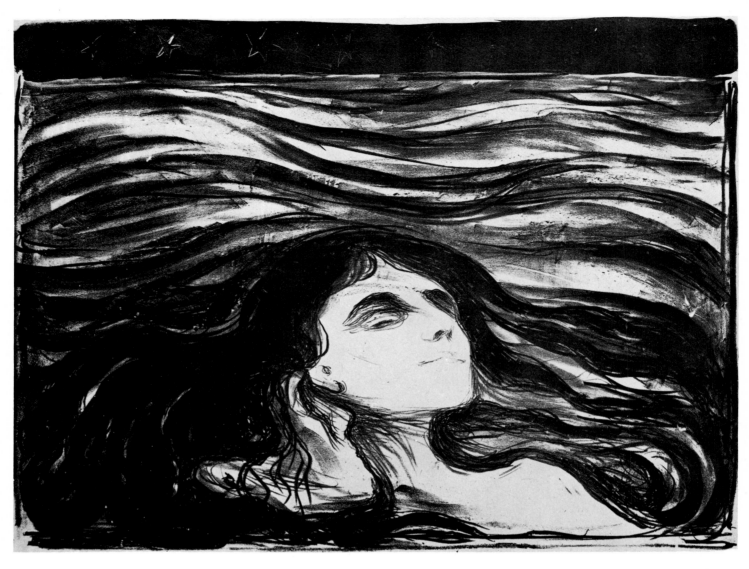

Edvard Munch, *The Lovers*, 1896 (above), and *Jealousy*, 1896 (right). Opposite: Emil Nolde, *Gloomy Man's Head*, 1907

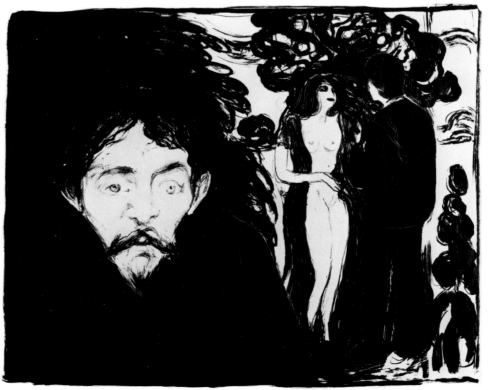

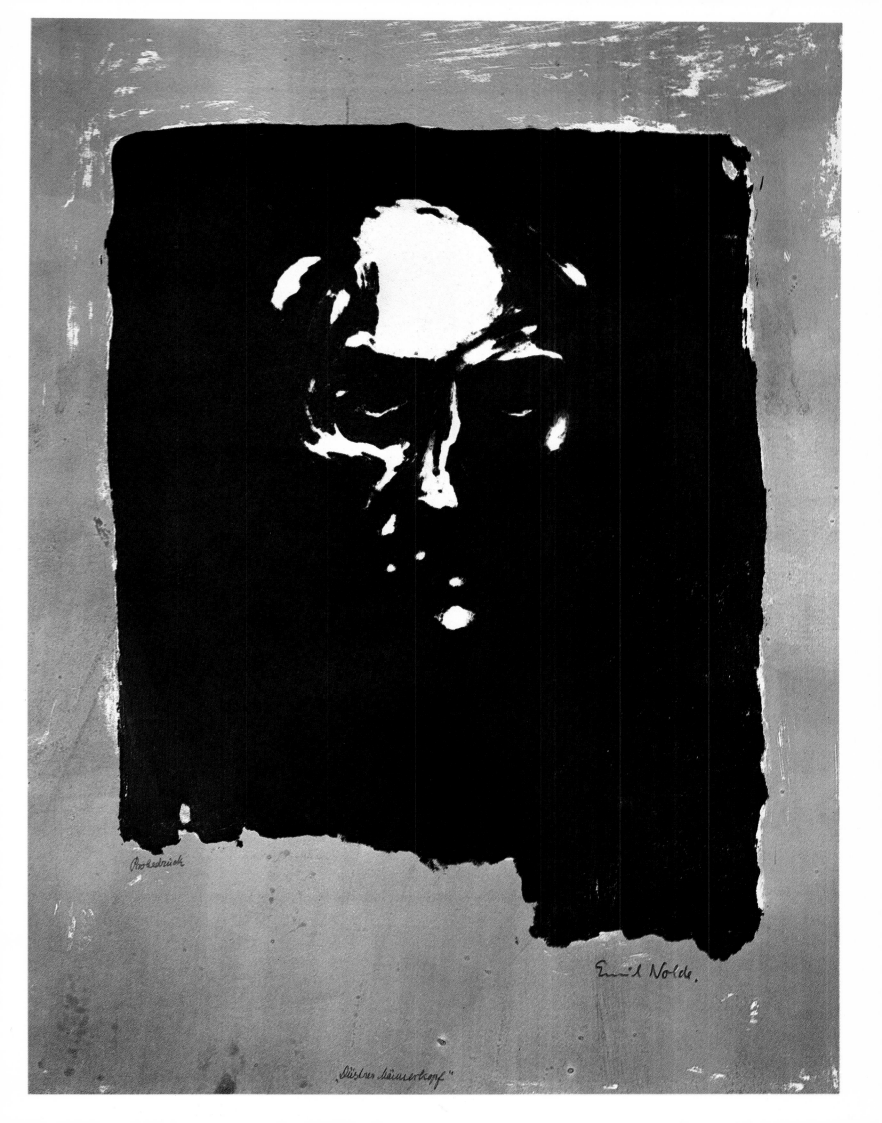

Probedruck

Emil Nolde.

„Düsterer Männerkopf"

Balluriau, Georges De Feure, Paul Berthon, Walter Crane, Henri Evenepoel, Eugène Grasset, Jan Toorop, and Edmond-François Aman-Jean. In most Art Nouveau prints, however, the foliar imagery does not always completely transcend its Symbolist origins.

Alphonse Mucha, a Czech who lived for a long time in Paris, is remembered for the extraordinarily inventive foliar qualities of his posters. He became the publicity artist for Sarah Bernhardt, and the elegance of his inimitable style made him famous during the 1890s.

MUNCH AND HIS HERITAGE

The Norwegian painter and graphic artist Edvard Munch (1863–1944) was one of the leading lights of German Expressionism and also a source of inspiration for other similar contemporary movements that emerged during the early years of this century. Like so many of his generation, Munch started his artistic career under the influence of naturalism and intimism, but his numerous trips to Paris and Germany soon brought him into contact with the thought-provoking works of Manet, Van Gogh, Toulouse-Lautrec, and, most significantly, Gauguin and Degas. His forays into Europe freed him from the restrictions of academism and gave him the means of achieving the sense of expressive freedom that fills his later works—the same intense feeling of weltschmerz one encounters in Ibsen and Strindberg. Munch's obsessive spirituality imparts a certain Symbolist quality to his paintings, but such tendencies are linked with a violent questioning of reality. His work is highly psychological and displays an exceptional degree of formal freedom; his hand succeeds in transmitting the emotions of desire, angst, and loneliness to his graphic oeuvre. His long stays in Berlin saw him become a major figure of the local artistic avant-garde and a member of the Secession movement, and his painting acted as a catalyst for much of German art during the opening decades of the century. His artistic heirs also included the Fauves, as they burst on the Parisian scene to howls of derision, even though he himself owes a considerable debt to the French Nabis. Munch devoted quite a large amount of his time to graphic art (woodcuts, drypoint etchings, lithography) because he wanted a wider circulation for his art, and particularly for its elements of social criticism. In Paris he executed several prints inspired by Toulouse-Lautrec but soon freed himself from outside influences; to what he had learned from others (including Van Gogh) he added a violent and tormented originality that can be clearly seen in *The Scream* of 1895. In the same year he completed *Madonna, Vampire*, and *Self-portrait with Skeleton Arm*, in which a ghostlike face emerges from total darkness. Although a master of graphic precision (*The Lovers, Jealousy, The Sick Child*), Munch enjoyed scant success outside Germany during his lifetime. Among his color lithographs was *The Death of Marat* of 1906.

GERMAN EXPRESSIONISM

The term "Expressionism" is one of the most sweeping cultural categorizations of all time: part of the terminology of both art history and literature, it identifies neither a historical reality nor a uniform group of practitioners. It is an approximation that, within a specific period of time, linked a certain number of artistic manifestations having a particular attitude toward art. Expressionism reflects a mood of unrelenting opposition against Impressionism and Symbolism that owed its existence to a somewhat vague stylistic amalgam of various European trends during the years before and after World War I. Its uniformity of intent seems even less apparent when

Opposite: Egon Schiele, *Male Nude,* 1912

114

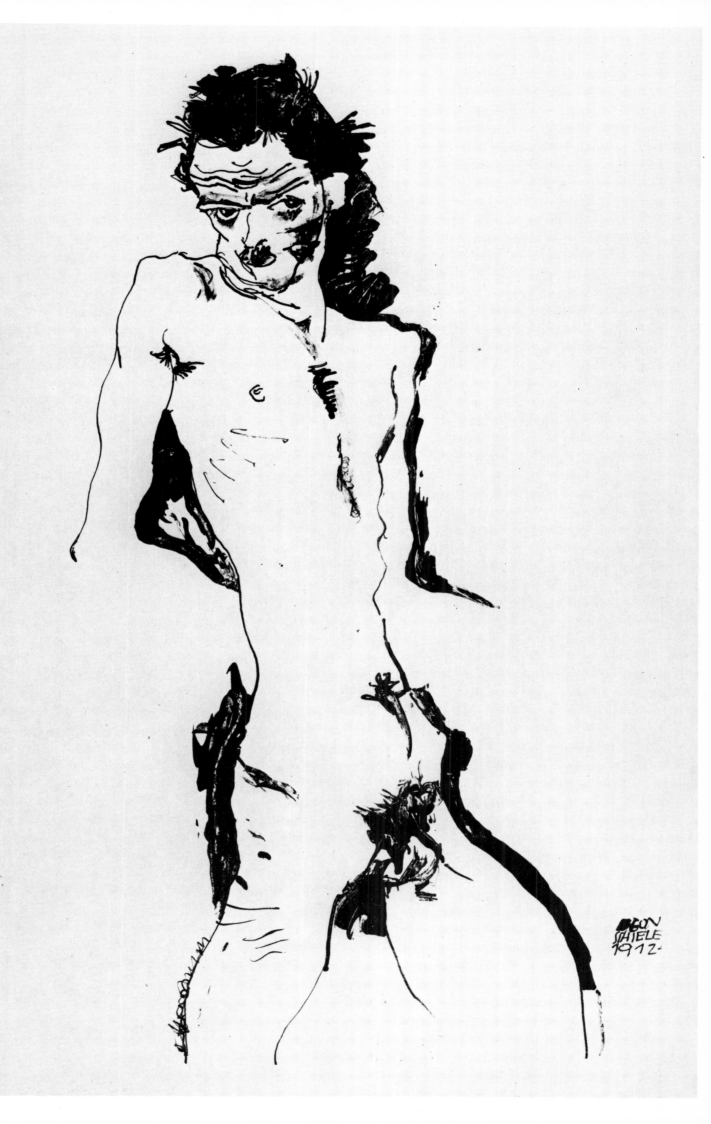

Ernst Barlach, *The Abandoned*, 1930–31

one considers the relevant period from a purely lithographical standpoint. One of the most important and earliest artistic groupings was Die Brücke ("The Bridge"), founded in Dresden in 1905. It is worth recording that the emergence of Die Brücke coincided with that of the Fauves in France. One of its leaders, Emil Nolde, later went on to take part in the Blaue Reiter ("Blue Rider") movement started by Franz Marc and Wassily Kandinsky, while the artists of Die Neue Sachlichkeit ("The New Objectivity") rejected the abstract tendencies of the Blaue Reiter and joined in the "spiritual" protest of the Expressionists. Austrian Expressionism, in revolt against the inflated style of the Vienna Secession, linked itself with Kubin, Kokoschka, and Schiele in upholding the aims of the German Expressionists. This important pan-Germanic agglomeration also attracted a number of exceptional literary figures and provided as well a breeding ground for the later movements of Dadaism and Surrealism. Needless to say, however, the annals of German lithography do include works by artists unconnected with the various movements previously mentioned. This is particularly true in the case of Max Slevogt, who began work around 1905 and created a total of more than two thousand black-and-white prints; Slevogt also provided some of the most original illustrations for Goethe's *Faust*. The solitary Ernst Barlach, a sculptor and wood engraver as well as a writer, who clearly worked in the Expressionist mold, proved himself to be a lithographer of above-average competence, while there is also an Expressionist feel to the unreal distortions of Max Beckmann, author of *Night*

Käthe Kollwitz, *Self-portrait*, 1924

and numerous memorable prints, including his series of eleven lithographs, *Hell*, and his twenty-seven colored lithographs depicting the Apocalypse.

All the members of Die Brücke, the official Expressionist movement launched in Dresden in 1905, were fine lithographers: Erich Heckel, Ernst Ludwig Kirchner, Otto Müller, Emil Nolde, Max Pechstein, and Karl Schmidt-Rottluff. Elsewhere in the field of lithography, mention should be made of the immense graphic talent of Käthe Kollwitz and the subtly disquieting work of Lyonel Feininger, who was close to both the Expressionists and the Blaue Reiter. A friend of Paul Klee, Feininger was one of the founders in 1924, with Kandinsky, Klee, and Jawlensky, of a group at the Bauhaus known as Die Blauen Vier (''The Blue Four''). The artists of Die Brücke hoped to bring about a renewal of art but were motivated more by antibourgeois social feelings and the ideal of community life than by aesthetic considerations. A thread of primitivism, often strident, runs through their work, a crude and cruel streak with a sense of immediacy that emphasizes their explosive use of color. The two pivotal members of the group were Nolde and Kirchner; the former remained true to his rural origins and displayed an ineradicable attraction toward mystical religiosity, while the latter was an intellectual interested almost exclusively in the exposure of contemporary social reality by means of paintings containing bitter moral judgments. The group as a whole regarded lithographic prints as an important means of personal expression: Kirchner, for example, produced more than four hundred examples, often of extremely high quality.

117

Another important figure in the field of lithography was Otto Müller. It fell to Nolde, however, to demonstrate the high level of proficiency achieved in German lithography during the period. His black-and-white prints produced at Flensburg in 1913 are among his best, and his color prints *The Danish Girl* and *The Dancing Girl* are also worth recording. All in all, Nolde produced more than a hundred prints.

The paintings and graphics of the Blaue Reiter group provide confirmation of that new freedom which lay at the roots of abstract art. Art for these men was a manifestation of the artist's inner being, to be revealed by means of lines and colors divorced from any connection with external reality: it is this quality that runs through the works, whether paintings or lithographs, of the men such as Jawlensky, Klee, and Kandinsky who subscribed to the doctrine of Expressionism.

The total number of lithographs by Klee is forty-two, a small number when compared to his approximately five thousand drawings, but his lithographs nevertheless do reveal both the importance that Klee placed on all

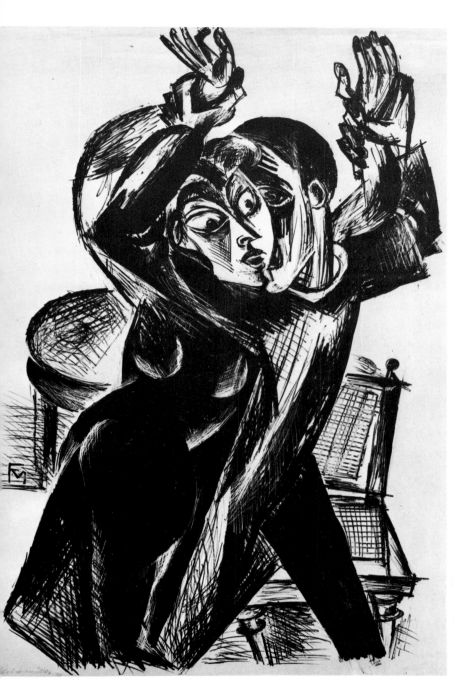

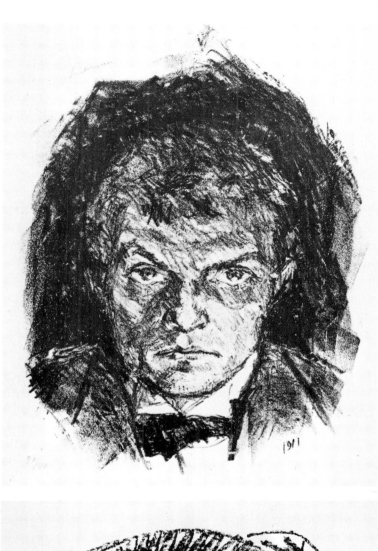

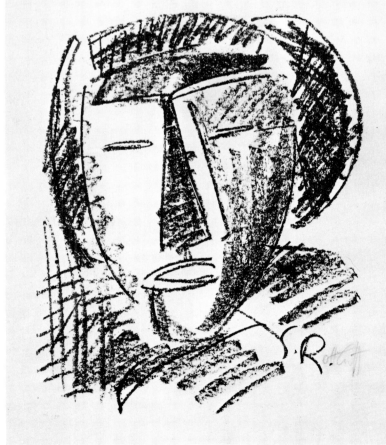

Opposite: Max Beckmann, *Self-portrait with Cat and Lamp*, 1920. Above, left: Conrad Felixmüller, *The Whirling Ones*, 1919; above, right: Max Beckmann, *Self-portrait*, 1911. Right: Karl Schmidt-Rottluff, *Head*, 1921

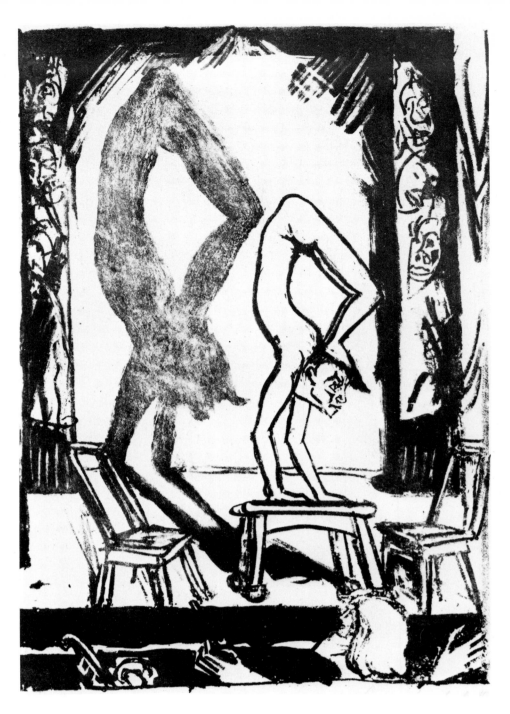

Erich Heckel, *Handstand*, 1916

means of self-expression and his awareness of the potential of graphic art. The latter medium, he wrote, "can, by its very nature, endow objects with a more ghostly and fabulous existence, and with incomparable precision." Klee executed his lithographs on transfer paper, and in his color prints he introduced only the most delicate shades within the network of lines.

The New Objectivity was active mainly in Germany between 1923 and 1924 against the background of the Weimar Republic. Rejecting the abstract subjectivism of the Blaue Reiter, it plunged into the Expressionist mainstream with a violent realism, both artistic and political, in keeping with the cultural and literary activities of Brecht, Toller, Piscator, and others. The figurative distortion practiced by its exponents was used to present biting satires of the ruling classes and their myths. Its best-known representatives were Otto Dix, George Grosz, and Christian Schad, whose style was one of cold, pitiless analysis, whereas Alexander Kanoldt, Georg Schrimpf, and Carlo Mense explored their subjects in a less violent mood. The most notable graphic artist of them all was Grosz, with his furious satires on war and social hypocrisy.

The Austrian Expressionist movement was championed by the painter, writer, and draftsman Alfred Kubin, the musician and painter Arnold

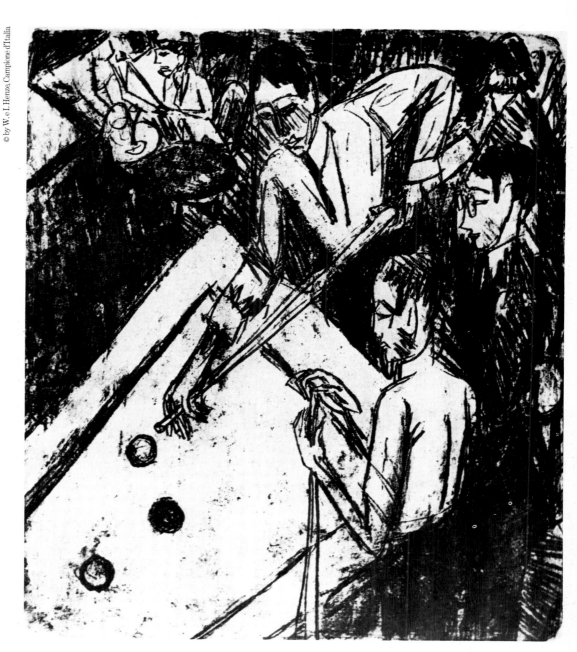

Ernst Ludwig Kirchner, *Billiard Players,*
1915

Schönberg, and by Richard Gerste, Oskar Kokoschka, and Egon Schiele. Temperamentally dissimilar and from different cultural backgrounds, they all opposed the Secession and the taboos of the middle classes with a style of painting stripped of hypocrisy and possessing great emotional strength. Horror, fantasy, exaltation, a search for the vital essence of a subject in order to reveal its innate spirit: these are the recurrent elements in Kokoschka's jarring, polemical works and in Schiele's investigations concerning the conflict of life and death. When the Austrian Expressionists turned to graphics, they revealed an uncommon mastery of the medium, and Kokoschka in particular found lithography an excellent means for conveying his cruel visions. Among Kokoschka's most notable prints are his illustrations for Karl Kraus's *Die Chinesische Mauer* and his twelve drawings for *Der gefesselte Kolumbus, The Passion of Christ,* and *Job.* At the end of World War II, he published his great poster entitled *Christ Crucified Helps the Starving Children.*

Within the context of this German artistic renewal we should remember, in the field of lithography, the albums dedicated by the Bauhaus at Weimar to the "New European Graphic Art." The first album contained lithographs by Paul Klee, Johannes Itten, Oskar Schlemmer, and others, while

121

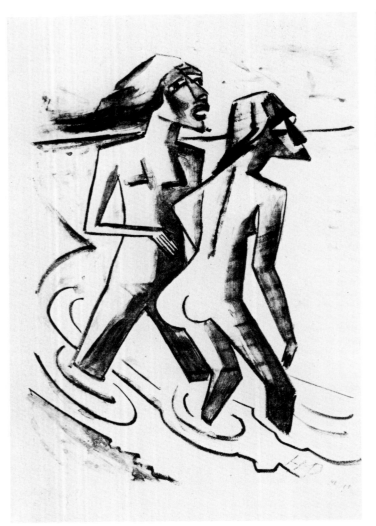

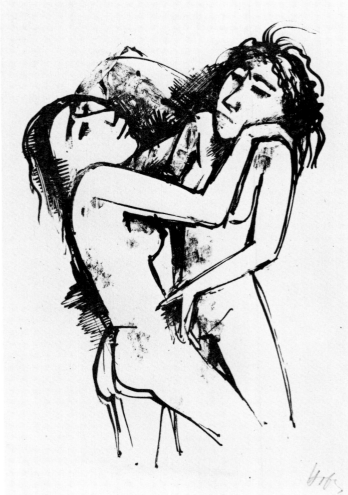

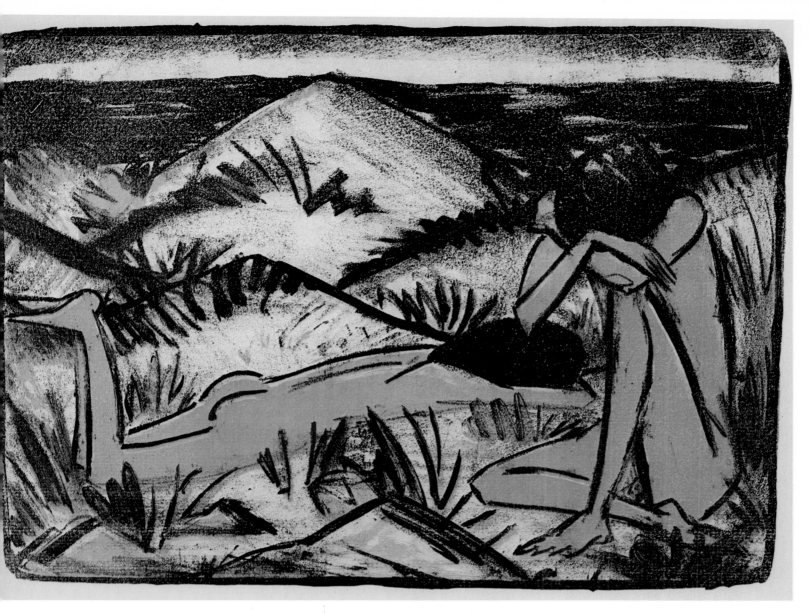

Above: Otto Müller, *Two Girls in the Dunes, One Sitting and One Lying Down,* 1920. Opposite, top left: Max Hermann Pechstein, *Bathers,* 1921; top right: Karl Hofer, *Two Girl Friends,* 1923; below: Georg Kolbe, *Female Nude,* 1921

the third one (the planned second one never materialized) included works by Kurt Schwitters, Willi Baumeister, Bernhard Hoetger, and Rudolf Bauer. The fourth album, to which Italian and Russian artists also contributed, is of particular importance. It included *Acrobats* by Carlo Carrà, *Pylades and Orestes* by Giorgio De Chirico, *Figures in Movement* by Enrico Prampolini, *Harlequin's Family* by Gino Severini, as well as Alexander Archipenko's *Two Female Nudes,* Natalia Goncharova's color print *Figure of a Lady,* Jawlensky's *Head,* and two works entitled *Composition,* one by Kandinsky and the other by Larionov. The fifth album contained lithographs by Max Burchartz, Otto Gleichmann, George Grosz, Oskar Kokoschka, and Alfred Kubin. Production of these albums eventually ceased for economic reasons, and the projected fifth album dedicated to French lithography —with works by Braque, La Fresnaye, Delaunay, Derain, Matisse, and Léger—never appeared.

THE FAUVES

Such heterogeneous personalities as Matisse. Vlaminck, Derain, Braque, Dufy, Van Dongen, and Rouault were grouped together under the ironic name "Fauves" (wild animals) on the occasion of an exhibition of their works at the Salon d'Automne in 1905. With the German Die Brücke movement, Fauvism represented the most important trend in European Expressionism during the first years of this century. The Fauve artists shared the same masters (Munch, Ensor, Van Gogh, Gauguin, Toulouse-Lautrec) and the same anxious desire to transmit the emotions and spiritu-

Above, left: Georg Grosz, *Veiled Lady*, 1914–15. Otto Dix, *Dame mit Reiher*, 1923 (above, right), and *Procuress*, 1923 (opposite)

ality of the real world, but they were separated by different cultural backgrounds and by different sensibilities: Romantic in the case of the Germans and classical in the case of the French. At the basis of the Fauves' pictorial activities lay the exaltation of color, which, as Gauguin taught, exists independently of any spatial and perspective naturalism.

Color for Henri Matisse (1869–1954) had a structural, plastic function: a means of harmonically translating a state of mind, it was an end in itself, an independent element of imagery. Spread in its pure state by rapid, broken brushstrokes, with a rhythmical, dancelike quality, color becomes endowed in Matisse's work with a powerful graphic character and reverberates with cultural and decorative echoes borrowed from Africa and the East. Painting as a subject of painting—an aesthetic principle that Matisse followed throughout his life—did not prevent him from being a great illustrator of books or from dedicating himself to several aspects of graphic art. A swift and deft draftsman, he also practiced lithography, portraying nudes and odalisques (*Nude on a Sofa, Her Arms Raised; Odalisque in a Dancing Girl's Trousers*). In keeping with the French publishing tradition, he executed lithographs for *Lettres de la religieuse portugaise*, Reverdy's *Visages*, and Baudelaire's poems, while at the same time creating one hundred and twenty-six prints for Ronsard's *Florilège des amours*. His idea, one of absolute freedom, was that a book did not need imitative illustrations, but rather that "Drawing should create shapes that have the same value and significance as the text." Matisse was a careful and patient lithographer to whom improvisation was completely alien, even though the freshness of his style and colors would seem to suggest otherwise.

Fauves such as Vlaminck, Derain, Braque, Dufy, and Rouault also made lithographic contributions. even though the explosive colors that characterized their aesthetic could not always be achieved through lithographic means.

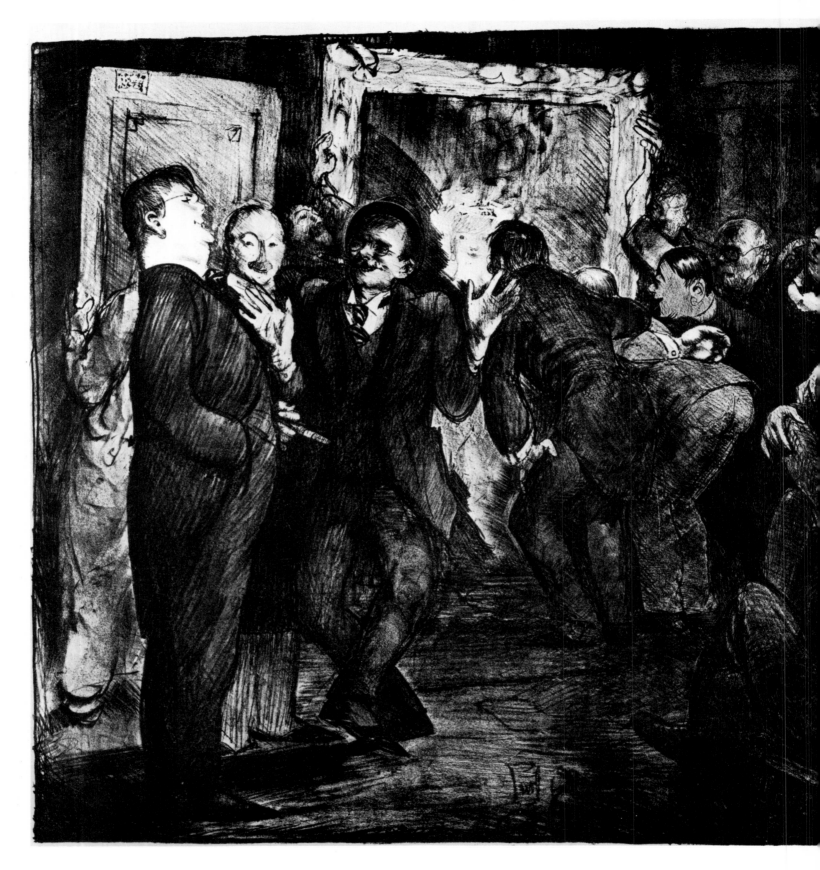

Above: George Wesley Bellows, *Artists Judging Works of Art*, 1916. Opposite, above: John Sloan, *Saturday Afternoon on the Roof*, 1919; below: Reginald Marsh, *Switch Engines, Erie Yards, Jersey City* (Stone No. 3), 1948

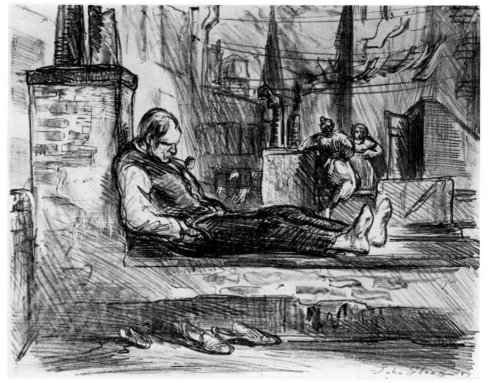

The graphic work of Georges Braque (1882–1963) is not as extensive as that of his contemporary Picasso; apart from his etchings and a few woodcuts, he created no more than one hundred and forty lithographs, including those used to illustrate more than one book. His best-known series are the *Cahiers de Georges Braque* and *Une Aventure méthodique*, and his color lithograph entitled *Glass and Fruit* was produced by Charlot. In 1928 Braque executed a black-and-white still life, and in 1932 Mourlot printed another of these, entitled *Athenaeum*. After 1945, and still under the auspices of Mourlot, he executed, among others, *Chariot*, the four variations of *Helios*, and *Teapot and Lemons*. One of his greatest works was *Leaves, Colors, Light*.

André Derain's few engravings are perhaps of greater significance

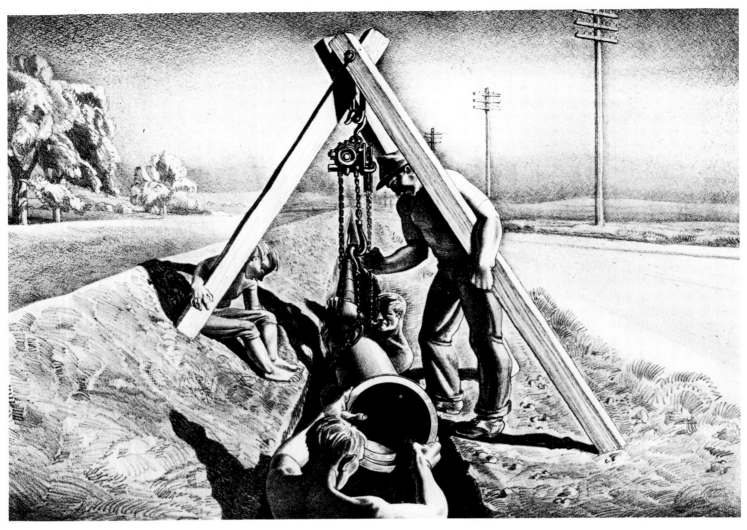

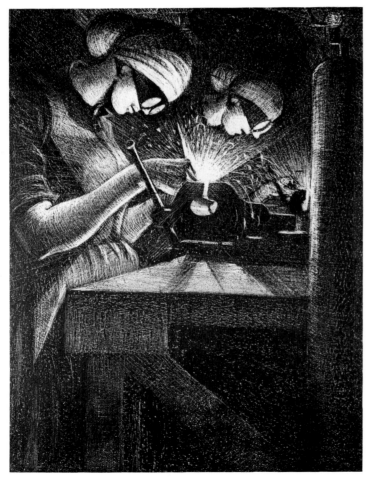

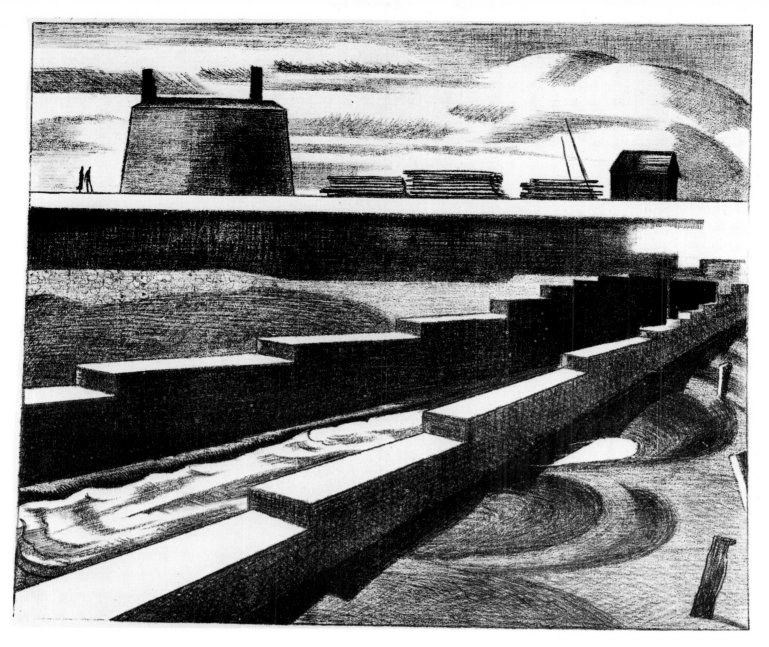

Above: Paul Nash, *The Sluice*, 1920. Opposite, above: Rockwell Kent, *Workmen Lowering Pipe Section into a Ditch*, 1941; below, left: Christopher Richard Wynne Nevinson, *Acetylene Welder*, 1917; below, right: Charles Sheeler, *Delmonico Building*, 1927

than his lithographs, while Maurice Vlaminck's lithographs possess no particularly unique qualities when compared with his paintings. Raoul Dufy, a delicate yet striking colorist, was a successful draftsman and experimental graphic artist (he also designed graphic materials). He had a craftsman's passion for the lithographic stone: his prints, the product of a surprising visual memory, are lively and vigorous tours de force. Dufy also executed some remarkable illustrations for Daudet's *Tartarin*.

Georges Rouault (1871–1958) was, as far as the Fauves are concerned, merely a bird of passage. Although his painting contains echoes of his apprenticeship as a restorer of stained glass, the strong, black lines that outline his figures and his colors are an Expressionist device in the sense that they were introduced in order to lower the chromatic scale of the adjoining shades. Dominating Rouault's work is a spiritual quality, replete with a dramatically revealed faith and an often aggressive sense of ethics. His graphic works—sometimes paradisiacal, sometimes infernal—convey this same spiritual quality. He worked for Vollard and he executed for Frapier a series of grotesque likenesses of judges, prostitutes, and clowns. Rouault also created some very fine portraits of literary figures (the *Portraits de Verlaine* suite, for instance), but his greatest lithograph is the one entitled *Autumn*.

If the ambiguous term "Expressionism" can be stretched to include the penetrating clarity with which Maurice Utrillo evoked the Paris of the

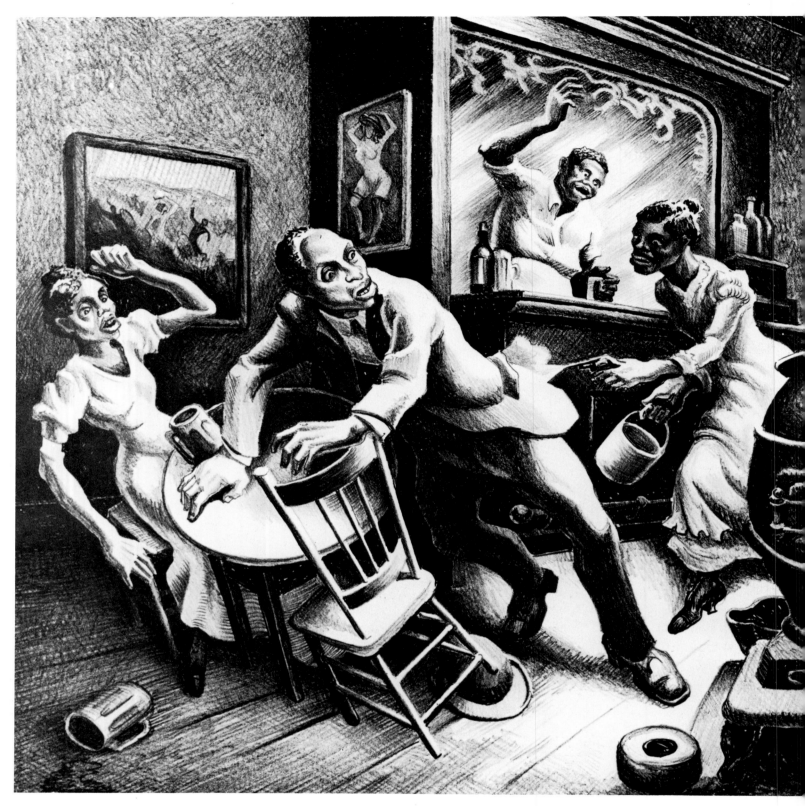

Above: Thomas Hart Benton, *Frankie and Johnny*, 1936. Opposite: John Steuart Curry, *Mississippi Noah*, Plate II, 1935

clochard, with its poverty-stricken streets and houses with rotting shutters and peeling plaster, then it must be added that the lithographic style of this solitary painter fluctuates between extraordinary incisiveness and an almost picture-postcard quality.

ENGLISH AND AMERICAN CONTRIBUTIONS

At the end of the nineteenth century, lithography, which had been introduced directly into England by Senefelder and his colleagues, found a very able exponent in the American James Abbott McNeill Whistler (1834–

1903). His prints retain the same delicacy and refinement encountered in his painting, which possessed exotic, decorative overtones that anticipated Art Nouveau. In London, another American emigré, Joseph Pennell, became president of the Senefelder Club and executed hundreds of lithographs. Other members of this club included the fine illustrator and portraitist Charles Shannon and the even more renowned portrait painter, William Rothenstein. The painters John Singer Sargent and Augustus John also practiced lithography. During World War I, the draftsman Muirhead Bone gained widespread success with his lithographs conveying impressions of life at the front; Paul Nash, an official war artist during both the world wars, was a painter, writer, and lithographer whose prints reveal a mixture of both symbolism and fantasy. Another official war artist was the painter and lithographer Christopher Richard Wynne Nevinson, who was greatly influenced by Cubism and Futurism, while the post-Impressionist Robert Bevan lithographed horses, landscapes, and street scenes. The most outstanding examples of modern English lithography bear the signatures of the sculptor Henry Moore and the painter Graham Sutherland. Moore employed lithography in order to repeat the qualities of his sculpture (archaic monumentalism, figurative surrealism, and formal abstraction). The visionary quality of Sutherland's vegetal and animal metamorphoses and the disquieting fantasy of his flowers, roots, trees, birds, and insects achieve a memorable degree of expressive and synthetic force.

The earliest American lithographs were probably the illustrations executed from 1818 on by Bass Otis for the *Analectic Magazine*; these are mostly rural landscapes that are curiously imitative of copper engravings. Among the pioneering names to be remembered are those of the portraitist Rembrandt Peale, who lithographed a famous portrait of George Washington; the landscapist Thomas Moran; the cartoonist Joseph J. Keppler; Winslow Homer; and William Rimmer. Popular lithography received a considerable boost in the United States from the famous New York company of Currier & Ives, which for fifty years specialized in documentary lithography. Without any artistic pretensions, this firm illustrated every aspect of American life in approximately eight thousand lithographs dealing with a wide variety of subjects. Lithography as a vehicle for social comment gained

Above: Paul Cézanne, *The Bathers*, large plate, 1898–1900. Opposite: Robert Delaunay, *Window on the Town*, 1909–25

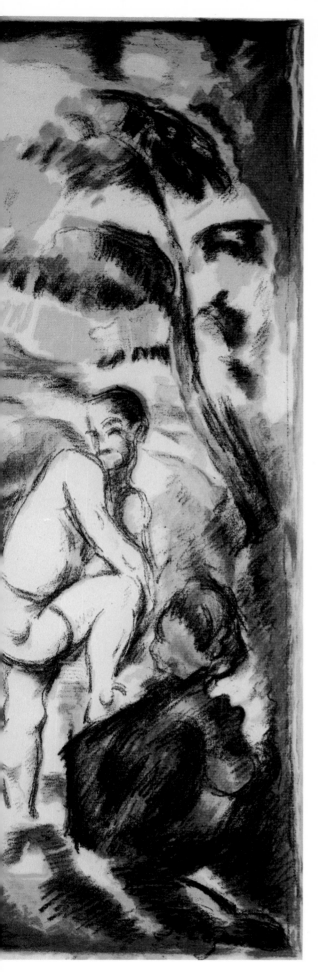

considerable impetus during the years of World War I from the works of John Sloan, while an echo of Daumier runs through the prints of George Bellows. A similar feeling of social conscience also recurs in the lithographs of Reginald Marsh and Ben Shahn. Rockwell Kent, an adventurous traveler and talented lithographer as well as painter, executed prints with strong contrasts of black and white around solid geometrical shapes. American lithography achieved a greater sense of independence through the work of Stuart Davis and Yasuo Kuniyoshi and especially through the strongly regional subjects of Thomas Hart Benton and John Steuart Curry. The urban landscapes of Charles Sheeler are also worthy of mention. As we have already seen, many American artists became part of the European lithographic mainstream; two such are the Impressionist Mary Cassatt and the Expressionist Lyonel Feininger. From the other side of the Atlantic came the lithographic prints of the Mexican painters David Alfaro Siqueiros and José Clemente Orozco, who initiated a vigorously oratorical style of mural painting with popular, epic overtones.

THE GENIUS OF PICASSO

If it is true that Picasso was not so much a creator as a seismographic recorder of his own artistic personality, registering the cold, tumultuous

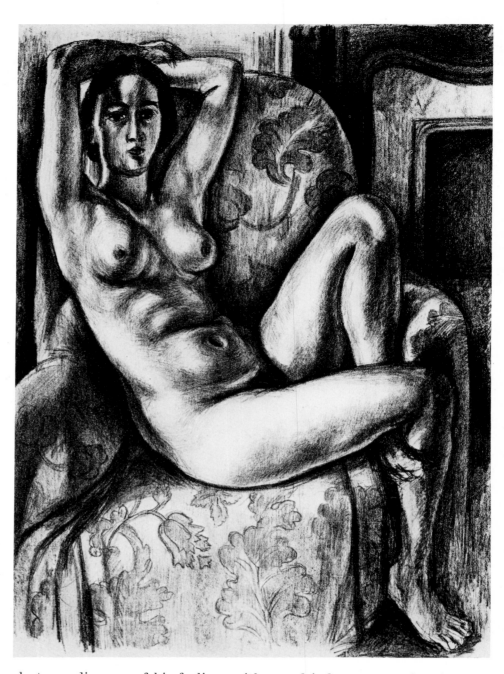

Henri Matisse, *Nude on a Sofa, Her Arms Raised*, 1925 (right), and *Odalisque in Dancing Girl's Trousers*, 1925 (opposite)

electrocardiogram of his feelings with proud independence, then it goes almost without saying that graphics would provide him with the medium to which he could best entrust his zeal for life and experimentation. It is, therefore, strange that this painter, who had first taken up brush and pencil professionally in 1896 and in 1907 had given birth to Cubism with *Les Demoiselles d'Avignon*, did not begin lithography until 1919 (on transfer paper) and only tackled the lithographic stone in 1921. During the entire period between 1920 and 1940, he created only about fifty lithographs, despite the attention that he gave to other forms of graphic art. It was after the end of World War II that Picasso, at the age of sixty-four, returned almost casually to lithography. The great Parisian printer Fernand Mourlot has recalled in his invaluable memoirs how the passion for lithography became reawakened in the artist.

At the end of November 1945, Mourlot had gone to Picasso's studio to tell him that he would like to make a few color prints of some of his paintings. The artist thereupon decided to go in person to the workshop of the Mourlot brothers, and once there he was particularly impressed by the warmth of his surroundings, for the printers had managed to acquire a load of coal

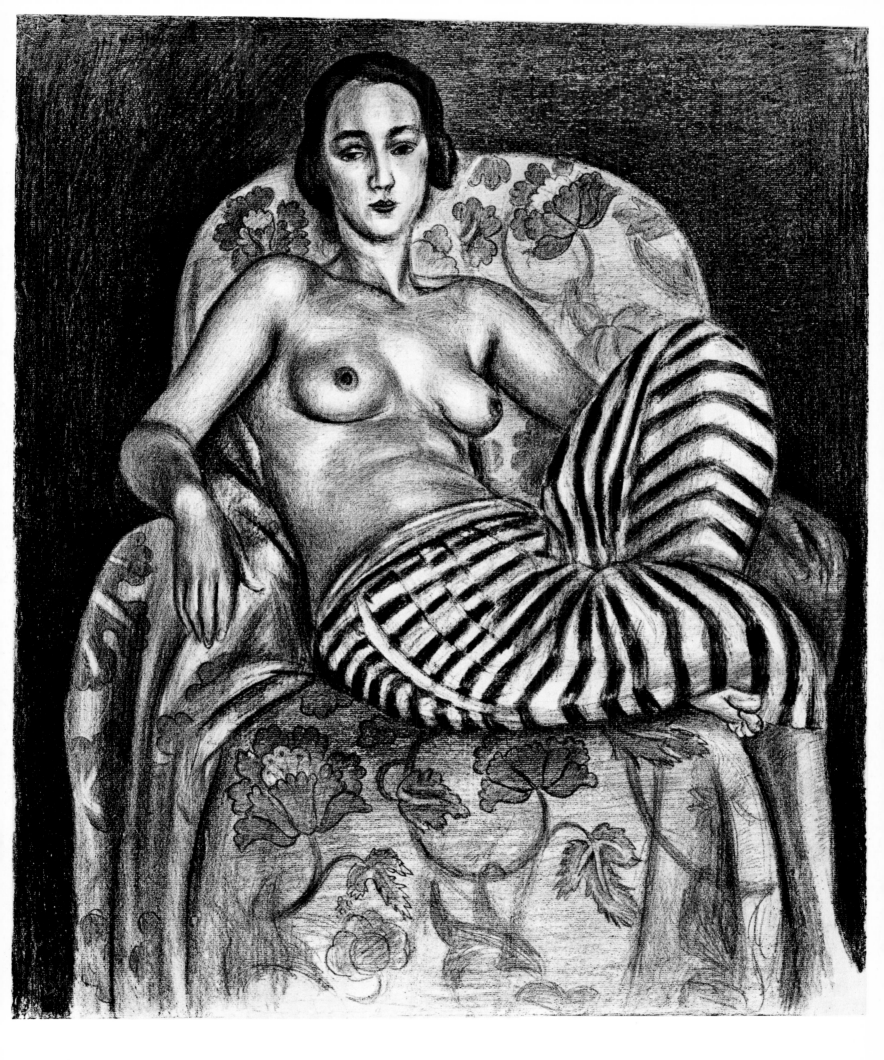

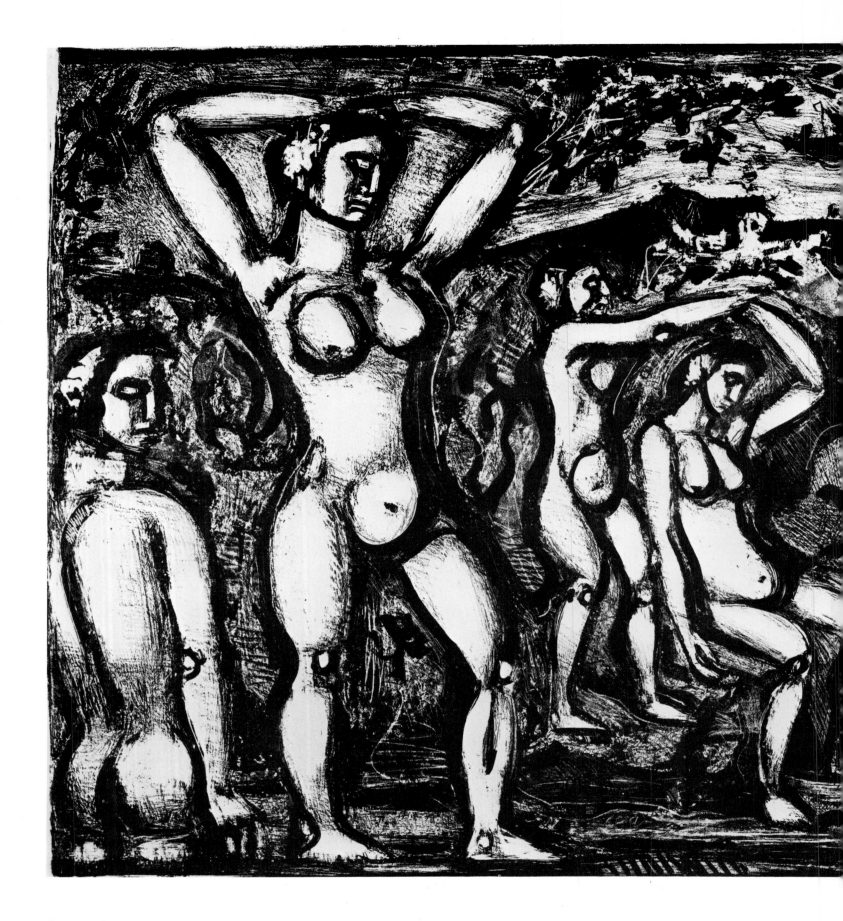

Georges Rouault, *Autumn*, 1927–33
(above), and *Portrait of Verlaine*, 1926–
33 (opposite, above). Opposite, below:
Maurice de Vlaminck, *Bowl of Fruit*, 1921

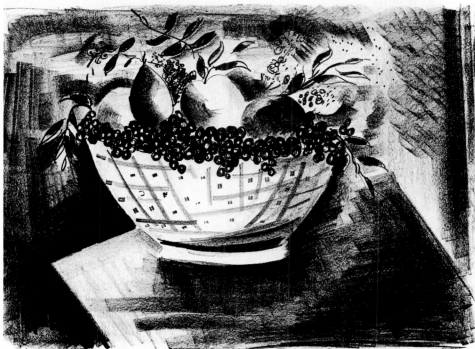

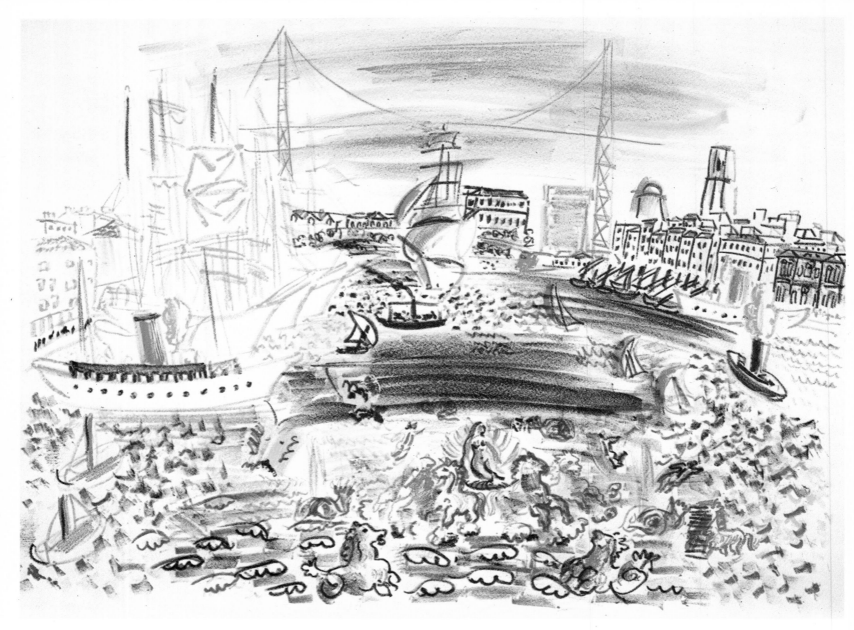

Raoul Dufy, *The Sea: Amphytrite's Procession or Marseilles Harbor*, 1925

for their heating stove, a rare event in that first cold postwar winter. Perhaps it was this fact that led him to travel every day for four months from his freezing studio to the warmth of the Mourlots' printshop. Having neglected lithography for some fifteen years, Picasso now flung himself into the process with renewed passion and vigor. Discovering the possibilities offered by this technique, which he had hitherto largely ignored, and ever ready to grasp the potential of any craft activity, he "reinvented" lithography for himself. He began with a naturalistic portrait, *Head of a Young Girl*, which seems to echo the Neo-Classicism of his much earlier work. He reworked it several times, making corrections and producing various "states" with different modifications and alterations in order to achieve the perfect balance between black and white. The printer remembers how Picasso's print of *Two Naked Women* was redone eighteen times between November 1945 and February 1946 before the definitive proof for an edition of fifty was produced.

Picasso altered the function of the lithographic stone or metal in that his various proofs were not intended to make minor modifications to a final print or to correct an individual state but, rather, as a continual starting point for further creative processes. A revealing illustration of this is provided by the eleven elaborations of his print *Bull*, completed during the winter of 1945–46: he started from a realistic drawing and gradually pared it down until he reached the essential core of his project—the purely graphic concept of a bull. For convenience, Picasso began increasingly to reject stone in favor of metal plates, working with extraordinary fe-

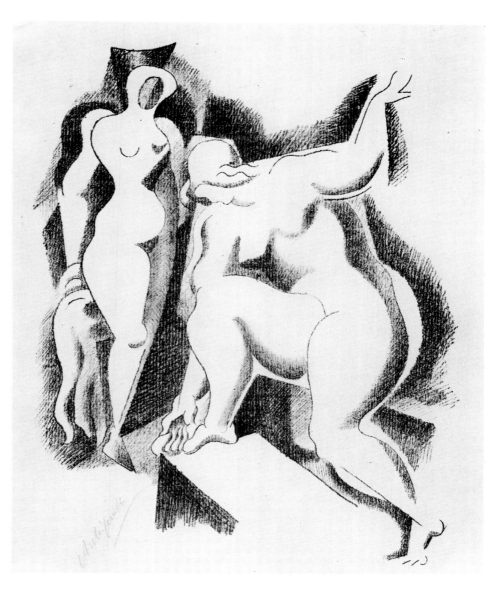

Alexander Archipenko, *Two Female Nudes*, 1921–22

cundity and with a vitality and eagerness that spread through both his black-and-white and his color prints. Birds, animals, female nudes, circus characters, fauns, still lifes, and portraits all filled his folios with the resounding sense of experimentation and joyous enthusiasm that is the hallmark of his whole artistic output. ''I am not a pessimist,'' he confessed on one occasion (*Cahiers d'Art*, December 1935). ''I love art, that is the sole goal of my life. Everything that I do related to art gives me enormous joy.'' When Picasso moved to Vallauris, Mourlot sent him plates and lithographic ink from Paris, but the supplies were never enough: often he would run off six lithographs in a single day. It was here, during the course of his research, that he discovered and reinvented colored linocuts.

Picasso's lithographs possess two distinctive features. First, this body of work forms, from a certain period onward, a sort of uninterrupted progress chart, a daily testament to work undertaken and to the artist's pressing search for new solutions. And, then, it reveals his attention to lithography as an objective means of visual expression in its own right. This interest, exemplified by the greater number of black-and-white prints than color ones, made his activities as a graphic artist a source of continual stimulus for the younger generation. In fact, at the hands of Picasso, lithography became an exemplary instrument of creative freedom.

THE LITHOGRAPHIC PERSONALITY

The way in which Picasso showed how lithography could exist as an inde-

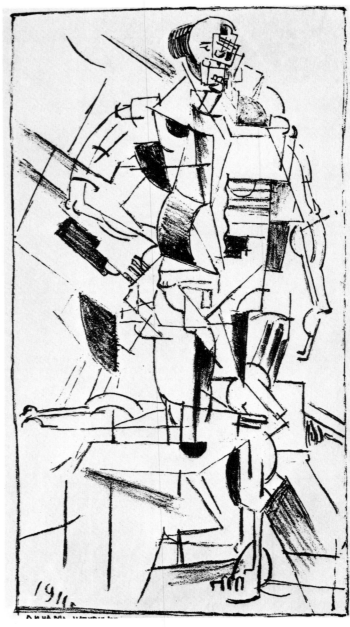

Above, left: Paul Klee, *Bird Comedy*, 1918; right: Kasimir Malevich, *Dinamo-naturshshik*, 1911. Opposite: Max Ernst, *Ernst* (from *Fiat Modes pereat ars*, Plate I), 1919

pendent medium reinforces the theory that the history of lithography is governed not so much by the vagaries of different schools of painting as by the sporadic emergence of individual personalities able to make an intelligent and sensitive contribution to graphic art. In fact, the various schools and artistic movements have succeeded in muddying rather than clarifying the waters of lithography, which, as far as quality is concerned, have either been at the flood or in a state of drought over the last two centuries. One particularly enigmatic figure, because he can be placed in no definite geographical or cultural context, is the Russian-born artist Marc Chagall (b. 1887). In painting, Chagall turned his hand to Symbolism, Fauvism, Cubism, and Surrealism, continually changing his artistic language but always retaining the same unmistakable Expressionist undercurrent. This underlying mood of religious lyricism, combined with a fabulous, fairy-tale quality, runs through his greatest and most characteristic paintings and also colors his best lithographic works. Lithography attracted him somewhat late in life, after he had already proved himself as an etcher and illustrator of books (*Dead Souls, Fables, The Bible*), and his first black-and-white lithographs were executed in Berlin in 1922. Both his paintings and lithographs reveal a lively and intense use of light, a sense of the sacredness of life, and an acknowledgment of the mystery of pain. Color

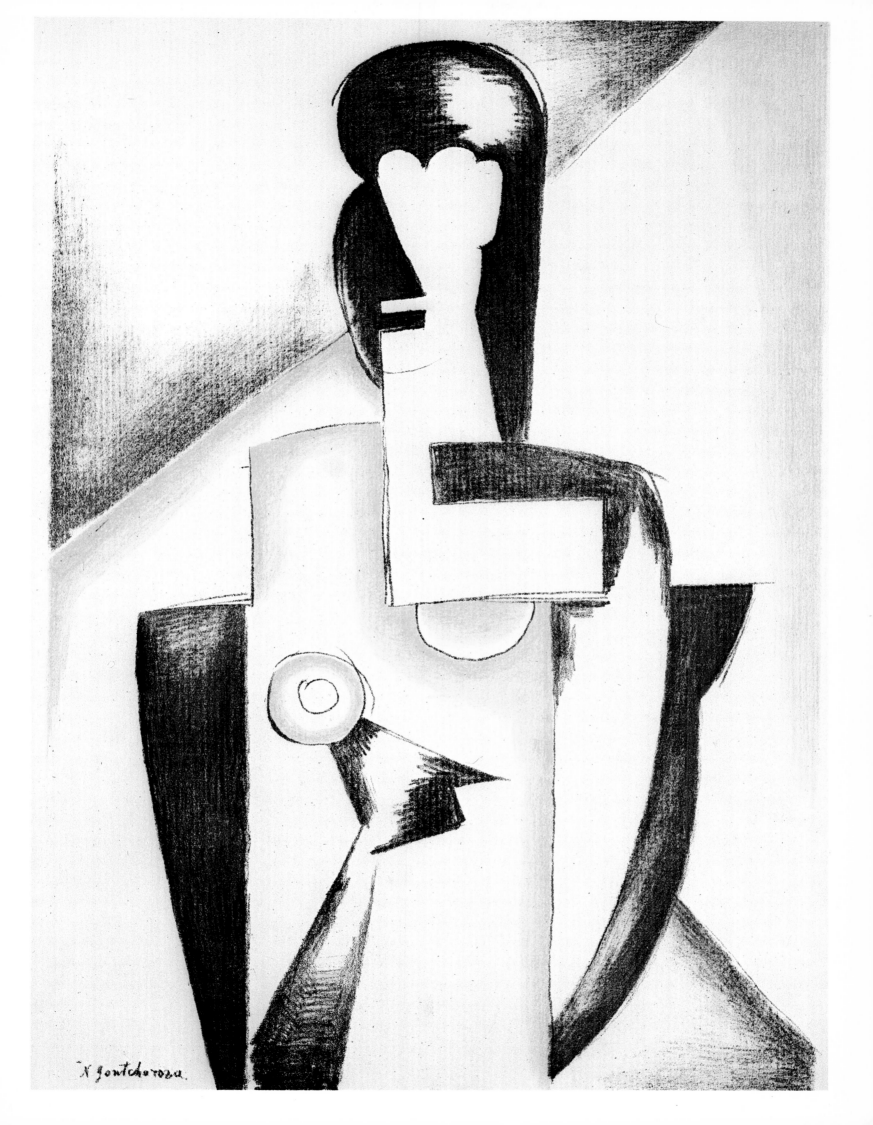

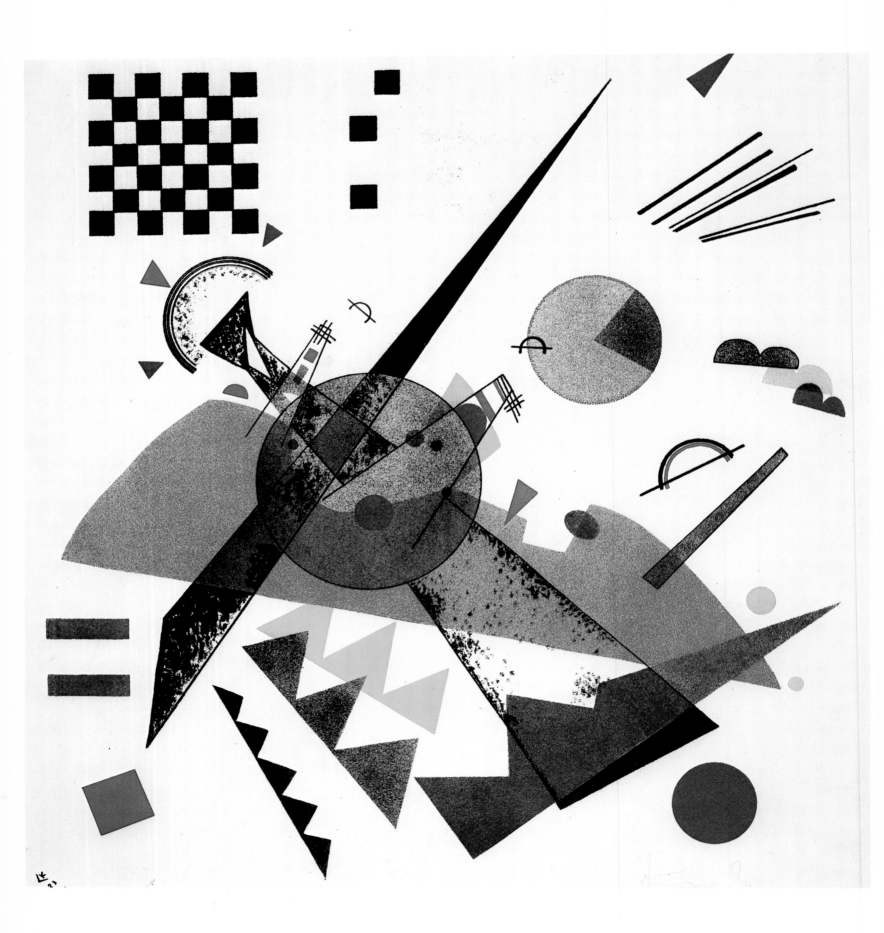

Wassily Kandinsky, *Orange*, 1923

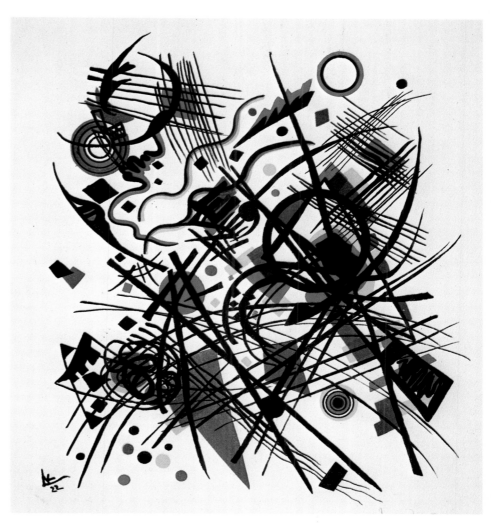

Wassily Kandinsky, *Lithograph for the Fourth Bauhaus Portfolio*, 1922

first entered Chagall's lithographic repertoire with the American series *Arabian Nights* and continued in France in the workshop of Fernand Mourlot with works ranging from illustrations of *Daphnis et Chloé* to posters for the great Paris Exhibition. *The Yellow Cock* and *The Brown Cock* date from 1952, and the same year also saw the production of the first lithographs in the ''Paris'' series, which were followed by numerous others. Although his activities as a lithographer run parallel to his activities as a painter, Chagall's prints are much more than a pale reflection of his painting: his subtle use of color and special technical knowledge as a painter are interpreted in a highly individual graphic way. His lithographs convey a sincerity and charm all their own: ''Whenever I held a lithographic stone or metal plate in my hand,'' he once wrote, ''I felt I was touching a talisman. It seemed that into them·I could pour all my sadness and all my joy ... everything that has passed through my life over the years: deaths, births, marriages, flowers, animals and birds, poor workmen, lovers in the night, Biblical prophets.... And, with old age, the tragedy of the life within us and around us.''

The lithographic physiognomy of the Norman painter Fernand Léger (1881–1955) is clearly revealed in his seventy-five prints of *Le Cirque* (1950), countersigned by the printer Mourlot, of which thirty are in color; their accompanying text, handwritten by the artist and also lithographically reproduced, is a statement of singular poeticism. The distinctive hallmark of Léger's work is an overall realism portrayed in a mosaic of pure, bright colors stretching, almost like a mural, across subjects taken mainly from the world of work and industry. But he also makes periodic incursions into the planned, rationally structured abstraction of Cubism. Apart

145

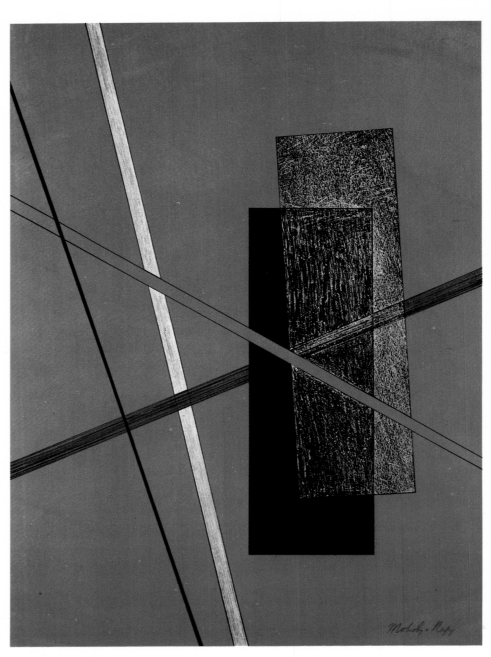

Right: László Moholy-Nagy, *Construction* (from *The Kestner Portfolio*, VI), 1923. Opposite: El Lissitzky, *Announcer*, 1923

from Braque and Picasso, the main lithographic personalities in the French Cubist movement were Robert Delaunay and Roger de La Fresnaye; the latter's graphic oeuvre is scarce but of remarkably high quality. Juan Gris and Marcoussis (the pseudonym of a Pole living in Paris), both of whom were Cubists, worked mainly for newspapers. In the post-Cubist world there was a particularly lyrical quality to the Impressionist Cubism of Jacques Villon, who nevertheless expressed himself better through his etchings than his lithographs, while a special place is occupied by the remarkable lithographic sensitivity of Luc-Albert Moreau, the talented illustrator of books by Francis Carco and Colette.

If with the arrival of Hans Hartung lithography acquired the dark and shapeless violence of Tachisme, then Jean Dubuffet's Art Brut brought to it a primitive impetuosity, intentionally infantile and divorced from any apparent cultural traditions. His style of combining random colored objects to produce works known as *pâtes* has produced some of the most original and outstandingly versatile manifestations of modern painting. The spontaneous, unaffected, antiartistic art Dubuffet provocatively proposes represents one of the most effective and uncompromising displays of Dadaism; its undeniably grotesque quality also contains echoes of Paul Klee, distorted by the evocative force generated by his continual experimentation with new materials. In many ways Dubuffet anticipated some of the more extreme and perhaps desperate measures taken by artists dur-

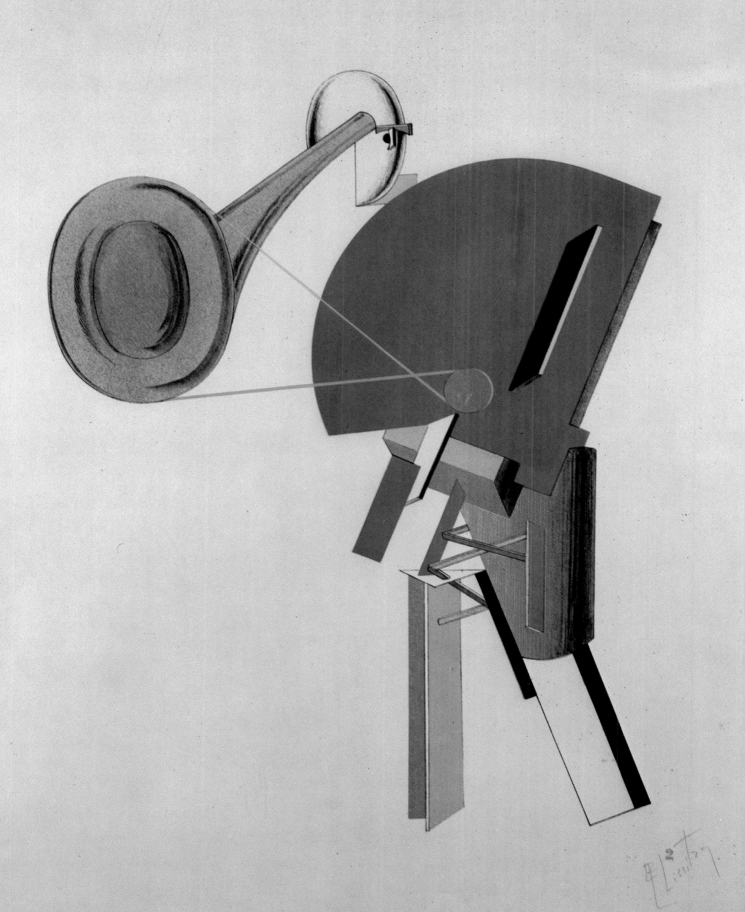

ing recent decades, in the same way that Jean Fautrier anticipated certain aspects of informal art in his engravings.

"I draw, paint and sculpt in order to attack reality, to defend myself, to resist death and to be absolutely free." This anguished libertarian statement by the Swiss Alberto Giacometti (1901–1966) explains the dramatic and poetic world of one of Europe's greatest artists during the first half of the century. Whether depicting the human figure or not, his etchings and lithographs share the same feeling of silence and solitude as his sculptures, whose preparatory shapes were obtained by the careful bending of iron wires so as to distill the essential reality of any object, however humble. In an atmosphere of almost unearthly fantasy, Giacometti endows all his subjects with a magical and visionary dignity.

THE RESTLESS, WANDERING RUSSIANS

If one looks at the human rather than the artistic behavior of the Russian painters who played such an important part in the history of art during the end of the nineteenth century and the beginning of the twentieth, two characteristics emerge. The first is their restlessness, whether within the environment of specifically Russian movements (Cubo-Futurist Primitivism, Constructivism, Suprematism), where they passed from one to another with often unbridled individualism, or within the French, German, or other Western circles in which they were active. This restlessness also explains their second characteristic: the wanderlust that led them (and not only for political reasons) to search for countries more attuned to their artistic ideals and their thirst for stimulation and modernism. As a result, many important Russian names, from Kandinsky to Archipenko and from Poliakoff to Chagall, have little to do with Russian art history and are therefore assigned to other countries where their activities were of greater relevance.

It should be pointed out that the actual word "Futurism" is practically the only thing that links Italian Futurism with the Russian movement of the same name that flourished in the years before World War I. The term itself is of Western derivation, like "Cubism" and "Impressionism," but in Russia even the latter movements shared little more than a name with their Western counterparts. "Cubo-Futurism," for example, is a dual concept, totally Russian by nature, referring to an artistic moment, in both painting and literature, that partly rejected and partly reelaborated the Primitivism that preceded it. Cubo-Futurism emerged during the years immediately preceding World War I, and, despite the debt it owed to the West, it established a unique artistic environment which laid the foundations for that style of abstract painting later pioneered by the Russians. The most important names in Cubo-Futurism (between 1907 and 1914) are Mikhail Larionov (1881–1964) and his wife and pupil Natalia Sergeevna Goncharova (1881–1962). Both of these artists, who were active at the turn of the century, initially proposed a formal reinterpretation of Russian popular tradition (Primitivism), but, after their contact with Paris (where they were invited by Diaghilev), their work absorbed elements of Cubism and Futurism. In Moscow, Larionov, a founder of the Blue Rose group and the acknowledged master of Tatlin and Malevich, turned more and more toward the abstract, advocating a style of painting that he called "Rayonism." Goncharova's family background was highly unusual in that she was the great-grandchild, on her mother's side, of Pushkin and of the musician Beljaev. After a time as a Fauve, she drew closer to the Blaue Reiter group in Munich and veered toward a form of dynamic painting

Opposite: Fernand Léger, *The Vase*, 1927

148

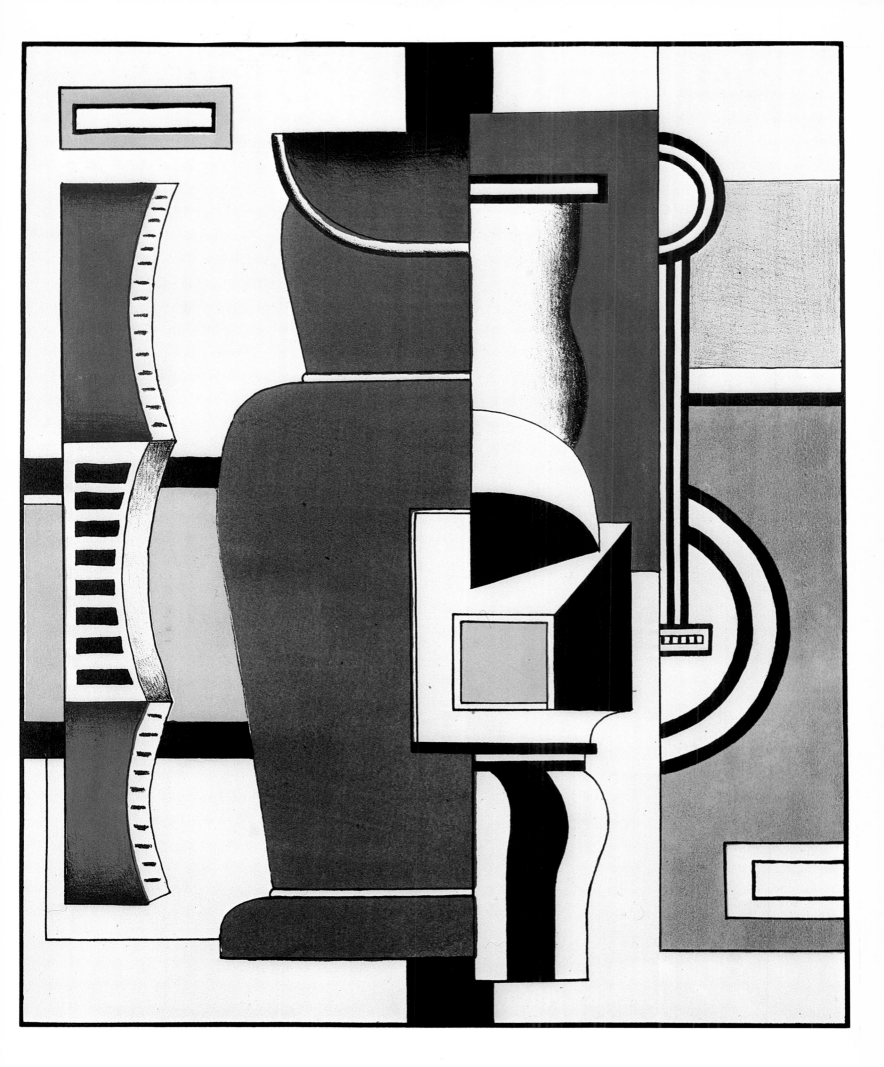

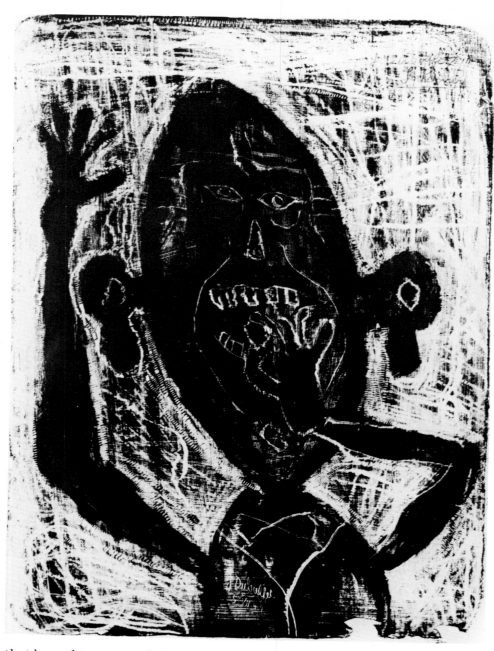

Jean Dubuffet, *Man Eating a Small Stone*, 1944

that brought a personal element of lyrical mysticism to the Cubo-Futurism of the Rayonists. It is strange that the Larionov-Goncharova partnership, which began in a mood of total respect for Russian popular tradition, should have arrived so soon at a position of total rejection of figurative, formal, and coloristic conventions.

Larionov was joined by other artists, men such as the David brothers and Vladimir Burljuk, who were attracted by his personality; some of these, like Tatlin, Gabo, Rodchenko, Malevich, Pevsner, and El Lissitzky, subsequently drifted away to join other movements. Many of these artists were involved with varying degrees of success in lithography and graphics, but their results were always interesting, especially their book covers and posters (El Lissitzky and Rodchenko were particularly outstanding in the latter). Kasimir Malevich (1878–1935), after having passed through a Primitivist and Cubo-Futurist stage, founded Suprematism in 1913 (the manifesto dates from 1915). This movement proclaimed the nonobjectivity of the world and rejected the aesthetic dimension of art, subordinating color and canvas to the aim of an exclusively spiritual communication. At almost the same time, Vladimir Tatlin (1885–1953), together with Gabo and Rodchenko, founded the Constructivist movement, which asserted the lack of any distinction between the arts of painting, sculpture, and architecture and proposed a synthesis of the three. Based on the figurative premises of Cubo-Futurism, Constructivism exalted the "culture of materials," ac-

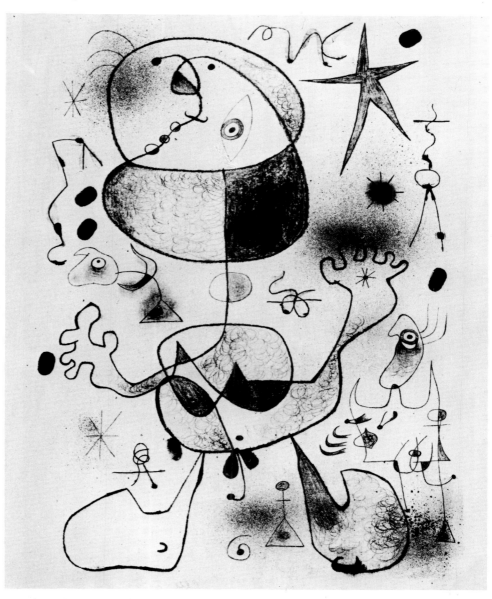

Joan Miró, *Barcelona*, 1944

cepting the aesthetic dimension of art and stressing the need for it to be comprehensible to the masses. The most outstanding members of the groups mentioned above were Archipenko and Poliakoff, partly because of their lithographic activities. Alexander Archipenko (1887–1964), a painter and sculptor, ultimately settled in America after a period in Paris with Léger and the Cubists. His lithographs mirror the evolution of his art, which developed from a rhythmical and decidedly plastic style to the elegantly ''archaic'' Mannerism of his final years. Serge Poliakoff (1906–1969), who settled in Paris in 1923 and eventually died there, belongs to the world of French abstract art. His few lithographs are composed of flat areas of color in simple, angular shapes arranged in a highly characteristic way that basically derived from the work of Malevich.

Another restless, cosmopolitan figure was the Bulgarian Jules Pascin, a collaborator on the satirical journal *Simplicissimus* and a fine lithographer and engraver.

LITHOGRAPHY AND THE AVANT-GARDE

Many of the names that figured in the most famous avant-garde movements of the first half of the twentieth century (Futurism, Cubism, Dadaism, Surrealism, Abstractionism) have already been mentioned in illustrating the historical evolution of lithography. We shall refer here to the way in which these different movements developed and also to their leading advo-

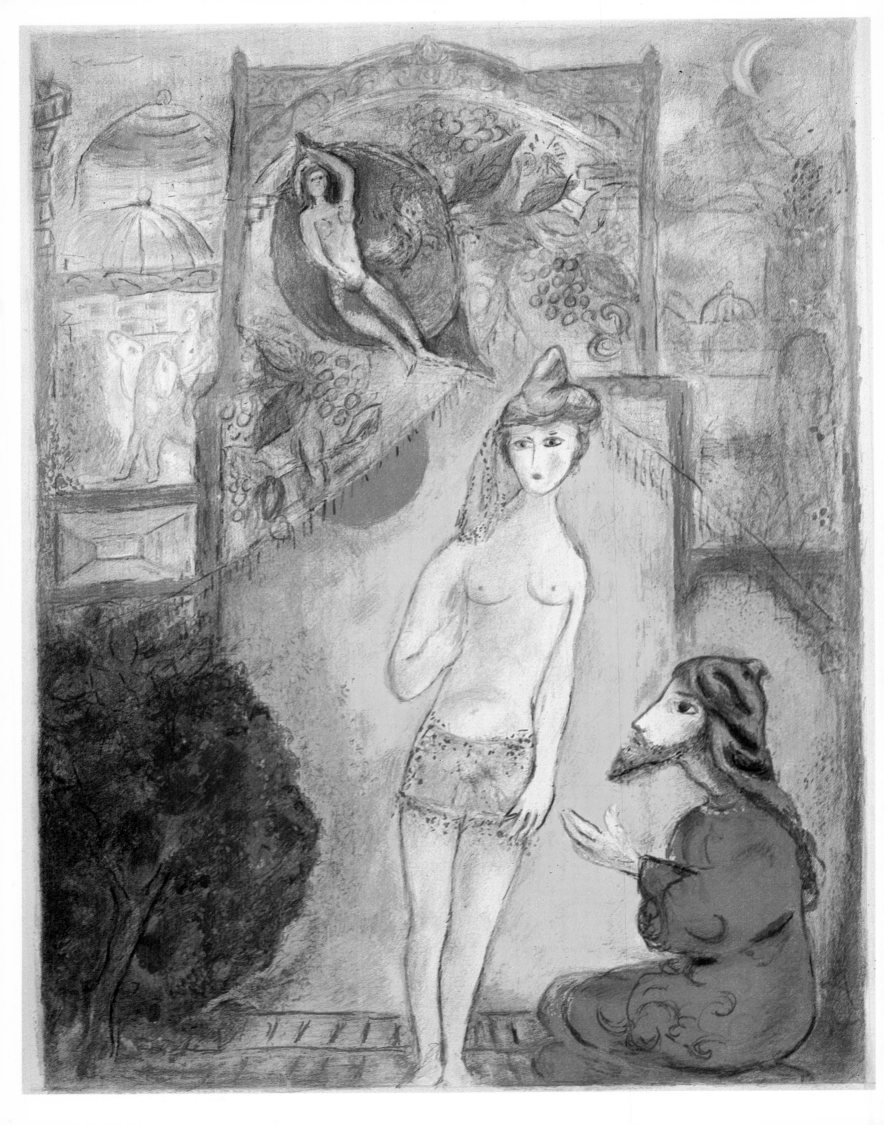

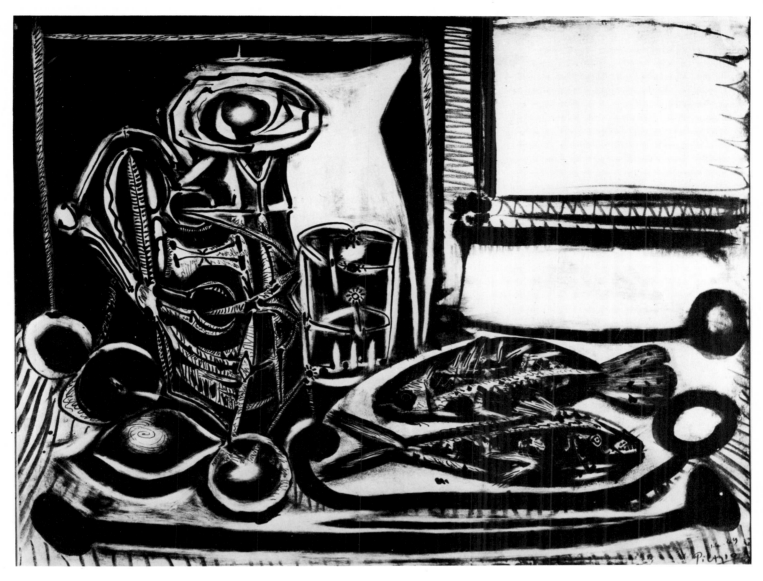

cates, bearing in mind that they were not all significant to the advancement of lithography.

Italian Futurism, whose *Manifesto for Futurist Painting* was published in 1910, experienced a growth in historical and creative importance. Its violent opposition to tradition, its myth of vitalism and dynamic space, and its rules on the decomposition of form and color either supplanted or were partly assimilated by other literary and artistic schools. In the area of lithography, the most noteworthy names in this movement are Carlo Carrà and Gino Severini.

Cubism, which began the process of breaking down visual surfaces in a highly original way, was spearheaded by Picasso and Braque, whose lithographic works we have already discussed because of their exceptional historical importance. Others important in the movement were Fernand Léger and Juan Gris. Robert Delaunay was working within the same interesting, albeit eccentric, environment, and Cubist elements can also be detected in the works of the great Dadaist exponents Duchamp and Picabia.

In fact, it was quite common for the work of artists, if not of actual schools, to overlap, and some artists therefore belonged to more than one movement. This happened in the case of Hans Richter, for example, who gradually abandoned Dadaism in favor of Abstractionism, or Hans Arp, whose work spans Dadaism (of which he was one of the moving forces), Surrealism, and Abstractionism. The Dada movement (1915–19) originated

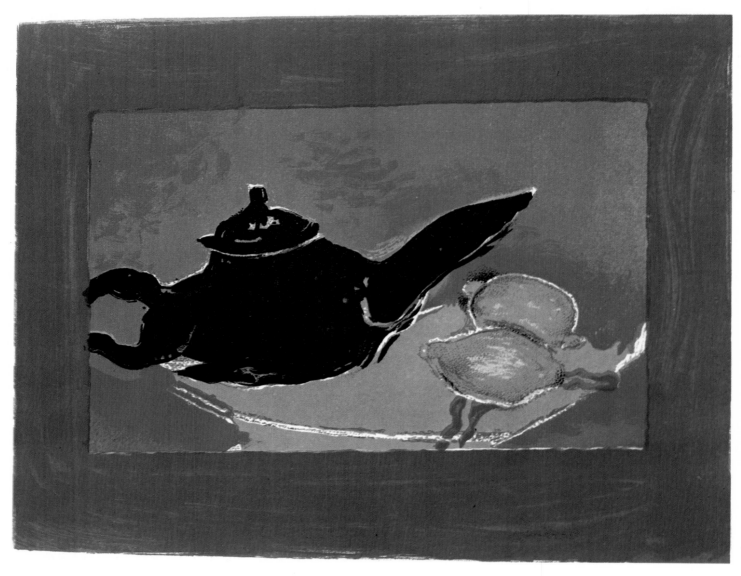

Georges Braque, *Teapot with Lemons*, 1949 (above), and *Leaves, Colors, Light*, 1954 (opposite). On the following pages, left to right: Marc Chagall, *Screen*, 1963, and *Self-portrait with Goat*, 1922–23

in Zurich, where its basic theories were formulated by Tristan Tzara, who was also one of the literary leaders of Surrealism. In anticipation of Futurism, Dada preached the rejection of any traditional values or models, proposing the ironical desanctification of form and its meaning. Its main exponents were Francis Picabia, Man Ray, Marcel Duchamp, Hans Richter, and Kurt Schwitters, whose Dadaist inclinations took an increasingly abstract turn. When Dadaism finally moved from Zurich to Paris, it was to a great extent absorbed into Surrealism.

The first Surrealist manifesto (Paris, 1924) was drawn up by the writer André Breton, who took over the word from the poet Guillaume Apollinaire. The movement was at the same time both figurative and literary, and it is perhaps as a literary phenomenon that it enjoyed its greatest flowering. Such writers as Louis Aragon, Antonin Artaud, René Char, Paul Eluard, Pierre Reverdy, and Philippe Soupault all shared a similar goal: to use the doctrine of Surrealism to destroy both the complacency of tradition and the worn-out sentimentality that marked contemporary literature. Surrealism proclaimed the importance of the dream world, not only in art but in every aspect of human nature; it advocated the liberation of the subconscious, the abolition of formal logic, the exaltation of the intuitive, the automatic, and the fantastical, and the introduction of dreamlike elements into reality. It owed much to Freudian psychoanalysis and quite a lot to the metaphysical explorations of De Chirico. Practically every Surrealist made notable contributions to graphic art, including the main protagonists of the movement

154

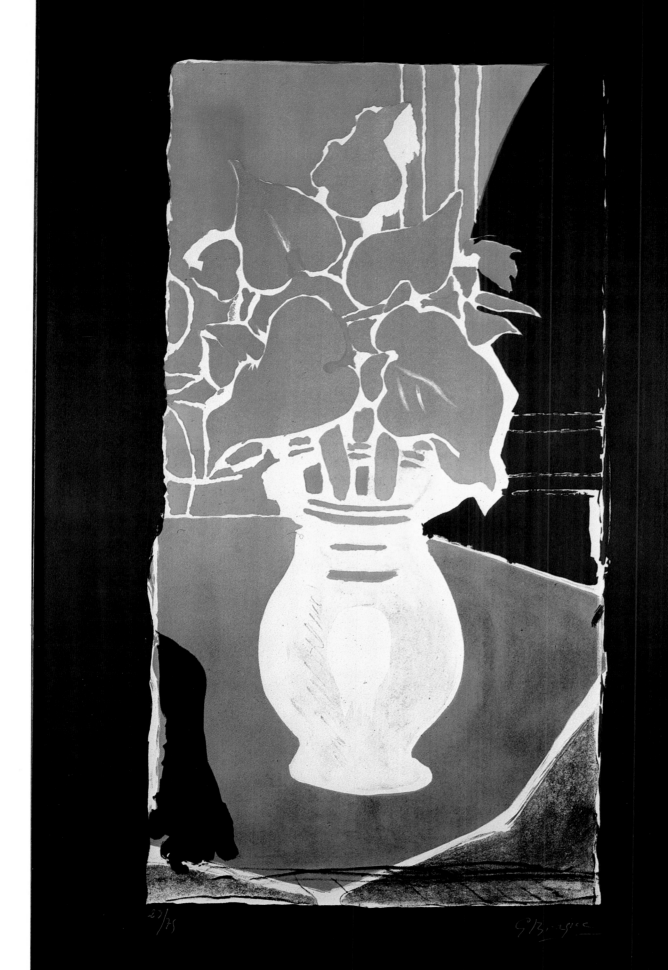

27/75 G Braque

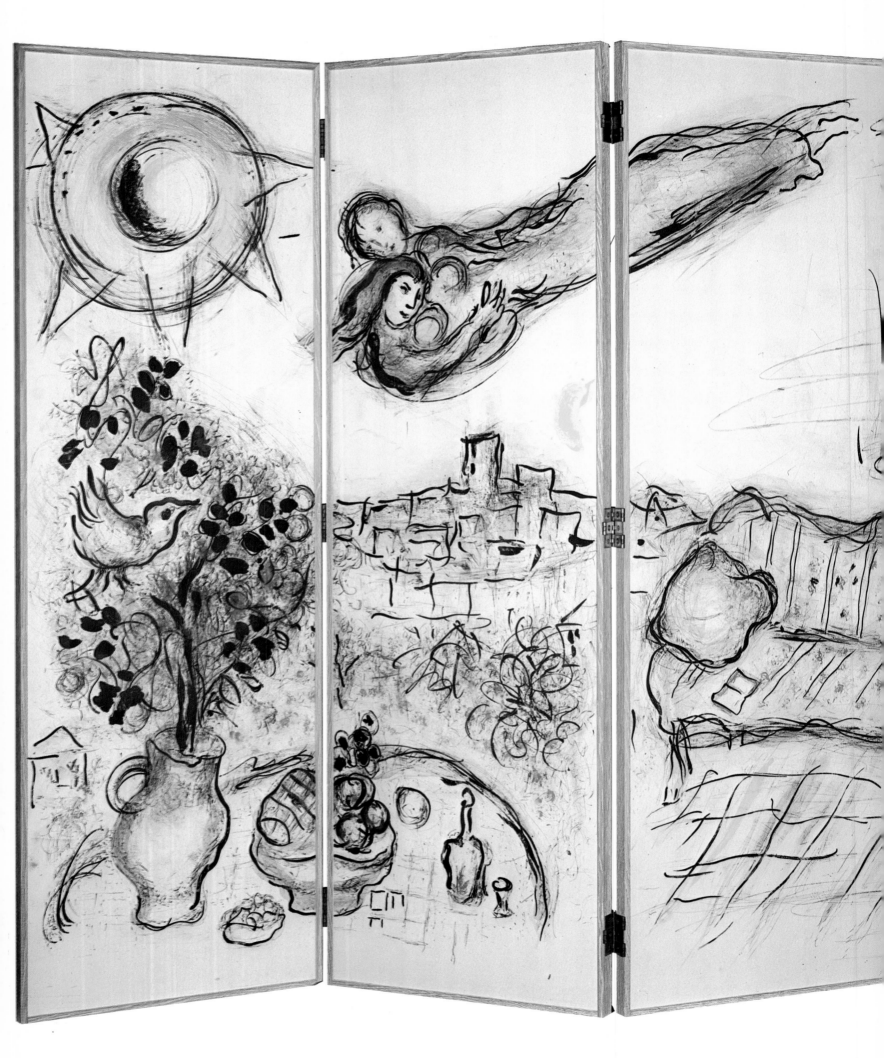

Marc Chagall
61/100

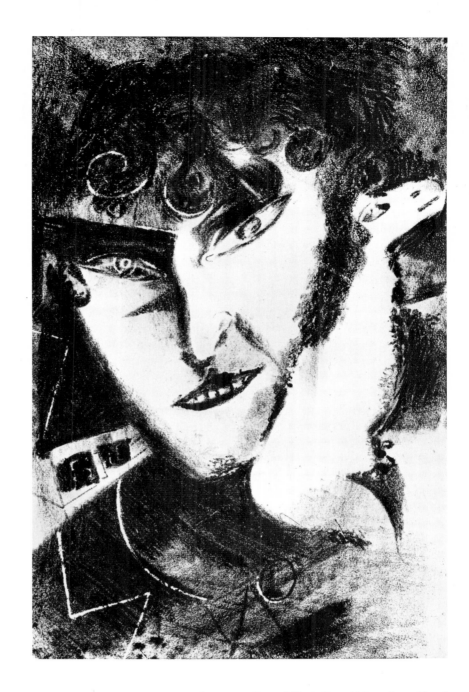

(Max Ernst, Salvador Dalí, André Masson, Joan Miró, René Magritte, Paul Delvaux, Maurits Cornelius Escher, and Wifredo Lam), its lesser luminaries (Roberto Sebastian Matta Echaurren), and its descendants (Arshile Gorky and Richard Lindner). As far as lithography is concerned, however, the best works are those by Ernst, Miró, Masson, Delvaux, Escher, and Lindner.

Abstractionism, as an escape from reality and from purely figurative representations, lay at the roots of the avant-garde movements from the beginning of the century (Fauvism and Cubism) and also contributed to later movements. In addition to the formal and geometrical Abstractionism of absolute purity that was initiated by the Dutch De Stijl group under Piet Mondrian, there was also the type that relied on color and matter for expressive force, a technique with origins in the lyrical abstractions of Kandinsky. Around the geometrical style there gravitated, with many subtle variations and without any precise boundaries, the figures of Malevich, Severini, Delaunay, Arp, Magnelli, Soldati, Licini, Baumeister, Calder, and Albers. The second style was favored—again with many modifications—by Tobey, de Staël, Pollock, and others, whose work eventually led to the reformulation of Abstractionism into Spatialism, Action Painting, and Op Art.

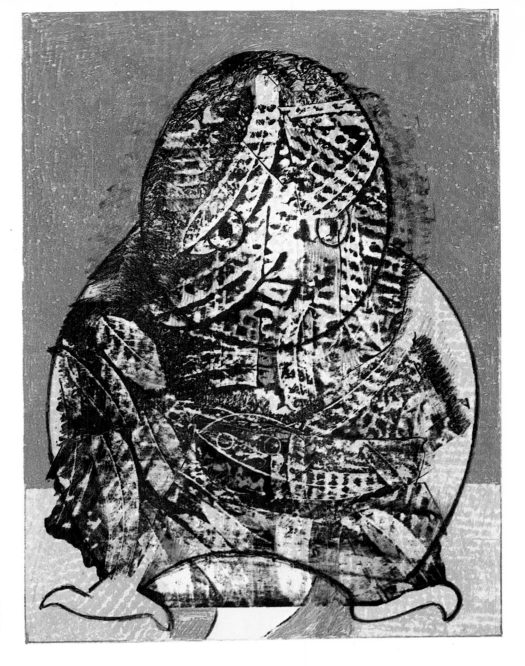

Right: Max Ernst, *Owl*, 1955. Opposite, above: Jacques Villon, *Virgilius Maro*, 1953; below: Lyonel Feininger, *Off the Coast*, Plate I, 1950

THE ITALIANS

Since the scope of this profile of lithography does not reach beyond the generations born during the early years of this century, it excludes, of necessity, some important and extensive contributions made by younger artists. To the somewhat modest contribution made by nineteenth-century Italy, which has already been recorded herein, should be added the prints produced by artists born during the final two decades of that century. Some of their names have been mentioned previously within the context of the avant-garde movements (Severini, Magnelli, Carrà, and others), where they more correctly belong. Others responded to Art Nouveau, which had a pronounced stylistic influence on Italian poster art, as did Art Deco in later years. Among the best-known graphic artists in this field are Marcello Dudovich, Leonetto Cappiello, and Marcello Nizzoli.

A decisive and intentional contrast between black and white, combined with a clarity of outline that is still nevertheless linked to a foliar style of formalism, characterizes the fine lithographic works of the Milanese sculptor Adolfo Wildt (1868–1931). The illustrator and graphic artist Alberto Martini (1876–1954) was one of the foremost lithographic personalities of the first half of the century. He studied in Munich and in 1902 he illustrated a German edition of Tassoni's *La secchia rapita*. The lithographic technique that Martini gradually developed consisted of re-

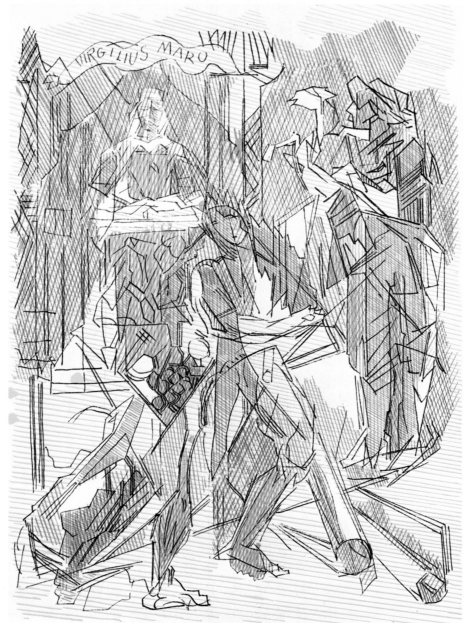

Above: Alberto Martini, *The Kiss I*, 1915.
Opposite: Adolfo Wildt, *Sudarium*, 1929

Above: Mario Sironi, *Country*, Plate XV, 1930–31. Opposite: Alberto Giacometti, *Interior*, 1965. Following pages: Giorgio De Chirico, *Villa on the Sea*, 1929 (page 164, top), and *The Archaeologists IV*, 1929 (page 165); Alberto Savinio, lithograph for *Clandestine Lottery*, 1948 (page 164, bottom left); Carlo Carrà, *Mannequin and Doll*, 1953 (page 164, bottom right)

placing the grainy pencil marks on the stone with a dense network of small dots that produced extraordinarily velvety effects in the blacks and grays. His compositions to some extent anticipate the angst-ridden fantasies of certain types of Surrealism, as can be seen in his six lithographs for *I Misteri*.

Apart from a few posters for their polemical theatrical performances, the painters that followed Marinetti in the Futurist adventure did not devote themselves to lithography with any great degree of consistency or skill. The lithographic works that Carlo Carrà (1881–1966) completed after the Futurist experience are perhaps the most interesting. During the final decades of his life, this Piedmontese painter illustrated numerous volumes of poetry with great sensitivity.

The "metaphysical" themes that characterize the most original and arguably the greatest paintings of Giorgio De Chirico (1888–1978) were transferred by the artist into his graphics. From the point of view of outline and precision, the most intense of his lithographs are *Métamorphosis*, the six works executed in Paris in 1929; the sixty-six prints for Apollinaire's *Calligrammes* (1930); and the ten for Jean Cocteau's *Mythologie* (1934). The subject of "the mysterious baths" also provided him with lithographic

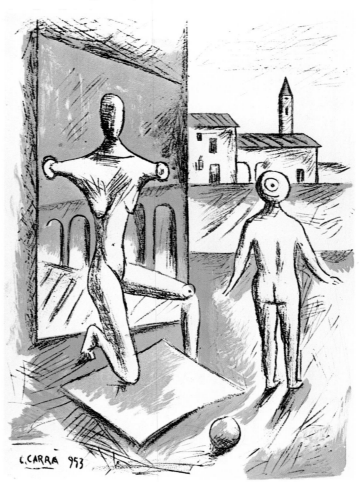

164

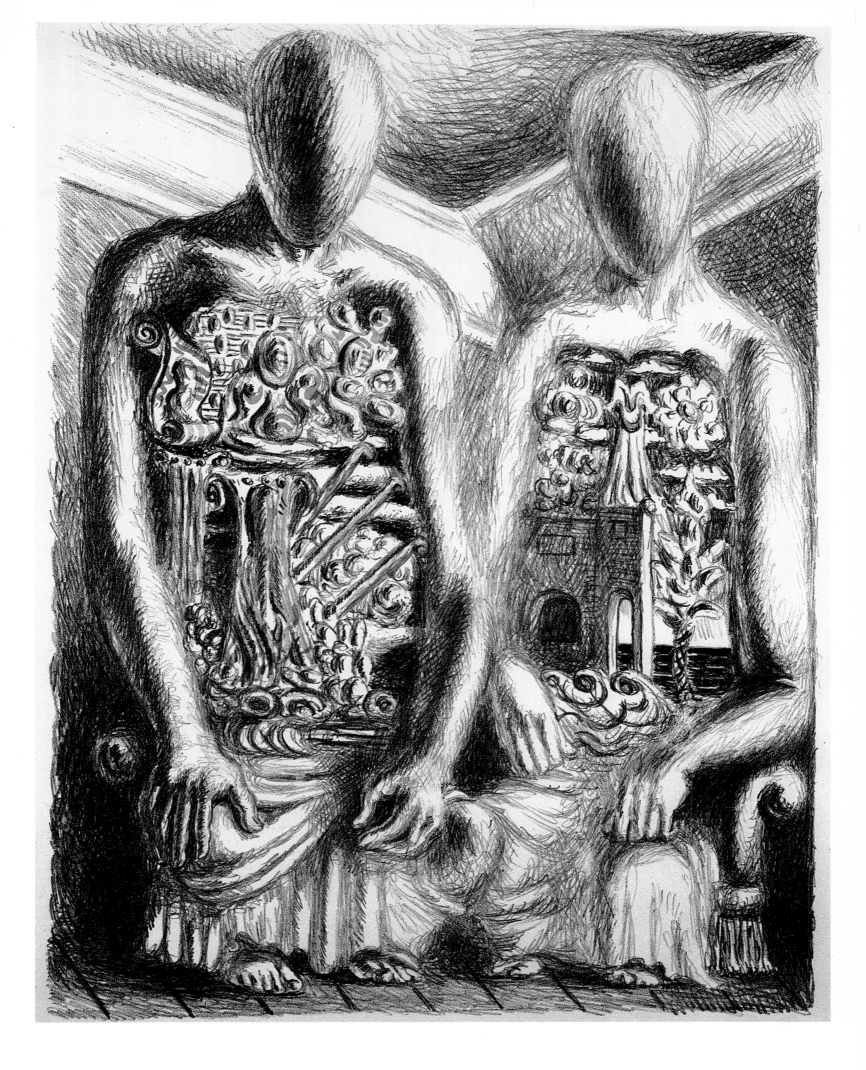

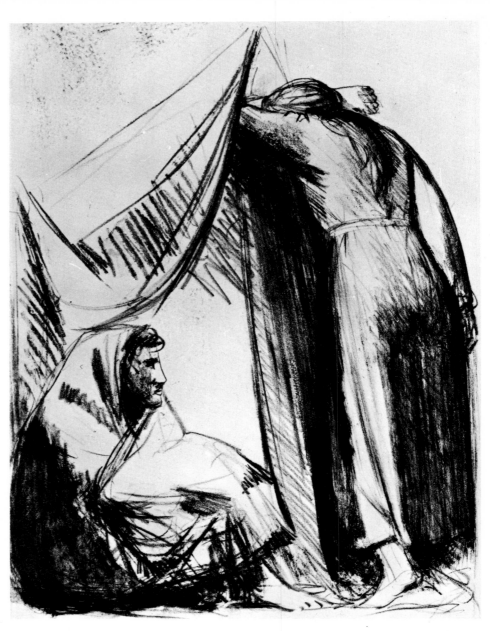

Giacomo Manzù, *Lady Weeping*, 1954.
Opposite: Marino Marini, *Acrobat*, 1956

inspiration. De Chirico's later prints, however, reveal neither a great interest in the medium nor any degree of successful inventiveness: his main concern, in fact, was always with painting. The same can be said of the lithographic prints of Alberto Savinio, even though they did display a certain consistency. Gino Severini (1883–1966), after a brief apprenticeship in Rome under Boccioni and Balla, settled in Paris, where he enhanced his early Futurist training with Cubist lessons from Braque and Picasso and, later on, with the teachings of geometrical Abstractionism. Severini's graphic oeuvre, including his lithographs, provides a faithful diary of his progress and of the different goals he gradually achieved.

The few prints of Mario Sironi (1885–1961) are a natural continuation of the highly charged and expressive tones of his painting and display the same undercurrent of solitude and anxiety. Felice Casorati (1886–1963), certainly one of the greatest and most rigorous of Italian twentieth-century painters, was not particularly attracted to lithography, indulging in it mainly during and after World War II, when he began to soften the severe and melancholy coldness of his earlier work with a feeling of greater warmth and emotion. By contrast, there is a fair degree of consistency to the graphic work of Alberto Magnelli (1888–1971), whose name has already been mentioned in connection with Abstractionism. Magnelli's most convincing lithographs are those in which the geometric purity of form and color is most evident. Massimo Campigli (1895–1971), who developed a highly personal form of Primitivism, displayed a lively interest in the graphic and lithographic interpretation of his style and succeeded in instilling his prints

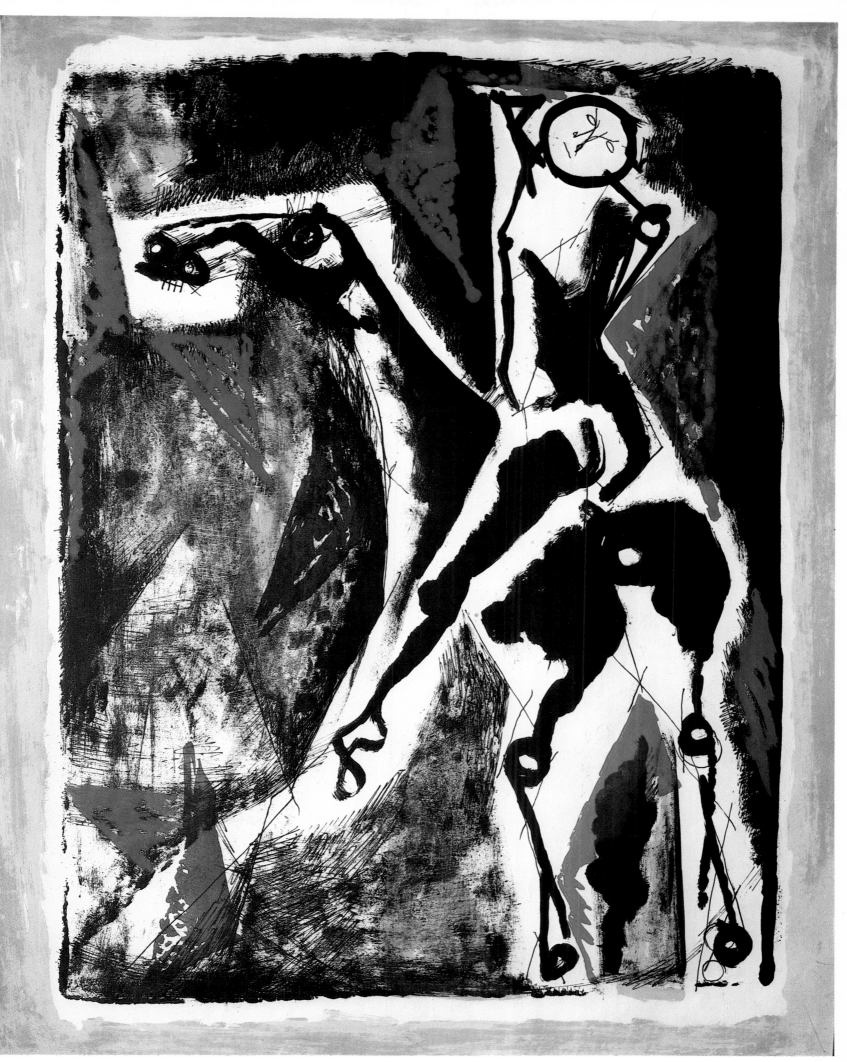

Right: Alberto Magnelli, *Composition with Red*, 1965. Opposite: Gino Severini, *Spanish Dance*, 1960–61

with the same mood of timelessness that appears in his paintings. The painter and sculptor Marino Marini (1901–1980) has been one of the most prolific graphic artists of twentieth-century Italy: the intensity and drama that he introduced—albeit in a more and more abstract way—into his sculpture reappear to memorable effect in his lithographs. The fascination of the lithographs of Filippo De Pisis (1896–1956) derives from their naturalness and from the joyful way in which the artist describes and captures the vibrancy of objects, nature, and reality. The rapid and sensual lyricism with which De Pisis endows everything that catches his eye is also the hallmark of his graphic work. Another sculptor, Giacomo Manzù, born at Bergamo in 1908, is a dominant figure in the world of graphics who has always displayed a great deal of technical and artistic skill during his long and important career as an illustrator. The sureness of his design, the simplicity of its execution, its carefully judged emotional content, and his Impressionistic attention to figures and their details often blend together in a powerfully Expressionist synthesis.

Another artist worthy of inclusion in this survey, however historically incomplete and restricted, is Giuseppe Capogrossi (1900–1972), whose lithographic prints reflect the repetitive and intensely simple style of his abstract paintings. Also worthy of mention are the prints of Renato Guttuso, with their deft, often dramatic style.

Above: Paul Delvaux, *Païolive*, 1975.
Right: André Masson, *Fragment d'un féminaire*, 1955. Opposite: Massimo Campigli, *Lady in Blue*, 1959

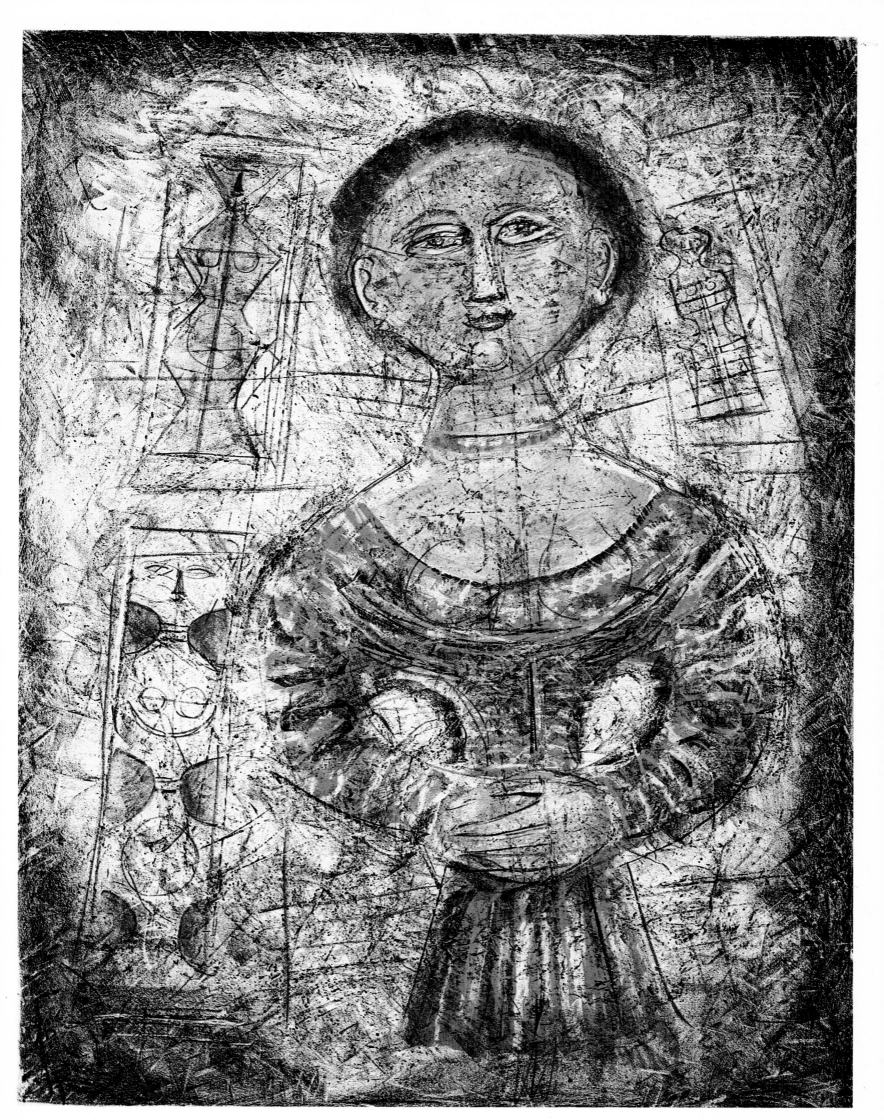

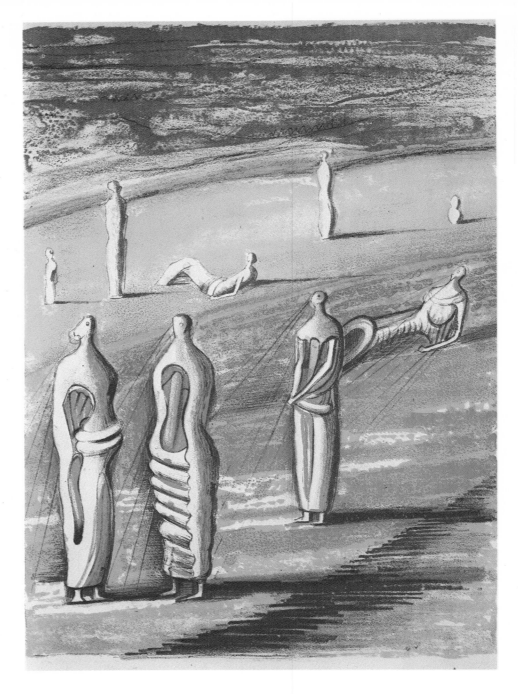

Right: Henry Moore, *People of Clay*, 1950.
Opposite: Graham Sutherland, *Predatory Form*, 1953

THE MOST RECENT GENERATIONS

The various generations of artists active in the figurative arts since the end of World War II have introduced so many new trends and moods and so many different plans and declarations of intent that the overall panorama can often seem confused and cluttered. Sometimes, in fact, the new avant-garde movements and new artistic waves overlap and their various exponents switch from one environment to another. The many different goals and intentions should not, however, come as any surprise: art always reflects or anticipates society, and the proliferation of movements is therefore nothing more than evidence of the complex transformations and anxious contradictions that have shaken and continue to shake contemporary society. In addition, the increasing speed of communication between the different artistic centers of the world means that experimental projects soon become widely broadcast, examined, and modified and also soon become easily exhausted.

Close observation reveals that the radically new proposals of recent decades are frequently deeply rooted in past traditions: for example, the Fauves, Malevich, Kandinsky, Duchamp, Max Ernst, and other unforgotten masters have provided an inexhaustible source of inspiration for the rest-

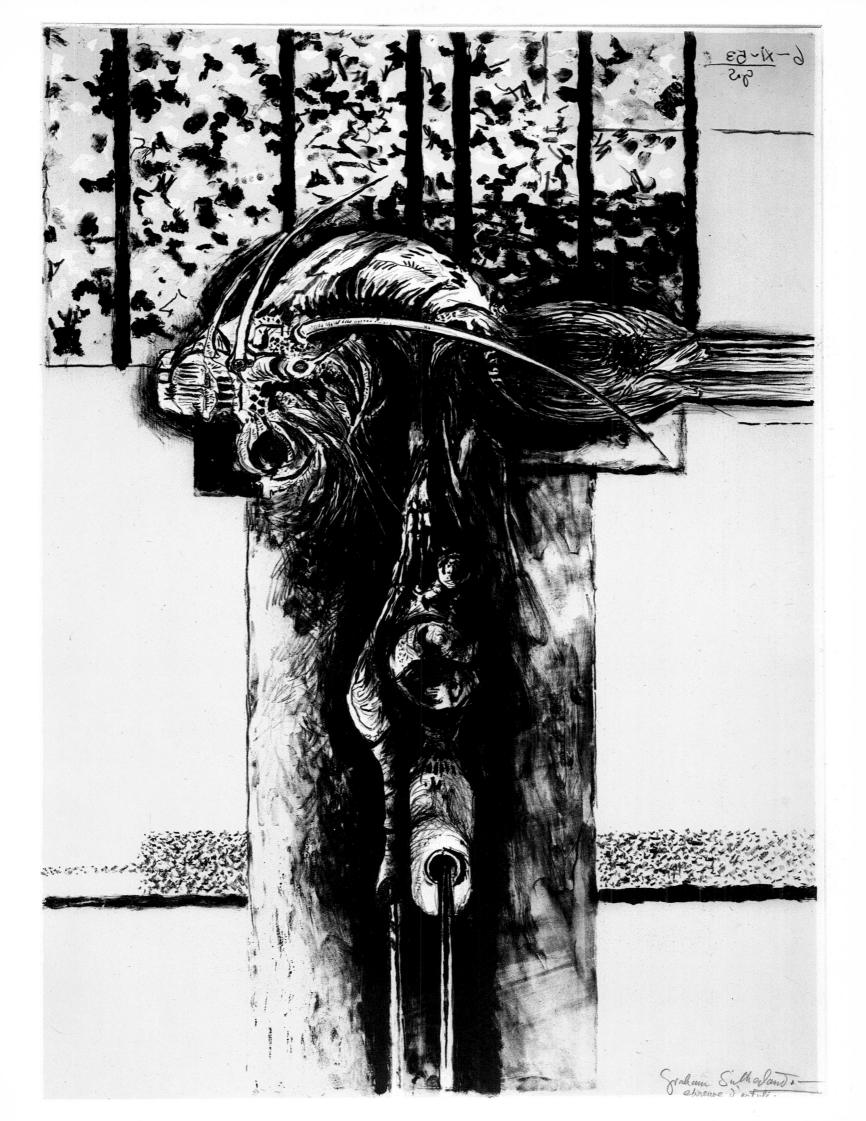

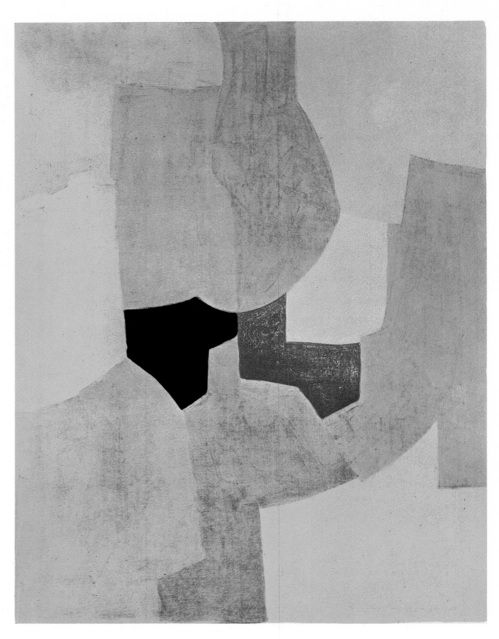

Right: Serge Poliakoff, *Yellow Composition*, 1965. Opposite: Asger Jorn, *On the Golden Bridge (Intimacies)*, 1969

less generations of their artistic heirs. The latter have remained true to the lessons of freedom and discipline preached by their elders and have adapted their inheritance to fit modern times, laying increasing emphasis on the cognitive and antidecorative function of art.

This explosion of creative energy and inquiry has had repercussions throughout every area of artistic expression, including graphics. In that field, however, things are not always as they might appear. To begin with, it is obvious that an artist may use graphic techniques any way that he thinks best, and he may resort to either lithography, photolithography, photogravure, or photoserigraphy. This is quite in order and causes no confusion: the print that rolls off the press will always be original and of a quality commensurate with the artist's talent. The confusion lies not in the technique chosen but in the inaccurate or omitted identification of the technique used. In brief, if instead of executing his lithograph on stone, metal plate, or transfer paper, the artist has his drawing, watercolor, or painting reproduced by some photomechanical process, the end product will be a photolithograph and not a lithograph. The distinction must be made in order to avoid misunderstanding.

An artist is free to dispense with the actual lithographic processes; instead of drawing directly on the stone, metal plate, or transfer paper, he may entrust his drawing to someone else to transfer photographically and mechanically onto paper. If this fact is made clear, then there is no harm done and everyone knows that the artist has not participated in the techni-

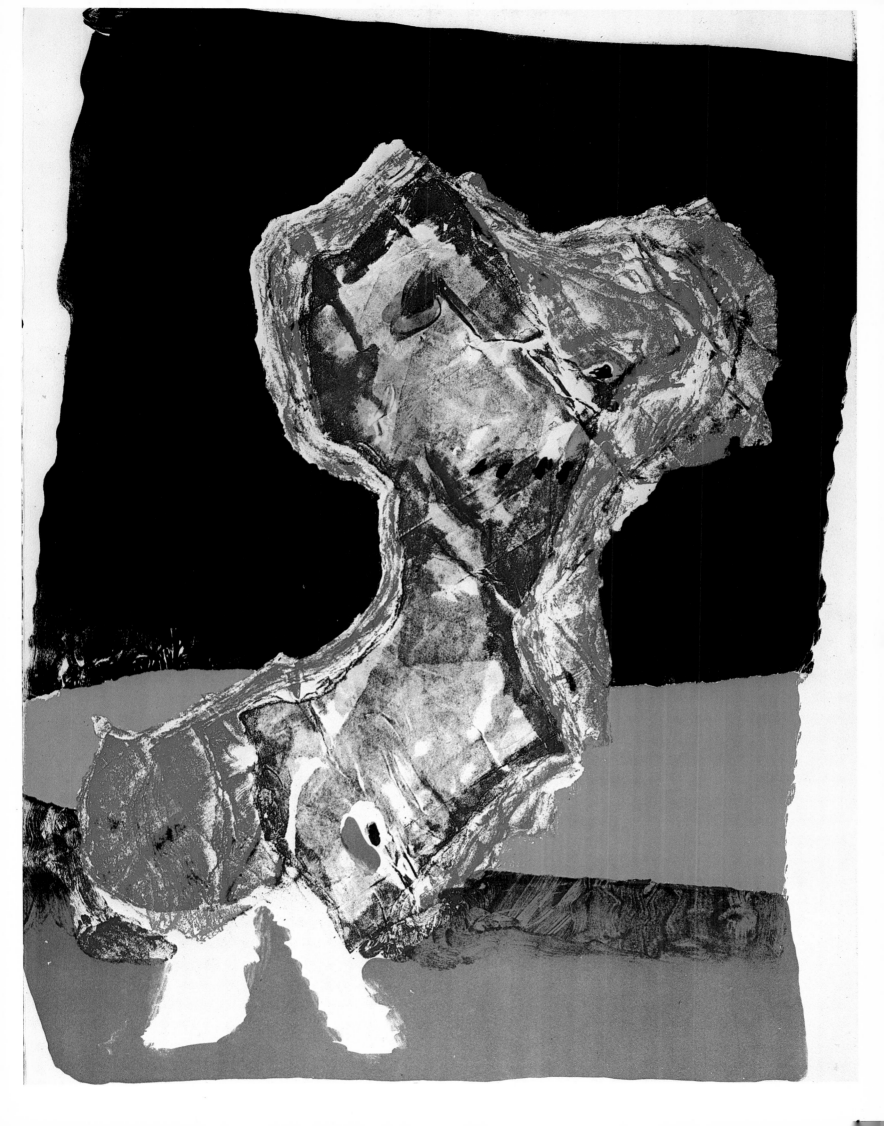

Right: Allen Jones, *Concerning Marriages*, Plate II, 1964. Below: Jasper Johns, *Light Bulb*, 1976. Opposite: Robert Rauschenberg, *Test Stone 2 (Booster and 7 Studies)*, 1967

cal production of his print. Alternatively, an artist can himself manipulate the new mechanical and photographic processes, intervening and modifying them so as to achieve a particular result. In this case his own creativity has been brought to bear on the instruments, which means that the print obtained is an original graphic work, whereas in the first example it was, strictly speaking, only a work "after" him. In recent decades, the instruments of graphic art have been more than perfected: they have been revolutionized by technological progress, allowing artists (and printers) to achieve such excellent results that misunderstandings can easily arise. Since production, stimulated by retailers, decorators, and naive enthusiasts, has been immense, and for the most part unhampered by any form of cataloguing, the ensuing chaos has given just cause for caution. In fact, the whole state of affairs has reflected badly on graphic art and on the large numbers of artists who have pursued it with enthusiasm and a deep sense of involvement.

And yet each movement that has appeared since the war has contained within its ranks artists capable of producing original graphic works, of expressing their own creative personalities through either traditional or photomechanical techniques. It is not always a simple matter, when cataloguing the historical progression of artistic movements, to assign artists to specific groups with any degree of precision, partly because of generic divisions and specific subdivisions. Painters like the Spaniard Tápies and the Italian Burri, for example, are part of the abstract tradition, but their extensive use of "material" in their works places them in the realm of "collage art," while the absence of defined shapes in their pictures makes them "nonformal" artists.

The terms "Nonformalism," "Tachisme," and "Action Painting" have much in common, but the latter is applied particularly to the work of the great American painter Jackson Pollock, even though it also embraces the Abstract Expressionism of Willem de Kooning and the Tachisme of Sam Francis.

Experiments with new forms of spatial expression characterize several European and South American movements, but the search for an abstract space in which to accommodate informal patterns is especially typical of the work of Lucio Fontana, Mark Rothko, Fritz Hundertwasser, and Enrico Castellani. The painting of Piero Manzoni could also be said to fall within the same category. The crowded chapter of nonfigurative geometric art, Kinetic Art, and Op Art includes the names of Atanasio Soldati, Max Bill, Victor Pasmore, Piero Dorazio, Yves Klein, Victor Vasarely, Jesús Rafael Soto, and Franco Grignani. A brightly colored form of Expressionism, with a tendency toward Abstractionism, characterizes the work of the artists in the European "Cobra" group: Pierre Alechinsky, Corneille, Karel Appel, and Asger Jorn. A certain figurative quality winds its way through the strange Primitivism of Jean Dubuffet and reappears in the ironical, neo-Dadaist compositions of Enrico Baj. There are also elements of figurativism and Expressionism in the great paintings of Francis Bacon and in the Surrealistic oeuvre of Gianni Dova and the more typically Surrealist, if no more complex, work of Valerio Adami. The dissimilar personalities of Arnaldo Pomodoro, César, and Umberto Milani, however, belong within the realms of "material" art. American exponents of Pop Art participated in the Venice Biennale in 1964: the founders of the movement were Robert Rauschenberg and Jasper Johns, but its most representative practitioners are Roy Lichtenstein, Claes Oldenburg, Tom Wesselmann, James Rosenquist, and Robert Indiana. Among the overseas followers of Pop Art are the Englishman Allen Jones and the Frenchman Martial Raysse, and it also echoes in the work of the Italians Franco Angeli and Mario

Opposite: David Hockney, *Celia Smoking*, 1973

178

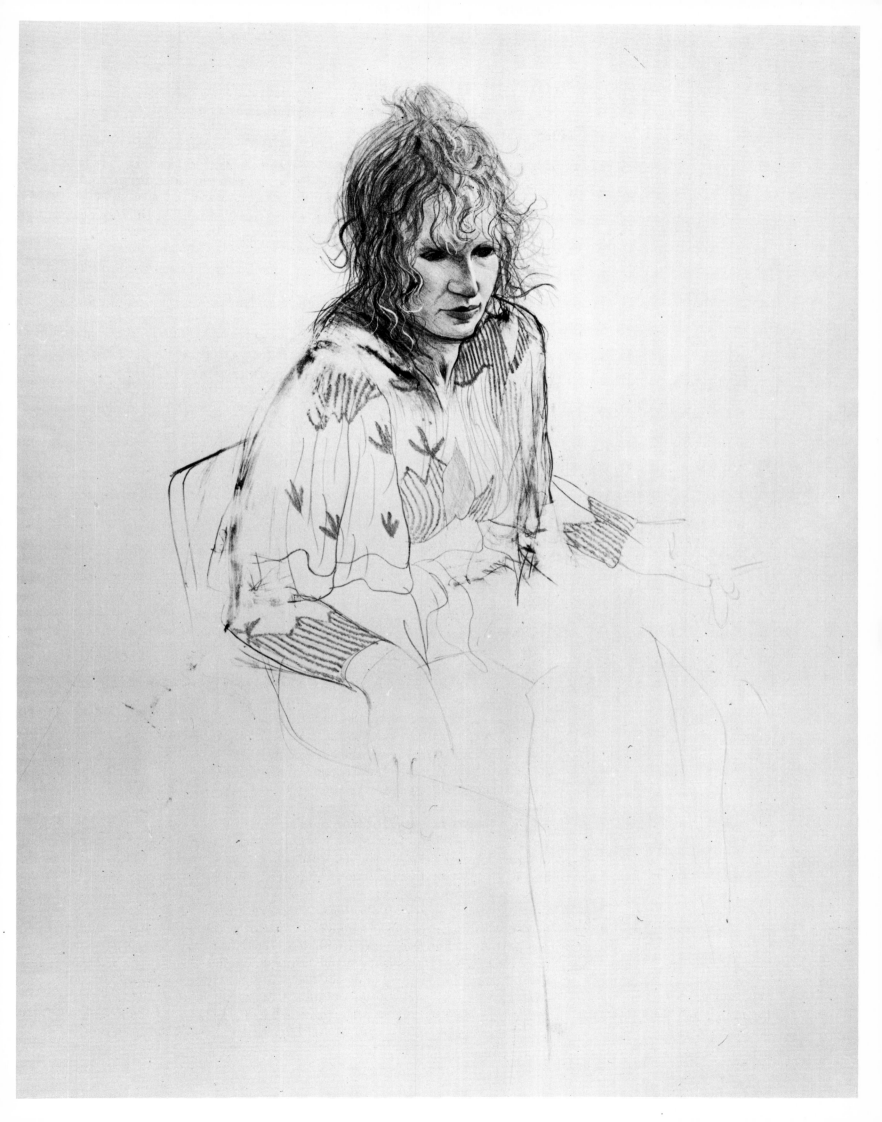

Opposite, above: Josef Albers, *Day and Night VIII*, 1963; below: Giuseppe Capograssi, *Composition*. Above: Lucio Fontana, *Composition*, c. 1960. Right: Sam Francis, *The White Line*, 1960

Schifano. Andy Warhol is of particular importance in this regard by virtue of his strange serializations of images through a mixture of different techniques (photography and silk-screen printing). Elements of American Pop Art also recur in the works of the Nouveau Réalisme group (Mimmo Rotella, Arman, and the already mentioned Raysse). Alexander Calder's famous mobiles, forerunners of an entire series of balanced sculptures, become, when their author records them in his graphics, a blend of the nonformal and the surreal. Minimal Art and Conceptual Art often overlap —both promote the reduction of visual elements to a minimum—and the graphic expressions of these movements serve to reinforce their basic tenet. Among the better-known exponents of this genre are Donald Judd, Robert Morris, Richard Serra, Mario Merz, Giulio Paolini, Joseph Kosuth, and Joseph Beuys. Graphic work has also been produced by artists of the Photo-Realist movement.

Whatever the basic inspiration of an artist may be, the intrinsic excitement of a lithographic print does not lie in its eventual inclusion in some particular chapter of art history. It comes, instead, from that grain of truth which the individual artist's touch imparts to the print, from the intuitively perceivable presence of his personality.

THE ARTIST
AND THE PRINTER
by Fernand Mourlot

If Senefelder, the inventor of lithography, had not tried to personally make his theatrical works more widely known; if he had not had the problem of reproducing large numbers of copies of musical scores in order to ensure a living for himself here history hesitates.

If he had not been, to use his own words, "endowed with an uncommonly inventive spirit and a persevering nature, and animated by a desire for independence...."

And last but not least, if nitric acid mixed with gum arabic had not produced, on a surface of calcium carbonate, "an obscure chemical action," then I would not now be talking to you about lithography.

At a very early age, after a few years spent studying in the Ecole des Arts Décoratifs in Paris, I decided to work in the printing works run by my father in the Rue Saint-Maur. The work enthralled me and, after several years of hard work, I became a good technician. As a preparer and sander of stones, a *chromiste*, a proof puller, and a tester of colors, I mastered all the skills of the true printer-lithographer, and it is precisely for this reason that I have agreed to write this chapter, pausing only to beg the reader's forgiveness for not being as deft with the pen as with the stone.

Speaking of the renewal of the lithographer's craft will also involve a certain amount of references to the Mourlot printing works, and for this I crave the reader's indulgence in advance. After the great strides made during the era of Daumier, Charlet, Delacroix, and Goya, lithography obtained a new lease on life with the first examples of color lithography that appeared at the end of the nineteenth century in the art of Lautrec, Vuillard, Bonnard, and others. Subsequently, however, it fell somewhat into disfavor among artists. Clearly the technique had not been completely abandoned and there were still good painters producing interesting prints, but it had somehow become unfashionable and had obviously evolved from a means of artistic creation to one of commercial reproduction.

The great posters of Chéret, Cappiello, and Cassandre were composed on stone—or by then also on zinc—by specialized draftsmen (the *chromistes*), who, using several stones (often as many as eight or ten), retraced each color until the artist gave his consent to the result obtained. By means of these great colored placards, chromolithography enabled the nascent advertising industry to "make the walls flower." The job of *chromiste* was an interesting one, but nowadays it has all but vanished. Drawing by hand

first state

second state

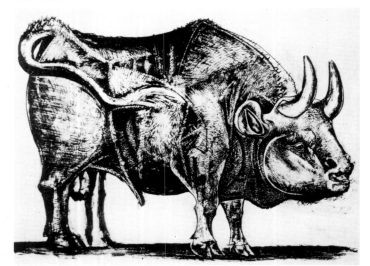

third state

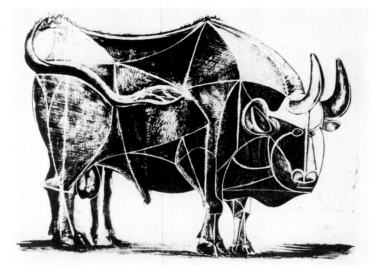

fourth state

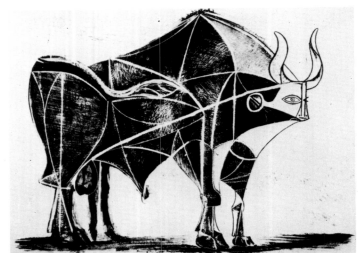

fifth state

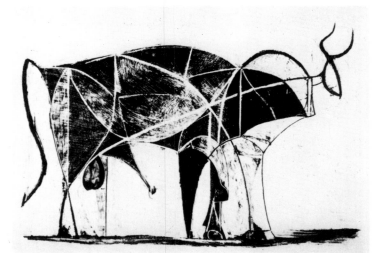

sixth state

has been replaced by colored photographic plates, generally in four colors, which makes the process not only quicker but also much less costly.

Lithography was therefore rather in the doldrums. Tired of merely printing labels for the cosmetic industry or producing religious pictures and letterheads, I tried to find some more artistic outlets but without much success.

Then World War I intervened. Having been mobilized at the outset

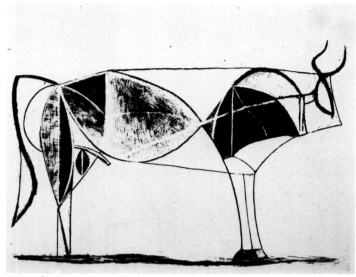

seventh state

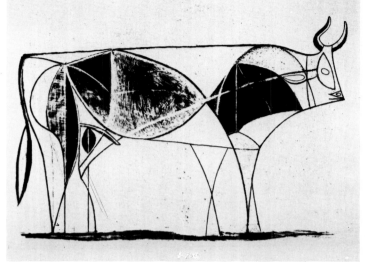

eighth state

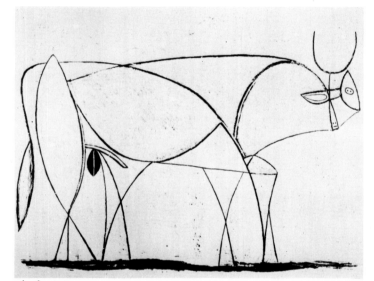

ninth state

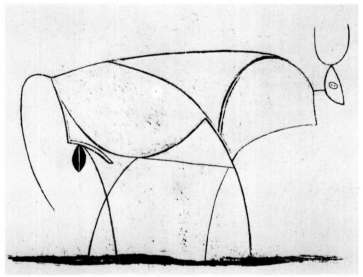

tenth state

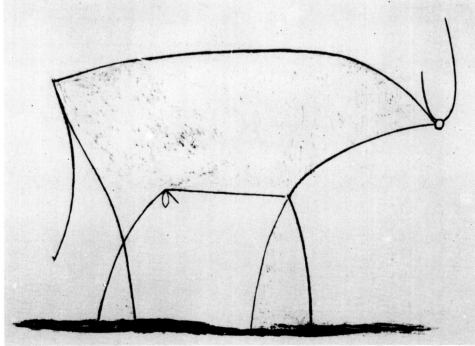

eleventh and final state

Picasso's famous *Bull*, first drawn by the artist on a lithographic stone at the printers Mourlot in December 1945 and reduced, in its final state, to its most simple expression by means of few lines of extraordinary mastery

into an infantry regiment, I was lucky enough to fall in with two painter friends, which revived my hopes for lithography. Wounded and discharged, I returned to Paris and rediscovered these two friends, who like me had survived. As you can well imagine, I discussed my lithographic obsession with them, and it was in this way that we began to work together. I then met Marcel Seheur, a young, rather eccentric publisher but a very able man nonetheless, and he put me in touch with Utrillo and Vlaminck. These two artists illustrated two works, in black, for him: remarkable lithographs that taught me a great deal. That was in 1926.

In the meantime, during the twenties, we had printed a poster for an exhibition of modern French art in Sweden, for which the painter Girieud had created an original lithograph portraying a naked (and rather heavy) woman in front of a Provençal landscape. She had, in fact, already been shown in Paris and had aroused considerable interest among people little accustomed to seeing artistic contemporary posters. Then, in 1924, Vertès had designed a small poster for an exhibition on nineteenth-century student life held at the Bibliothèque Sainte-Geneviève; this very pretty poster had also already been on display in Paris. One day, the assistant-director of the Musées de France, Monsieur Jaujard, who had noticed these two posters, expressed a desire to see me. After a long conversation, I left the museum almost totally sure that I was going to be asked to print the posters for future exhibitions organized by the directorship of the National Museums. This was, in fact, precisely what happened, and after producing some satisfactory examples, I became official printer for all their exhibitions. These posters quickly caught the eye not only of the public but particularly of painters. It was the first time that art-exhibition posters had been pasted up in the streets of Paris, and shortly afterwards picture galleries and libraries followed the example of the museums. The great artists of the day gave permission for their works to be reproduced for their exhibition posters, and very often they themselves made the preparatory sketches and original lithographs for the posters. A new fashion was launched, and the name of Mourlot soon became common currency among painters. When Matisse, then Braque, and finally Picasso made their way to the Rue de Chabrol, where our workshop was situated at the time, I knew then that the battle for acceptance had been won.

The collaboration that exists, and which must exist, between the artists and the "technicians" of lithography is extremely delicate. This relationship is a very important, in fact basic, feature of our craft, since a feeling of empathy and mutual understanding must exist at every stage between the artist and the *pressier* (pressman). I realized quite well that the artist-lithographer initially felt somewhat lost when confronted by his stone, the lithographic pencil, the ink, the scraper, and such. Faced with this beautiful limestone surface, the printer must be fully aware of the reactions inherent in each stage of the process.

The preparation with acid of the stones bearing the artist's design, their correct inking, and the meticulous laying of each successive state —the quality of the final proof depends on the care and talent the printer displays in ensuring the perfect execution of each of these successive steps in the process. His role is that of "artist's assistant," and his skill and competence will be significant in obtaining the successful outcome of any lithographic project. Did not Lautrec, in recognition of services rendered, immortalize old Cotelle, a printer in the Ancourt press, as he went about his work?

After preparation and a few hours' wait (the drying time), the stone, cleaned and then inked with a hand roller, passes through the press, and a

Marino Marini (above, left) and Richard Lindner (right) in Fernand Mourlot's atelier

proof is taken. This is one of the great moments of lithography. Faced by the result of his work, the artist may declare himself satisfied, but he may equally want to make some corrections. It is then that the printer intervenes and supervises the retouching that the artist carries out, sometimes patiently and sometimes feverishly, depending on his character. A new proof is then taken and, once again, the two men put their heads together. At Mourlot's, as in all true lithographic workshops, this privileged relationship forms the basis of all creative work. Once the *bon à tirer* has been granted, the definitive printing process can be started, with each print being numbered and then signed by the artist.

When faced by the stone on which he is going to work, every artist reacts as though he were standing in front of a blank canvas, but perhaps he feels an even greater sense of excitement since he will have to face all the surprises held in store by the lithographic pencil, the ink, the acid. It is not a question of technique but of all sorts of different attitudes that an artist may happen to adopt. Picasso, for example, experimented in the Rue de Chabrol with all the techniques—transfer paper, stone, zinc, pencil, pen, knife, brush, wash tint—and even used glue and petroleum!

At the beginning of December 1945, in the Rue de Chabrol, Picasso drew a bull, using a wash tint. It was a magnificent bull, beautifully drawn, noble even. We then presented him with a proof, pulling barely two or three of them, which makes this particular bull a rare animal indeed. A week later, he returned and asked for a new stone, redrawing his bull with wash and pen, and on December 18 he started all over again. In the third state, the bull was redone using a scraper and then a pen, with great emphasis placed on its bulk: it became a terrifying beast with horns and frightening eyes. Still Picasso was not satisfied, and on December 22 he executed a fourth state, with a fifth state being completed two days later: each time he

simplified the basic design, which became more and more geometric, with flat, black areas. His printer, Tutin *père*, one of the "grand old men" of the establishment, did not always agree with what was happening and did not hesitate to voice his misgivings.

The sixth and seventh states were completed on December 26 and 28 respectively, and then, after Picasso's return, a further four states were produced (bringing the number up to eleven) on January 5, 10, and 17. The bull had been reduced to its most simple expression: a few extraordinarily skilfully drawn lines that symbolize, like a sort of artistic pun, this unfortunate beast with its tiny head and ridiculous, antennalike horns. The workers in the printshop were desolate at seeing such a magnificent bull transformed into a sort of ant. One of them said to me: "He kept on cutting his bull down, and each time he did we would pull a proof."

Picasso himself had noticed that the workers were somewhat perplexed, a fact that no doubt excited him. He once said to Deschamps, one of our best *chromistes*: "Look, Henri, that's what one should give a butcher. The housewife would say, 'I want that piece there. Or that one there.'" It was Célestin, Miró's personal *pressier*, who had the final word on the subject, saying "That Picasso! He finished where, *normally*, he ought to have started."

Eighteen examples of each of these states were pulled and became the property of the artist; a further fifty prints were made of the eleventh, final state and were signed and numbered by the artist.

When Chagall was faced by the stone, his face would literally light up. I used to watch him sometimes without his noticing, and I admired how completely oblivious he was of what was going on around him: he was happy in a way that only those who create happiness can be. He was able to begin with a large bouquet of flowers, and then the bouquet would become the head of a woman...

Braque worked in a way that was quite different from Picasso's. The latter drew rapidly, with a single line, immediately asking for proofs to see what effect it gave, whereas Braque was slow, stopping and starting, retouching, and remaining for hours at the stone. On the whole, most artists like to stay at the stone by themselves, which explains why, although I am very close to Maurice Estève, I have never seen him working.

I must admit that I have had a certain good fortune in being able to meet all these great artists, and I have ended up by admiring them and by learning things from and with them. And if I have done some things in my life as a printer that are not too bad, it is primarily because I have realized the importance of listening to these artists who, without seeming to, gave me advice that I have subsequently followed. I therefore thank them for all that they have done for me personally and for the world at large.

Fernand Mourlot, one of the world's greatest printer-lithographers, studied at the Ecole des Arts Décoratifs in Paris. Among the great modern artists with whom he has worked are Picasso, Matisse, Chagall, Miró, Dubuffet, Léger, Derain, and Braque.

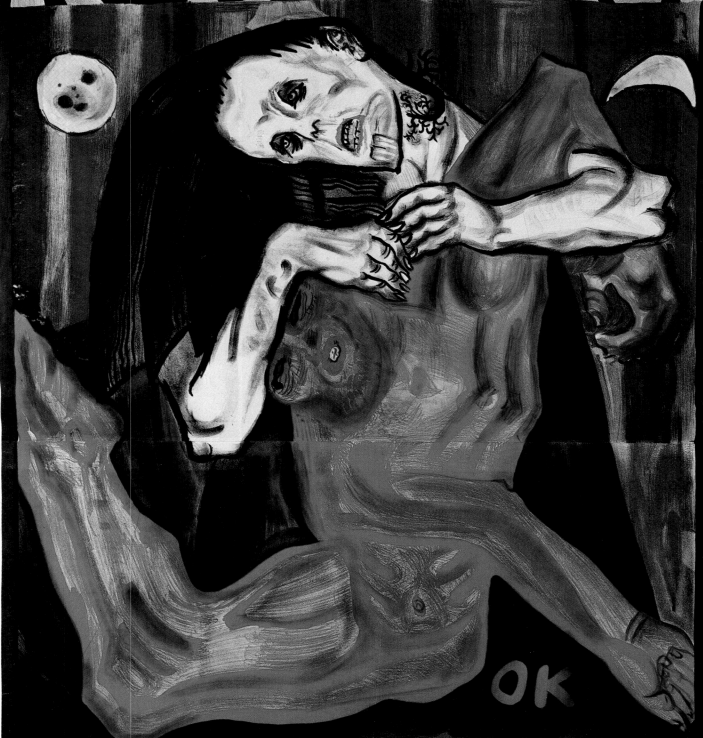

THE POSTER

by Alain Weill

L ithography was, without doubt, one of the key elements in the development of posters at the end of the nineteenth century. The extraordinary boom in advertising at the time was clearly the product of the twin phenomena of industrialization and urbanization, but it was in France that, thanks to a remarkable array of artistic talents, advertising gave birth to the concept of publicity graphics. Publishers had already shown the way during the July Monarchy, yet even though their lithographic posters were signed by the greatest names of the day (Gavarni, Raffet, Nanteuil, Johannot), they had passed out of fashion by the second part of the century.

Jules Chéret is quite rightly regarded as being the father of the color poster. After a first, short-lived success in 1859 with a design for Offenbach's *Orpheus in the Underworld* and a stay in London, where he perfected his technique, Chéret returned to Paris in 1866. He began to cover the city's walls with posters which, despite being printed in only two or three colors, stood out from the other efforts of the day by virtue of their elegant designs. At the beginning of the 1890s, he had already produced several hundred posters and had achieved complete mastery over the process. Using only the primary colors (red, yellow, blue, and black), he succeeded in reproducing every nuance of shade through the careful use of superimposition and lithographic *crachis*. It should be pointed out that the process patented by the two Engelmanns, father and son, in 1837 had been continually perfected and elaborated since its inception. Thus, in the period from 1870 to 1890, the French poster had, thanks to the work of artists like Chéret and other pioneers such as the Choubrac brothers, assumed an artistic dimension that was completely absent in contemporary Germany and England (apart from such rare exceptions as Frederick Walker's *Woman in White* of 1871). The revolt of an entire generation against the hidebound conventionalism and academicism of the Ecole des Beaux-Arts and the Salon found, in lithography, one of its most powerful means of expression. Two influences gave this new generation a doctrine and a style: William Morris's Arts and Crafts Movement, which was echoed in France by a powerful renaissance in decorative arts, and the great renewal of interest in Japanese prints, the first examples of which to arrive in Europe had overturned the accepted rules of Western graphics. This artistic backlash was also encouraged by theorists such as Claude Roger-Marx, who hoped to "bring culture to the masses" by means of everyday objects, berating the "super-

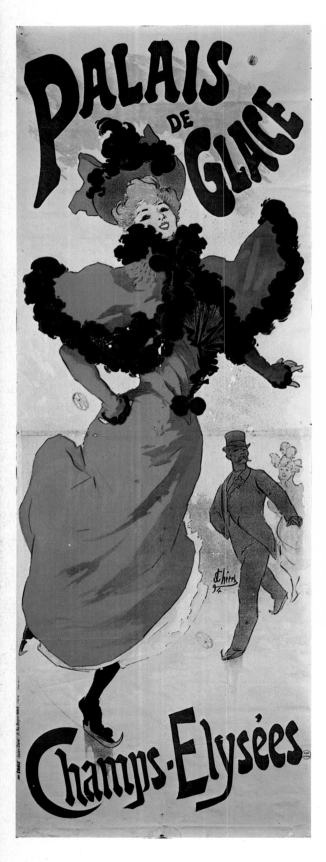

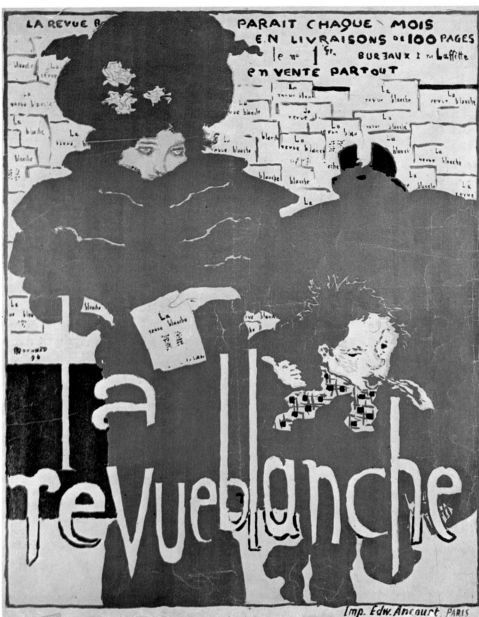

stitious veneration accorded by dilettantism to rarity.'' In his *L' Art social*, Roger-Marx was one of the first to pay tribute to Chéret for having, as he put it, known how to convert the bases of buildings into surfaces for decoration and how to make the open-air museum reflect the character of the people, to encourage the unwitting education of taste.

Eugène Grasset, a pioneer and theorist of Art Nouveau in France, began producing posters in 1886. Inspired by both medieval and Japanese art, he was the first to introduce flora and fauna into his prints as well as a type of woman with long, flowing hair which, after being taken up by his pupils Berthon and Verneuil, was popularized to the point of stereotype by Alphonse Mucha. After the staggering success of Mucha's first poster in 1895 for Sardou's *Gismonda*, starring Sarah Bernhardt, his prolific production of posters and panels popularized a style that characterizes an entire epoch whose thirst for images proved to be almost unquenchable. During the same period, at the beginning of the 1890s, the Nabis launched themselves into advertising art in the wake of Bonnard and his *France-Champagne* (1891). They were completely under the spell of the Japanese engravers of the Ukiyo-e school, whose principles—blocks of flat color,

Above, left: Jules Chéret, *Palais de Glace, Champs-Elysées*, 1894; right: Pierre Bonnard, *La Revue blanche*, 1894. Opposite: Henri de Toulouse-Lautrec, *La Goulue at the Moulin Rouge*, 1891

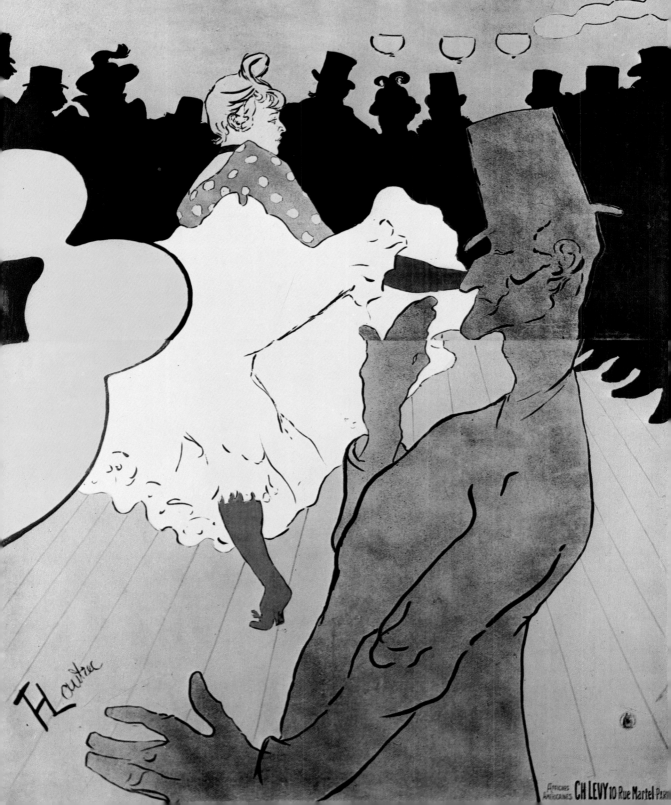

strongly outlined figures, and bold compositions and layout—they consistently applied. Lithography, which lends itself admirably to this style because of the freedom it gives the artist, gradually ensnared the Nabis one by one; the poster particularly interested them because its format allowed them to express themselves in a more spectacular way. In addition, it should be pointed out that posters gave impecunious young artists the chance to earn money as well as fame. Bonnard, Denis, Ibels, Vallotton, and Vuillard all tried their hand at lithography with varying degrees of success and perseverance, while Toulouse-Lautrec, who was the most deeply involved of all, produced thirty-one posters of uniquely expressive intensity between 1891 and 1900. His bright colors (for example, the yellow, red, and blue of his *Bruant at the Eldorado*) and his revolutionary compositions (the "cutoff" head of Yvette Guilbert in *Japanese Divan* or the giant double bass in the foreground of *Jane Avril at the Jardin de Paris*, to name but the two most spectacular examples) blazed new artistic trails, creating a visual impact that had never before been seen in advertising imagery.

Posters were all the rage in France between 1890 and 1900: exhibition followed exhibition, special galleries opened, critical and reference books were published, and periodicals (for the most part ephemeral) sprang up everywhere. *Affichomanie* spread like wildfire, with posters signed by painters, illustrators, and countless caricaturists rolling off the presses by the hundred; even Puvis de Chavannes, the stern president of the Société des Beaux-Arts, succumbed. From France the craze soon spread to other countries where, after a delay of two or three years, it became firmly established during the mid-1880s. In Brussels, the hub of Art Nouveau, the whole of the European avant-garde was attracted to the Salon de la Libre Esthétique, whose posters bore the signatures of Combaz, Lemmen, and Van Rysselberghe. The graphic skills of Privat Livemont rivaled those of Mucha, while the Liégeois artists Rassenfosse, Donnay, and Berchmans also produced some very impressive works. In London, where Hassal and Dudley Hardy displayed a classical style of design reminiscent of Chéret's work, Beardsley and, more especially, the Beggarstaff Brothers (Pryde and Nicholson) continued the great intuitive tradition of Lautrec and, by their juxtaposition of flat areas of color, provided yet another source of inspiration for modern posters. In Scotland, the Glasgow School, centered on Charles Rennie Mackintosh, retained links with the German and Vienna secessions, and the same influences can be seen at work in the posters of the Dutch artists Toorop (who was very influenced by Javanese art) and Thorn-Prikker. In the United States, where the poster was introduced by magazines such as *Harper's* and *Lippincott's*, a whole host of young graphic artists emerged (Penfield, Bradley, Gould, and others). Finally, in Italy, while the fashion was waning in other countries, the publishers Ricordi were issuing the luxuriant prints of Dudovich, Hohenstein, and Mataloni. Germany, by contrast, had remained relatively unaffected by the vogue for art posters. Although academicism reigned supreme there, Satler's poster for *Pan* (1895) and, more especially, Thomas Theodor Heine and his bulldog for *Simplicissimus* (1897) did succeed in overturning tradition.

The Secession movements that appeared almost everywhere at the end of the century sounded the death knell for both academicism and the swirling, foliar scrolls of Art Nouveau. The first geometrical elements appeared both in Darmstadt (Behrens, Olbrich) and Munich (Bruno Paul), echoing the work of the Viennese artists Kolo Moser and Roller. All the revolutions that within a matter of years were to upset the world of fine arts were now beginning to germinate, ready to burst out everywhere. Henry van de Velde, who had opened the way to nonfigurative geometricality with his *Tropon*,

Above: Gisbert Combaz, *La Libre Esthétique*, 1889. Opposite, left: Alphonse Mucha, *La Dame aux Camélias, Sarah Bernhardt*, 1896; right: Manuel Orazi, *Théâtre de Loïe Fuller*, 1900

LA·DAME·
AUX·CAMELIAS

SARAH BERNHARDT

THEATRE DE LA
RENAISSANCE

IMP. F. CHAMPENOIS. PARIS

THÉÂTRE DE
LOIE FULLER
EXPOSITION UNIVERSELLE

RUE DE PARIS

Affiches Artistiques MANUEL ORAZI. 8 Rue de l'Orient

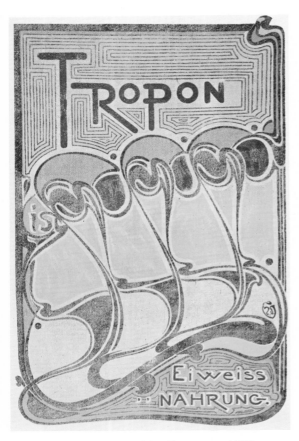

Henry van de Velde, *Tropon*, c. 1897

helped to found the Deutscher Werkbund (1907), from which the Bauhaus later originated; El Lissitzky and Malevich applied the principles of Constructivism to the posters of the Russian Revolution; the posters of Die Brücke were followed by those of Der Blaue Reiter, while in the background Cubism prepared for its triumphant takeover.

Apart from the posters they produced for themselves, which are of art-historical importance, these revolutionary movements had little influence on advertising art in its truest sense. Even though artistic posters ''in the French style'' had become a thing of the past by 1900, the reasons for this change are less dramatic than one might expect, however crucial they were for the art of communication.

Arriving in Paris from Italy, Cappiello violated the sacrosanct rules of realism with his woman riding an orange horse in an advertisement for Klaus chocolate (1904). He established the basic rules of legibility (pale colors against a dark background, or vice versa), he clearly articulated the necessity for a graphically expressed idea (the arabesque), and also invented a series of characters, like the fire-breathing clown for Thermogene cotton, that became synonymous in the minds of the public with the product they were advertising, thereby leading to instant recognition. The other two main proponents of the new advertising techniques were German. Lucian Bernhard proposed a more radical formula, which involved displaying the product to passersby on a vastly enlarged scale. His advertisements for ''Stillerschuen'' or Stricher matches (1907), were the first examples of an ''object poster'' (*Sach-Plakat*) and exercised considerable influence, particularly on the Swiss school. On the other hand, Ludwig Hohlwein perpetuated the style of the all-too-rare posters of the Beggarstaff Brothers, using flat areas of color and camaïeux to delineate dozens of magnificent animals (in his Munich Zoo poster) and an impressive array of human characters.

World War I, naturally enough, saw commercial advertising give way to propaganda. However one looks at it, one finds the same underlying themes: scenes of horror and misery or the recruiting officer's pointing finger. Even the best artists sacrificed their talent to the cause of patriotism.

The postwar period saw a resumption of work by the two giants of commercial art: in France, Cappiello inspired an entire generation of followers, but even the most talented of these (Jean d'Ylen, for example) were never able to produce images with the same impact as his *Kub* poster (1931); in Germany, Hohlwein's hundreds of poster designs became less static and more refined, incorporating a greater variety of color. Apart from these two exceptions, the field was dominated by a new generation who were to impose their own style on the period. First of all, there were the fashion illustrators, who used their often exuberant talents to portray the luxury and style of the Roaring Twenties. In Paris, the pleasure capital of Europe, there were many such figures, either working for the *Gazette du Bon Ton* (Lepape, Barbier, Marty, Brunelleschi), for the music halls (Zig or Gesmar, who was Mistinguett's personal poster- and stage-designer), or for the car industry (René Vincent). They drew their colors from the palette of Diaghilev's Ballets Russes, their eccentricities from Paul Poiret, and some of their geometrical line from Art Deco exhibitions. The same sophistication was to be found in Munich in the work of Schnackenberg (*Odéon Cabaret*) and Kainer. In England, the Bordeaux-born artist Jean Dupas was active, and Tom Purvis brought an elegantly virile, sporting quality to his brightly colored posters, whether they were designed for shops such as Austin Reed or for commercial organizations such as the railways. All these artists portray the easygoing life-style of a generation dedicated

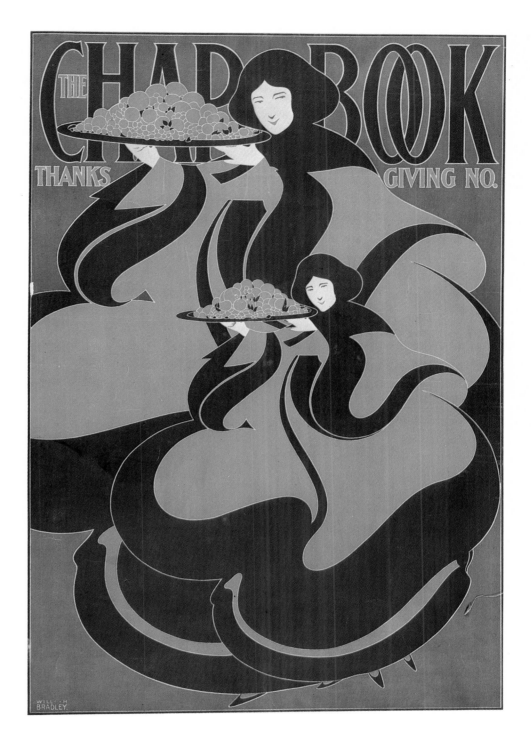

Will Bradley, *The Chap-Book*, 1895

to sport and cocktails, whose women wore bobbed hair and men soft collars. But there were other, more revolutionary changes made during the period—in the realm of graphics, at least. The avant-garde movements whose early stirrings have previously been mentioned turned the world of advertising upside down. The Russian Constructivists, the members of the Bauhaus, and the followers of De Stijl, although they produced only a small number of posters, played their avant-garde role to the fullest, establishing models that were to be of crucial importance for future generations. They introduced photography (El Lissitzky, Klutsis, Tschichold, Schuitema), which, after being taken up by the Swiss (Herbert Matter), introduced a new dimension of extraordinary importance. They were also responsible for the invention of modern typography (Piet Zwart, Herbert Bayer, Walter Dexel).

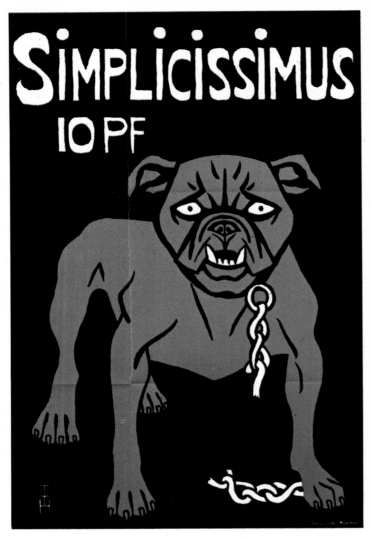

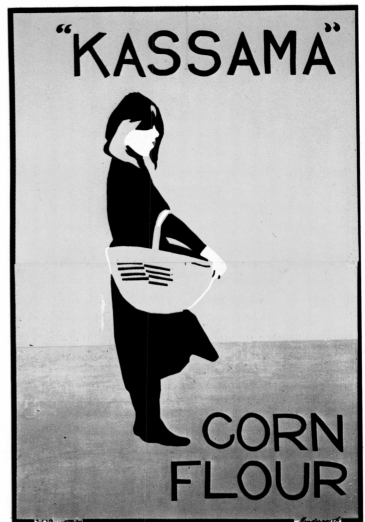

Above: E. McKnight Kauffer, poster praising the dynamics of flight (1918). Opposite, top left: Thomas Theodor Heine, *Simplicissimus*, 1897; top right: the Beggarstaff Brothers, *Kassama Corn Flour*, 1900; bottom left: Lucian Bernhard, *Provodnik Galoshes*, 1913; bottom right: Ludwig Hohlwein, *Confection Kehl*

During the same period, the problems of how to communicate a message were reexamined throughout Europe by professionals who revolutionized the character of publicity posters. Believers in machines and modernism, they adapted the principles of Cubism to create forceful, easily readable posters that "packed a punch," abandoning anecdotalism and, as Cassandre himself said, seeking a clear, powerful, and precise means of communication. As he put it, this is why "posters are not pictures, but become announcing machines." In France, four artists dominated the scene: Cassandre, Carlu, Colin, and Loupot. Cassandre succeeded in creating geometrical images of extraordinary power, whether for the railways (*Etoile du Nord*; *Nord Express*; *London, Midland and Scottish Railways*) or for ferries (*Normandie*). His vivid closeup view of a tennis ball (for the Davis Cup), his Celtiques packet, and his cinematographic declension of "Dubo-Dubon-Dubonnet" are only a few examples of his extraordinary talent, which embraced all the new techniques (in his Pernod advertisements, for example, he used photomontage). Another restless genius, closely linked to Cubism, was Jean Carlu, who created advertisements for Monsavon soap and Gellé Frères and who defined his purpose as creating "the graphic expression of an idea." He was also a pioneer in the fields of photomontage (his disarmament poster), posters in relief, in collaboration with the Martel brothers (*Odéon*), and neon signs (gas cookers, *luminographs*). From 1924 onward, Charles Loupot, a lithographic enthusiast, broke new ground with his posters for Voisin airplanes. His designs, such as those for Valentine and for the Barbès galleries (the wooden manikin), reached a creative highpoint with his brilliant work for the *apéritif* St. Raphaël. Finally, we come to Paul Colin, who concerned himself almost exclusively with the area of show business. Beginning in 1925, he revolutionized entertainment posters, particularly those of the Ballets Nègres, and was followed in this field by Wiener and Doucet, *Maya*, and others. Colin also ran a school for poster artists.

CINZANO

VERMOUTH TORINO

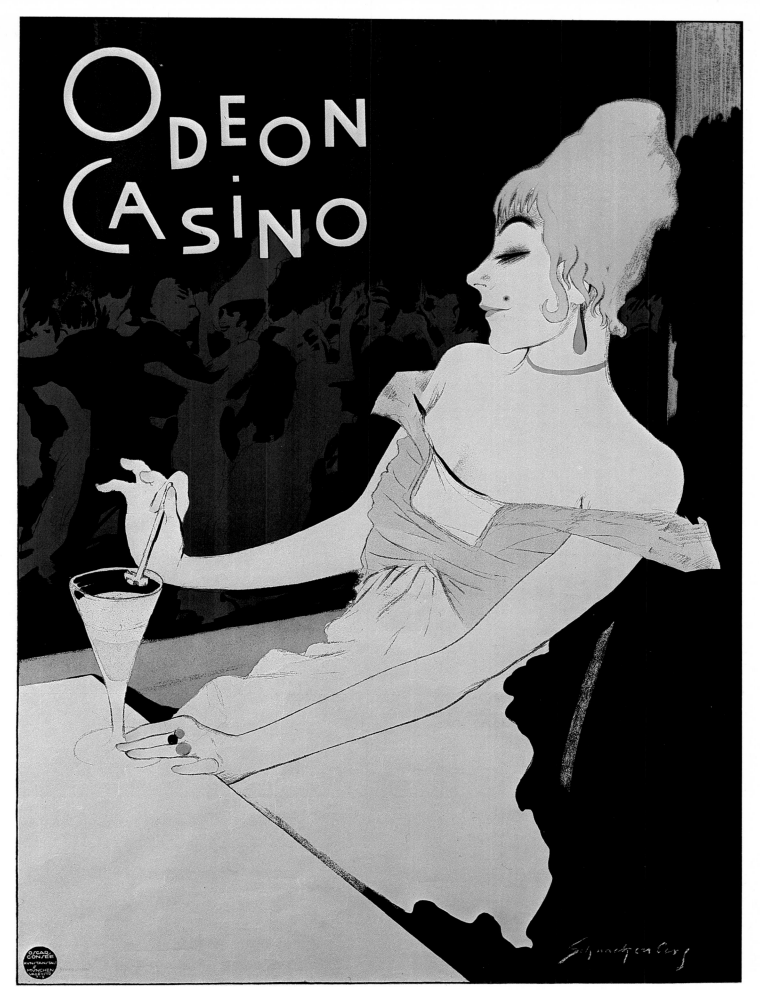

Above: Walter Schnackenberg, *Odéon Casino*, c. 1925. Opposite: Leonetto Cappiello, *Cinzano*, 1910

Above, left: Adolfo Hohenstein, *Esposizione d'igiene*, 1900; right: Aldo Mazza, *Corse a S. Siro*, 1909. Opposite: Marcello Dudovich, *Mele & C. Mode-Novità*, c. 1908

Along with these four great names, mention should also be made of Francis Bernard, a member of the U.A.M. (Union des Artistes Modernes), of Kow and Dil for their car advertisements, and of Perot and Coulon. In Belgium, Leo Marfuct produced works of extraordinarily high quality: his posters for Chrysler, Remington, and the Flying Scotsman possess a rare feeling of power. Other notable Belgian poster artists were Delamare-Cerf and Mambour. In England, the new style developed under the aegis of E. McKnight Kauffer, whose series of posters for Shell and the London Underground reveal an exceptional mastery of layout and a great creative freedom. While the flight of birds in Kauffer's *Daily Herald* poster was clearly Cubist in inspiration, he was equally capable of switching from geometric to rounded shapes or of combining them both without sacrificing the clarity of his message. Ashley Haviden, a tireless researcher of advertising techniques, also deserves a mention for his exemplary campaigns for Chrysler and Eno's Fruit Salts. Austin Cooper was highly skilful in the layout of his posters for museums (commissioned by the London Underground) and in his marvelous montages for Southern Railways. Cooper was particularly fascinated by the shape and form of letters. Other names worth recalling are those of F. K. H. Henrion, Frederick Charles Herrick, and Abram Games, who was a master of photomontage. In Italy, apart from Achille Mauzan and Sepo (Severo Pozzati), who were also active in France, the most outstanding figures were Marcello Nizzoli (Campari, the Milan Fair), Fortunato Depero and his small Cubist figures for San Pellegrino, and Marcello Dudovich, who created elegant yet practical works

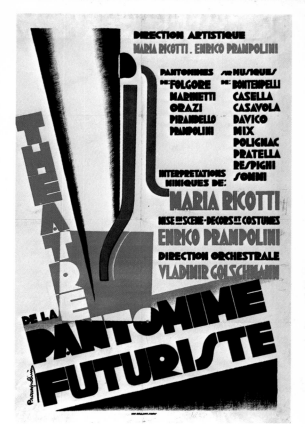

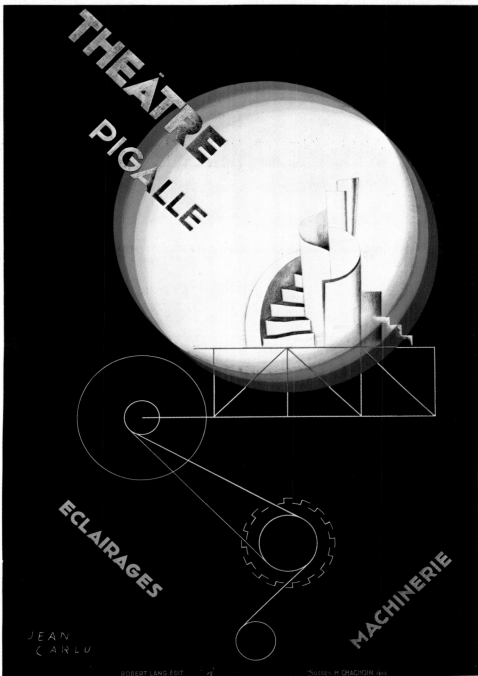

Above: Enrico Prampolini, *Théâtre de la pantomime futuriste;* right: Jean Carlu, *Théâtre Pigalle, éclairages, machinerie,* 1929. Opposite: Cassandre, *Chemin de Fer du Nord, Nord Express,* 1934

Alain Weill, conservator of the Musée de l'Affiche in Paris, has written prefaces, articles, and papers on art and advertising and on popular entertainments (music halls, cafés-concerts).

right up until 1952. Finally, the Swiss showed themselves to be most creative with the poster in the exemplary works by pioneers Otto Morach and Cardinaux, in the "object posters" of Otto Baumberger, Niklaus Stöcklin, Alex Diggelman, and Fritz Bühler, and in the photographs of Herbert Matter and Walter Herdeg.

All the posters we have described—whether geometric or figurative, photomontages or drawings with great blocks of color—made full use of every possibility offered by the lithographic process, which for practical reasons was by then using a zinc or aluminum sheet that could be fixed to a roller. The quality of the different editions (the depth of color resulting from the inking of the paper, the lithographic grain), which diminishes as a result of the chemical separation of the colors and the offset process, undoubtedly plays an important part in the interest many collectors show nowadays in posters. And when they are signed by the great names of painting and graphics, posters clearly represent the most spectacular form of print the lithography enthusiast can possess.

SOCIAL COMMENT
AND CRITICISM
by Michel Melot

If one may speak of "social" lithography, it is because the basic characteristic of lithography—the one that explains its invention, its success during the first part of the nineteenth century, its subsequent decline, and even its artistic renewal during the twentieth century—consists of the fact that it was, initially, the least expensive means of reproduction. In economic terms, it represented a real revolution in the diffusion of images, which until then had been tied to the long and costly process of engraving. This "revolution" was, of course, part of a whole series of attempts at solving the same problem: how to supply images to an ever-growing public, who were better educated than their parents, more inquisitive, and more geographically diffuse (the nineteenth century, which had witnessed the triumph of the bourgeoisie and the growth of democracy, also saw an increase in the power of the provinces).

Lithography, therefore, answered two social needs. On the one hand, it allowed for the growth of a small industry that could provide a livelihood for entrepreneurial craftsmen in an area that had previously been of benefit to only a small group of talented individuals. On the other, it allowed images to be used as vehicles for the spread of knowledge, for propaganda purposes, and for pure pleasure at a time when social reformers were preaching education through the medium of the senses. Lithography was an effective educational tool for the direct and immediate instruction of a whole new sector of the public that had only recently become socially and politically aware—the new urban and rural middle classes, who had few formal qualifications but were extremely active and eager to learn—and it could even be used for the illiterate lower classes, whose ideological and intellectual appetites could be satisfied solely by imagery.

It is for these reasons that one may be allowed to speak of "social" lithography. What remains now is to examine its consequences, which are an integral part of the history of lithography. By aiming itself at a poorly educated public and by producing a cheap and widely available product, lithography itself soon became accused of poor taste and technical poverty; it even became suspected of being vaguely subversive (in the aesthetic, as well as the political and moral sense) by the conservative sectors of society. Lithography became the symbol of "penny art," aimed at the common people and a vehicle for vulgarity, and it unleashed the same type of debate that breaks out every time any form of mass entertainment appears,

207

Honoré Daumier, *The Banker—Called financial capacity because he is nothing more than a receptacle, a coffer fit only for finances*, 1836

the same kind of reaction provoked by modern-day television programs. This fact has to be borne in mind if one wants to fully understand the historical significance of the attempts made by certain artists, such as Géricault and Delacroix, to deliberately adopt the new technique in order to exploit its ability to sell their works, which had thitherto been the property of a privileged elite, to a large number of people at a low price. Lithography became the target of all those who lashed out at the bourgeoisie, whom they regarded as the epitome of mediocrity. Théodore de Banville defined a bourgeois as "one who likes facile music and lithography," while Flaubert referred scathingly to lithography as "the delight of the bourgeoisie."

In the eyes of the public during the early years of the nineteenth century, therefore, lithography represented an avalanche of images steeped in easy sentimentality, providing endless reproductions of mawkish notions concerning Love and the Family. This avalanche was bounded on the one side by a feeling of coarseness and of more or less overt eroticism, and on the other by respectability and "holy pictures." The painter Jean-François Millet, who arrived as a young man in Paris from the country in 1837, tells the following story: "There was a print-seller, and I looked at his wares while nibbling on the last of the apples that I had brought with me from the country: the lithographs gave me no pleasure at all. They were pictures of *grisettes* wearing *décolleté* dresses, bathers, women at

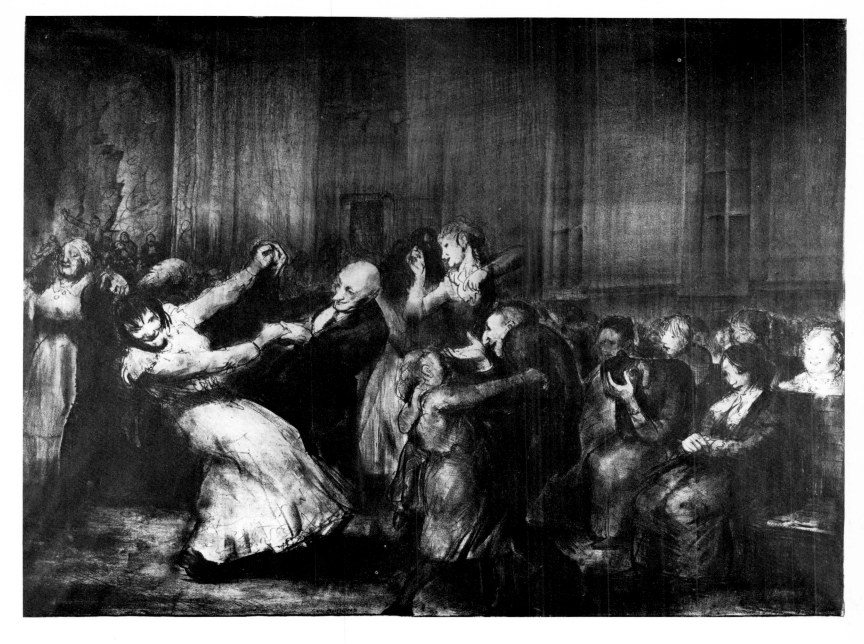

George Wesley Bellows, *Dance in a Mad-house*, 1917

their toilet, of the kind that Devéria was producing at the time: to me they looked just like signs for fashionable dress shops or perfumeries.''

This new public, which was either overenthusiastic or ingenuous, or made up of nouveaux riches, had very specific requirements: it wanted realism, or rather the illusion of reality. It craved the easily comprehensible, the concrete, and the mundane, and lithography, because it allowed the draftsman to model his subject with great attention to detail without reducing it to merely a flat outline like engraving, fulfilled all these requirements. As a result, there arose a great confusion in the minds of the educated public, who found it hard to reconcile this form of cheap imagery with the aesthetic sensuality encountered in the lithographs of the Romantic avant-garde, which displayed forceful expression of movement, relief, contrast, and caricature. This aesthetics of ''effect,'' even in its most *recherché* manifestations (Bonington's brilliant light effects, Delacroix's tangled lines, Daumier's caricatures), was always to remain tainted by a suspicion of vulgarity and easy superficiality by those who favored old-style classicism.

The first artists to exploit lithography in order to make contact with a hitherto untouched section of the public, by means of caricature, salacious humor, or sentimentalism, were slow to grasp the expressive potential of the new technique. The first lithographic caricatures, such as those by Delacroix and almost all pre-1830 examples, are too consciously ''graphic'' and, from a formal point of view, vary little from the thousands of carica-

tures engraved laboriously on copper at the end of the eighteenth century. But when the initial idea, whether violently aggressive or ingenuously sensual, finally flowed into the greasy ink of the lithographer and took realistic shape on his stone, then it could be said that the bourgeoisie had found its own means of expression.

Under the influence of lithography, a vast iconographical flood poured onto the market, inspiring Baudelaire to remark that ''Our century worships images.'' It was in these images, initially through the creation of character types, that the new society saw its own foibles and shortcomings. The popular figure of Traviès de Villers's ''Mayeus,'' whose origins still lay in the old tradition of farce, was soon joined by contemporary characters: Monsieur Prudhomme, the ridiculous petit bourgeois made famous by Henri Monnier; Robert Macaire, the unscrupulous businessman; the English John Bull; and the bourgeois Herr Biedermeier of the German-speaking world. These were followed by the lithographic series of Eugène Lami and Gavarni, which took such forms as burlesque inventories and parodies of positivist encyclopedias. Lithography eventually ended up by poking fun at the whole public, which began to laugh at its own shortcomings, recognizing both its strong points and its weaknesses.

Most of this output, however, was aimed at the easiest target—fashion. Here, too, lithography remained firmly anchored in the imagery born of the eighteenth-century bourgeois movement, exploiting it to the fullest. The series of *modes ridicules* from the Restoration period in France were, in form, direct descendants of the colored etchings ridiculing the *incroyables* of the Directoire. But the ''crinoline mania'' of the Second Empire provided a subject that was dealt with in a typically lithographic way, with

Above, right: Charles-Joseph Traviés de Villers, *Face it! (All Frenchmen are naturally susceptible to civilian and military jobs)*. Opposite, above: Henri Monnier, *Burial of the People;* below: Edme-Jean Pigal, *In everything one must consider the end*

shapes and movements that accentuated the grotesque and endowed the puppets and marionettes of traditional caricature with a feeling of weight, physical verisimilitude, and comic force that sprang from very real technical differences. A number of different artists exploited this lithographic vein, which was linked directly to the aesthetics of ugliness proclaimed by such Romantics as Victor Hugo, who exalted the grandeur of the grotesque in his famous Preface to *Cromwell* (1827).

The "lithographer-reporters" of the 1820s—Charlet (who advised his pupils that what they really needed was someone "who, without inducing them to despise old Laocoön, would say to them: 'That's all very fine, but *you* must portray what is stirring around *you*.'"), Gérard-Fontallard, Traviès, Pigal, and especially Raffet (confirmed in realism with his scenes of the Napoleonic campaigns)—paved the way for that group of draftsmen who were quite literally unleashed by the Revolution of 1830: Gavarni, Grandville, and, the most important of them all, Daumier. It was Daumier who was finally able to exploit all the formal resources of lithography to compose satires in which the new public of the July Monarchy could see its own obsessions revealed and find a mirror image of all its efforts, struggles, hates, and petty dislikes. Daumier was a Michelangelo in the eyes of Balzac, who wrote elsewhere: "In man, beauty is but a flattering exception, a chimera in which he strives to believe." Théodore de Banville, in his elegy for Daumier, summed up the basic contradiction which had made his work so successful and which only lithography had been able to portray: "It is

Cham, *National Assembly—Beginning to suffer from the cold and awaiting the moment of return with impatience*, 1851

COME RIDVCE LA PAVRA !!!!!

Top: Théophile-Alexandre Steinlen, *Coming out of the mine*, 1907. Left: Paul Gavarni, *A fanfare for you...*, *strolling musicians*, 1853. Above: *How fear reduces people!*, satirical cartoon from the magazine *Il Pappagallo*, 1848

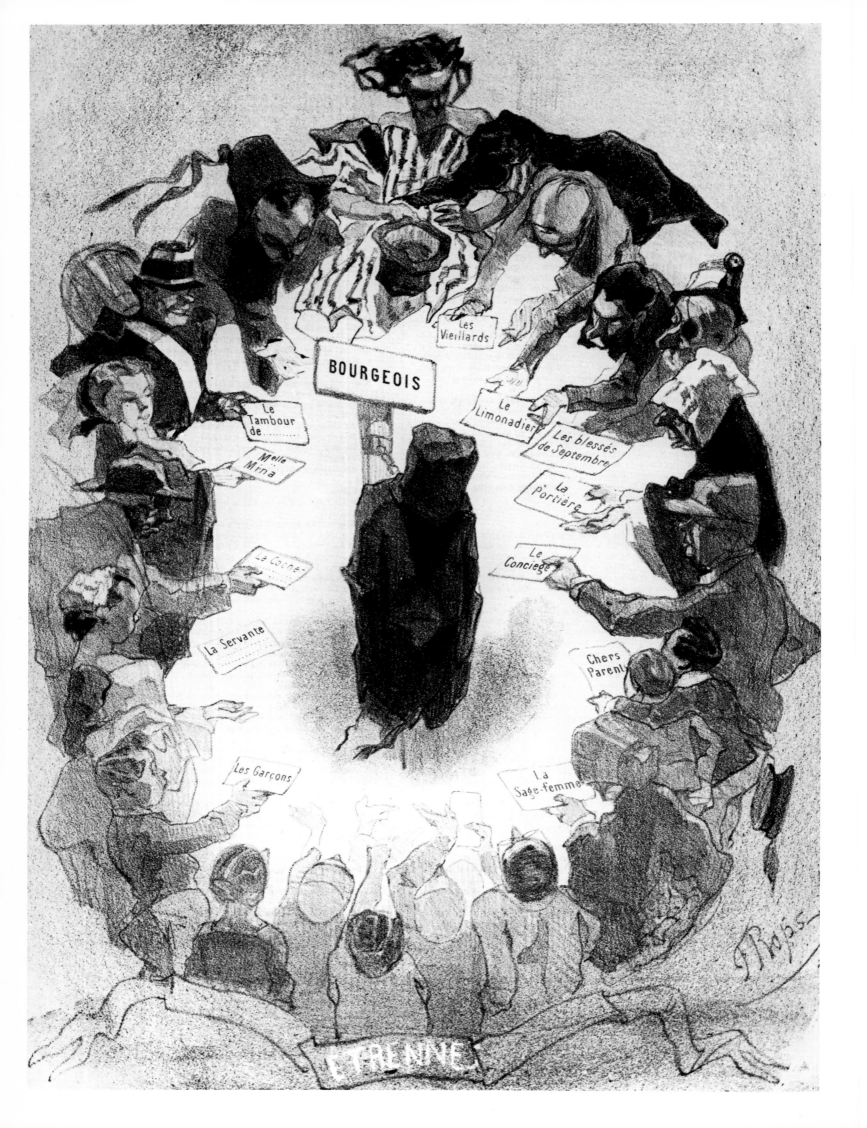

the bourgeois...Daumier shows him to us in all his stupidity...and with something of the supernatural and the divine...that is the bane of Beauty! But represented with cruel truth, will this model seem hideous? Don't you believe it, it will have a beauty of its own." This "beauty of its own" resulted from a perfect balance between the demands of a visual language (the lithographic outline drawn sensually on the stone in sweeping curves) and those of a public who were not only hungry for realism to the point of "cruel truth" but also involved in politics to the point of revolution.

The development of social lithography was linked directly to a spectacular rise in the number of printed publications: 45 newspapers in 1812, 309 in 1830, 440 in 1845. The first newspapers with any large circulations were *La Presse* and *Le Siècle*, founded in 1836, but by November 4, 1830, there had already appeared the first weekly newspaper with regular illustrations (*La Caricature*), made possible by the speed of the lithographic technique. Prior to that date there had been a number of newssheets sporadically accompanied by lithographs outside the text: *Le Nain Jaune*, to which the young Delacroix had contributed; *Le Miroir*; and *La Silhouette*, launched in 1829 by the same publisher Aubert, whose shop in the Passage Véro-Dodat was to replace that of Martinet, the seller of the lightweight lithographs that had been so fashionable during the Restoration in France. The reason for this was that Aubert and his partner Charles Philipon, both of them solidly Republican, matched the political mood of the public who had launched the July Revolution.

Lithography was no longer a vehicle for frivolity: it had found a cause it was able to serve by virtue of its speed and efficiency. It is said, for example, that Eugène Lami drew sketches at the barricades which were printed the same day thanks to lithography. Most importantly of all, however, Philipon gathered round him a team of young artists, both Romantic and Republican, who were able, each in his own way, to make exemplary use of this new means of expression offered them. Gavarni revived the frivolous genre but endowed it with a substantial feeling of realism; Grandville employed the graphic freedom to express his own highly active imagination; Traviès, the most radical of them all, inclined toward a violent and outrageous graphic style; and Daumier embarked on a veritable *comédie humaine*, which, through four thousand prints completed prior to 1874, provided a comprehensive view of life in the nineteenth century. Although *La Caricature* was undoubtedly of seminal historical importance, it collapsed under the weight of the lawsuits brought against it, even though Philipon, in order to pay the fines, made a separate publication of the prints of the *Association mensuelle*, which represent a high point in political lithography. Better known is *Le Charivari*, the first newspaper to publish, at a price of 20 centimes, a new lithograph each day; it lasted from December 1, 1832, to 1893. The heyday of political lithography, however, was between 1830 and 1835.

After that time, lithography began to suffer, first from the effects of censorship, reestablished in France in 1835, and then from the competition provided by new processes better suited to industrial production: engraving on wood cut against the grain (wood engravings as opposed to woodcuts), which was used to illustrate weekly magazines and popular books, and the *clichage* processes, as practiced from 1850 on by Tissier and Gillot, which reduced the stone to the level of a line block and allowed for more rapid printing, to the detriment of both perspective and the strength of the black tones. Finally, lithography proved unable to survive the slow but inexorable advance of photomechanical means of reproduction that took place

Opposite: Félicien Rops, *The New Year's Gift*, 1857

Above: Marcel Vertès, *Houses . . .* , c. 1925.
Left: Jean-Louis Forain, lithograph for
The Private Dining Room, 1892. Opposite:
Luc-Albert Moreau, *Cabigi de Mannequins*,
1926

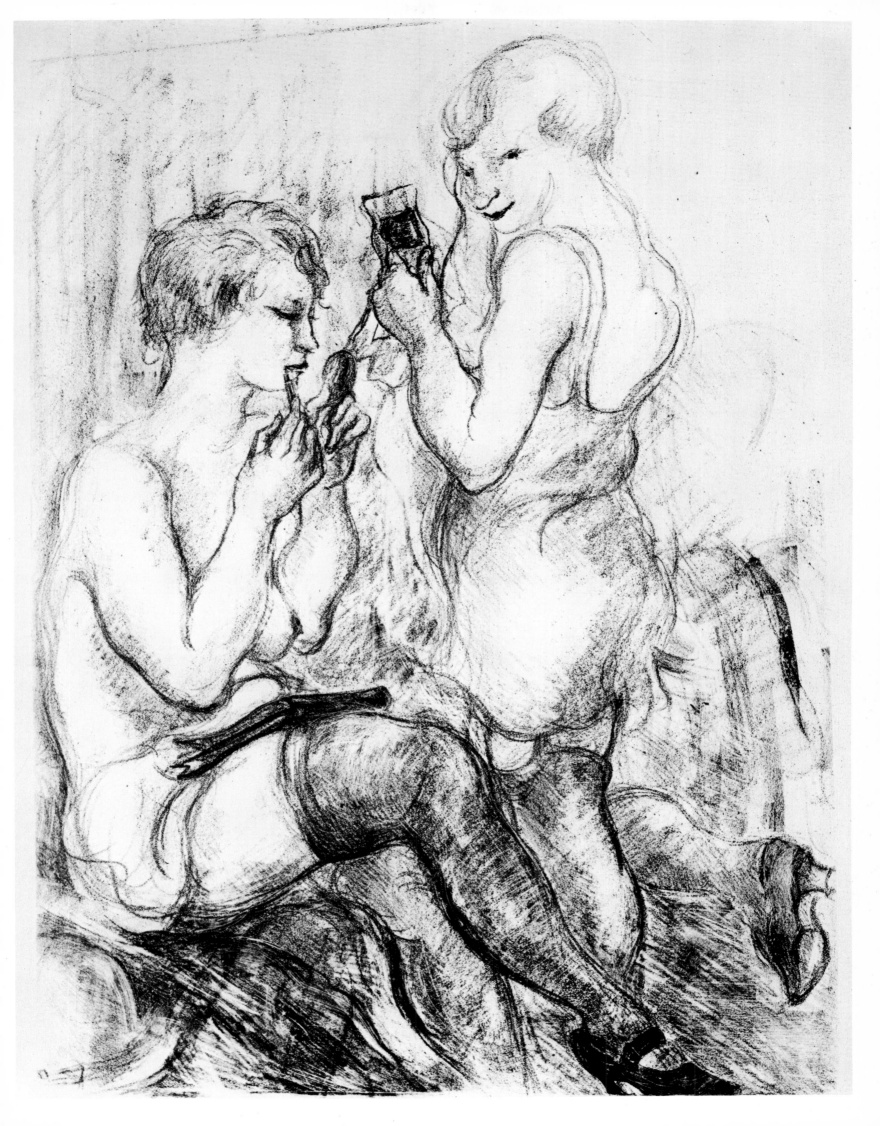

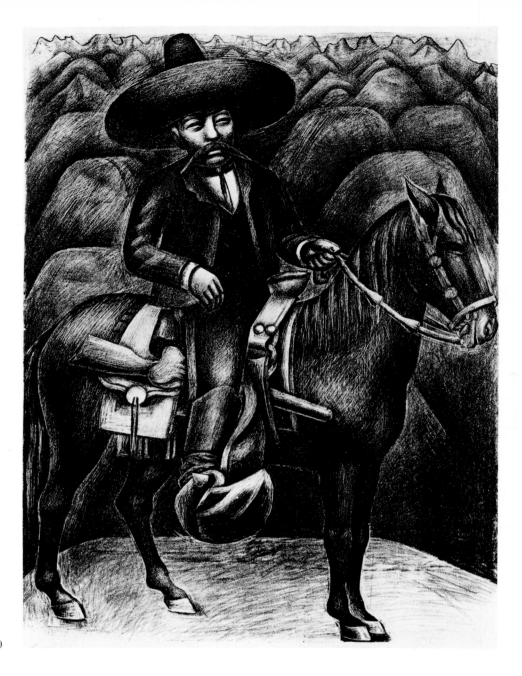

David Alfaro Siqueiros, *Zapata*, 1930

throughout the second half of the nineteenth century and ultimately triumphed in its closing decade.

Le Charivari continued to use traditional lithographic techniques for a very long time (up until 1870, in fact), but it had already lost its political edge following Daumier's replacement in 1861 by Cham, a more fashionable figure, who had a lively intellect but lacked the depth of his predecessor. After a certain liberalization on the part of the authoritarian regime of the Second Empire, a considerable political upheaval took place around 1864 with the publication by the caricaturist and photographer Etienne Carjat of a Republican magazine, *Le Boulevard.* This proved a short-lived enterprise, however, and the imperial dictatorship soon deprived France of all freedom of expression. Nevertheless, opposition grew stronger and stronger until finally the regime fell, and in 1870–71 the Commune seized control of Paris. Yet it was not until the new, very liberal press laws promulgated by the Republican government in 1884 that another wave of social and political images became possible; by that time, true lithography had had its day and *gillotage*, zincography, and other lithographically inspired means of transposing images were the order of the day.

Thus far, we have dealt only with France, since Paris was clearly the center of the phenomenon of social lithography (just as London was the

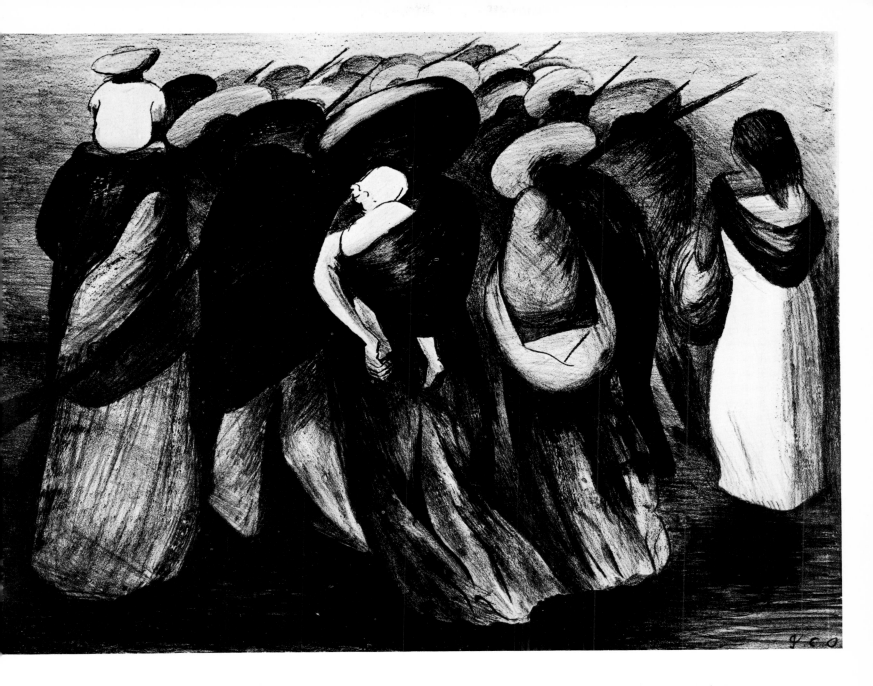

José Clemente Orozco, *Rearguard*, 1929

center of steel-plate engraving), largely as a result of political circumstances. The English publishing industry, which was more industrialized, had increasingly relied on wood engravings for its cheaper illustrations. The various regimes in the small states and principalities of Germany and Italy, however, had effectively delayed the birth of any form of politically assertive lithography until the revolutions of 1848. It was in the wake of these revolutions, which raged throughout the Continent, that political and social lithography began to appear outside France, albeit still in the French mold. In Prussia, where there had been freedom of the printed image since 1842, one of the earliest journals containing caricatures and prints of current events, the *Illustrierte Zeitung*, appeared in 1843. It was published in Leipzig by Johann-Jacob Weber and, like the English journals, it preferred wood engraving as a technique. In Italy, by contrast, from 1848 onward, a great many satirical journals began to emerge that made extensive use of lithography. The most famous of these was *Il Fischietto*, published in Turin from 1846 to 1916, but there were others: *L'Arlecchino*, which appeared in Naples during the year 1848–49; *Lo Spirito Folletto*, published in Milan from May to July 1848; and *Sior Antonio Rioba*. a Venetian publication of 1848–49. Florence produced *Il Lampione*, Rome *Don Pirlone*, Genoa *La Maga*, and, between 1873 and 1915, Bologna the well-known

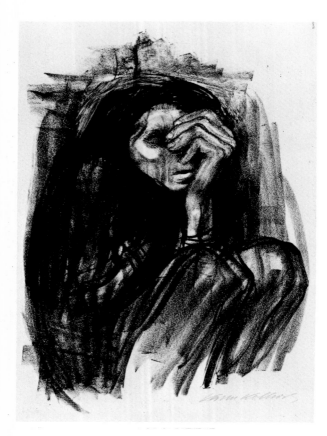

Above: Käthe Kollwitz, *Death on the Main Road*, 1934. Opposite: Félix Vallotton, *That one there?...He shouted Long Live Liberty!*, 1901

Michel Melot, a professor at the Ecole du Louvre, is editor-in-chief of the Nouvelles de l'Estampe *and author of numerous articles and papers on the subject of prints. Since 1981, he has also been director of the Department of Prints and Photography in the Bibliothèque Nationale, Paris.*

Pappagallo, ''the first political and humorous journal in color.''

We have become better acquainted with these journals thanks to recent studies, and we can detect a very special flavor to their illustrations, despite the way in which they all too clearly imitate French and English publications (*Le Charivari* and *Punch*). One of the regular contributors to *Le Charivari*, Jules Platier, even worked on *Il Fischietto* under the name of ''Giulio.''

In Italy, as in France and Germany, the last decade of the nineteenth century was marked by a new wave of biting lithographs, violently political, often anarchical, but with a completely different style that corresponded to a reappearance of the traditional lithographic process under a more artistic and decorative guise. These lithographs, often in color, were aimed at a more intellectual and affluent public: the heirs to the generation of 1848 had either become well-off bourgeois, whose political radicalism was now markedly blunted and who favored frivolous or erotic images (like the lithographs of Willette in France), or, conversely, they had become extremists in sympathy with the anarchist movement, favoring very aggressive social graphics. In France, the most interesting journal in this respect, *L'Assiette au beurre*, resorted only once to color lithography, when it published the magnificent series entitled *Crimes et Châtiments* by Félix Vallotton. Apart from the journals, in which their drawings were reproduced mechanically, the most deeply committed artists published separate lithographic suites aimed at collectors. Equally violent in tone, such works include the sweeping panoramas of working-class misery that appear in the lithographs of Théophile-Alexandre Steinlen, the mordant sketches aimed at the corrupt bourgeois by Forain, and the somber, desperate lithographs of his successor at *Le Figaro*, Hermann-Paul. In Germany, mention should be made of Thomas Theodor Heine and Olaf Gulbransson, artists working on the journal *Simplicissimus*, while in Italy a new wave of satirical images appeared in Rome in *L'Asino e il Popolo* (1892–1925) and *Il Pupazzetto* (1886), and in Milan in the *Guerin Meschino* (1882–1950) and *O di Giotto* (1890).

By the end of the nineteenth century, lithography had been overtaken as a means of popular expression by mechanical processes and was hardly ever used except by artists working for the collector's market. This does not mean to say that it had completely abrogated its social and political role. Its ''craft'' quality makes it, like wood engraving, an economical and easily worked means of reproduction for militant political purposes. For this reason every politically motivated artistic movement of the twentieth century has seen the production of lithographs, often in extremely primitive workshops: in pre–World War I Germany, with the tragic, Expressionistic prints of Käthe Kollwitz; in Mexico, with the revolutionary output of Siqueiros and Orozco; and in the United States, with the lithographic works of the Depression, when the government subsidized artists in order to combat unemployment. Prints by George Bellows and other Social Realists now take pride of place in the folders of collectors and the writings of modern art historians. Even in 1968, the *ateliers populaires* producing the black-and-red posters that festooned the walls of Paris resorted to lithography as being a less costly means of reproduction for small printing runs than offset (the more mechanized process derived from lithography, which has taken over its utilitarian functions). The character of lithography has therefore changed, yet behind every modern lithographic print there still lurks an aftertaste that smacks slightly of bourgeois vulgarity or authentic popularism —and it is this quality that has proved throughout history to be both lithography's virtue and its vice.

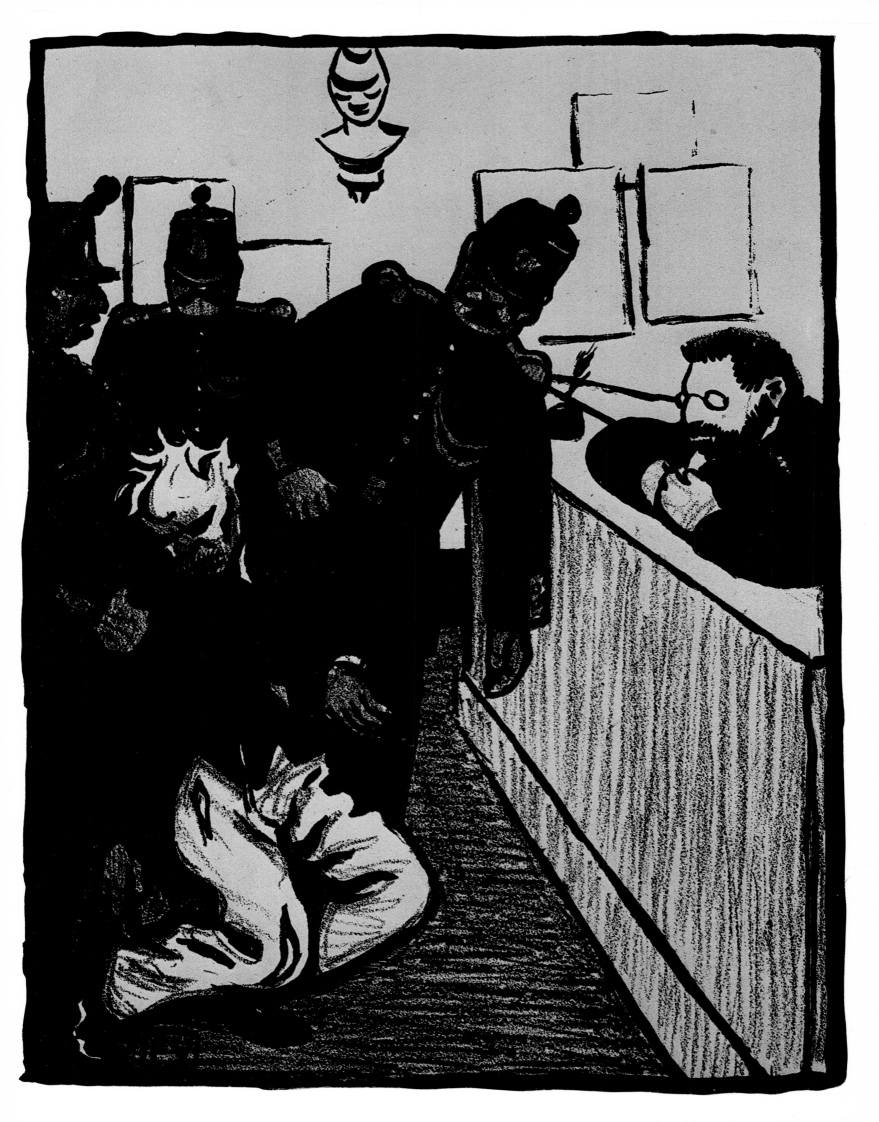

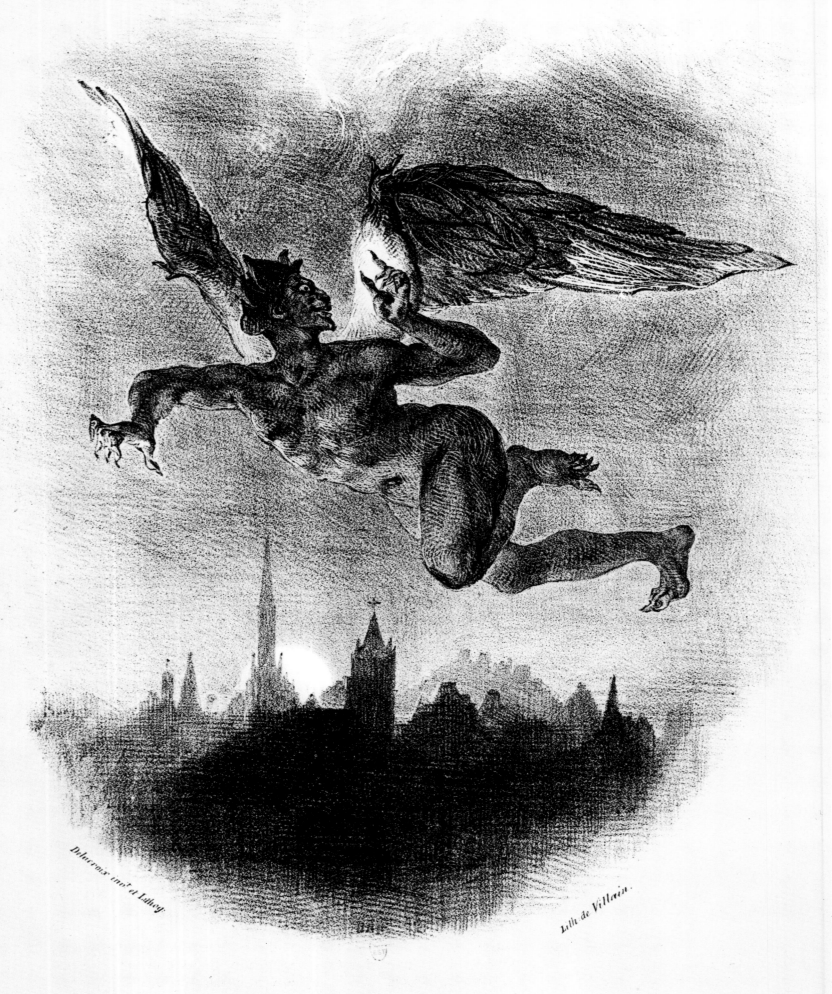

Delacroix inv^t et Lithog.

Lith. de Villain.

............De temps en temps j'aime à voir le vieux Père,
Et je me garde bien de lui rompre en visière............

THE ILLUSTRATED BOOK

by Jacqueline Armingeat

*Of all the graphic means of accompanying
a text, lithography is perhaps the one which
is best suited to poetry.*

Paul Valéry

When lithography first appeared at the beginning of the nineteenth century, books were in the throes of a profound transformation. Within a few years they were to undergo an unprecedented process of renewal, as all the necessary preconditions of this revolution—technical, literary, and social—came together at the same time.

Immense technical advances were radically to alter the manufacture of books: the appearance of the steam-driven, mechanical press (a little before 1830), which replaced the old manual type; the invention of new machines for the "continuous" manufacture of paper; the renewal of typography by Pierre Didot; and the creation of the first factories devoted to making ink.

A prodigious rise in literary activity was another feature of this period. An insatiable appetite for reading matter swept through every country: reading rooms sprang up everywhere, as did the bookshops that were gradually to replace them.

It was also at this time that new illustration processes began to emerge, such as cross-grain engraving (invented by the Englishman Thomas Bewick) and lithography, which were to end up by transforming the appearance of books. More and more emphasis began to be placed on the pictures that the public demanded.

Lithography very quickly developed at a phenomenal rate, but, despite its importance in the history of engraving, during the nineteenth century it was of only limited importance in the world of books, where cross-grain engraving and steel engraving reigned supreme. And yet it soon grew out of the secondary role attributed to it by its inventor, which was that of a quick, cheap, and easy means of multiple reproduction and became one of the means of expression most favored by artists. Unlike other engraving processes, lithography demands no special skill apart from that of drawing; in the words of Félix Bracquemond, "it offers its potential to anyone who knows how to hold a pencil." Because it requires neither an apprenticeship in the craft of engraving nor the intervention of an engraver between the illustrator and the reader, as is the case with wood or copper engraving, lithography allows the artist to express himself directly, with a great deal of freedom and spontaneity. This is how nineteenth-century lithography came to produce certain masterpieces of illustration that formed the basis of the twentieth-century concept of the *livre d'artiste.*

Opposite: Eugène Delacroix, *Mephisto-pheles in the Air,* a lithograph for Goethe's *Faust,* 1828

223

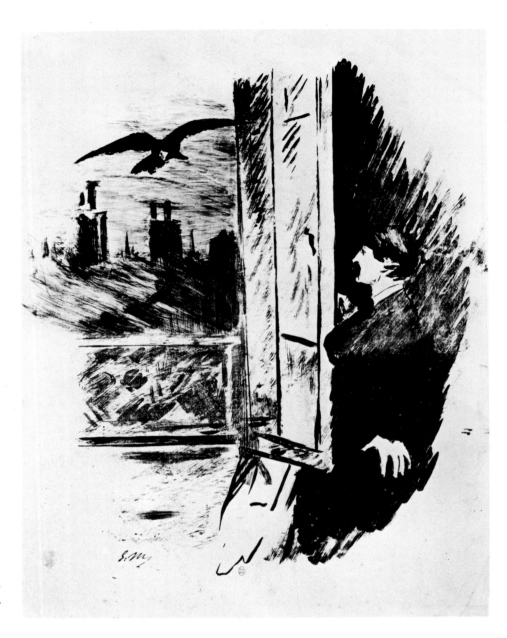

Edouard Manet, *At the Window*, a lithograph for Edgar Allan Poe's *The Raven*, 1875

THE NINETEENTH CENTURY

Although lithography was invented by a German, it was rarely used in that country as a means of illustrating books in color, except in the case of children's books. Besides, in his *Complete Course of Lithography*, published in English in 1819, Senefelder insists on its role as a means of reproduction. Yet mention should be made of the very fine lithographs drawn for several books by the painter Adolf von Menzel, whose hand-colored prints for the three volumes of the *Uniforms of the Army of Frederick the Great* are still famous today.

England was the first country to use lithography in a book, in J. T. Smith's *Antiquities of Westminster*, which first appeared in 1807. This was followed by books of landscapes, views of London, birds (the hand-colored lithographs of Gould), and, in particular, railways. However, these publications were collections of lithographs accompanied by a text—in fact, albums rather than true books. Cross-grain engraving predominated in England up until the end of the century, both in books and in two magazines that appeared between 1835 and 1842, *Punch* and the *Illustrated London News*.

Although France had been less quick than England to adopt the new technique of lithography for books, it was in France that it found its finest

Edouard Goerg, lithograph for *Les Fleurs du mal* by Charles Baudelaire, Plate I, 1947 and 1952

expression, in a number of remarkable works. Among the numerous albums of lithographs that appeared even before 1820 as collections portraying different subjects—pictorial ''cocktails'' that became a craze among the public—the most widespread genre was the landscape album, the *voyage pittoresque*. The most important of these publications, and justifiably the most famous, was the *Voyages pittoresques et romantiques dans l'ancienne France*, published by Taylor and Nodier in twenty-five volumes between 1820 and 1878. An exceptional record of nineteenth-century France, it is the greatest compendium ever published of lithographs dedicated to views of towns, Gothic monuments, châteaux, and landscapes. It comprises more than 2,700 prints, including major contributions by both French and non-French artists such as Bonington, Isabey, Boys, and Nanteuil (who provided some very Romantically inspired settings). Quicker than engraving on copper, more precise, and lending itself to large printing runs, lithography proved to be the ideal process for this purpose. The interest that these charming and poetic compositions has excited among art historians is matched by the fascination they hold for modern-day archaeologists, since a number of the monuments portrayed have since disappeared. It was, in fact, one of the aims of the authors to preserve their memory.

Aristide Maillol, lithograph for Ovid's *Ars Amatoria*, 1935

Painters were beguiled by the ease of execution and the freedom that lithography offered them. Delacroix was the first to use it for illustrating books, in an edition of Goethe's *Faust* (1828) that is one of the most beautiful books of the Romantic era and also a milestone in the history of book illustration, being the first *livre de peintre.*

Delacroix, who had seen the play during a stay in London some years earlier, was quite taken by it, and the memory of the performance continually haunted his imagination. He put all his genius into a series of eighteen lithographs of passionate Romanticism, creating a superb and tragic interplay of black and white and revealing an extraordinary sense of drama. Certain of the theatrical effects presage the revolution in the French theater that was to be unleashed by *Hernani* in 1830. ''It is the graphic manifesto of the new school, just as Victor Hugo's preface to *Cromwell* is its literary manifesto'' (H.-J. Martin, *Histoire du livre*, 1964).

Goethe was very happy with the results: ''Mr Delacroix has a great talent, which in *Faust* has found ideal sustenance. . . . He has surpassed the mental images that I had formed of the scenes written by myself. . . . It is very curious that the spirit of an artist should have found such pleasure in

this obscure work and should have assimilated so well all the darkness contained in the original idea, and that he has been able to outline the main scenes with a pencil as tortured as the hero's destiny'' (*Conversations with Eckermann*).

And yet the book was a failure with the public, who were incapable of grasping the beauty and power of the work. Baudelaire admired it without reservation, believing it to be one of Delacroix's greatest achievements.

After *Faust*, one must wait almost half a century before encountering another example of a writer and lithographer collaborating. The other great names of nineteenth-century lithography, including Daumier, Gavarni, Traviès, and Devéria, did not illustrate books. Their prints appeared individually or in newspapers like *Le Charivari, La Caricature, Le Journal Amusant*. Their works were sometimes gathered together into collections (particularly the caricatures), but these cannot properly be called books, even when the captions are very long, as in Daumier's *Les Cent un Robert Macaire*. And although certain of these artists did illustrate texts, they did not use lithography for that purpose. The drawings of Tony Johannot, whose work as an illustrator dominated the Romantic era in France, were engraved mainly on steel, while the great majority of Gustave Doré's illustrations were engraved on wood.

An event of great importance was to alter radically the face of book illustration in the mid-nineteenth century: the triumphal advent of photography, with its attendant techniques of photomechanical reproduction, which began to emerge between 1870 and 1885. Baudelaire expressed disquiet at his contemporaries' infatuation with the idea that ''art means photography,'' and he clearly sensed the dangers of such a misconception: ''The poor application of the advances made by photography has contributed greatly to the impoverishment of French artistic genius.'' He recognized that it clearly had an important role to play, ''but if it is allowed to trespass into the domain of the impalpable and the imaginary, into that which has value solely by virtue of the amount of his soul that a man puts into it, then woe betide us!'' (*Salon de 1859*, reprinted in *Curiosités esthétiques*).

The influence of photography on lithography, although at first baleful, finally turned out to be beneficial. Since the exactitude of photography made the documentary role of lithography redundant, lithography was obliged to branch out in different directions and find new expressive possibilities. And it found these new opportunities in the artistic field, with all the concomitant benefits we can appreciate today.

The first painter after Delacroix to interest himself in lithography as a means of illustrating books was Manet. In 1875, for Mallarmé's translation of Edgar Allan Poe's *The Raven*, Manet drew five lithographs in which he exploited with consummate skill all the black-and-white possibilities offered by the medium, using them to interpret a mysterious and sometimes spectacular interplay of light and shade.

During the second half of the century, after several isolated attempts at color lithography from 1837 on, lithography was once again eclipsed in the field of book illustrations, but chromolithography enjoyed a considerable triumph. Its application, by means of a photomechanical process, to everyday books gave these books a more lively and attractive appearance. However, this revolutionary introduction of color into lithography did not affect ''fine'' books until the twentieth century.

During the closing years of the nineteenth century, there was a revival of lithography as a means of illustrating books that has lasted, almost with-

out interruption, until the present day. John Grand-Carteret acknowledged the start of the process in 1893: "It can be said that a whole school is being formed to combat objective sterility, and that is why lithography will find itself summoned to a future in book illustration" (*Le Livre et l'image*). This renewal in the art of the illustrated book began with the Nabis, who used lithography as well as woodcuts. In 1893, André Gide asked Maurice Denis, whose work he greatly admired, to illustrate *Le Voyage d'Urien*. In his wish to establish a true spirit of collaboration with the artist and to make his book a "common word," Gide completely transformed the writer-illustrator relationship, bringing "a new contribution to the art of the book." On his part, Denis, in the twenty-nine lithographs he executed, strove to free illustration from an overly literary interpretation.

A few years later, Odilon Redon took on the role of illustrator, also in the same spirit. In 1896, the painter for whom "black is the essential color" drew twenty-four dreamlike compositions for Flaubert's *La Tentation de Saint Antoine* that excited the admiration of Huysmans: "He seems to have thought of that aphorism of Poe's which says that all certainty lies in dreams." For a variety of reasons, however, the book was not published until 1938. At the very end of the century, Toulouse-Lautrec made his contribution to book illustration. At the request of his friend the publisher Fleury, he drew ten black-and-white lithographs for a collection of articles by Georges Clemenceau, which appeared in 1898 under the title of *Au pied du Sinaï*, and the following year he completed twenty-three lithographs for Renard's *Histoires naturelles*. Here, Lautrec, who had always been fond of animals, revealed astonishing powers of observation and portrayed them with masterly skill and great economy of means. "He competed with the writer in brevity and equaled him." But Lautrec reproached Renard for having dealt only with well-known animals: "There's more to it than just donkeys, dogs, horses, and cocks," a fact that he proved elsewhere, notably with his fine drawings of cormorants. The book, however, was a commercial failure: it sold badly, and the publisher ended up by remaindering the copies that had stayed too long in stock and were thus priced too high for the current market.

During the nineteenth century, the other European countries generally followed France's example. In Spain, lithography was officially launched in 1826 with the *Colección litográfica* of reproductions of paintings in the Prado, published under the patronage of Ferdinand VII. But is it possible to regard as Spanish the edition of *Don Quijote* published in Madrid in 1853, which had lithographic illustrations by the Frenchman Célestin-François Nanteuil?

As for the illustrated books of the Swiss author Rodolphe Toepffer, published during the 1830s and 1840s (*Les Amours de M. Vieuxbois, Histoire de M. Crépin*), which take the form of "strip cartoons" lithographed by their author, should they not be regarded as being albums rather than illustrated books?

In Italy, where the influence of Bodoni was still strong, more care was given in books to typography than to illustration, and, in any case, lithography was rarely used.

In Holland, a notable figure was Theodoor van Hoytema, an illustrator of children's books whose color lithographs for Hans Christian Andersen's *Fairy Tales* (1893, 1898) were executed in a completely new and original style. They were to have a profound influence on the illustration of children's books in other countries and anticipated by more than thirty years the famous collection of *Père Castor*.

Illustration in America during the nineteenth century derived primarily from Europe, but lithography was rarely used. The middle of the century saw the birth of numerous illustrated magazines, to which artists devoted much more time than to books, but the main feature of American graphics was the degree of perfection achieved by photomechanical methods of reproduction.

THE TWENTIETH CENTURY

The French *livre de peintre* or *livre d'artiste* occupies a unique place in twentieth-century art. Since the majority of great painters and sculptors contributed to the genre, it reflected the way in which the different artistic movements evolved; it also established itself as an art form in its own right, allowing artists to find a new means of expression that often represented an important part of their oeuvre. "I make no distinction between the construction of a book and of a picture," said Matisse. One of the dominant features of this century is the close relationship between art and literature, with a great feeling of empathy and friendship often linking writers and poets with artists. It is these personal links, during a period marked by large-scale experimentation in new art forms, that was to give rise to a number of true masterpieces.

No longer is such artistic work merely textual "illustration," in the narrowest sense of the term, but rather it is a new "creation." Artists working in the field of the figurative arts "discover a new sense in the work on which they are collaborating, enriching it with their own substance" (Raymonde Hesse, *Le Livre d'artiste du XIX^e siècle à nos jours*, 1927). The artist's intervention in a literary work becomes an act of creativity in its own right.

Book illustration is breaking new ground: often rejecting the figurative and the descriptive and ceasing to be merely a visual commentary on the text, it is striving to speak a new language, to provide a "graphic equivalent" of the written word. How else could one illustrate a poem? As the contemporary poet Jean Lescure so neatly expresses it: "It has to be agreed that a good illustrator does not illustrate. He neither comments nor explains. He throws no light on any darkness, if there is any. And there certainly is. He should make it even more enigmatic. For it is of this enigma that he is the accomplice . . ." (*Images d'images*, 1964). From the encounter between two artists, a subtle "correspondence" is established.

Although every sort of engraving technique has been used for illustration work, lithography, because of the variety and wealth of its expressive possibilities, occupies a very important position, particularly since the 1920s. Its real triumph has occurred since World War II, to such an extent, in fact, that we have been forced to select only certain books for mention, since it would be impossible to refer to all the titles in which lithography appears.

The beginning of the twentieth century was marked in Paris by the activities of two publishers of extraordinary genius: Ambroise Vollard and Daniel-Henry Kahnweiler. By asking Bonnard to illustrate Verlaine's *Parallèlement*, Vollard established himself in 1900 as an innovator of decisive importance. As François Chapon remarks, "to these publisher-dealers must go the honor of having understood that in the nineteenth century the evolution of painting did not take place independently of literature, and of having allowed these two means of expression to appear in unison so as to effect a closer contact, almost a union. Ambroise Vollard quite rightly remains famous for

ÉTÉ.

Et l'enfant répondit, pâmée
Sous la fourmillantè careſſe
De sa pantelante maîtreſſe :
« Je me meurs, ô ma bien-aimée !

« Je me meurs : ta gorge enflammée
Et lourde me soûle & m'oppreſſe ;
Ta forte chair d'où sort l'ivreſſe
Eſt étrangement parfumée ;

17

having been the pioneer of this alliance, and for having succeeded, right from his first attempt, in producing a masterpiece: *Parallèlement*'' (*Gazette des Beaux Arts*, July-August 1979). Bonnard's 109 lithographs, which Cezanne admired, were married to the text in accordance with a new and original system of layout, with the maximum of freedom. This ''miracle of harmony, in which the visions of the poet and the painter overlap'' lies at the basis of all contemporary *livres d'artiste*.

The book was not a success at the time, any more than *Daphnis et Chloé*, published by Vollard two years later with 151 lithographs by Bonnard that were more classical in their inspiration and took the form of bucolic scenes of ''wonderful freshness.'' Yet this double disaster did not deter Vollard from his chosen course. He subsequently completed twenty-six similar undertakings during his own lifetime, with the collaboration of such artists as Redon, Denis, Picasso, Dufy, Maillol, Braque, Léger, Chagall. And a further twenty-four, which were in the process of preparation when he died, were completed later, most notably by the publisher Tériade.

For his part, Kahnweiler, who sponsored young painters like Picasso, Gris, Braque, and Derain, produced thirty-six *livres d'artiste* with their collaboration over a period of fifty years.

The importance of such publishers as Skira, Maeght, and Tériade in determining the ''architecture'' of the *livre d'artiste* during the twentieth century cannot be stressed enough. As Antoine Coron observes in the catalogue of the exhibition *Le Livre et l'artiste, 1967–1976*, held in the

CALLIGRAMMES

Voici de quoi est fait le chant symphonique de l'amour
Il y a le chant de l'amour de jadis
Le bruit des baisers éperdus des amants illustres
Les cris d'amour des mortelles violées par les dieux

213

Above, left: Giorgio De Chirico, lithograph for *Calligrammes* by Guillaume Apollinaire, 1930; right: Juan Gris, lithograph for *Denise* by Raymond Radiguet, 1926

Bibliothèque Nationale in Paris, "it is symptomatic that three of the greatest publishers in past years—Iliazd, Pierre Lecuire, Pierre-André Benoit—should have also been poets, like Guy Lévis Mano."

Although every artistic movement has to a certain degree contributed to book illustration, it should be pointed out that during the first two decades of the century artists tended to favor wood engravings. But it was lithographs that the Cubist painter Juan Gris drew to illustrate the texts of Max Jacob (*Ne coupez pas, Mademoiselle*, 1921), Salacrou (*Le Casseur d'assiettes*, 1924), Gertrude Stein (*A Book Concluding with As a Wife Has a Cow*, her first book published in France, 1926), and Radiguet (*Denise*, 1926). The end of the twenties, the *années folles* of the postwar period, was marked by the advent of Surrealism, one of whose pioneers, Giorgio De Chirico, succeeded in achieving a marvelous sense of spiritual empathy with the poet Guillaume Apollinaire in the sixty-nine lithographs that he drew for the latter's *Calligrammes* in 1930.

The first book illustrations by Miró, also lithographs, were executed for *L'Arbre des voyageurs* (1939) by Tristan Tzara, the favorite poet of the Surrealists and the Cubists. The lithographs that Miró drew for another work by the same poet (*Parler seul*, 1950) represent one of his most successful undertakings.

André Masson similarly chose lithography for his interpretation of a Surrealist poem by Michel Leiris (*Glossaire j'y serre mes gloses*, 1939).

It was not long before two other great figures of Surrealism embarked on lithographic illustration. In a 1957 edition of *Don Quijote*, Salvador Dalí gave full rein to his talents as an illustrator in fifteen color lithographs. Max Ernst, who attempted and invented so many processes and whose influence made its mark on two generations of artists, created eleven lithographs for a collection of poems by René Char (*Dent prompte*, 1969), nineteen for Patrick Waldberg's *Aux petits agneaux* (1971), and twelve for *Festin*, written by himself and P. Hebey (1974).

Already suspicious of lithography, bibliophile societies became frightened by the daring of young artists. They often contented themselves with the work of minor artists, placing more emphasis on the quality of paper and typography and on limited editions. "We still respect the rules. Painters are not illustrators," protested one member of the Cent Bibliophiles in a remark reported by Vollard in his memoirs.

It was lithography, once again, which was chosen by Vlaminck (*Le Diable au corps; Tournant dangereux*, with a text by the artist, 1930), by Roger de la Fresnaye (*Paludes* by André Gide, 1921), by Luc-Albert Moreau (*La Naissance du jour* by Colette, 1924, "one of the most beautiful books that we owe to lithography since Bonnard"; works by Francis Carco; *La Physiologie de la boxe* by E. des Courières and Henri de Montherlant, 1929, which contained sixty powerful, classically drawn lithographs), by Dufy (*Le Poète assassiné* by Apollinaire, 1926), by Robert Delaunay (*Allo, Paris!* by J. Delteil), by Rouault (*Souvenirs intimes*), and by Picasso (*Lysistrata* by Aristophanes, 1926).

Certain sculptors also contributed to book illustration: Despiau created forty-three lithographs for a selection of poetry by Baudelaire (extracts from *Les Fleurs du mal*, 1933), while Maillol produced twelve superb "sculptural lithographs" for Ovid's *Ars Amatoria* (1935).

In the many *livres d'artiste* that appeared during the exhilarating enthusiasm of the post–World War II period, lithography was the means of expression favored by artists as diverse as Atlan (*Description of a Struggle* by Kafka), Dubuffet (*Matière et mémoire* by Francis Ponge), Matisse (the anonymous *Lettres de la religieuse portugaise*), André Marchand (*Les Nourritures terrestres* by Gide), Van Dongen (*Les Lépreuses* by Henri de Montherlant), Lurçat (*Le Bestiaire fantastique*), and Clavé, who displayed enormous talent in illustrating *Carmen* (in color) and *Candide* (in black and white). By 1948 color lithography had triumphed, and in the same year a highly original work by Picasso appeared. This master artist, who had already experimented with every method of book illustration, turned to lithography for Pierre Reverdy's *Le Chant des morts*. Freeing himself totally from tradition and convention, "Picasso reinvents book illustration. Make no mistake: he is not content just to limit himself to adapting his pictorial language to the space provided by the book, but radically renews the relationship between the text and the image." With Reverdy's calligraphic poems, he "now intervened not in the margin, but in the very body of that litany . . . he in fact enriches the poem with new meanings. . . . This intervention represented an important departure in his work: he was now discovering action painting" (*Hommage à Tériade*, 1973).

Other lithographed "manuscript" books appeared later; *Cirque* (1950), composed entirely by Fernand Léger, both in its text and its illustrations, is one of the best-known examples. Text and illustration are similarly indivisible in the book created wholly by Le Corbusier: *Poème de l'angle droit* (1955), "the work of a painter and visionary poet—in the way that Leonardo da Vinci sometimes is—and not an architectural treatise at all" (*Hommage à Tériade*). Matisse designed both text and illustrations for the poems of

Luc-Albert Moreau, lithograph for *Physiologie de la boxe* by E. Des Courières and Henri de Montherlant, 1929

Charles d'Orléans (1950), as did Manessier for Péguy's *Présentation de la Beauce à N.-D. de Chartres* (1964).

This rich and diverse century has also produced other masterpieces, such as Emile-Othon Friesz's forty lithographs for *Satyricon* and Léger's illustrations for Rimbaud's *Illuminations*. Dubuffet asserted his originality in two works: *La Métromanie* by Jean Paulhan, a manuscript book in which text and lithographic imagery are closely intermingled, and *Les Murs* by Guillevic, where all the characteristics of Art Brut can be seen. Jacques Villon, in the meantime, translated Vergil's *Bucolics* into colored compositions constructed in the same way as his paintings.

A most imaginative use of lithography is displayed by Edouard Goerg, who, using an Expressionist style, brought his full talent to bear on the illustration of *Les Fleurs du mal*, revealing a sensitivity very much in harmony with that shown by Baudelaire. And mention should also be made of the ''sculptural'' lithographs of Henry Moore, especially the fantastical figures that illustrate Goethe's *Prometheus* (1951).

Thanks to artists such as Lurçat, Derain, Beaudin, Carzou, Aizpiri, Minaux, Tamayo, Manessier, Léonor Fini, Singier, Bram van Velde, Topor, and others, lithography in books has retained all its vitality and quality,

and it has been assisted in this by the numerous technical innovations that have recently emerged. It was color lithography that Chagall chose when asked by Tériade to illustrate *Daphnis et Chloé* in 1961 (he paid two visits to Greece before executing this book, in which "color and light attain their greatest perfection"); he also chose color for *Cirque* (1967), "the most personal of all his books, and also the most exceptional, by virtue of its intensity of line and color, but also by virtue of the harmony that he creates between text and painting" (*Hommage à Tériade*). Manessier (*Les Cantiques spirituels de St.-Jean de la Croix*, 1959) and Zao Wou-ki (*La Tentation de l'occident* by Malraux, 1962) similarly employed color to provide a "graphic equivalent" of the text.

"Oh, the longing to make pictures of Paris all over the place!" exclaimed Giacometti. "The only possibility of that lies in the lithographic pencil, not in painting or in drawing: that pencil provides the only means of acting quickly, the impossibility of turning back, of cancelling, erasing, starting over again." The result: *Paris sans fin* (1969), which is still undeniably Giacometti's most important book.

We cannot ignore the violent and explosive collaboration between Miró and Alfred Jarry, when the former, after having illustrated *Ubu roi* (1966), imagined a new adventure for the character (*Ubu aux Baléares*, 1971) and gave full vent to his genius in twenty-three color lithographs, which he accompanied with a frenzied, Surrealistic preface.

Although the *livre d'artiste* developed to such an extraordinary degree in France that it has become intimately associated with that country, it was by no means unknown elsewhere. During the twentieth century, Italian illustration freed itself from the outside influences it had been sub-

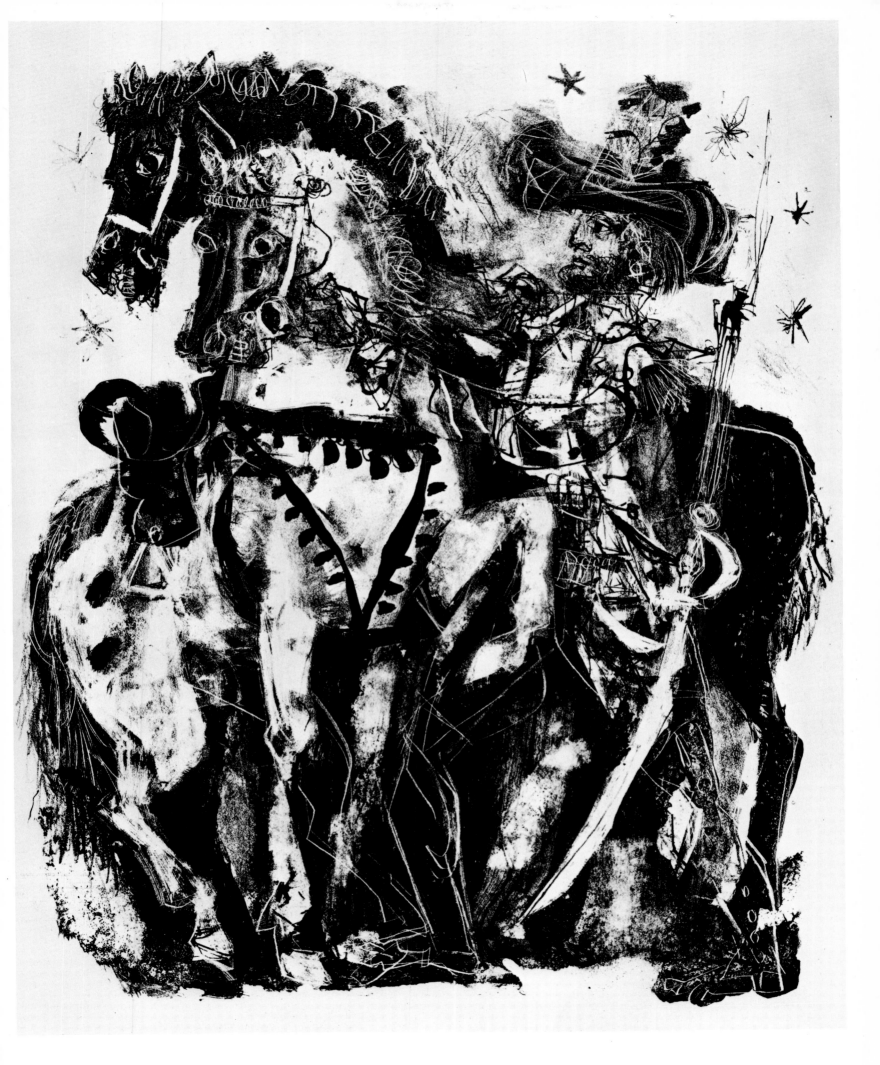

jected to during the preceding century. Giovanni Mardersteig, who ran the Bodoni press in Verona, played a fundamental part in the development of art printing in Italy. In addition to ordinary books, he also published limited-edition texts carefully selected by himself. Lithography was one of his favorite methods of illustration: among his best works are the *Carmina* of Catullus (1945), illustrated by Filippo de Pisis, and the *Epistulae* of Ovid (1953), illustrated by Luigi Castiglioni. Vagnetti executed some fine lithographs for Aldo Palazzeschi's *Stampe dell'800* that were colored by hand, and Fabrizio Clerici also designed lithographs: for Leoncillo Leonardi's *Bestiario* (1941) and Giambattista Marino's *Paris 1615* (1952). Other highly original lithographs were executed by Massimo Campigli for Raffaele Carrieri's *Lamento del gabelliere* (1957) and by Carlo Leoni for Franco Fortini's *La poesia della rose* (1962).

In England, artwork for books was more usually provided by illustrators than by painters, and at the beginning of the century they favored wood engraving over almost any other technique. The only exception was the magnificent and prolific output of children's books, which were lithographically illustrated and were a speciality of the English as well as the Americans. However, several British artists did show themselves to be brilliant lithographic illustrators of books: Barnett Freedman, for example, used the technique to illustrate Siegfried Sassoon's *Memoirs of an Infantry Officer* (1931) and Tolstoy's *War and Peace* (1938), and Edward Ardizzone gained considerable fame for his series of children's books entitled *Tim*, which began in 1936. Also noteworthy are the lithographs (printed in France by Mourlot) by the sculptor Jacob Epstein for *Les Fleurs du mal*, Anthony Gross's color work for Galsworthy's *Forsyte Saga* (1950), Lynton Lamb's superb illustrations for George Eliot's *Silas Marner* (1953), and the vigorous, highly imaginative lithographs drawn by Keith Vaughan for Rimbaud's *Une Saison en enfer* (1949).

In the United States, illustrators worked primarily for magazines, with books taking second place. Photogravure and photomechanical processes developed at a much greater rate in America than in any other country, and photographic reproduction, which was used in countless books, achieved a high degree of perfection. "Deluxe editions," however, remained almost unknown in the United States. The techniques most frequently used for illustration were wood or copper engraving and aquatint, but Fritz Eichenberg, a German artist who had settled in America in 1933, drew some fine lithographs for an edition of *The Brothers Karamazov* (1949). Walasse Ting assembled a number of artists from different schools to illustrate a collection of his poetry entitled *1¢ Life*, which appeared in 1964 with sixty-two lithographs by such artists as Andy Warhol, Claes Oldenburg, Jim Dine, and Roy Lichtenstein. It was the first attempt at using Pop Art as a means of illustration.

A variety of different trends can be detected in German illustrated books at the beginning of the century, reflecting the influence of a number of very different artists, both German and English, combined with that of the Jugendstil movement, the German equivalent of Art Nouveau and the precursor of Abstractionism. Three great painters, often called German Impressionists despite the fact that they had little in common with French Impressionism, placed lithography a close second to painting as their favorite means of illustration: Max Liebermann in Heinrich von Kleist's *Kleine Schriften* (1917); Max Slevogt, a highly original artist with extraordinary powers of imagination, "who restored the art of book illustration to its place of honor," in a 1908 edition of *Sinbad the Sailor* (in which he drew the illustrations on the same page as the text, a practice that became cur-

rent in Germany during the period) and, above all, in a 1917 edition of Goethe's *Faust* (containing 510 lithographs in pen and wax pencil); and Lovis Corinth, a painter of visionary inspiration who also devoted a great deal of his time to the illustration of books.

The Expressionist painter Oskar Kokoschka similarly discovered in lithography a further means of expression, using it with great freedom in works such as *Die Chinesische Mauer* by Karl Kraus (1914) and *Der gefesselte Kolumbus* (1913), and the lithographs he drew for his play *Hiob* (1927) are also justly famous.

Lithography still occupies an important place in the *livres d'artiste* that continue to appear each year, with no lessening of either originality or quality. Yet it should be emphasized that this quality stems from the fact that the production of such books remains a true craft.

Nowadays, the *livre d'artiste* enjoys considerable popularity among the general public, as is shown by the increasing number of exhibitions that have been held in recent years: *Hommage à Tériade* in the Grand Palais in Paris (1973), *La Rencontre Iliazd-Picasso* in the Musée d'Art Moderne de la Ville de Paris (1976), as well as exhibitions of *livres d'artiste* in the Boston Museum of Fine Arts (1961), the Bibliothèque Nationale in Paris (1977), the Museum of Modern Art in New York (1981), and the Canadian National Gallery in Ottawa (1981).

How right Grand-Carteret was when he ''prophesied'' in 1893 (*Le Livre et l'image*): '' It can be safely said that the twentieth century will see the realization of that great revolution of which we are seeing the first seeds: Imagery, the language of graphics, walking side by side with Writing, the language of literature.''

Jacqueline Armingeat, a contributor to the Gazette des Beaux-Arts, *is an authority on iconography and has also written essays on Daumier.*

LA LITHOGRAPHIE
fut decouverte en Bavière par Al: Senefelder
en 1796,
Elle fut importée en France
par Ant: André en 1800.

Dessin dans le genre Etrusque.

THE DISCOVERY OF THE LITHOGRAPHIC STONE

FROM THE COMPLETE
COURSE OF LITHOGRAPHY
by Aloys Senefelder

Had I been allowed to follow my own inclinations, I should certainly have embraced the profession of my father, Peter Sennefelder [*sic*], who was one of the performers of the Theatre Royal at Munich. This, however, being contrary to my father's wishes, I devoted myself to the study of jurisprudence at the University of Ingolstadt; and had no other opportunity of indulging my predilections for the stage, than by occasionally performing at small private theatres, and by employing my leisure in some trifling dramatical productions.

It was in this way that I wrote the little comedy, *Die Miedchenkenner*, in the year 1789, which was received by my numerous friends with such applause, that I was induced to send it to the press; and I had the good fortune to clear fifty florins after defraying the expenses of the printing.

Soon after this I had the misfortune to lose my father, and, as my reduced circumstances did not allow me to continue my academical studies, I could no longer withstand the desire to devote myself entirely to the dramatic art, as performer and author; for the success of my first essay had inspired me with the most sanguine hopes. Having, however, for the space of two years, suffered a great deal of misery and disappointment at several theatres, at Ratisbon, Erlangen, and other places, my enthusiasm cooled to such a degree, that I resolved to forsake this unpromising profession, and to try my fortune as an author.

But even in this plan I was not very successful, and the very first attempt I made to publish another of my dramatic productions entirely failed, as the piece could not be got ready for the Easter Book-fair at Leipzig: it therefore produced scarcely enough to pay the expenses I had incurred. In order to accelerate the publication of this work, I had passed more than one whole day in the printing-office, and had made myself acquainted with all the particulars of the process of printing. I thought it so easy, that I wished for nothing more than to possess a small printing press, and thus to be the composer, printer, and publisher of my own productions. Had I then possessed sufficient means to gratify this wish, I should never, perhaps, have been the inventor of the Lithographic art; but as this was not the case, I was obliged to turn to other projects.

My first idea was to engrave letters in steel, stamp these matrices in forms of hard wood, and thus form a sort of stereotype composition, from which impressions could have been taken in the same manner as

Opposite: A plate from the examples of drawings and prints published by Senefelder in 1819 to illustrate the practical application of lithography. The plate exemplifies the style known as *étrusque*, which is clearly of Neoclassical inspiration. These examples served to illustrate the adaptability of the lithographic system of printing and the numerous possibilities it offered, on both the commercial and the artistic level.

from a wooden block. But I was compelled to relinquish this plan, for want of proper tools, and sufficient skill in engraving in steel; but it is my intention to submit this idea, with the subsequent improvements, to the public, on another occasion.

The next plan that occurred to me was, to compose one page of letter-press, in common printing characters, to make a cast of this composition in a soft matter, and, by taking another cast from this cast, to obtain a sort of stereotype frame. This experiment did not wholly disappoint my expectations. I composed a sort of paste, of clay, fine sand, flour, and pulverized charcoal, which, mixed with a little water, and kneaded as stiff as possible, gave a very good impression of the types; and, in a quarter of an hour, became so hard, that I could take a perfect cast from it in melted sealing-wax, by means of a hand-press. I afterwards applied the printer's ink to this stereotyped block, in the usual manner, and thus obtained a perfectly clear impression from it. By mixing a small quantity of pulverized plaster of Paris with the sealing wax, the composition became much harder than the common type-metal of lead and antimony; and, to my invention of thus forming a sort of stereotype tables, nothing was wanting but a few preparatory improvements, and a small stock of types; but even this was too much for my limited finances, and I was therefore obliged to abandon this plan, which I did the more readily, as I just then chanced to hit upon another, still more easy in its execution.

This was no other than to learn to imitate the printed characters, very closely, in an inverted sense; to write these with an elastic steel pen on a copper-plate, covered with etching ground, to bite them in, and thus to take impressions from them. By practice I soon acquired some skill in this mode of writing, and began to make a trial of it. The greatest difficulty that I met with here, was how to correct the mistakes I occasionally made in writing; for I was then utterly unacquainted with the common *covering varnish* of the engravers. I, therefore, tried to cover the faulty places with melted wax; but the cover I thus obtained was generally so thick, that I could not well work through it. I now called to my assistance the little knowledge of chemistry I had obtained at school; I well remembered that most of the resins, that withstand aqua-fortis, are dissoluble in aether, spirit of wine, or alcali. I tried many experiments with these, but all in vain; I then contrived a mixture of turpentine and wax, but this likewise did not answer any purpose, as I probably made it too thin. Fortunately I did not try more experiments with these substances, for, if I had pursued them, I might never have hit on the invention of the lithographic art. At present I know very well how to prepare a covering varnish, perfectly *fit* for this purpose, with turpentine, wax and mastic. Another experiment with wax and soap, was at last perfectly successful. A composition of three parts of wax, with one part of common soap, melted together over the fire, mixed with a small quantity of lampblack, and dissolved in rain-water, produced a black ink, with which I could with great ease correct the faults I accidently made.

Though I had thus overcome my greatest obstacle, yet the want of a sufficient number of copper-plates, the tediousness of grinding and polishing those I had used, and the insufficiency of tin plates, which I tried as a substitute, soon put an end to my experiments in this way.

It was at this period that my attention was accidentally directed to a fine piece of Kellheim stone, which I had purchased for the purpose of grinding my colours. It occurred to me that by covering this plate with

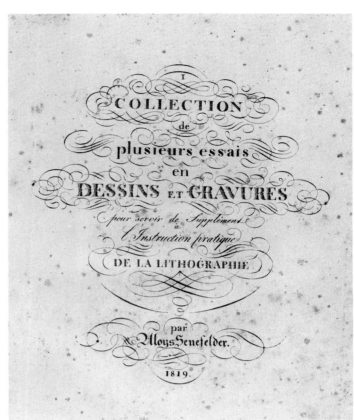

Above, left: A lithographic portrait of Aloys Senefelder, the inventor of lithography; right: The frontispiece of the "essays" assembled by Senefelder in an album of 1819

my composition ink, I could use it as well as the copper or tin plates, for my exercises in writing *backwards*. The little trouble that the grinding and polishing of these plates would cost, were my chief inducement to try this experiment. I had, till then, seen only very thin plates of this stone, and therefore I had no conception that I should be able to use them for taking impressions from them, as they would not resist the pressure necessary for this purpose, without breaking; but in regard to writing, I soon discovered that I could do it better and more distinctly on the stone, than on the copper-plates. Being, soon after this, informed by a stone-mason that he could procure these plates from one to eight inches thick, I began to conceive the possibility of using them likewise for the impressions; but before this could be done, it was absolutely necessary first to discover a method to give a higher polish to the stone, or to prepare a colour that could be better wiped off the stone, than the common printer's ink. For the stone never admits that sort of polish which is requisite for the application of the common ink; and this, I suppose, is the very reason why the stone having, not long before, been used by engravers for etching, as a substitute for copper, (for I am well aware that many similar experiments had already been tried,) the attempt did not succeed, and was soon relinquished.

I tried all possible methods of polishing and grinding the stone, but my success was not such as I could have wished. As to the polishing of the stone, I found it the best way to apply to the smoothly-ground surface of it a composition of four or five parts of water, and one part of rectified oil of vitriol. This liquid produces a sudden effervescence on calcareous stone, which, however, almost instantly ceases, so that we might be tempted to believe the vitriol saturated; but this is not the case, for on the same liquid being applied to another part of the stone yet untouched, it produces a similar effervescence; the reason of this is, that the surface

of the stone is almost instantly covered with a coat of gypsum, which is impenetrable to the vitriol. When this liquid is wiped off, and the stone dried, it acquires, by a slight rubbing of a rag, a most brilliant polish; this, however, is so thin, that it scarcely allows fifty impressions to be taken from it, without a repetition of the above process, which, however, is attended with some injury to the drawing. But if impressions are taken according to the present chemical method, and the stone has been polished before the drawing is made, several thousands of impressions may be obtained, as will be more fully described in another place.

As to the second difficulty, of discovering a colour that could be easily wiped off the stone, I found, after many experiments, that none was better than a light varnish of oil, mixed with purified lampblack, which could be wiped from the stone by means of a weak solution of potash, and common salt, in water; but if this was not done with sufficient care, it sometimes happened that the drawing or writing on the stone was at the same time effaced, and could not be restored without great trouble. The recollection of this fact, which at that time I was unable to explain, led me, some years afterwards, to the invention of the present chemical lithography.

I have been very minute in describing the process of inventing this ink of wax, soap, and lampblack, as it was principally this invention which opened to me the way to the chemical lithography. It so happened, therefore, that I knew the ink, before I even thought of applying it to the stone; in the first instance, I only used the stone for my exercises in writing; the ease with which this was done, (and which, indeed, is far greater than on metal covered with etching ground,) induced me to use the stone for the printing; but, in order to do this, it was requisite to clear the stone as perfectly as the copper-plate printer does his copper-plate, though the stone will not take so high a polish as the latter.

I was trying some farther experiments for this purpose, when a new and accidental discovery prevented me from pursuing this plan.

In all the experiments I have hitherto described, I could not boast of having invented any thing new, as I had been only applying the theory of printing from copper-plates to stone plates, or rather used the latter as a substitute for the former. Had I not gone farther in my discoveries, it is more than probable that, if my circumstances had improved, I should have returned to copper-plates, as the thickness and size of the stones rendered their use by no means more convenient, and as the novelty of the invention would not have encouraged me to follow this new path.

I was firmly convinced that I was not the inventor of the art of etching or engraving on stone, or of taking impressions from stone; I even knew that etching on stone had been practised several centuries before me. But from the moment that I abandoned the *principle of engraving*, and directly applied my new invented ink to the stone, of which I am about to treat more amply, I could consider myself as the inventor of a new art, and from that moment I relinquished all other methods, and devoted myself exclusively to this.

As I come now in my narrative to that period, from which the Art of Lithography may be said to have drawn its direct origin, I hope I may crave the indulgence of the reader, if I mention even the most trifling circumstances, to which the new art was indebted for its existence.

I had just succeeded in my little laboratory in polishing a stone plate, which I intended to cover with etching ground, in order to continue my exercises in writing backwards, when my mother entered the room, and

desired me to write her a bill for the washer-woman, who was waiting for the linen; I happened not to have even the smallest slip of paper at hand, as my little stock of paper had been entirely exhausted by taking proof impressions from the stones; nor was there even a drop of ink in the ink-stand. As the matter would not admit of delay, and we had nobody in the house to send for a supply of the deficient materials, I resolved to write the list with my ink prepared with wax, soap, and lampblack, on the stone which I had just polished, and from which I could copy it at leisure.

Some time after this I was just going to wipe this writing from the stone, when the idea all at once struck me, to try what would be the effect of such a writing with my prepared ink, if I were to bite in the stone with aqua-fortis; and whether, perhaps, it might not be possible to apply the printing ink to it, in the same way as to wood engravings, and so take impressions from it. I immediately hastened to put this idea in execution, surrounded the stone with a border of wax, and covered the surface of the stone, to the height of two inches, with a mixture of one part of aqua-fortis, and ten parts of water, which I left standing five minutes on it; and on examining the effect of this experiment, I found the writing, elevated about a 10th part of a line, (or 1-120th part of an inch.) Some of the finer, and not sufficiently distinct, lines, had suffered in some measure, but the greater part of the letters had not been damaged at all in their breadth, considering their *elevation*; so that I confidently hoped to obtain very clear impressions, chiefly from printed characters, in which there are not many fine strokes.

I now proceeded to apply the printing ink to the stone, for which purpose I first used a common printer's ball; but, after some unsuccessful trials, I found that a thin piece of board, covered with fine cloth, answered the purpose perfectly, and communicated the ink in a more equal manner, than any other material I had before used. My farther trials of this method greatly encouraged my perseverance. The application of the printing ink was easier than in the other methods, and I could take impressions with a fourth part of the power that was requisite for an engraving, so that the stones were not at all liable to the danger of breaking; and, what was of the greatest moment to me, this method of printing was an entirely new invention, which had occurred to nobody before me. I could, therefore, hope to obtain a patent for it, or even some assistance from the government, which, in similar instances, had shown the greatest liberality in encouraging and promoting new inventions, which I thought of less importance.

Thus the new art was invented, and I lost no time in making myself a perfect master of it; but, in order to exercise it so as to gain a livelihood by it, a little capital was indispensable to construct a press, purchase stones, paper, and other utensils. But as I could not afford even this trifling expense, I saw myself again on the point of being obliged to relinquish all my fond hopes and prospects of success, unless I could devise an expedient to obtain the necessary money. At length I hit upon one, which was to enlist as a private in the artillery, as a substitute for a friend of mine, who promised me a premium of 200 florins. This sum I thought would be sufficient to establish my first press, to which I intended to devote all my leisure, and the produce of which, I hoped, would soon enable me to procure my discharge from the army; besides my knowledge of mathematics, mechanics, and fortification, might possibly promote my views in this new career.

I was quickly resolved, and, on the third day after forming my resolution, I went to Ingolstadt, with a party of recruits, to join my regiment. It was not without some feelings of mortification and humbled pride, that I entered this city, in which I had formerly led the independent life of a student; but the consciousness of my own dignity, and enthusiasm for my new invention, greatly contributed to restore my spirits. I slept in the barracks, where I was not a little disgusted by the prevailing filth, and the vulgar jests of a corporal. The next morning I was to enlist; but, to my great disappointment, the commander of the regiment discovered that I was not a native of Bavaria, and therefore, according to a recent order of the Elector, could not serve in the army, without obtaining a special license.

Thus my last hope failed me, and I left Ingolstadt in a state of mind bordering on despair. As I passed the great bridge over the Danube, and looked at the majestic river, in which I had been twice nearly drowned while bathing, I could not suppress the wish that I had not been then saved, as misfortune seemed to persecute me with the utmost rigour, and to deny me even the last prospect of gaining an honest subsistence in the military career.

But though from my earliest years I had been uniformly deluded by hope, I still continued to yield myself up to its allurements, and new projects soon consoled me for my late disappointment; I resolved to give up, for the present, all thoughts of being an author, and to become a journeyman printer.

A page of wretchedly printed music from a prayer-book, which I accidentally met with at a shop at Ingolstadt, suggested to me the idea that my new method of printing would be particularly applicable to music printing; I, therefore, resolved, on my return to Munich, to go directly to Mr. Falter, a publisher of music, to offer him my invention, and beg his assistance. My natural shyness alone prevented me from executing this plan immediately; I had twice passed his door, without having the courage to enter the house, when I accidentally met an acquaintance to whom I had occasionally communicated something of my invention; and, in conversing with him, I learned that Mr. Gleissner, a musician of the Elector's band, was just about to publish some pieces of sacred music. This was most welcome news to me, as Mr. G. was a particular friend of mine.

Without farther delay, I called on Mr. Gleissner, to whom I communicated my new invention, offering him, at the same time, my services for the publication of his music. The specimens of music, and other printing, which I showed him, obtained his and his wife's highest approbation; he admired the neatness and beauty of the impressions, and the great expedition of the printing; and, feeling himself flattered by my confidence, and the preference I gave him, he immediately proposed to undertake the publication of his music on our joint account. I had, in the mean time, procured a common copper-plate printing press, with two cylinders; and, though it was very imperfect, it still enabled me to take neat impressions from the stone plates. Having, therefore, copied the twelve songs, composed by Gleissner, with all possible expedition, on stone, I succeeded in taking, with the assistance of one printer, 120 copies from it. The composing, writing on stone, and printing, had been accomplished in less than a fortnight; and in a short time we sold of these songs to the amount of 100 florins, though the whole expense of stones, paper, and printing, did not exceed 30 florins, which left us a clear profit of 70 florins; and, in the exultation of my hopes, I already saw myself richer than Croesus.

Lithographic prints from the album by Senefelder. They were intended to illustrate, for promotional purposes, the extraordinary versatility of the process, which allowed for the reproduction of all sorts of writing—both old and new—musical scores (particularly popular at the time), designs of every style, and even illuminated manuscripts. The inventor was clearly also concerned with emphasizing the commercial potential of his new process.

Two landscapes: the one above, reproduced by means of etching, and the one below, a lithographic landscape. It can be seen that lithography produces a much softer effect.

Mr. Gleissner succeeded, through his patron Count Torring, in laying a copy of this our first work before the Elector Charles Theodore, from whom we received a present of 100 florins, with the promise of an exclusive privilege. The next work, Duettos for two flutes, by Gleissner, yielded us again a little profit; and an order from the Countess of Hertling, to print 150 copies of Mr. Cannabick's Ode, on the death of Mozart, promised us a still greater profit.

It was about this time that I laid a copy of our first work before the Electoral Academy of Sciences, with a Memoir, in which, after explaining the mode of printing, and other advantages of the new art, I also mentioned the cheapness of the press, which did not cost more than six florins. How much was I, therefore, disappointed, when, instead of seeing my new invention honourably mentioned in the transactions of the Society,

Above: A lithograph created by means of several stones in order to achieve different intensities of black and gray. Right: Examples of lithographs created with a burin. One of the earliest and most useful applications of lithography was in the field of cartography.

I received from its Vice President Von Vachiery, a present of twelve florins, with the intimation, that my Memoir had been very favourably received; and, as the expenses of the press, according to my own statement, did not exceed six florins, he hoped that a double compensation would satisfy my expectations. I, indeed, expected a very different treatment from the guardians of science and art, whose duty it is to investigate the value of every new invention; and, if approved, to submit it to government.

Promising as this beginning appeared, (in the year 1796,) we soon had the mortification of seeing things assume a very different aspect. As our income increased, we resolved to construct a new and more perfect press, by which we hoped greatly to facilitate the printing of our works. How sadly, therefore, were we disappointed, when, on the first trial with it, we obtained a blotched and dirty impression, instead of the model of

perfection which we anticipated; we took off twenty more with the greatest care, but not more than two or three were even tolerable. It is, and will be as long as I live, perfectly incomprehensible to me, how I could be so perplexed as not to discover immediately the cause of this failure. I discovered it a long time afterwards, by mere chance, but it cost me two years of great trouble and anxiety. The cause why we did not succeed, was a most trifling circumstance. In my first, and imperfect press, it happened that by the splitting of the two wooden cylinders, each of them had a fissure, two inches wide; but as the diameter of the upper cylinder was large enough to print the whole page in one circumvolution, without the fissure touching the stone, I made shift with the cylinder as it was, placing it always so that the fissure did not touch the stone. But, in our new press, it was necessary that the upper cylinder, in order to lay hold of the stone, should draw it first between the two cylinders; before this could be done, however, it carried with it the cloth of the printing frame, till it would stretch no longer, and forced the stone under the cylinder; but in this act, the paper under the printing frame was carried over the charged stone and spoiled. Every expedient I tried to remedy this inconvenience proved unsuccessful; and most likely I should have hit at last on the very simple mode of using leather, instead of the thin cloth, but I was too much perplexed and anxious about fulfilling our engagements, and therefore preferred having another press constructed, in which the pressure, as in the printing presses, was to be vertical and uniform. In less than a week this rough press was finished; the first trials promised success; but the greater stone plates did not give equal impressions, probably on account of the unevenness of the table, which was only of wood. I tried to increase the pressure as much as I could, and by means of a lever, and a stone of 300 pounds, which descended from a height of ten feet, I produced a pressure of more than fifty tons on the stone; by this means I did not fail to obtain good impressions, but after the second or third the stones always broke. To ascertain the vertical pressure requisite to take an impression from a stone plate, I tried numerous experiments, and found that the space of one square inch, required a pressure of 300 pounds to produce a good impression in the space of a few seconds; but leaving the weight for a minute or longer on the stone, scarcely one half of that pressure was requisite. According to this statement, the weight requisite for our music stones, of about 100 square inches each, would have been fifteen tons; but the unevenness of the table, and the general imperfection of the machine, rendered it necessary to increase this pressure threefold, and such a weight the stone was absolutely incapable of bearing. I was soon after deterred from farther improving upon this press, as, on one occasion, I had a very narrow escape from being killed by the great stone of 300 pounds, which always fell from a height of ten feet. The consideration that the same accident might occur in future to the printers, rendered the whole press odious to me; and I was, therefore, easily induced to pursue another plan for constructing a new and perfectly simple printing press, which I had just conceived.

At the time when I had not yet the advantage of a press, I used the following method to take impressions from the stones. Having first placed the wetted paper on the charged stone, I covered it with a few sheets of waste paper; then placing a sheet of thick paper over it, I took a piece of polished wood and rubbed the surface of the paper, which with the other hand I prevented from slipping, till I believed that every part of it had been sufficiently pressed. In this way I often obtained impressions as good and clear as from a press.

This method I proposed to imitate on a larger scale. A wooden frame, of two feet square, was covered with cloth on one side; upon this cloth I pasted a sheet of thick paper, and fastened the frame by means of two hinges upon a common square table, in which the stone was fixed beneath the frame: in the inner side of the frame the paper was fixed by means of threads: in this way I applied it to the stone, and with a piece of wood or glass, rubbed the surface of the frame, till I thought I had touched every part of it. The first specimens surpassed our most sanguine expectations, and the hope of being yet able to keep our engagements, re-animated our depressed spirits. Two other similar presses were soon finished; I employed myself incessantly in writing upon the stones; the printing began with six printers: but,—Oh! the uncertainty of human expectations!—not one of all the six printers could make himself master of the simple process of rubbing the surface of the stone; out of ten impressions, scarcely one was perfect; and if they even succeeded in printing three pages of a sheet perfect, the fourth was sure to fail, and spoil the whole. Thus, out of three reams of the best paper, only thirty-three perfect sheets could be produced.

The time fixed for the delivery of the work which we had engaged to print was now elapsed, without our having been able to furnish the requisite number, and thus we were exposed to the reproaches of our employers; our new art lost almost all its credit and reputation, and even the privilege which the Elector had promised, was refused us; and, during the life of Charles Theodore, we never could obtain it. Our little gains were consumed, even debts were incurred, and the ridicule of those whom the success of our first trials had rendered jealous, was all the fruit we had earned from our laborious endeavours to promote a new art.

As the want of a good press was the only cause of our failure, I tried to induce Mr. Falter, music-seller at Munich, to furnish me with the means of constructing one; and engaged myself to superintend the printing in his own house, if he would give me leave to write the stones in my apartments. To this Mr. Falter, who, upon the whole, had a very good opinion of the art, readily agreed, and I ordered a large press, with cylinders, to be constructed; the cylinders, provided with what are termed the cross, were both to be turned by the workmen at the same moment, and this precaution produced the most perfect impressions; for the double action of the two cylinders, forced the frame with the stone between them, while in our former press the lower cylinder directly counteracted this movement. This circumstance, together with the greater thickness of the upper cylinder, which was fifteen inches in diameter, prevented the paper from changing its position on the stone. This sort of press I still believe to be best adapted for all lithographic printing, provided the stones are of sufficient thickness, and despatch is not a consideration; for, in that respect, this press is not to be compared with the lever-press, and several others, but the impression is softer, more equal and exact, than can be obtained from any other press.

As soon as this press was finished and put together, I began to write on stone Mozart's *Zauberflöte*, arranged in quartettos by Danzy, and to print it, with the assistance of Mrs. Gleissner, at Mr. Falter's house; but Mrs. Gleissner being soon after prevented from assisting me, I instructed two soldiers in the process of printing, and only furnished Mr. Falter with the written stones. But these workmen, not entering into the spirit of the art, spoiled a great deal of paper, so that Mr. Falter at last preferred printing again from copper.

About the same time Mr. Schmidt, then Professor of the Royal Military College, at present Dean of Miesbach, began to etch on stone; he was an intimate friend of Mr. Gleissner, and often used to visit him. For about a year past it has been asserted that Mr. Schmidt is the first inventor of Lithography, and several pamphlets on the subject of this claim are already before the public. Without entering more minutely into the particulars of these rumours, I leave the thing to speak for itself. The reader will have seen, from the present simple and unvarnished account, the natural. but troublesome, way that conducted me to the new invention. If Mr. Schmidt, about the same time, made a similar discovery, without my knowing of it, it certainly must be said that he was more fortunate than myself. According to his own statement, published in a letter from him in the "*Anzeiger für Kunst, und Gewerbfleiss,*" the course of his invention was the following:—He saw in the Cathedral of Our Lady, at Munich, a grave stone, with raised letters and figures; this he supposed to have been effected by aqua-fortis; and, therefore, concluded that it would be possible to take an impression from it. Such was the whole amount of his discovery. If the merit and credit of a new invention may thus easily be obtained, I have certainly been much less fortunate in having been obliged to make such an endless variety of experiments in search of it. But, in my opinion, there is nothing new in Mr. Schmidt's discovery; for the idea that those letters and figures were etched, pre-supposes the existence and use of etching, and every one, who is ever so little acquainted with the process of printing, would easily conceive the possibility of blackening, and taking an impression from these large and raised characters on grave stones, in the common manner of letter-press printing. If, however, Mr. Schmidt joined to this first idea a second, *viz.*, that fine and slightly-raised characters and drawings could be blackened by means of an instrument to be devised for the purpose, and that impressions could be taken from them, then, certainly, he is entitled to the honour of having invented, at the same time with or previous to me, the mechanical process of raised Lithography, as it was then practised. But, upon the whole, neither he nor I can boast of having been the first to conceive the idea of using stones for printing; it is only the manner of effecting this which constitutes the novelty of the invention. At that period (1796) I had discovered, first, not only the art of printing from stone plates, but an ink to write on stone, which, at the same time, was proof against aqua-fortis, of my own composition, and not from an old Nuremberg book, from which Mr. Schmidt took his receipt:—secondly, a useful instrument to blacken the imperceptibly-raised characters:—and, thirdly, the upright pole, or lever-press, of which I shall speak more minutely hereafter.

As I am perfectly ignorant of Mr. Schmidt's experiments at the above-mentioned period, and am precluded from obtaining more particular information, I am ready to believe it on his assertion, as a gentleman, that he printed from stone so early as previous to July, 1796; but I have the most incontestable proofs, that his method widely differed from mine; and, above all, that he was perfectly ignorant of the chemical printing, which I discovered in 1798. Mr. Schmidt, and his pupils, made several trials to produce drawings on stone, but, as it appears, he could not succeed in taking impressions from them. Some of his stones, which I saw a long time afterwards, were first etched; but, subsequently, the spaces between the lines cut out to a considerable depth by steel instruments, in the same way as wood cuts: he had impressions taken from his stones at the printing-office of the Royal Establishment for School-books, and some impressions are said to have been very clear; I myself never happened to

Top: A type of hunting trophy, lithographed in 1818. Above: An example of lithographically transposed writing, printed by Ackermann in London in 1819. Ackermann also published, in 1819, the English translation of Senefelder's *Complete Course of Lithography.*

see any of them. The experiments of Professor Schmidt, however, procured me the acquaintance of the Rev. Mr. Steiner, who, by his liberal encouragement, greatly contributed to lead me, in order to satisfy his different requests, to several improvements, to which Lithography owes much of its present perfection. The Rev. Mr. Steiner, an intimate friend of Professor Schmidt, was Director of the Royal School Establishments, and in this capacity he had several publications under his care. Professor Schmidt's idea of publishing prints of all poisonous plants from stone, for the use of the schools, met with his approbation; and, as several experiments for this purpose did not succeed, he resolved to apply to me, in order to attain his object. Wishing, at the same time, to publish some church music, he came to me, and requested me to cut the music lines in stone that they might be inserted between the letter-press lines, and printed all together in the common printing-press. I tried to accomplish this, but the cutting out of the intermediate spaces, was found to be so troublesome, that it would have been much easier to cut the notes in wood at once. We, therefore, adopted the expedient of first printing the letter-press in the common way, and afterwards added the notes from the stone in our press. I, nevertheless, tried several other experiments to attain our purpose, and, among these, I thought the following the best: I covered a well polished plate of stone with a composition of burned pulverised gypsum, butter, and alumina, mixed with a sufficient quantity of water, to the thickness of two or three cards. When this mass was dry, I drew in it the lines and points, or, in short, the whole of the music, with a steel needle down to the surface of the stone; and, that I might see it more distinctly, I chose a dark-coloured, almost brown, stone. Having completed the drawing, I took melted sealing-wax, spread on a thin board of wood, and pressed it, while still warm, on the stone, by means of a hand-press. When it became cold, the white ground which was loosened from the stone, and adhered to the sealing-wax, was cleaned with a brush and water, and the drawing, or writing, appeared clear and raised on the sealing-wax, like a wood cut, and admitted of being printed in the usual way. I afterwards tried to substitute the composition of lead, tin, and bismuth, for the sealing-wax, which, likewise, with proper management, perfectly succeeds. When the stone is covered with the same composition, but to a greater thickness, the finest cotton patterns may be drawn on it, with greater facility, and in less time, than they can be cut in wood. All my experiments perfectly succeeded, and I greatly regret, that in the sequel, I have never had occasion to improve upon this invention, which I had almost forgotten, and which only came into my mind again when I was writing this history, which recalls many things to my memory. In the second section of this work, or in the description of the process of stone printing, I shall take an opportunity of speaking on the subject more at large, and of relating some experiments in preparing blocks for cotton printing, which I afterwards tried at Vienna.

A musical composition on the Conflagration of New Oetting, in Bavaria, which I printed for Mr. Lentner, with a vignette representing a house in flames, induced Mr. Steiner to have some small drawings for a Catechism, printed on stone. As drawings, they were but indifferent; but he, nevertheless, encouraged me to try whether the new invention might not be applicable to the higher departments of the art. This gentleman, with the exception of Mr. André, of Offenbach, was the only person who thus reasoned: Lines and points of any degree of fineness and strength, can, according to this new manner, be produced on stone; consequently, drawings, resembling copper-plate engravings, are to be produced in a similar way; and if we cannot yet succeed in producing them, the reason

of it is not to be looked for in the insufficiency of the art, but in the want of practice and experience of the artists. He, even at this early period, wisely refrained from hastily judging, as some self-sufficient and conceited connoisseurs continue to do at the present day, that the art was still in its infancy; but he was convinced, when I shewed him my first specimens of the improved chemical method of printing from stone, that the invention had already attained its highest pitch of perfection; that artists might acquire greater skill; that the operations might be simplified, and facilitated; the manners be diversified and multiplied; but that the art itself was not susceptible of being further perfected. And, indeed, though I myself, when, after the lapse of twenty years, I consider in a superficial manner, all the different improvements which I have made in the art during this space, the gratifying results of which are recorded in the contents of this Treatise, and seen in the specimens annexed, and which greatly surpass the expectations which I then ventured to entertain, am tempted, for a moment, to believe that the present and past state of the art, admit of no comparison whatever; yet, upon closer examination, I am convinced that I had even then invented the whole of the art; and that all that others and myself have since done, consists only in the improvement of the application of it.—The whole still rests upon the same principles: ink, composed of wax, soap, &c., gum, aqua-fortis, or any other acid, of which no one has a decided advantage over another, oil, varnish, and lampblack, are still, and in the same manner, the chief ingredients of Lithography, as they were then. In the fundamental principle, nothing has been improved, altered, or newly discovered; no drawing, even of any lithographer, has since appeared, which has to boast of lines and points more clear, powerful, or black, than my first specimens at that period contained in some of their parts.

Those, therefore, who endeavour to excuse the want of patronage, which the art of Lithography, in its beginning, experienced, by the argument that it was impossible to guess, at that time, to what perfection it was capable of attaining, and who pronounce recent drawings, which, in respect of the mechanical part of points and lines, are inferior even to those that were then made, to be better lithographic productions, merely because the drawing is executed by an abler artist, and the subject is nobler;—those, I say, plainly discover that they want that liberal and impartial spirit, which the Rev. Mr. Steiner so honourably displayed in the reasoning above alluded to. It has happened several times, that the art, and its inventor, have been confounded with the artist; and some publications have even gone so far as to assert, that though I had invented the outline of the art, I had only been able to apply it to music-printing; but that such or such a one, had the merit of having applied it to subjects of art, and had even produced prints. If these conceited and forward judges, had taken care to obtain better information, and had learned that, besides myself, (the invention of the Rolling-Press of Professor Mitterer excepted,) no person, in all the different branches of Lithography, has effected any new improvement of consequence, which he had not received directly, or indirectly, from me; that all those artists, and producers of prints, made their first essays under my immediate direction, or were trained and instructed by persons who derived their information from my instructions, and that none of them can boast of having penetrated into the innermost recesses of the art, like Mr. Rapp, of Tubingen, the esteemed author of a work, entitled, *"The Secrets of Lithography;"* then certainly they would never have made use of these ridiculous arguments, or have entertained these unfounded prejudices, of which they ought to be ashamed.

Top: A lithographically reproduced drawing. Above: A lithographically reproduced engraving. Both works appear in Senefelder's album of examples.

Had I, at that period, possessed greater facility in writing and drawing on stone, the Rev. Mr. Steiner would have furnished me with ample occupation. The next work I executed for him, was a copy-book for young girls, which possessed little merit, as I had little practice in writing. He then desired me to draw some scenes of sacred history on stone. Schoen, at Augsburg, was just then engraving for him the seven holy Sacraments, after Poussin, but they were too expensive in this shape, and he wished to render them cheaper, so that even clergymen in the country might give them as presents to the children of their parishioners; and, in general, he endeavoured to substitute for the sacred caricatures that filled the prayer-books of the devout, such drawings as might contribute to improve the public taste. In order to accomplish this the more expeditiously, it was deemed advisable to instruct young artists in the process of drawing on stone with my ink, and thus many drawings, more or less perfect, were produced.

I was certainly now exposed to the risk of losing the secret of my art; and, indeed, except the exact proportion in the composition of my ink, it was already lost; but, as I still entertained the hopes of obtaining the long looked-for privilege, or patent, for Bavaria, I did not hesitate to give instruction to all those that wished it. But amongst all the young artists, there was none who did not expect the most ample success on the very first trials; and as it was necessary that they should first learn for some time, they soon relaxed in their attendance, which greatly displeased Mr. Steiner, but was a matter of indifference to me, as I was just occupied in applying a new and important discovery, in such a way, as to give an entirely new shape to my art, and to be able to produce drawings without even the assistance of an artist.

Being employed to write a prayer-book on stone, which was to be done in the common current hand, I found great difficulty in producing the letters reversed upon the stone. My ordinary method of writing music on stone, was first to trace the whole page with black lead-pencil on paper, wet it, place it on the stone, and pass it through a strong press. In this way I got the whole page traced, reversed, on the stone. But this being extremely tender, and easily wiped off, I should have preferred an ink to the pencil. After having tried some experiments with red chalk and gum-water, and common writing-ink, which did not satisfy me, I prepared a composition of linseed-oil, soap, and lampblack, diluted with water; with this ink I traced the music or letters on paper, and transferred it to the stone, and thus obtained a perfect reversed copy on the latter. This led me to the idea whether it would not be possible to compose an ink, possessing the property of transferring itself to the stone, so that the drawing might be made at once complete, and to prepare the paper in such a manner, that, under certain circumstances, it might discharge the ink, with which writing or a drawing was executed on its surface, upon the stone plate, and not retain any part of it.

Having observed that the stone ink, when it came into contact with the common writing ink, coagulated, (because the acid of the vitriol attracts the solvent alcali from it,) I wrote with common ink, into which I had put vitriol in excess, on paper; and when the writing was dry, I dipped the whole sheet, for a few seconds, in a thin solution of stone ink in water; then, taking it out, I cleaned it in rain water, or a weakly diluted ley [lye]. I found the stone ink precipitated strongly on all the places covered with writing ink. After leaving the paper to dry a little, I put it on the stone, and passing it through the press, obtained a complete copy, but the impressions I took from it were never perfectly clear and equal. I tried it, therefore, in another way; I besmeared the paper with a solution

Above and opposite: Two drawings lithographed and printed by Ackermann in London. Both belong to the Greek, or Etruscan, style that became popular during the Neoclassical era.

of vitriol of iron in gum-water; when dry, I wrote on it with my stone ink, dried it again, moistened it with common water for some time in order to loosen the ink; then put it on the stone plate, which I had previously covered with a solution of oil varnish, in oil of turpentine. The result of this experiment was more satisfactory, though not yet perfect, and induced me to undertake an endless variety of other experiments, in which I altered the proportion of the ingredients, and added others. I can safely assert that this circumstance alone cost me several thousand different experiments, but I was sufficiently rewarded by the final attainment of my object. Besides, these experiments led me to the discovery of the present chemical Lithography. The art of transferring from the paper to the stone, rested principally on the greater or less affinity of one ingredient to another; for instance, I observed that every liquid, especially a viscous liquid, such as a solution of gum, prevented the ink from attaching itself to the stone. I drew some lines with soap on a newly-polished stone, moistened the surface with gum-water, and then touched it with oil colour, which adhered only to the places covered with soap. In trying to write music on the stone, with a view to print it in this way, I found that the ink ran on the polished surface; this I obviated by washing the stone with soap-water, or linseed-oil, before I began to write; but in order to remove again this cover of grease which extended over the whole surface, (so that the whole stone would have been black on the application of the colour,) after I had written or drawn on the stone, it was necessary to apply aqua-fortis, which took it entirely away, and left the characters or drawings untouched. My whole process was, therefore, as follows:—to wash the polished stone with soap-water, to dry it well, to write or draw upon it with the composition ink of soap and wax, then to etch it with aqua-fortis; and, lastly, to prepare it for printing with an infusion of gum-water. I had hoped to have been able to dispense with the gum-water, but was soon convinced that it really enters into chemical affinity with the stone, and stops its pores still more effectually against the fat, and opens them to the water. In less than three days after my first idea, I produced as perfect and clear impressions, as any that have since been obtained. Thus this new art had, in its very origin, arrived at the highest degree of perfection as to the principle, and good and experienced artists were only wanting to shew it in all the varieties of application.

Aloys Senefelder (Prague 1771–Munich 1834) was the inventor of lithography.

GLOSSARY

*By Rosalba
and Marcello Tabanelli*

ANNOTATION (Annotated proof). Handwritten addition by the artist. This can be either the title of the work, the state, the date, or any inscription other than the number, the date, or the dedication.

ARTIST'S PROOF. This phrase once referred to the proofs made by an artist before the final printing. Nowadays, as a result of prevailing custom, it defines a certain number of prints that are given to the artist as of right, over and above the numbered edition. As a general rule, these artist's proofs do not exceed five per cent of the total run.

AUCTION CATALOGUES. See *Auctions.*

AUCTIONS. Everyone is aware of their function and the fascination that they hold for lovers of art and antiques; we shall therefore here dwell briefly on only a few essential features. Auction houses are traditionally the place where dealers buy their stock, but they can also prove to be a happy hunting ground for private collectors, provided the latter keep their wits about them and bear in mind all the relevant information concerning this type of marketplace. Life teaches us that sudden flashes of intuition can lead to some great discovery, but this is a once-in-a-million occurrence. It often happens that private individuals, carried away by the spirit of competition, pay absurd prices for a print that they could buy much cheaper from a dealer, or, hoping to make a "find," buy a large lot for very little, thinking that amid a hundred examples they are going to discover the one that will make their fortune. The large auction houses are obviously the most prestigious and best organized. They have at their disposal specialized and competent personnel, which means that their cataloguing is rarely inaccurate, since it is the catalogue that determines the quality of a sale. The author, title, and medium of a work are not enough by themselves: it is also important to know its reference number and that of its state, any possible damage or unusual features, the width of its margins, the dates of its execution and its publication, the size of the edition, and any other information that has a bearing on its identification. An auction catalogue composed along these lines is a sign of competence and experience. Even under these conditions, the first rule to observe is that of closely examining the print before the actual sale, of assessing its quality and, because anyone can make mistakes, of ensuring that the catalogue description is completely accurate. If the individual feels that he or she is not sufficiently knowledgeable, then it is quite common for an expert to be called in to view a particular lot and then bid on the person's behalf. These precautions are especially important when the description of a print is either vague or actually incorrect. It would be possible to quote endless examples of fanciful catalogue descriptions; one thinks of the lot in an Italian catalogue described as "Drawing attributed to Leonardo da Vinci—Estimate 200,000 lire" (about $140)!

AUTOGRAPH. A lithograph reproduced on autographic paper (see *Lithographic transfer*).

CANCELLATION OF THE PLATE. This operation is applied to plates after the final run of a print has been completed in order to prevent unauthorized reprints. It is a term and process used only in connection with lithographic plates. In catalogues, one often finds the expression "leveled plate," which, however, refers to the cutting of the plate. It signifies the same thing as "cancellation," but it is carried out by scratching a large "X," or some other mark that spoils the print, on the plate. Sometimes an artist, in order to avoid ruining the plate—an object of considerable beauty in its own right—will invalidate it by using scratch marks or by drilling a hole through it.

CATALOGUES RAISONNÉS. These are systematic and comprehensive lists containing all the engravings and lithographs by a given artist. The word *raisonnés* is used because each work is accurately appraised and described. Every item is illustrated (or described, if no illustration is available), together with its title, its date, the technique used, its dimensions (taken at the edges of the subject in the case of a lithograph and at the borders of the plate in engravings). There then follows, when applicable, a list of the various states with an enumeration of any differences that may exist among them. Each title is followed by a number and it is this number, preceded by the name of the catalogue's author, that provides the relevant information. One could, for example, find in either an auction or a gallery catalogue the following entry: "Edouard Vuillard—*Les deux belles soeurs*—1899—355 × 280 mm., 13 2/5 × 11"—Claude Roger-Marx 43 II/3''. Given the competence of the cataloguer, the information thus provided will allow the purchaser to buy the lithograph without having to examine it first. The description makes no mention of any defects, which means that the print is in very fine condition. By consulting No. 43 in Vuillard's *catalogue raisonné*, as well as the illustration, it can be seen that we are dealing here with one of the twelve lithographs in the series *Paysages et intérieurs*, that it exists in three states, that the publisher was Ambroise Vollard, that the run of the definitive state (State III) consisted of 100 examples, that the printer was Clot, and that the artist did not sign the whole run but only some of the series. In addition, we can see that the print offered here belongs to State II and that it is unsigned, since no mention is made of any signature. No expert could ever comprehensively catalogue the work of an artist without the assistance of these invaluable *catalogues raisonnés*, and it is universally accepted that an engraving or a lithograph "must" appear in one of these *catalogues*. They are, in fact, an indispensable aid: the stock-in-trade of the professional and an invaluable *aide-mémoire* for the serious amateur.

CATALOGUING. See *Catalogues raisonnés.*

CHROMOLITHOGRAPHY. A method of lithographic printing achieved by using different stones, one for each color. Discovered in about 1816 by means of experiments conducted by Lasteyrie du Saillant and Engelmann, it soon became established as the most common technique of printing in color.

COLLECTING. This fascinating subject could take up an endless amount of space. The *Shorter Oxford Dictionary* defines a collection as being "a group of things collected or gathered together; *e.g.* of specimens, works of art, etc.," but the decision to embark on such a collection is purely subjective, whether it is inspired by something that the individual has read or merely by a desire to emulate someone else. The first acquisitions are generally the most curious: the lack of experience in the field is replaced by enthusiasm, with the new collector being attracted by quantity rather than quality, and visiting markets, junk shops, and minor dealers. He buys, swaps, and generally enjoys himself. We are, of course, referring to the small collector and not to the limited number of people with almost boundless resources whose urge to acquire works of art often has a very different rationale. The latter already possess the three main characteristics that make up a collector: learning, love of art, and money. They are well aware that collecting works of art is, and always has been, an investment as well as a pleasure, and so their selections have to be "right." They

collect in a rational, some would say scientific, way: they reject lesser or imperfect works, works by mediocre artists (however pleasing), and works of purely national importance that will never attain international status. Their criteria for buying are many and varied, but they are all grounded in common sense. It is reassuring to be able to say—and there are many precedents for this statement—that a great collector normally tries to arrange things so that his collection is not broken up after his death. It often happens that a collector will, during his lifetime, bequeath an entire collection to his home town or to some particular museum. There is nearly always an element of exhibitionism in the desire to collect—a belief that "Everyone will be able to enjoy these works and everyone will know that I collected them"—and it is this feeling that leads to bequests and donations. It is, however, a very human and understandable trait in a man that, having dedicated a great part of his life to collecting, he should want to leave a reminder of himself and of his love for art. When the community benefits from such an action, then the motives of the individual are unimportant. Let us, however, return to the small collector. After an initial period of euphoric self-sufficiency, he will begin to feel the need to take stock. He will recognize his mistakes and try to rectify them, beginning to clarify his own taste. He will turn more and more to specialists, listening closely to their opinions and their advice based on technical knowledge. Sometimes he may even prove overzealous, but he has realized that there is no other possible way of absorbing all the necessary information. He learns how to "read" a work—to see if its condition is good or just passable, to recognize its quality, and to understand the different techniques involved—as well as to learn how to consult *catalogues raisonnés* and other relevant literature. He also develops the skill of being able to differentiate between great artists and mediocre ones without allowing himself to be influenced by trends, fashions, or parochial sentiment; he learns to dig below the surface. In fact, he gradually becomes an educated collector.

COLOPHON. The inscription used by a publisher to inform the purchaser how, when, where, and by whom a book or album has been composed, printed, and published.

CONSERVATION. As a basic principle, collectors should acquire only prints in perfect condition. In the case of Old Master prints, the concept of perfection may be somewhat—but only slightly—more elastic, both because of their age and because perfect examples rarely come onto the market nowadays. However, for lithographs, even

the oldest of which are relatively modern, condition is of paramount importance in determining their value. Let us consider the elements to be taken into account before acquiring a lithograph, and the steps to be taken after its acquisition. The first rule is never to buy an important print that has already been framed without examining it first. It may have been stuck to the *passe-partout* or, even worse, to board or cardboard; or, it may have pieces of sticky tape attached to it. In addition, the lithograph should have no indelible stains, no tears or folds, no repairs, and no cutdown margins. These rules are basic, but they are worth repeating because many people let themselves be blinded by a cheap price being asked for an important but damaged work. If the price is low there is a reason for it, and it will always remain low in relation to the value of the same lithograph or engraving in perfect condition. Many collectors like to have their prints framed by a professional. Whoever the craftsman may be, it is a wise precaution to remind him that he is dealing with a valuable object and that he should under no circumstances use glue on it or fix it to the mount by means of sticky tape. This latter method, although commonly used, is highly damaging to the print: sticky tape will, over the years, leave permanent stains on the paper, and its place can just as easily be taken by gummed paper, which is harmless. A useful trick when hanging the framed print is to stick self-adhesive felt pads on the back of the picture frame at its four corners, thereby preventing it from coming into direct contact with the wall, which can sometimes act as a vehicle for dampness. It is also worth remembering that any nearby source of heat will weaken the paper, and that direct light will yellow and discolor lithographs and color engravings.

COPY. This is the word given to the result when someone copies another artist's work, whether for study purposes or for lack of any creative abilities of his own.

COUNTERPROOF. The result obtained by pressing a fresh print proof hard against a sheet of paper. The ink, which is still wet and greasy, will produce an image on the clean sheet. The result, also known as a reversed proof, will allow the artist to examine his work as it appears on the plate or stone, thereby enabling him to make any necessary alterations. A counterproof's primary function is to make the artist's work easier. It is not to be confused with a reversed print.

DEALER'S CATALOGUES. In this case the dealer is the cataloguer: it is he who selects the prints, describes their quality

and condition, and fixes the prices. His reputation is the buyer's guarantee: either he is a reputable and reliable dealer or he is not. It is up to the collector to rid the art world of the dishonest and incompetent.

DECLARATION OF RUN. A brief text found in limited-edition illustrated books and on posters in which the publisher states how many examples have been printed, the types of paper used, the different styles of numbering employed (Roman, Arabic, letters)—in fact, all the information that the collector needs to know. At the end of the declaration (which the French call *justification*) is the number of each example and—often in books, but always on posters—the signature of the artist responsible for the engravings or lithographs. Very occasionally, the editor will combine the declaration of run with the colophon in a single text inserted at the end of the volume (see also *Colophon*).

DELINEAVIT (DEL.). See *Lettering*.

EDITION (Run). This refers to the overall number of copies pulled from a plate in a particular state and at a determined time. It is possible for several editions of the same work to exist, sometimes produced at different times, which can be identified by the state, the quality, the paper used, the numbering, the lettering, or other details. In order to define a particular edition, it is useful to consult the *catalogue raisonné* of the artist who has engraved or lithographed the print. Mention is often made of posthumous editions, which are generally of poor quality because they are beyond the artist's control and are sometimes absolutely inferior when obtained from wornout plates. The execution, pulling, and publication of a print generally coincide, but there are cases in which these three stages occur at different times, for example, Flaubert's *Tentation de Saint-Antoine*, illustrated with lithographs by Odilon Redon, or Gogol's *Dead Souls*, illustrated with engravings by Chagall. An equally famous example is provided by Rouault's *Miserere*. The idea for this work grew out of the complex relationship that existed in 1912 between the artist and the dealer Ambroise Vollard. It developed and underwent radical alterations between 1914 and 1918 under the influence of the dramatic events of that historic period. By 1921 the number of Rouault's engravings had risen to one hundred, and during seven years of passionate involvement and suffering the artist toiled to transform and perfect them. By 1927 the printer Jacquemin had pulled the entire edition of fifty-eight plates chosen by Vollard, but when the latter died in 1939, the *Miserere* still remained unpublished. Then World War II broke out and was

followed by the hard years of postwar austerity; in 1948, after countless delays, this amazing work finally saw the light of day.

EXCUDIT (Excud.). See *Lettering*.

FAKE. This term can have two meanings when applied to the world of graphics. The first, and more readily understood, involves counterfeiting, the copying of another person's creation in order to pass the copy off as genuine. The second, and more complex, is used as the opposite of "original" rather than the opposite of "genuine." When an artist, whether from technical inability, laziness, or greed, permits some form of photomechanical technique to be used to reproduce a work of his that was originally executed in another medium—a watercolor or drawing, for example—and then signs it, he is not only perpetrating a sterile repetition, but also producing something that many people would class as a "fake" (see also *Original*).

FRAMING. See *Conservation*.

GENUINE. There is often confusion or uncertainty concerning the use of the definitions "genuine" and "original." The former means that the work has indeed been executed by the artist indicated as being its author (see also *Original*).

INVENIT (Inv.). See *Lettering*.

LETTERING. This term describes inscriptions placed above, below, or within a work. It can include the title, the names of all or the majority of those who have taken part in the production, or any other dedicatory, advertising, or explanatory legend. The artist's signature or monogram is not regarded as being part of the lettering. Recurrent examples of lettering are: *delineavit (del.), pinxit (pinx.)*, or *invenit (inv.)*, followed by the name of the painter; *excudit (excud.)* followed by the name of the publisher; *lith.* or *litho.*, generally used to indicate the name of the printer or, on occasion, that of the person responsible for the lithographic interpretation. When the lithograph has been conceived and executed by the same artist, then it is his name that is succeeded by the word *delineavit*. "Before letters," "after letters," and "lettering cancelled" are expressions currently used in catalogue entries to define the proofs obtained by different states of the plate.

LITHOGRAPHIC CAMAÏEU. An effect obtained by the superimposition of several plates. First experimented with by Engelmann in 1818, it became commonly used during the period between 1840 and 1860.

It is not to be confused with *camaïeu* or chiaroscuro, a technique that was used particularly in Germany and Italy from the early sixteenth century by wood engravers.

LITHOGRAPHIC CRACHIS. A technique for covering large areas of the lithographic stone with tiny drops of ink. It is achieved by rubbing a brush steeped in ink over a special mesh. This simple operation produces small specks of ink on the stone and allows particular effects to be created. Chéret and Toulouse-Lautrec were masters of the technique.

LITHOGRAPHIC INCUNABLE. The term "incunable" refers to printed books and engravings that can be dated to before 1500. By extension, the name "lithographic incunable" is applied to any of the first lithographically printed works produced during the end of the eighteenth century and the beginning of the nineteenth.

LITHOGRAPHIC TRANSFER. The process that allows for an image to be transposed from one backing to another. This technique obviates the need to draw directly onto the stone. which is fragile, unwieldy, and often cumbersome. The stone is replaced by a type of paper that allows for an image drawn on it to be transferred to a stone or metal plate. Several types of paper can be used in the lithographic transfer process. Autographic paper has a smooth surface that is spread with a water-soluble glue; the design is drawn with lithographic or autographic ink and transferred from the very damp paper to the plate by means of heavy pressure. Lithographic paper possesses a rough surface that mimics the graininess of the stone; either lithographic or autographic ink and a lithographic pencil may be used, and the transfer process is similar to the one described above. There is also a means of transferring a design that has already been drawn on a stone or zinc plate to a further one or more plates. This process, carried out by means of transfer paper, is used for large runs (posters, illustrations, etc.) in order to preserve the original plate, which could either deteriorate or prove unable to sustain the planned production. Such great artists as Corot, Fantin-Latour, Redon, and Picasso have made transfer lithography acceptable, having overcome, in works of indisputable quality, the bitter controversy unleashed at the end of the last century (and still not totally settled) by those purists who totally rejected its use.

NUMBERING. The use of numbering dates from the late nineteenth century. Because the lithographic technique and the practice of coating bronze plates with steel made

it possible to achieve large runs without any loss of quality, it therefore became necessary to give the collector some guarantee concerning the number of examples that had been produced of a particular print. It is important to emphasize, however, that the number on a lithograph or engraving does not necessarily correspond to the overall number of prints made. For example, a print may be produced in an edition of one hundred on Arches paper numbered from 1/100 to 100/100, plus fifty on Japanese paper with Roman numbers (from I/L to L/L), plus twenty-five proofs for the assistants or for private circulation numbered with letters of the alphabet, plus the usual artist's proofs. If a collector wants to know the full extent of a run, then he must ask the dealer for its complete cataloguing. The use of double numbering, although not very common, has become fairly widespread in recent years. In our opinion it would be more straightforward to use single numbering: if there are three hundred examples of a print in circulation, they should be numbered out of three hundred, especially since the size of edition does not affect the attractiveness of the print (see also *Rarity*). Often collectors will favor the low numbers, but our advice is to concentrate solely on the quality of the print. The number has no meaning because a run is numbered after the printing process has been completed and after several operations have been conducted in which the order of the sheets is repeatedly changed: it is therefore unlikely that the numbers will actually correspond to the original order of printing.

ORIGINAL. A definition formulated in 1964 by the Comité National de la Gravure has now been taken up by the majority of craftsmen in all countries: "We regard as original engravings and lithographs only those proofs drawn, whether in black and white or in color, from matrices entirely conceived and manually executed by the artist himself; any technique may be used, with the exception of all mechanical and photomechanical processes." This is a clear-cut statement, readily understandable by all, but even so it is not always respected: as the French quite rightly say, *L'argent fait la guerre*. Modern techniques of reproduction are so sophisticated that even expert eyes can be deceived, but there is still that indefinable "something" that will reveal a fraud, that dead feeling that any reproduction of a work originally conceived and executed in another medium will always carry with it. We support the idea that any technique can be used in the creative process, even photography, provided that it is not used as a means of reproducing a work with the intention of passing it off as an original. To

the definition mentioned above we would add the words of Jean Laran: "In order to create a truly original work an artist. at the moment of creation, should also think like an engraver or like a lithographer." By this he means that any engraving or lithograph is a totally independent entity, with its own style and qualities, and that anyone trying to translate into graphic form a work conceived in some other medium is achieving nothing except usurping that work's originality.

PINXIT (Pinx.). See *Lettering*.

POCHOIR (Stencil). A technique of hand-coloring black-and-white prints. It is carried out by means of metal shapes that mask the areas to be left uncolored.

PROOF BEFORE LETTERS. See *Lettering*.

QUALITY. This refers solely to the particular print under examination. It includes everything that determines its perfection, depending on the harmonious interplay of all the different elements that go into a single lithograph: the type of paper, its color, the ink, the inking, the ability of the artist and the printer to blend art and craft in perfect equilibrium. The author's choice of subject can and should be personal, but the other elements require attention. There are those who have an innate feeling for quality, who can tell at a glance that a print is "right," and there are those who need time. There is no substantial difference between the two groups: the only thing that matters is the judgment reached.

RARITY. There are two kinds of rarity: "absolute" rarity, resulting from a very low number of prints being produced, and "relative" rarity, which depends on the frequency with which examples of a particular print appear on the international market. It has been shown that rarity does not always reflect the number of examples in existence, since even a print from a large edition, most of which has been acquired by museums or has "disappeared" into collections, is to be regarded as rare. In the world of graphic art, the concept of rarity is a very complex one and depends on a number of factors, not all artistic. For example, an important lithograph by a major artist produced in an edition of three hundred is effectively rarer than a print produced in a run of fifty by some lesser artist—if not in real terms, then certainly in terms of future expectations. Sale catalogues very often use the adjectives "rare," "very rare," and "extremely rare." These definitions are frequently the result of research done by the cataloguer or of firsthand knowledge, but they are some-times also taken from *catalogues raisonnés* which, especially if they are old ones, are not always accurate in this respect. Collectors, therefore, are quite right to be wary of the description "rare" when it is not the opinion of an expert, but merely taken secondhand from some other authority.

REMARQUE PROOFS. These proofs contain small sketches that echo or develop a composition's main subject; the sketches are engraved or lithographically reproduced in the work's margins or unfilled spaces. At the beginning of this century, it was a very common practice to enrich proofs with these additions, which were then often cancelled in the definitive state.

REPRODUCTION. The act of duplicating, by whatever technical means, a particular work.

REVERSED PRINT. It is well known that a lithograph or engraving will turn out as a printed mirror image of the original drawing on the stone or plate. If an artist, therefore, finds inspiration in a landscape painting or portrait and does not reverse the image and signature on the plate—generally by means of a mirror or a counterproof—the end result will be a reversal of the original. In the past such prints were often made by minor artists who were "copying" engravings or paintings by the great masters and transferring them directly onto the plate without making any allowances for the reversal effect.

REVERSED PROOF. See *Counterproof*.

SIGNATURE. The inclusion of a signature and monogram "on the plate" is a very old custom, but the first autograph works did not appear until the late nineteenth century. It was not a happy inspiration that led Seymour Haden and Whistler, among others, to append a signature or some distinctive autographical sign to the lower margin of their prints; this fashion spread slowly but surely through the market, with the result that a distinction came to be made between the monetary value of signed and unsigned prints—as though an artist's signature, often visually unattractive, could somehow add beauty to a work of art. The mania for signatures among collectors has led to ridiculous prices—a signed lithograph can fetch more than three times as much as its unsigned counterpart —as well as to a proliferation of fake signatures. One thinks of the *boutade* of Parisian auctioneers when offering an unsigned print by a dead artist: *Très belle epreuve pas encore signée*! Fortunately, in recent years there has been a slight softening of this particular fixation: intelligence is beginning to overcome speculation.

STATE. During the process of creation, artists often feel the need to see how their work is developing; they therefore print proofs at various stages. In this context, the word "state" clearly refers to the condition of the plate at the time when the particular proof is pulled. In *catalogues raisonnés*, the term "state" is applied to all the variations made to the plate, whether by the artist himself or by someone else.

TRANSFER PAPER. See *Lithographic transfer*.

BIOGRAPHIES
Essential information on artists of
major importance

Wherever possible, the catalogue raisonné
of each artist's graphic work has been given.

Albers, Josef (1888–1976). American
painter and lithographer. Born in Ger-
many, he emigrated to the United States in
1933 following the closing of the Bauhaus
in Weimar. A protagonist of geometric Ab-
stractionism and forerunner of Op Art.

Jean Laran, *Inventaire du fonds français après
1800*, Bibliothèque Nationale — Département des
Estampes, Paris 1930–33.

Art Nouveau—Posters & Graphics, New York
1977.

Aman-Jean, Edmond-François (1860–
1935). French painter and engraver. He
executed lithographs during the final dec-
ade of the nineteenth century, subsequently
dedicating himself to etching.

Jean Laran, *Inventaire du fonds français après
1800*, Bibliothèque Nationale — Département des
Estampes, Paris 1930–33.

Archipenko, Alexander (1887–1964). Rus-
sian-American sculptor. He took part in
Paris in the Cubist movement. After hav-
ing created ''sculpture-paintings'' and
geometric and Constructivist sculpture he
emigrated to America, where he opened a
school. His concave shapes introduced a high-
ly original element into modern sculpture.

Donald Karshan, *Archipenko—The Sculpture
and Graphic Art—Catalogue Raisonné*, Tübingen
1974.

Heinz Peters, *Die Bauhaus-Mappen*, Cologne 1957.

Aubry-Lecomte, Hyacinthe (1797–1858).
French draftsman and lithographer who
was born and died in Nice. The quality of
his graphic style earned for him the title
''prince of lithographers'' among his
contemporaries.

Jean Laran, *Inventaire du fonds français après
1800*, Bibliothèque Nationale — Département des
Estampes, Paris 1930–33.

Balluriau, Paul (1860–c. 1920). Painter,
draftsman, and lithographer of the French
School. A pupil of Paul Saïn, he exhibited
in the Salon at the beginning of the cen-
tury. He contributed to numerous news-
papers and magazines.

Jean Laran, *Inventaire du fonds français après
1800*, Bibliothèque Nationale—Département des
Estampes, Paris 1930–33.

Barlach, Ernst (1870–1938). German sculp-
tor, wood engraver, lithographer, and writer,
as well as protagonist of the Expressionist
movement. He was persecuted by the Nazis,
who in 1933 confiscated some four hundred
of his works.

Friedrich Schult, *Ernst Barlach Werkverzeichnis:
Das graphische Werk*, Hamburg 1958.

Baumeister, Willi (1889–1955). German
painter, lithographer, and art critic, he was
the father of abstract art in Germany. His
shapes hover between the geometric and the
surreal.

Heinz Peters, *Die Bauhaus-Mappen*, Cologne 1957.

H. Spielmann, *Willi Baumeister, das graphische
Werk*, Hamburg 1963, 1965.

Bayot, Adolphe (1810–?). Born in Alessan-
dria, Piedmont, of French parents, Bayot
added figures to plates by artists specializ-
ing in landscapes and architectural scenes
in order to enliven them. His name appears
on a large number of such lithographs,
which during the nineteenth century
aroused the general public's interest in tour-
ism and in archaeology.

Jean Laran, *Inventaire du fonds français après
1800*, Bibliothèque Nationale—Département des
Estampes, Paris 1930–33.

Beaumont, Charles-Edouard de (1821–
1888). French painter, draftsman, and li-
thographer, and pupil of Boisselier. He was
nicknamed ''the poor man's Gavarni.''

Jean Laran, *Inventaire du fonds français après
1800*, Bibliothèque Nationale—Département des
Estampes, Paris 1930–33.

Beckmann, Max (1884–1950). German
painter, wood engraver, and lithographer,
and a leading member of the Expressionist
movement. His expressive and allegorical
realism is particularly evident in his
portraits.

Klaus Gallwitz, *Max Beckmann—die Druckgra-
phik: Radierung, Lithographien, Holzschnitte*,
Karlsruhe 1962.

Beggarstaff Brothers (William Nicholson
and James Pryde). The more important of
the two is William Nicholson (1872–1949),
a painter, wood engraver, and lithographer
whose work shows certain signs of being
influenced by Félix Vallotton.

Bellows, George Wesley (1882–1925).
American painter and lithographer whose
art reveals a great deal of social criticism
in its illustrations of contemporary Amer-
ican life.

Lauris Mason, *The Lithographs of George Bellows*,
New York 1977.

Benevello della Chiesa, Cesare (1788–1853).
Italian painter, draftsman, and lithogra-
pher. In 1820 he created a lithographic ''self

caricature.'' Apart from throwing himself
wholeheartedly and very successfully into
lithography, he was also a patron of the art,
encouraging and assisting artists and print-
ers to become involved in the new technique.
In 1842 he founded the *Promotrice di Belle
Arti.*

Benton, Thomas Hart (1889–1975). Amer-
ican painter and draftsman with an accu-
rate and descriptive insight into rural and
small-town life, and leader of the Regional-
ist movement. He executed a large number
of murals and was one of the greatest
exponents of the twentieth-century tradi-
tion of American Realism.

Creekmore Fath, *The Lithographs of Thomas Hart
Benton*, New York 1969.

Berthon, Paul (c. 1848–1909). French
painter and lithographer. A pupil of Eugène
Grasset, he absorbed his master's teachings,
developing them and transferring them into
his own unmistakable world: Art Nouveau
tempered by medievalism and a love of
Japanese prints.

Victor Arwas, *Berthon & Grasset*, 1978.

Besnard, Paul-Albert (1849–1934). French
engraver, painter, and lithographer. A
pupil of Cabanel, he was a fine etcher whose
art possesses a certain diluted Impression-
ist style.

André Charles Coppier, *Les Eaux-fortes de Bes-
nard*, Paris 1920.

Loys Delteil, *Le Peintre-graveur illustré: Albert
Besnard*, Paris 1926.

Billmark, Carl Johann (1804–1870). Swe-
dish painter, lithographer, and landscape
artist. A member of the Stockholm Acad-
emy, whose museum contains many of his
drawings, he worked for some years in
Paris, where he died.

Jean Laran, *Inventaire du fonds français après
1800*, Bibliothèque Nationale—Département des
Estampes, Paris 1971.

Boilly, Louis-Léopold (1761–1845). French
painter, draftsman, and lithographer,
famous for his courtly subjects. In his
Grimaces he proved himself to be one of
the forerunners of Expressionism.

H. Harisse, *L.-L. Boilly, peintre, dessinateur et
lithographe: sa vie et son oeuvre*, Paris 1898.

J. Laran and J. Adhémar, *Inventaire du fonds
français après 1800*, Bibliothèque Nationale—
Département des Estampes, Paris 1971.

Bonington, Richard Parkes (1802–1828).
English painter and lithographer who
worked in Paris creating lithographs of ro-
mantic and picturesque landscapes.

A. Curtis, *Catalogue de l'oeuvre lithographié et gravé de Richard Parkes Bonington*, Paris 1939.

Bonnard, Pierre (1867–1947). French painter, draftsman, and lithographer. He belonged to the Nabis, who developed a style of symbolism inspired by Gauguin's work. His lithographs, with their large blocks of color, had a great influence on the evolution of lithographic expression.

Claude Roger-Marx, *Bonnard lithographe*, Monte Carlo 1952.

Francis Bouvet, *Bonnard, l'oeuvre gravé*, Paris 1981.

Boys, Thomas Shotter (1803–1874). English watercolorist and lithographer who created delicate, colored lithographs and views of Paris by means of his own special process, "Lithotint."

Gustave von Groschwitz, *The Prints of Thomas Shotter Boys*, New York 1962.

Bradley, Will (1868–1962). American illustrator and commercial artist. Self-taught, he entered the world of graphics as an apprentice printer, and in 1887 moved to Chicago, where he embarked on a career as an illustrator and commercial artist. The strength and skill of his covers for *The Inland Printer* and his illustrations and posters for *When Hearts Are Trumps* brought him countless commissions. He illustrated and printed a number of books, including two children's stories, *Peter Poodle* and *Toy Maker to the King*. He is regarded as one of the greatest exponents of American Art Nouveau.

Will Bradley—His Graphic Art, published by Clarence P. Hornung, New York 1974.

Braque, Georges (1882–1963). French painter, engraver, and illustrator, and one of the major figures of the European avant-garde. After early experiments with Fauvism and Post-Impressionism, he became a leader of the analytical Cubist movement.

Fernand Mourlot, *Braque lithographe*, Monte Carlo 1963.

Bresdin, Rodolphe (1825–1885). French painter, lithographer, and engraver. The extraordinary visionary qualities of his lithographs and etchings make him one of the forerunners of the twentieth-century European avant-garde.

Dick Van Gelder, *Monographie en trois parties* (Vol. I) - and *Rodolphe Bresdin—Catalogue de l'oeuvre gravé* (Vol. II), Ed. du Chêne 1976.

Campigli, Massimo (1895–1971). Italian painter and lithographer, and originator of a highly personal, archaic style derived from two-dimensional Etruscan painting. His work is very representative of Italian art between the wars. He moved to Paris during the final years of his life.

Capogrossi, Giuseppe (1900–1972). Italian painter and lithographer who, together with Corrado Cagli, founded the Roman School. In 1949 he moved on to an abstract and spatialist style of painting, increasingly typified, over the years, by simple, constant shapes in a variable, calligraphic network.

G. Dorfles, *L'Alfabeto di Capogrossi*, Milan 1962.

Cappiello, Leonetto (1875–1942). Italian painter and graphic artist. One of the great masters of modern poster art, he also created humorous drawings. As a painter, he decorated the halls of the Galeries Lafayette in Paris.

Jacques Viénot, *L. Cappiello—sa vie et son oeuvre*, Paris 1946.

Carlu, Jean (b. 1900). French illustrator and commercial artist. He has dedicated himself exclusively to posters and illustrations, consciously welcoming and reflecting different experiences and influences ranging from Cappiello to Cubism and Surrealism, although always retaining an unmistakably personal exactness of color and design. He worked in the United States between 1940 and 1953, a particularly fruitful period during which he completed the famous *America's Answer: Production* and his posters for Perrier and Cinzano.

Rétrospective de Jean Carlu, Musée de l'Affiche, Paris 1981.

Carrà, Carlo (1881–1966). One of the greatest painters and draftsman of twentieth-century Italy. He was one of the protagonists of Filippo Tommaso Marinetti's Futurist movement and created a number of remarkable paintings in accordance with its tenets. He then moved on to a poetically metaphysical style, into which he introduced echoes of the plastic language of Giotto and Masaccio.

Massimo Carrà, *Carlo Carrà: opera grafica*, Vicenza 1976.

Carrière, Eugène (1849–1906). French painter, engraver, and lithographer. The magical, Symbolist mood of his post-1890 prints assures him of an important place in the history of lithography.

Loys Delteil, *Le Peintre-graveur illustré: Eugène Carrière*, Paris 1913.

Cassandre (Adolphe Jean-Marie Mouron; 1901–1968). French painter, draftsman, and graphic artist, and one of the major exponents of the modern poster.

Max Gallo, *Manifesti nella storia e nel costume*, Milan 1972.

Cassatt, Mary (1845–1926). American painter, etcher, and lithographer. French by adoption and a pupil of Degas, she became part of the Impressionist group. Her work is characterized by a delicate touch.

Adelyn Dohme Breeskin, *Mary Cassatt—A Catalogue Raisonné of the Graphic Work*, Washington 1979.

Cézanne, Paul (1839–1906). French painter whose work had a determining effect on the development of modern painting. From the underlying abstractionism of his final works emerged Cubism. He executed few, but nevertheless masterly, etchings and lithographs.

L. Venturi, *Cézanne: son art, son oeuvre*, Paris 1936.

Una E. Johnson, *Ambroise Vollard, Editeur: Prints, Books, Bronzes*, The Museum of Modern Art, New York 1977.

Chagall, Marc (b. 1887). Russian-French painter, draftsman, and lithographer; an isolated figure in the contemporary art scene. His romantic, surreal, and allegorical language, partly derived from the traditions of popular Russian literature, has a uniquely fairy-tale and dream-like quality.

Fernand Mourlot, *Chagall lithographe*, 4 volumes, Monte Carlo 1960–74. A fifth volume is in preparation.

Cham (Amédée de Noé; 1818–1879). French humorous draftsman of considerable talent. His immense output proved especially popular among his contemporaries.

Jean Adhémar, *Inventaire du fonds français après 1800*, Bibliothèque Nationale—Département des Estampes, Paris 1949.

Charlet, Nicolas-Toussaint (1792–1845). French draftsman, lithographer, and painter. He was a pupil of Gros and was also influenced by Géricault. From 1830 to 1840 his graphic oeuvre made an important contribution to the celebration of the Napoleonic legend.

J. F. de la Combe, *Charlet: description raisonnée de son oeuvre lithographique*, Paris 1856.

Jean Adhémar, *Inventaire du fonds français après 1800*, Bibliothèque Nationale—Département des Estampes, Paris 1949.

Chéret, Jules (1836–1932). French lithographer and draftsman. During the 1870s he was largely responsible for the artistic renewal of advertising posters; his very decorative and "Parisian" style quickly gained favor with the public.

E. Maindron, *Les Affiches illustrées 1886–1895*, Paris 1896.

Clavé, Anthoni (b. 1913). Spanish painter, draftsman, and illustrator who lives in Paris, where he has also designed sets for ballets and operas.

Combaz, Gisbert (1869–1941). Belgian painter, sculptor, graphic artist, and writer who attended courses in the Academy of Fine Arts in Brussels. An expert in Oriental art, he published a number of works, including *Les Palais impériaux, Les Temples de la Chine, de l'Inde et de l'Asie Occidentale*, and *Masques et dragons de l'Asie*. He also produced a number of important posters, among the most memorable being those for the *Salon de l'estampe, La Libre Esthétique*, and *L'Exposition de l'éléctricité*.

L'Affiche en Belgique 1880–1980, Musée de l'Affiche, Paris 1981.

Corot, Jean-Baptiste-Camille (1796–1875). French painter, draftsman, and engraver. The tonal values and light effects of his paintings, combined with the freshness of their color, made him the most important precursor of the Impressionists. He was also an excellent etcher.

Loys Delteil, *Le Peintre-graveur illustré: Corot*, Paris 1910.

Crane, Walter (1845–1915). English painter, watercolorist, and illustrator. A collaborator of William Morris, he was also an exponent of Art Nouveau.

Donna Stein and Donald Karsham, *L'Estampe Originale: A Catalogue Raisonné*, New York 1970.

Cross (Henri-Edmond Delacroix) (1859–1910). French painter and illustrator. His Divisionist experimentation links him with Seurat and Signac.

Una E. Johnson, *Ambroise Vollard, Editeur: Prints, Books, Bronzes*, The Museum of Modern Art, New York 1977.

Currier & Ives. Famous American publishers of popular color lithographs. Following the establishment in 1857 of a partnership between Nathaniel Currier (1818–1888) and James Ives (1824–1895), the firm was active during the final decades of the nineteenth century.

Frederic A. Conningham, *Currier and Ives Prints: An Illustrated Check List*, revised edition, New York 1970.

Curry, John Steuart (1897–1946). American painter, muralist, and illustrator who became a highly important figure in the Regionalist school of painting. He taught at

the University of Wisconsin. His best-known murals are those he created in Topeka, Kansas.

Sylvan Cole Jr., *The Lithographs of John Steuart Curry—A Catalogue Raisonné*, New York 1976.

Daumier, Honoré (1808–1879). French sculptor, painter, and one of the greatest figures in the history of lithography. His powerful prints are animated by the brilliantly satirical way in which he observed the habits and shortcomings of society.

Loys Delteil, *Le Peintre-graveur illustré: Honoré Daumier*, Paris 1926–30.

Decamps, Alexandre-Gabriel (1803–1860). French painter and draftsman responsible for some very violent caricatures depicting events of the Revolution of 1830.

Henri Béraldi, *Les Graveurs du XIXe siècle*, Paris 1886.

J. Adhémar and J. Lethève, *Inventaire du fonds français après 1800*, Bibliothèque Nationale—Département des Estampes, Paris 1953.

De Chirico, Giorgio (1888–1978). Italian painter and draftsman, and one of the masters of modern European figurative art. His "metaphysical" style of painting has had international influence.

Alfonso Ciranna, *Giorgio de Chirico—catalogo delle opere grafiche (incisioni e litografie)*, Rome 1969.

De Feure, Georges (Joseph van Sluijters; 1863–1943). French painter and illustrator. Born in Paris of Dutch origin, he returned there to settle in 1890 after a period spent in his native country. He investigated the possibilities of new forms for everyday objects (furniture, glassware, ceramics, wall hangings) and also played an important role as an inventor and creator of Art Nouveau lithographs and posters, actively contributing to the creation of a style for the latter. Among his best-known posters are *Salon des Cent-Paris-Almanach* and *Affiches et estampes, Pierrefort*.

Degas, Edgar (Hilaire-Germain-Edgar de Gas; 1834–1917). French painter, sculptor, draftsman, and lithographer. He took part in almost all the Impressionist exhibitions, even though his painting only partly adhered to the "rules" of the movement. The quality of his oeuvre has ensured him a place among the great artistic figures of the European nineteenth century, while some of his lithographs are masterpieces of the genre.

Loys Delteil, *Le Peintre-graveur illustré: Degas*, Paris 1919.

J. Adhémar and F. Cachin, *Degas: gravures et monotypes*, Paris 1973.

Delacroix, Eugène (1798–1863). French painter, engraver, and lithographer, and leader of the Romantic school. He executed more than one hundred lithographs, the most outstanding of which are his extraordinary illustrations for Goethe's *Faust*.

Loys Delteil, *Le Peintre-graveur illustré: Ingres et Delacroix*, Paris 1908.

Delaunay, Robert (1885–1941). French painter and lithographer. He advanced interesting theories concerning the relationship among color, light, movement, and other optical phenomena, which were taken up by the Blaue Reiter group and had an influence on a considerable number of other twentieth-century artists. Apollinaire defined his style as "Orphic Cubism."

Delvaux, Paul (b. 1897). Belgian painter, draftsman, and lithographer. Starting from an initially realistic style with Impressionistic overtones, he graduated to Surrealism, developing a figurativism that wedded De Chirico's metaphysical sense of space to the enigmatic estrangement of Magritte.

Mira Jacob, *Paul Delvaux Graphic Work*, Munich and New York 1976.

Denis, Maurice (1870–1943). French painter, engraver, and lithographer, and a founder of the Nabis. His style is simultaneously linked to both Symbolism and mysticism. He was a theoretical exponent of antinaturalism in painting, and his search for syntheses between subtlety and clarity and between dreams and consciousness can be seen clearly in many of his lithographic prints.

P. Cailler, *Catalogue raisonné de l'oeuvre gravé et lithographié de Maurice Denis*, Geneva 1968.

Una E. Johnson, *Ambroise Vollard, Editeur: Prints, Books, Bronzes*, The Museum of Modern Art, New York 1977.

Devéria, Achille (1800–1857). French lithographer and draftsman, and a major figure in Romantic Paris. He was among the first artists to embrace lithography as a means of expression. The most outstanding products of his prolific oeuvre are his portraits, a genre that he cultivated with talent and great enthusiasm.

Henri Béraldi, *Les Graveurs du XIXe siècle*, Paris 1887.

J. Adhémar and J. Lethève, *Inventaire du fonds français après 1800*, Bibliothèque Nationale—Département des Estampes, Paris 1953.

Dix, Otto (1891–1969). German painter, engraver, and lithographer. An artist endowed with a strong plastic sense, he was, together with Grosz, among the main protagonists of the New Objectivity movement. A piti-

less chronicler of contemporary mores, Dix imbued his graphic oeuvre with a biting social criticism.

Florian Karsch, *Otto Dix, das graphische Werk*, Hanover 1970.

Doré, Gustave (1832–1883). French painter, watercolorist, sculptor, engraver, lithographer, and—above all—illustrator. His amazingly prolific work includes numerous series of original lithographs. His illustrations of Cervantes, Ariosto, and Dante are particularly famous.

Henri Leblanc, *Catalogue de l'oeuvre complet*, Paris 1931.

Henri Béraldi, *Les Graveurs du XIXe siècle*, Paris 1886.

Dubuffet, Jean (b. 1901). French painter, lithographer, and theorist of spontaneous art free of any cultural ties (Art Brut). One of the most original and provocative artists of recent decades, he has used a wide variety of unexpected materials in his canvases, proposing a new and heretical concept of art known as *art autre*.

Max Loreau, *Catalogue des travaux*, Paris 1964.

Dudovich, Marcello (1878–1962). Italian illustrator and commercial artist. Author of noted posters in the Art Nouveau style displaying lively attention to contemporary detail.

Roberto Curci, *Marcello Dudovich cartellonista*, Trieste 1976.

Dufy, Raoul (1877–1953). French painter, engraver, draftsman, and lithographer who in 1905 joined the Fauves. Influenced by Matisse, his art acquired a nervous and emphatically graphic quality that can be seen both in his lithographs and in his designs for printed materials and tapestries. He created a series of beautiful illustrations for Apollinaire's *Bestiaire*.

Dupré, Jules (1811–1889). French painter and lithographer and member of the Barbizon group. He was a highly rated landscape artist whose work contains echoes of Constable.

Loys Delteil, *Le Peintre-graveur illustré: Millet, Rousseau, Dupré, Jonkind*, Paris 1906.

Engelmann, Godefroy (1788–1839). French printer and lithographer. In 1816, following a visit to Munich, he opened a workshop for which Girodet, the Vernets, and others worked. In 1857 he obtained a patent for chromolithography.

J. Adhémar and J. Lethève, *Inventaire du fonds français après 1800*, Bibliothèque Nationale—Département des Estampes, Paris 1954.

Ensor, James (1860–1949). Belgian painter, engraver, and lithographer. His painting, which had its roots in *décadentisme* and Symbolism, achieved a fantastic and grotesque Expressionism; its subject matter anticipated the Surrealists in certain of its aspects.

Loys Delteil, *Le Peintre-graveur illustré: Leys, Braekeleer, Ensor*, Paris 1925.

Auguste Tavernier, *L'Oeuvre graphique de James Ensor*, Ghent 1973.

Ernst, Max (1891–1976). German painter, draftsman, and lithographer. He was one of the greatest exponents of the Surrealist movement, which he joined in 1921 when he moved to Paris from Cologne, where he had been a Dadaist and theorist of the new avant-garde. He proposed a renewal of the illustrated book by means of unusual layout, the use of a variety of techniques and of extraneous subject matter, and the eventual suppression of the text. Ernst's Surrealism has a personal quality of lyrical narration.

Brusberg, *Dokumente 3—Max Ernst: Jenseits der Malerei—das graphische Oeuvre*, Hanover 1972.

Helmut R. Leppien, *Max Ernst: das graphische Werk*, Cologne 1975.

Escher, Maurits Cornelius (1898–1972). Dutch draftsman, lithographer, and graphic artist. His work is based on Constructivist and mathematical premises: it aims to translate the concepts of time and infinity by means of images.

M. C. Escher, *The Graphic Work of M.C. Escher*, New York 1960.

Evenepoel, Henri (1872–1899). Belgian painter, engraver, and lithographer, and pupil of Gustave Moreau.

J. Adhémar and J. Lethève, *Inventaire du fonds français après 1800*, Bibliothèque Nationale—Département des Estampes, Paris 1954.

Fanoli, Michele (1807–1876). Italian lithographer. He dedicated himself totally to lithography after a sojourn in Paris, where he learned the technique and worked for Lemercier and the publisher Goupil. He settled in London and eventually in Milan, where he was appointed professor of lithography in the Accademia di Brera.

Fantin-Latour, Henri (1836–1904). French painter and lithographer, famous for his portraits of the painters and literary figures of his day. His lithographic compositions, often of very high quality, are permeated by a personal lyrical realism and an exemplary structural rhythm.

G. Hédiard, *Les Lithographies de Fantin-Latour*, Paris 1906.

Fantin-Latour—Lithographies, Cabinet des Estampes, Geneva 1980–81.

Feininger, Lyonel (1871–1956). American painter, engraver, and lithographer who belonged to the Bauhaus group and taught at Weimar. He achieved an intermingling of Expressionism and Cubism in a delicate synthesis of simplified lines and planes sustained by a lyrical tension that is particularly apparent in his landscapes.

Leona E. Prasse, *Lyonel Feininger—A Definitive Catalogue of His Graphic Work: Etchings, Lithographs, Woodcuts*, Cleveland, Ohio 1972.

Felixmüller, Conrad (1897–1977). German painter, engraver, and graphic artist who founded, together with others, the Group 1919 in Dresden. He was one of the more moderate exponents of pictorial Expressionism.

Gerhart Söhn, *Conrad Felixmüller—das graphische Werk 1912–1974*, Düsseldorf 1975.

Fontana, Lucio (1899–1968). Italian painter, sculptor, ceramist, and lithographer, and a theorist and protagonist of spatialism. His art ranged from the neo-Baroque to the abstract and informal. His strong personality influenced more than one generation of Italian painters.

Forain, Jean-Louis (1852–1931). French painter, engraver, and lithographer. His lithographic style reflected the influence of Honoré Daumier in its critical and satirical approach to contemporary mores.

Marcel Guérin, *Jean-Louis Forain lithographe*, Paris 1910.

Francis, Sam (b. 1923). American painter and lithographer. His work, steeped in Oriental nuances, belongs to the current of Abstract Expressionism and Action Painting.

Klipstein and Kornfeld, *Lithographien*, 3 vols., Bern 1961–63.

Gauguin, Paul (1848–1903). French painter, engraver, and lithographer. Rich in different influences (Symbolism, Decorativism, Impressionism, Japanese painting), his work had a decisive effect on both the Nabis and the Fauves and was an important point of reference for later generations of European artists. He was a precursor of the aesthetic concept of the collage and of the rhythmical decomposition of colors later taken up by abstract artists.

Marcel Guérin, *L'Oeuvre gravé de Gauguin*, Paris 1927.

Gavarni, Paul (Sulpice-Guillaume Chevalier; 1804–1866). French draftsman, engraver, and lithographer. An ironical and

much-praised illustrator of the life and customs of his day, he challenged Daumier's lessons with his courtly and lighthearted style.

J. Armelhaut and E. Bocher, *L'Oeuvre de Gavarni*, Paris 1975.

Géricault, Jean-Louis-André-Théodore (1791–1824). French painter, engraver, sculptor, and lithographer. Because of the energy and intensity of his style, the whole of his lithographic oeuvre warrants a place among the masterpieces of the genre.

Loys Delteil, *Le Peintre-graveur illustré: Théodore Géricault*, Paris 1924.

Giacometti, Alberto (1901–1966). Swiss painter, sculptor, and lithographer. After experiments with Cubism and Surrealism he arrived at a figurative language that underlines the total alienation and insubstantiality of contemporary man. His stylistic hallmark is one of the most exciting in twentieth-century art.

H. C. Lust, *Giacometti—The Complete Graphics*, New York 1970.

Goerg, Edouard (1893–1969). French painter, engraver, and lithographer who has synthesized, in a very personal way, the lessons of Redon, Renoir, and Chagall. He illustrated numerous books, including Baudelaire's *Les Fleurs du mal*.

J. Adhémar and J. Lethève, *Inventaire du fonds français après 1800*, Bibliothèque Nationale—Département des Estampes, Paris 1955.

Goncharova, Natalia Sergeevna (1881–1962). Russian painter, theatrical designer, and lithographer. Basing her work initially on a modern reworking of Russian popular tradition, she progressed to ever more avantgarde means of expression. She signed the Futurist and Rayonist manifestos, arriving at a dynamic style that blended echoes of Cubism, Futurism, and mysticism.

Heinz Peters, *Die Bauhaus-Mappen*, Cologne 1957.

Gould, John (1804–1881). English zoologist and draftsman. A very talented ornithologist, he illustrated, with his wife's help, his own monumental monographs.

Goya y Lucientes, Francisco (1746–1828). Spanish painter and engraver. The series of four lithographs of bulls that he completed in Bordeaux three years before his death not only ensure him a place in the forefront of the history of art lithography, but also show the extent of his genius in perceiving the potential of this expressive medium.

Loys Delteil, *Le Peintre-graveur illustré: Goya*, 2 vols., Paris 1922.

Tomás Harris, *Goya—Engravings and Lithographs*, Oxford 1964.

Grasset, Eugène (1841–1917). Swiss-French architect, draftsman, and illustrator who also invented typographical characters. He was an important figure in the development of Art Nouveau, also creating posters and textile designs.

Una E. Johnson, *Ambroise Vollard, Editeur: Prints, Books, Bronzes*, The Museum of Modern Art, New York 1977.

Gris, Juan (José Victoriano González; 1887–1927). Spanish painter, engraver, and lithographer who lived for a long time in France and was part of the Cubist group. He also designed scenes for Diaghilev's ballets. The architectonic composition of planes of color characterized the last and most important period of his activity.

D. H. Kahnweiler, *Juan Gris: His Life and Work*, Paris 1946, London 1947.

Grosz, George (1893–1959). German painter, draftsman, and lithographer. After experimenting with Dadaism he founded, with Otto Dix, the New Objectivity movement. His social art was bitterly satirical of power and the ruling classes, and with the onset of Nazism his works were classed as "degenerate" and confiscated. After moving to the United States, where he taught in New York, he exercised a clear influence on Ben Shahn and on the painters of the school of Social Realism.

Alexander Dückers, *George Grosz—Das druckgraphische Werk*, Berlin 1979.

Hayez, Francesco (1791–1882). Italian painter and draftsman who lived for a long time in Milan and was one of the forerunners of historical Romanticism. He was a good portraitist and taught at the Accademia di Brera. He also experimented with lithography.

Heckel, Erich (1883–1970). German painter, wood engraver, and lithographer whose early works reflect the influence of Munch. He was one of the founders of the Die Brücke group, around which German Expressionism developed. In his final years he tempered the harshness and angst of his painting, probably under the influence of the painters of the Blaue Reiter.

A. and W.D. Dube, *Erich Heckel—das graphische Werke*, Berlin 1964.

Heine, Thomas Theodor (1867–1948). German painter and illustrator and protagonist of the Jugendstil movement in Germany. He worked for the illustrated satirical magazine *Simplicissimus*, eventually becoming its co-editor.

Hockney, David (b. 1937). English painter, illustrator, and lithographer and major figure of Pop Art. His painting, which is sometimes tinged by a feeling of Surrealism, frequently mocks the false and hypocritical happiness of consumerism.

André Emmerich Gallery Downtown, *David Hockney: The Weather and Other Lithographs*, New York 1973.

Peter Plagens, *David Hockney's New Prints*, New York 1973.

Hofer, Karl (1878–1955). German painter, wood engraver, engraver, and lithographer. His painting, which tended toward Realism during the early years, subsequently veered toward Expressionism, with visionary overtones, in the final decades. Symbols and grotesque deformities, masks and phantoms people his paintings and his prints.

Ernest Rathenau, *Karl Hofer—das graphische Werk*, Berlin 1969.

Huet, Paul (1803–1869). French painter, engraver, and lithographer. An excellent Romantic landscape artist, he was a friend of Delacroix and Bonington and used to paint in the open air, in anticipation of the Barbizon School. Some of his pictures also anticipate elements typical of the Impressionists.

Loys Delteil, *Le Peintre-graveur illustré: Paul Huet*, Paris 1911.

Isabey, Jean-Baptiste (1767–1855). French portrait painter, miniaturist, and lithographer who studied with David and was a friend of Napoleon. He was one of the first artists to use lithographs for portraits and book illustrations.

J. Adhémar, J. Lethève, and F. Gardey, *Inventaire du fonds français après 1800*, Bibliothèque Nationale—Département des Estampes, Paris 1960.

Jawlensky, Alexei von (1864–1941). Russian painter, engraver, and lithographer. His initial style was eclectic but after visits to France and Germany and a lengthy, if polemic, friendship with Kandinsky, he developed a personal style with strong color contrasts and with his shapes outlined by means of strong black lines. In 1924, in conjunction with Kandinsky, Klee, and Feininger, he formed Die Blaue Vier (The Blue Four).

Heinz Peters, *Die Bauhaus Mappen*, Cologne 1957.

C. Weiler, *Alexei Jawlensky: with a Catalogue of Works*, Cologne 1959.

Johns, Jasper (b. 1936). American painter, sculptor, and lithographer in the Neo-Dadaist tradition. Strong visual images

(flags, targets) and everyday objects appear in his very elaborately colored pictures. He was a direct forerunner of Pop Art.

Carlo Huber, *Jasper Johns Graphik*, Berne 1970.

Richard S. Field, *Jasper Johns: Prints*, Middletown, Connecticut 1978.

Jones, Allen (b. 1937). English painter and graphic artist of the Pop Art school. The main theme of his paintings, with their strong colors and ironical overtones, is the myth of eroticism for mass consumption.

Editions Alecto Ltd., *Allen Jones Catalogue*, London 1966.

Jorn, Asger (1914–1973). Danish painter, lithographer, and essayist. An abstract Surrealist during the war, in 1948 he became one of the founders of the Cobra group. He created harshly Expressionist and figuratively abstract paintings.

Kandinsky, Wassily (1866–1944). Russian painter, engraver, lithographer, and essayist. The father of lyrical Abstractionism, he is one of the most important figures of the European avant-garde. In 1912, together with Klee and Franz Marc, he founded the Blaue Reiter group, and his *Abstract Watercolor* (1910) is regarded as the first modern abstract painting. He was one of the founders of the Moscow Academy of Arts and Sciences and also president of the Bauhaus at Weimar, as well as being one of the members of Die Blaue Vier. Condemned as "degenerate" by the Nazis, he settled in Paris. Behind his art lies the dream of endowing painting with the language of music.

Hans Konrad Roethel, *Kandinsky—das graphische Werk*, Cologne 1970.

Kauffer, E. McKnight (1890–1954). American graphic and commercial artist. He did much work in London and was one of the first to bring Cubist formalism to graphics.

Kent, Rockwell (1882–1971). American painter, illustrator, and writer. He favored marine and rural landscapes interpreted by means of strong contrasts of light and shade, and the solid, geometrical shapes of the city. A wanderer by nature, he was a great traveler and wrote memoirs of his travels, as well as tracts on social philosophy, whose themes reappeared in his paintings and his graphic oeuvre.

Dan Burne Jones, *The Prints of Rockwell Kent—A Catalogue Raisonné*, Chicago 1975.

Kirchner, Ernst Ludwig (1880–1938). German painter, sculptor, and lithographer. He was one of the founders of Die Brücke, a group that formed the nucleus of much of German Expressionism. His style, whether in portraits, landscapes, or cityscapes, remained constantly within the Expressionist orbit.

A. and W. D. Dube, *E.L. Kirchner—das graphische Werk*, Munich 1967.

Klee, Paul (1879–1940). Swiss painter, draftsman, lithographer, and essayist. One of the founders of the Blaue Reiter and a teacher at the Bauhaus, he interpreted Nature in fantastical hieroglyphs with an extraordinary rhythm of both color and outline, propounding one of the most revolutionary visual languages in modern painting. He saw the world in terms of a vibrant geometry of line and light. The theoretical writings of this artist are of fundamental importance in understanding his oeuvre.

Eberhard W. Kornfeld, *Verzeichnis des graphischen Werkes von Paul Klee*, Bern 1963.

Kokoschka, Oskar (1886–1980). Austrian painter, draftsman, engraver, and lithographer who received his early training under Klimt in Vienna. His admiration for Munch, Kirchner, and the Fauves and his participation in exhibitions by the Blaue Reiter led him to an Expressionist style of violent psychological insight with strong use of color. The stylistic quality of his work, rooted in a sarcastic and tragic vision of the world, makes him one of the greatest exponents of Expressionism.

H. M. Wingler and F. Welz, *Kokoschka—das druckgraphische Werk*, Salzburg 1975.

Kolbe, Georg (1877–1947). German sculptor, draftsman, and lithographer whose work was influenced by Rodin and Maillol. He ultimately yielded to the monumentality of the Nazi aesthetic.

Kollwitz, Käthe (1867–1945). German painter and lithographer. Her graphic oeuvre, in particular, reflects an Expressionist realism with a strong social content. Her lithographs reveal a masterly degree of skill and sensitivity.

August Klipstein, *Käthe Kollwitz: Verzeichnis des graphischen Werkes*, Berlin 1955.

Larionov, Mikhail Fedorovich (1881–1964). Russian painter, draftsman, theatrical designer, and essayist. One of the outstanding figures of the Russian avant-garde, he founded the Blue Rose group. From a primitivist phase, aimed at rescuing popular tradition, he passed to an increasingly abstract style of painting. He was also influenced by the theories of the Futurists. Among his followers was Kasimir Malevich.

Léger, Fernand (1881–1955). French painter, ceramist, and lithographer. After a Post-Impressionist apprenticeship, he developed a very personal style of painting with broad, compact stretches of color grafted onto a Cubist-inspired sense of decomposition. The figurative content of his work underscores his deep-seated interest in the world of work and industrial civilization. He also created murals, wall hangings, mosaics, and stage sets.

Lawrence Sapphire, *Fernand Léger—The Complete Graphic Work*, New York 1978.

Liebermann, Max (1847–1935). German painter and lithographer. An artist with a strong social conscience, he happily tempered his realism with the palette of the Impressionists. He was one of the leading lights in the Berlin Secession, which was a meeting point for French Impressionism and German Expressionism.

G. Schiefler, *Das graphische Werk von Max Liebermann*, 3 vols., Berlin 1902–14.

Lissitzky, El (Eliezer M. Lissitzky; 1890–1941). Russian painter, architect, graphic artist, and lithographer. A member of the Constructivist movement, he also espoused Suprematism, proposing his famous designs known as "Proun," which he himself defined as "constructions of new shapes." He made a notable theoretical contribution to the theses of Tatlin. In 1922, together with Arp, Richter, Moholy-Nagy, and others, he founded the G Group in Berlin, becoming more and more the main link between the revolutionary Abstractionism of the Russians and the experimental work of the Bauhaus. He was an exceptional pioneer in several fields of artistic expression.

Horst Richter, *El Lissitzky: Verzeichnis der lithographien*, Cologne 1958.

Longhi, Giuseppe (1776–1831). Italian engraver and lithographer. He was a pupil of Vangelisti and worked for many years in Milan.

Lunois, Alexandre (1863–1916). French lithographer and painter. His lithographs were especially admired by his contemporaries.

Edouard André, *Alexandre Lunois: peintre, graveur et lithographe*, Paris 1914.

Magnelli, Alberto (1888–1971). Italian painter and lithographer. After early experiences as a Post-Impressionist, he became acquainted in Italy with the Futurists and in Paris with Picasso and Apollinaire, as a result of which he developed an increasingly abstract and mystical style of painting. His theme of material fragmentation, inaugurated during the period after World War I with his "lyrical explosions," remained almost constantly in

his work, becoming gradually more clearly defined by the strictness of the compositions.

Maillol, Aristide (1861–1944). French sculptor, draftsman, and lithographer. Having absorbed the experiences of Rodin and Renoir, he developed his own plastic style, which can be clearly seen in his nudes. He stripped figures of any allegorical veil, freezing them in a solid shape whose essentiality lies at the root of a great part of modern sculpture.

M. Guérin, *Catalogue raisonné de l'oeuvre gravé et lithographié d'Aristide Maillol*, Geneva 1965.

Malevich, Kasimir (1878–1935). Russian painter, lithographer, and essayist. Initially a Post-Impressionist, he later joined the Rayonists and then, together with Larionov and a number of Russian avant-garde poets including Mayakovsky, he developed an abstract movement called "Suprematism," which was the most important manifestation of Russian Cubist-Futurism. After the Revolution he advocated a kind of advanced cultural politics and taught at the National School in Moscow, but soon fell into disgrace. He was a friend of Kandinsky. The Bauhaus published his famous treatise *The World of Representation*.

Donald Karshan, *Malevich—The Graphic Work 1913–1930*, Jerusalem 1974.

Manet, Edouard (1832–1883). French painter, engraver, and lithographer. He was one of the great innovators within the European tradition and forerunner, as well as friend, of the Impressionists. His painting proposed, with scandalous audacity, the abolition of perspective, halftones, and chiaroscuro in favor of flat, detached, and strongly contrasting colors.

M. Guérin, *L'Oeuvre gravé de Manet*, Paris 1944.

J.C. Harris, *Edouard Manet: Graphic Work—A Definitive Catalogue Raisonné*, New York 1970.

Manzù, Giacomo (b. 1908). Italian sculptor, draftsman, engraver, and lithographer. The basic influences on his work were Maillol, the Impressionists, and Medardo Rosso. He achieved a plastic style of firm monumentality, with surfaces of shimmering light, and created one of the doors of St. Peter's.

Alfonso Ciranna, *Giacomo Manzù—Catalogo delle opera grafiche*, Milan 1968.

Marini, Marino (1901–1981). Italian sculptor, painter, engraver, and lithographer. From archaic and Etruscan art he drew inspiration for ecstatic and monumental shapes that became increasingly spare and lean over the years. He succeeded in blending the lessons of Rodin, Medardo, and the artists of the historic avant-garde in a highly personal style that was one of the most remarkable in twentieth-century Italy.

G. di San Lazzaro, *Marino Marini: l'opera completa*, Milan 1970.

L.F. Toninelli, *Le litografie de Marino Marini*, Milan 1966.

Marsh, Reginald (1898–1954). American painter, illustrator, and lithographer. He belonged to the Realist school and emphasized, particularly in his graphics, the least attractive aspects of city life. He used art to make a statement, and he expressed himself in a style that reflected a deep sense of human involvement.

Norman Sasowsky, *The Prints of Reginald Marsh*, New York 1976.

Martini, Alberto (1876–1954). Italian illustrator, engraver, and lithographer. His lithographs employed a new pointillist technique, which achieved remarkable results in portraying blacks and grays. He was an isolated figure whose style and shapes seem to anticipate Surrealism.

F. Meloni, *L'Opera grafica di Alberto Martini*, Milan 1975.

Masson, André (b. 1896). French painter, engraver, and lithographer who progressed from Cubism to a visionary and irrational style of painting. Having entered into the orbit of Breton, he became an exponent of Surrealism. He also worked on the development of "automatic writing." During his stay in the United States he had a visible influence on those painters who later became leaders of the Action Painting movement.

Roger Passeron, *André Masson: gravures 1924–1972*, Fribourg 1973.

Matisse, Henri (1869–1954). French painter, sculptor, graphic artist, lithographer, and theatrical designer. A pupil of Moreau, he passed from a naturalistic style to an increasingly atmospheric and contemplative use of color. He was one of the exponents of Fauvism, but he adhered to the idea of spiritual art, as opposed to the rationality of Cubism. The sources of inspiration for his painting included Oriental art, African art, and Persian ceramics. He was one of this century's masters of Western painting.

M. Hahnloser-Ingold, *Henri Matisse—gravures et lithographies de 1900 à 1929*, Bern 1970.

S. Lambert, *Matisse Lithographer*, London 1972.

Mazza, Aldo (1880–1964). Italian painter, illustrator, and commercial artist. He was trained in the Accademia di Brera, where he attended the courses of Cesare Tallone. In 1908 he began working with Ricordi, also illustrating a number of children's books during the same period, and between 1904 and 1924 he contributed to "Guerin Meschino." Among his best-known posters are the ones for *Corse a San Siro, Mele-Mode-novità* and *Giovinezza*.

Miró, Joan (b. 1893). Spanish painter, sculptor, illustrator, and lithographer. In Paris he fell under the influence of the Cubists, but he later turned to Dadaism and to Surrealism, whose manifesto he signed. Surrealism for him meant a means of recapturing one's childhood, and an enchanted, fairy-tale atmosphere permeates even his most abstract works, in which memory and the subconscious are crystallized in elementary shapes.

F. Mourlot, *Joan Miró lithographe*, Paris, 4 vols., 1972–81.

Moholy-Nagy, László (1895–1946). Hungarian painter, sculptor, graphic artist, and lithographer. He learned from both Constructivism and Suprematism and was a relentless experimenter even during his time at the Bauhaus, where he taught at the invitation of Gropius. He created kinetic sculptures and developed new techniques of photography. He is regarded as a forerunner in the field of visual-kinetic research and Pop Art.

Monnier, Henri (1805–1877). French painter and lithographer who created more than seven hundred lithographs on the subject of contemporary life and society that are among the most amusing works of the 1830s.

Champfleury, *Henri Monnier—sa vie, son oeuvre avec un catalogue complet de l'oeuvre*, Paris 1889.

Moore, Henry (b. 1898). English sculptor, engraver, draftsman, and lithographer. He has readopted the motifs of the avant-garde movements, including those of Surrealism, concentrating on the process of formal abstraction and deepening the relationship of his works with their surrounding space, even to the point of architectonic integration. After 1940 he recovered the plastic essentiality of the human figure, distorting it in mythical and inorganic shapes that are among the most successful sculptures of the twentieth century.

G. Cramer, *Henry Moore: Catalogue of Graphic Work 1931–1972*, Geneva 1973.

Moreau, Luc-Albert (1882–1948). French painter, lithographer, and illustrator. He was exceptionally skilful at recognizing the possibilities offered by lithography, of which he wrote an analytical history. He illustrated books by Francis Carco, Emile

Paul, and Colette with extraordinary sensitivity.

Mucha, Alphonse (1860–1939). Czech painter and commercial artist who was the most famous creator of posters of his day. He contributed to the decorative language of Art Nouveau with extraordinary talent, blending vegetable forms with Slavic and Oriental imagery.

Iri Mucha, *The Graphic Work of Alphonse Mucha*, New York 1973.

Müller, Otto (1874–1930). German painter, engraver, and lithographer. A member of the Expressionist group Die Brücke, he distinguished himself by his less violent style, often tending toward a gentle portrayal of the reality that he endowed with an almost mythical quality.

F. Karsch, *Otto Müller—Das graphische Gesamtwerk*, Berlin 1975.

Munch, Edvard (1863–1944). Norwegian painter, engraver, and lithographer. He played a principal role in the evolution of modern lithography and was an acknowledged forerunner of Expressionism. He developed a personal style of Symbolist painting, with a deep feeling of spirituality and inner drama.

G. Schiefler, *Verzeichnis des graphischen Werks: Edvard Munch bis 1906* (Vol. I), Berlin 1907; *Edvard Munch: das graphische Werk 1906–1926* (Vol. II), Berlin 1928.

Nash, Paul (1899–1946). English painter and lithographer. After experimenting with a Post-Impressionist style, he was influenced by the Surrealists and by De Chirico. He specialized in landscapes, a subject that he restored to the visionary tradition of William Blake.

A. Postan, *The Complete Graphics of Paul Nash*, London 1973.

Nevinson, Christopher Richard Wynne (1889–1946). English painter, engraver, and lithographer. He joined the Futurist movement and, together with Marinetti, signed the English Futurist Manifesto. He was a sensitive and observant illustrator of events during World War I.

Nolde, Emil (Emil Hansen; 1867–1956). German painter, wood engraver, engraver, and lithographer. After early Impressionist beginnings he drew closer to Die Brücke but remained an isolated figure. His violent Expressionism has personal religious and symbolic overtones, and his graphic oeuvre is one of the most remarkable in modern German art.

G. Schiefler, *Emil Nolde: das graphische Werk* (2nd ed. revised by Christel Mosel), 2 vols., Cologne 1966–67.

Orazi, Manuel (1860–1934). French lithographer and commercial artist. Defined by Maindron as a "master lithographer," he created several Art Nouveau posters, the most notable of which are the superb *La Maison moderne* and *Théâtre de Loïe Fuller*. He also illustrated books.

Orozco, José Clemente (1883–1949). Mexican painter and lithographer. After frequenting European avant-garde circles, he created in Mexico, together with Siqueiros and Rivera, a number of large celebratory and decorative murals tinged with an element of satirical Expressionism and executed in a contemporary style. His painting had roots in Aztec art and folklore.

John H. Hopkins, *Orozco: A Catalogue of His Graphic Work*, Flagstaff, Arizona 1967.

Luigi Marrozzini, *Catálogo completo de la obra gráfica de Orozco*, Puerto Rico 1970.

Pechstein, Hermann Max (1881–1955). German painter, engraver, and lithographer. He belonged to the Expressionist Die Brücke group, which he left in order to found the New Secession. His oeuvre is varied, but it constantly reflects the attention that he paid to the decorative aspect of color, a lesson learned from Matisse.

Paul Fechter, *Das graphische Werk: Max Pechstein*, Berlin 1921.

Picasso, Pablo (1881–1973). Spanish-born painter, sculptor, engraver, ceramist, and lithographer. Everything that this indefatigable genius created in the field of graphics, including lithography, continues to provide an exemplary point of reference in the history of twentieth-century art.

Bernhard Geiser, *Picasso peintre-graveur—catalogue illustré de l'oeuvre gravé et lithographié—1899–1934*, 2 vols., Bern 1955.

Georges Bloch, *Picasso—catalogue de l'oeuvre gravé et lithographié*, Bern 1968, 1971, 1979.

Pigal, Edme-Jean (1798–1873). French draftsman and lithographer. He was an astute observer of bourgeois foibles.

Pissarro, Camille (1830–1903). French painter, engraver, and lithographer. A friend of Monet, he joined the Impressionists and took part in all their exhibitions. Aware of the problems of light, he made a thorough examination of the technical researches conducted by Seurat and the Neo-Impressionists. His search for a solution to the problems of atmosphere, light, and spontaneity can be seen clearly in his lithographs.

Loys Delteil, *Le Peintre-graveur illustré: Pissarro, Sisley, Renoir*, Paris 1923.

Poliakoff, Serge (1900–1969). French-naturalized Russian painter and lithographer. The examples of Delaunay and Kandinsky led him toward geometric Abstractionism, which he developed in a highly personal way, introducing evocative combinations of light and color linked together by a sense of contemplative harmony derived from the Russian icon tradition.

Serge Poliakoff, *Les Estampes*, Paris 1974.

Prampolini, Enrico (1894–1956). Italian painter, engraver, theatrical designer, lithographer, and writer. An adherent of Futurism, he practiced a Cubist style of painting that gradually became increasingly abstract. He founded avant-garde magazines and strove for a "plastic lyricism" which he believed would give life to a work independently of its creator.

Raffet, Auguste (1804–1860). French painter, engraver, and lithographer. He was a pupil of Charlet, and his passion for detail, the clarity of his style, and the lyrical quality of his chiaroscuro are all characteristics that reappear throughout his vast lithographic oeuvre, a great part of which is dedicated to the Napoleonic epic. He also illustrated books.

H. Giacomelli, *Raffet, son oeuvre lithographique… Eau-fortes*, Paris 1862.

Rauschenberg, Robert (b. 1925). American painter, sculptor, and lithographer. An exponent of the Dadaist movement, he has created "combine-paintings" consisting of collages and assemblages of *objets trouvés*. Works of this type are intended to debunk contemporary consumerist myths.

Institute of Contemporary Art, *Rauschenberg: Graphic Art*, Philadelphia 1970.

Redon, Odilon (1840–1916). French painter, engraver, and lithographer. With extraordinary technical skill, particularly in lithography, he expressed the mysterious world of dreams, the lure of the fantastic, the terror of the incubus, and the abandonment to melancholy—all ingredients of Symbolist art. Highly regarded by Mallarmé, Huysmans, Gide, and Valéry, he was an important and for a long time unrecognized precursor of the Symbolist movement, and therefore a source of inspiration for the Surrealists.

André Mellerio, *Odilon Redon*, Paris 1913.

Renoir, Auguste (1841–1919). French painter, draftsman, and lithographer. He was one of the greatest exponents of

Impressionism, but it was not until after 1890 that, at the instigation of friends and publishers (notably Vollard), he created some twenty etchings and some thirty lithographs, in black and white and in color, in which he rediscovered his love for shapes bathed in shimmering light.

Loys Delteil, *Le Peintre-graveur illustré: Pissarro, Sisley, Renoir*, Paris 1923.

Rivière, Henri (1864–1951). French engraver, lithographer, and wood engraver. His style was influenced by Japanese painting, by Monet, and by Sisley. He was an excellent lithographer, notably in his views of Paris including the Eiffel Tower.

Georges Toudouze, *Henri Rivière, peintre et imagier*, Paris 1907.

Rops, Félicien (1833–1898). Belgian engraver and lithographer. He began his career by creating lithographs in the manner of Daumier and Gavarni. Conscious of the lessons to be learned from the French Symbolists, he favored themes of eroticism, passion, and death. He illustrated *Les diaboliques* by Barbey d'Aurevilly.

Maurice Exteens, *L'Oeuvre gravé et lithographié de Félicien Rops*, 4 vols., Paris 1928.

Rouault, Georges (1871–1958). French painter, engraver, and lithographer. A pupil of Gustave Moreau, he was attracted to the Fauves, introducing into his pictures a religious fervor and a bitterness that make him one of the forerunners of Expressionism. Rouault's most moving series of engravings is the *Miserere*. He illustrated a number of books for Vollard using a variety of techniques.

I. Rouault and F. Chapon, *Oeuvre gravé: Rouault*, 2 vols., Monte Carlo 1978.

Roussel, Ker-Xavier (1867–1944). French painter, engraver, and lithographer. His art reflects the influence of his friends Bonnard, Vuillard, and Denis.

Jacques Salomon, *Introduction à l'oeuvre gravé de K.-X. Roussel*, Mercure de France, 1968.

Rysselberghe, Théo van (1862–1926). Belgian painter, draftsman, and lithographer. Along with Seurat and Signac he was part of the Neo-Impressionist movement, but he finally opted for a Divisionist technique very similar to that of Giacomo Balla. His graphic work reveals clear echoes of Puvis de Chavannes.

Savinio, Alberto (Andrea de Chirico; 1891–1952). Italian painter, lithographer, musician, and writer, and brother of Giorgio de Chirico. He began painting in 1927, initially in the "metaphysical" style of his brother, but he gradually developed a more ironical and grotesque Surrealistic style rooted in a background of deep literary learning.

Schiele, Egon (1890–1918). Austrian painter and lithographer. A friend of Klimt, he was only marginally influenced by the latter's art. His own dramatic style of painting owed more to Expressionism, and he tried, often in a cruel way, to capture the conflict between life and death.

Otto Kallir, *Egon Schiele—das druckgraphische Werk*, Wels 1970.

Schlemmer, Oskar (1888–1943). German painter, sculptor, theatrical designer, and lithographer who taught at the Bauhaus. In his art he paid particular attention to the importance of spatial relationships.

Will Grohmann, *Oskar Schlemmer—Zeichnungen und Graphik Oeuvrekatalog*, Stuttgart 1965.

Schmidt-Rottluff, Karl (1884–1976). German painter, sculptor, engraver, and lithographer, and one of the founders of Die Brücke. After his early Expressionist period he came under the influence of Cubism and African art. His painting gradually assumed a solid monumentality in which the main considerations were structural values and the simplification of style and color.

Ernest Rathenau, *Karl Schmidt-Rottluff—das graphische Werk seit 1923*, Hamburg 1964.

Rosa Schapire, *Karl Schmidt-Rottluff—graphisches Werk bis 1923*, Hamburg 1965.

Severini, Gino (1883–1966). Italian painter, sculptor, lithographer, and essayist. As a young man he moved to Paris, where he joined the avant-garde. He was a Futurist and a Cubist who became increasingly influenced by geometric Abstractionism, to which he brought his own classical ideas.

Sheeler, Charles (1883–1965). American painter, photographer, and lithographer. He gave a highly personal interpretation of the European Post-Impressionist and Cubist experiences, incorporating them in a clear, photographic style that has similarities with the German New Objectivity.

Signac, Paul (1863–1935). French painter and lithographer. Inspired by the work of Monet, he and Seurat laid the foundations of the Neo-Impressionist movement. Among other things, he produced glowing watercolor landscapes and wrote a highly important theoretical work entitled *De Delacroix au Néo-Impressionisme*.

E.W. Kornfeld and P.A. Wick, *Catalogue raisonné de l'oeuvre gravé et lithographié de Paul Signac*, Bern 1974.

Siqueiros, David Alfaro (1898–1974). Mexican painter, draftsman, and lithographer. Using a neo-Realist technique, he illustrated the triumph of the Mexican Revolution in paintings and large-scale murals. His dramatic realism is enlivened by a burning ideological passion. He was a friend of Diego Rivera, with whom he laid the theoretical foundations of an epic and monumental art rooted in pre-Hispanic tradition.

Sironi, Mario (1885–1961). Italian painter, draftsman, and lithographer. After belonging, with his friend Boccioni, to the Futurist movement and having absorbed the lessons to be learned from metaphysical painting, this major figure in twentieth-century Italian art embarked on an increasingly independent style, portraying urban life in all its harshness and solitude. He belonged to the *Novecento* movement, his work emphasized by a realism portrayed with a feeling of violence and depicted in dark, somber shades; he also devoted himself to reviving such traditional skills as mosaic and fresco. During his final years his plastic shapes became even more evocative.

Sigfrido Bartolini, *Mario Sironi—l'opera incisa, con appendice e iconografia*, Reggio Emilia 1976.

Sisley, Alfred (1839–1899). French painter, draftsman, and lithographer of English descent. One of the main exponents of Impressionism, he showed a particular affinity with Monet in his river scenes and his gentle, rural landscapes.

Loys Delteil, *Le Peintre-graveur illustré: Pissarro, Sisley, Renoir*, Paris 1923.

Sloan, John (1871–1951). American painter and lithographer. He was one of the founders of The Eight, a group that contributed greatly to the modernization, in an anti-academic sense, of American painting. A great feeling of immediacy and spontaneity also characterizes his graphic oeuvre.

Peter Morse, *John Sloan's Prints—A Catalogue Raisonné of the Etchings, Lithographs, and Posters*, New Haven and London 1969.

Steinlen, Théophile-Alexandre (1859–1923). Swiss-born, naturalized French painter, engraver, and lithographer. He worked with Toulouse-Lautrec under the pseudonym of Treclan, and illustrated the first two volumes of the songs of Aristide Bruant. For several years he also worked on the *Gil Blas illustré*.

E. de Crauzat, *L'Oeuvre gravé et lithographié de Steinlen*, Paris 1913.

Strixner, Nepomuk Johann (1782–1855). German engraver and lithographer.

Sutherland, Graham (1903–1981). English painter, engraver, and lithographer. One of the major figures in European art of recent decades. He was inspired by Surrealism in his probing investigation of both the psychoanalytical ramifications of reality and of the wide variety of materials that constitute it. His art, elegant yet anguished, pursues the continual metamorphosis that circumscribes and regenerates all matter, whether animal, vegetable, or mineral.

Felix H. Man, *Graham Sutherland—das graphische Werk 1922–1970*, Munich 1970.

Toorop, Jan Theodor (1858–1928). Dutch painter, draftsman, and lithographer. He was a friend and admirer of the Pre-Raphaelites, but they only partially influenced his very eclectic style of art, which was pervaded by echoes of Symbolism, memories of Java, the perversity of Ensor and Beardsley, as well as by Catholic spirituality.

Una E. Johnson, *Ambroise Vollard, Editeur: Prints, Books, Bronzes*, The Museum of Modern Art, New York 1977.

Toulouse-Lautrec, Henri de (1864–1901). French painter, draftsman, engraver, and lithographer. His style, which was both precise and influenced by the arabesque, his bold use of color, and his formal originality all revolutionized the techniques of poster art and make him one of the greatest figures in the history of European lithography.

Loys Delteil, *Le Peintre-graveur illustré: Toulouse-Lautrec*, 2 vols., Paris 1920.

Jean Adhémar, *Toulouse-Lautrec: lithographies et pointes-sèches*, Paris 1965.

Traviès de Villers, Charles-Joseph (1804–1859). French draftsman and lithographer. He worked on *La Caricature* and *Le Charivari* and was highly praised by Baudelaire.

Vallotton, Félix (1865–1925). Swiss painter, wood engraver, and lithographer. He was greatly attracted by the Post-Impressionist works of Seurat, but later developed a style that tended toward deformation and a technique that some people see as anticipating Picasso. His graphic oeuvre grafted a series of fantastical and evocative distortions onto a precisely perceived realism.

M. Vallotton and Ch. Goerg, *Félix Vallotton—catalogue raisonné de l'oeuvre gravé et lithographié*, Geneva 1972.

Velde, Henry van de (1863–1948). Belgian architect and painter. He was one of the most important exponents of Art Nouveau, particularly in the realm of architecture, and his graphic oeuvre also tends to rationalize the decorativism of that style.

Vertès, Marcel (1895–1961). Hungarian painter, engraver, and lithographer. He worked in Paris and then in the United States, and created numerous albums of lithographs dedicated to views of Paris.

Bibliographies de Marcel Vertès, Preface de Claude Roger-Marx, Brussels 1967.

Villon, Jacques (Gaston Duchamp; 1875–1963). French painter and lithographer who synthesized the colorism of the Fauves and the structuralism of the Cubists. He then progressed toward an increasingly abstract and lyrical decomposition of shapes and surfaces.

C. Ginestet and C. Pouillon, *Jacques Villon—les estampes et les illustrations*, Paris 1979.

Vlaminck, Maurice de (1876–1958). French painter, writer, and lithographer. After having championed the cause of the Neo-Impressionists he drew closer to the Fauves, being particularly influenced by Matisse. He used strong colors and ignored tonal conventions, especially in his landscapes, which reveal remarkably close attention to the effects of light.

Katalin de Walterskirchen, *Maurice de Vlaminck —catalogue raisonné de l'oeuvre gravé*, Bern and Paris 1974.

Vuillard, Edouard (1868–1940). French painter and lithographer. A friend of Bonnard, he sided actively with the Nabis, but soon turned independently toward that decoratively rhythmical *intimisme* that underlies the best of his oeuvre. He also worked as a theatrical designer.

Claude Roger-Marx, *L'Oeuvre gravé de Vuillard*, Monte Carlo 1948

Whistler, James Abbott McNeill (1834–1903). American painter, draftsman, and lithographer. He lived in Europe from childhood, residing for a long time in Paris, where he frequented the same circles as Fantin-Latour, Courbet, the Impressionists, and Baudelaire. The tenor of his painting reflects the great importance he placed on color, as well as traces of exotic influences. His refined tonal decorativism anticipated the mood of Art Nouveau.

Mervyn Levy, *Whistler Lithographs—A Catalogue Raisonné*, London 1975.

Wildt, Adolfo (1868–1931). Italian sculptor and lithographer. In his sculpture and his graphics he developed a very meticulous style linked to a strictly controlled display of technical virtuosity. He evolved a method of concentrated plastic expression based on smooth materials and uncluttered lines that gave rise to a formalism very similar to Art Nouveau.

BIBLIOGRAPHY

Even a much abbreviated bibliography of those artists who, during the course of almost two centuries, have contributed to original lithography would call for several dozen pages and would lie beyond the scope of this book; we have therefore restricted ourselves to a recommendation of certain general works.

Senefelder, Aloys. *A Complete Course of Lithography.* London, 1819.

Camillo, Doyen. ''Litografia,'' in *Enciclopedia della Arti e Industrie*, Issue 32. Turin, 1885.

Calabi, Augusto. *Saggio sulla litografia italiana.* Milan, 1931.

Vollard, Ambroise. *Souvenirs d'un marchand de tableaux.* Paris, 1937.

Gombrich, Ernst H. *The Story of Art.* London, 1950.

Mourlot, Fernand. *Picasso lithographe.* Monte Carlo, 1950.

Vallentin, Antonina. *Goya.* Paris, 1950.

Laran, Jean. *L'Estampe.* Paris, 1959.

Mathey, François. *Les Impressionistes et leur temps.* Paris, 1959.

Moreau, Luc-Albert. *Eloge de la lithographie.* Paris, 1960.

Weber, Wilhelm. *Histoire de la lithographie.* Paris, 1960.

Dorfles, Gillo. *Ultime tendenze nell'arte d'oggi.* Milan, 1961.

Meyer, Franz. *Marc Chagall.* Cologne, 1961.

Mittner, Ladislao. *L'espressionismo.* Bari, 1965.

Waldberg, Patrick. *Chemins du surréalisme.* Cologne, 1965.

Tschudi Madsen, S. *Art Nouveau.* Paris, 1967.

McGraw-Hill Dictionary of Art. New York, 1969.

Apollonio, Umbro. *Futurismo.* Cologne, 1970.

Antreasian, Garo Z., and Adams, Clinton. *The Tamarind Book of Lithography: Art and Techniques.* New York, 1971.

Gray, Camilla. *The Russian Experiment in Art 1863–1922.* London, 1971.

Nochlin, Linda. *Realism.* London, 1971.

Lucie-Smith, Edward. *Symbolist Art.* London, 1972.

Melot, Michel. *L'Oeil qui rit, le pouvoir comique des images.* Freiburg, 1975.

Phaidon Dictionary of Twentieth-century Art. Oxford, 1975.

Donson, Theodore B. *Prints and the Print Market.* New York, 1977.

Eichenberg, Fritz. *Masterpieces of Lithography and Silkscreen, Art and Technique.* London, 1978.

Adhémar, Jean. *La Gravure des origines à nos jours.* Paris, 1979.

Harthan, John. *The Illustrated Book.* London, 1981.

INDEX OF ILLUSTRATIONS

The dimensions of the lithographs, taken along the outside edge of the image, are expressed in millimeters and inches (width × height).

Clavé, Anthoni, lithograph for *Candide* by Voltaire, 1948. Paris, Bibliothèque Nationale.

Combaz, Gisbert, *La Libre esthétique*, 1899 (430 × 735 mm., 16⅞ × 28⅞″). Paris, Musée de l'Affiche.

Corot, Jean-Baptiste-Camille, *Cuincy Mill, near Douai*, 1871 (259 × 211 mm., 10¼ × 8¼″). Paris, Bibliothèque Nationale.

Crane, Walter, *Dancer*, 1894 (272 × 434 mm., 10¾ × 17⅛″). Milan, Il Mercante di Stampe.

Cross, *The Walk*, 1897 (411 × 284 mm., 16⅛ × 11⅛″). New York, Museum of Modern Art, Purchase Fund.

Currier & Ives, *"Wooding up" on the Mississippi*, 1863 (526 × 343 mm., 20¾ × 13½″). Centro Documentazione Mondadori.

Curry, John Steuart, *Mississippi Noah* (Plate II), 1935 (349 × 250 mm., 13¾ × 9⅞″). Print Collection (Art, Prints and Photographs Division), The New York Public Library, Astor, Lenox and Tilden Foundations.

Daumier, Honoré, *Nadar raising photography to the level of art*, 1861 (222 × 272 mm., 8¾ × 10¾″). Paris, Bibliothèque Nationale.
The legislative belly, 1834 (431 × 280 mm., 17 × 11″). Paris, Bibliothèque Nationale.
The Rue Transnonain, 1834 (445 × 290 mm., 17½ × 11⅜″). Paris, Bibliothèque Nationale.
The Banker, 1836 (176 × 238 mm., 6⅞ × 9⅜″). Paris, Bibliothèque Nationale.

Decamps, Alexandre-Gabriel, *Landscape*, 1830. Paris, Bibliothèque Nationale.

De Chirico, Giorgio, *Villa on the Sea*, 1929 (402 × 304 mm., 15⅞ × 12″). Milan, Private Collection.
The Archaeologists IV, 1929 (300 × 401 mm., 11¾ × 15¾″). Milan, Private Collection.
Lithography for *Calligrammes* by Guillaume Apollinaire, 1930 (158 × 159 mm., 6¼ × 6¼″). Paris, Bibliothèque Nationale.

De Feure, Georges, *Return*, 1897 (255 × 327 mm., 10 × 12⅞″). Milan, Il Mercante di Stampe.

Degas, Edgar, *The Song of the Dog*, c. 1879 (230 × 352 mm., 9 × 13⅞″). Paris, Bibliothèque Nationale.

Leaving the Bath (large plate), c. 1890 (301 × 280 mm., 11⅞ × 11″). Paris, Bibliothèque Nationale.

Delacroix, Eugène, *Wild Horse*, 1828 (225 × 237 mm., 8⅞ × 9¼″). Paris, Bibliothèque Nationale.
Royal Tiger, 1829 (465 × 326 mm., 18¼ × 12⅞″). Paris, Bibliothèque Nationale.
Baron Schwiter, 1826 (194 × 219 mm., 7⅝ × 8⅝″). Paris, Bibliothèque Nationale.
Mephistopheles in the Air, lithograph for *Faust* by Goethe, 1828 (230 × 270 mm., 9 × 10⅝″). Paris, Bibliothèque Nationale.

Delaunay, Robert, *Window on the Town*, 1909–25 (495 × 650 mm., 19½ × 25⅝″). Milan, Fabio Castelli Collection.

Delvaux, Paul, *Païolive*, 1975 (785 × 590 mm., 30⅞ × 23¼″). Milan, Fabio Castelli Collection.

Denis, Maurice, *On the Pale Silver Sofa*, 1898 (285 × 401 mm., 11¼ × 15¾″). New York, Brooklyn Museum.
The Reflection in the Fountain, 1897 (240 × 400 mm., 9⅜ × 15¾″). New York, Museum of Modern Art, Purchase Fund.

Devéria, Achille, *Victor Hugo*, 1829. Paris, Bibliothèque Nationale.

Dix, Otto, *Dame mit Reiher*, 1923 (275 × 380 mm., 10⅞ × 15″). Berlin, Kupferstichkabinett, Staatliche Museen Preussischer Kulturbesitz.
Procuress, 1923 (368 × 483 mm., 14½ × 19″). Munich, Bayerische Staatsgemäldesammlung, Gift of Sofie and Emanuel Fohn.

Doré, Gustave, *Hosannah! Voici les osanores!*, 1849. Paris, Bibliothèque Nationale.

Dubuffet, Jean, *Man Eating a Small Stone*, 1944 (240 × 320 mm., 9⅜ × 12⅝″). Milan, Il Mercante di Stampe.

Dudovich, Marcello, *Mele & C. Mode-Novità*, c. 1908 (1450 × 2000 mm., 57 × 78¾″). Milan, Civica Raccolta di Stampe A. Bertarelli.

Dufy, Raoul, *The Sea: Amphytrite's Procession or Marseilles Harbor*, 1925 (460 × 360 mm., 18⅛ × 14⅛″). Paris, Bibliothèque Nationale.

Dupré, Jules, *Views Taken at Alençon*, 1839 (190 × 136 mm., 7½ × 5⅜″). Paris, Bibliothèque Nationale.

Engelmann, Godefroy, *Bowl of Fruit with Two Birds*. Paris, Bibliothèque Nationale.

Ensor, James, *The Vengeance of Hop Frog*, 1898 (265 × 377 mm., 10⅜ × 14⅞″). Brussels, Bibliothèque Royale Albert Ier, Cabinet des Estampes.

Ernst, Max, *Ernst (*from *Fiat Modes pereat ars*, Plate I), 1919 (320 × 437 mm., 12⅝ × 17¼″). Milan, Il Mercante di Stampe.
Owl, 1955 (362 × 490 mm., 14¼ × 19¼″). New York, Museum of Modern Art, James Thrall Soby Fund.

Evenepoel, Henri, *In the Square*, 1897 (230 × 330 mm., 9 × 13″). Paris, Bibliothèque Nationale.

Fanoli, Michele, *Remembrance*, 1833. Milan, Civica Raccolta di Stampe A. Bertarelli.

Fantin-Latour, Henri, *Sara the Bather*, 1892 (265 × 346 mm., 10⅜ × 13⅝″). Milan, Fabio Castelli Collection.

Feininger, Lyonel, *Off the Coast*, Plate I, 1950 (394 × 230 mm., 15½ × 9″). New York, Museum of Modern Art, Gift of the artist and his wife.

Felixmüller, Conrad, *The Whirling Ones*, 1919 (430 × 660 mm., 16⅞ × 26″). Munich, Staatliche Graphische Sammlung.

Fontana, Lucio, *Composition*, c. 1960 (330 × 490 mm., 13 × 19¼″). Milan, Private Collection.

Forain, Jean-Louis, lithograph for *The Private Dining Room*, 1892. Paris, Bibliothèque Nationale.

Francis, Sam, *The White Line*, 1960 (631 × 908 mm., 24⅞ × 35¾″). Milan, Il Mercante di Stampe.

Gauguin, Paul, *Manao Tupapu*, 1894 (271 × 180 mm., 10⅝ × 7⅛″). Paris, Bibliothèque Nationale.

Gavarni, Paul, *Monsieur in the Kitchen, Madame at the Piano*, 1843. Paris, Bibliothèque Nationale.
A fanfare for you . . . strolling musicians, 1853. Paris, Bibliothèque Nationale.

Géricault, Théodore, *Boxers*, 1818 (416 × 352 mm., 16⅜ × 13⅞″). Paris, Bibliothèque Nationale.
The Flemish Farrier, 1821 (315 × 230 mm., 12⅜ × 9″). Paris, Bibliothèque Nationale.

Giacometti, Alberto, *Interior*, 1965 (498 × 669 mm., 19⅝ × 26⅜″). Milan, Fabio Castelli Collection.

Goerg, Edouard, lithograph for *Les Fleurs du mal* by Charles Baudelaire, Plate I, 1947 and 1952. Paris, Bibliothèque Nationale.

Goncharova, Natalia, *Female Half-figure*, 1922–23 (250 × 360 mm., 9⅞ × 14⅛"). Berlin, Bauhaus-Archiv für Gestaltung.

Gould, John, *Goosander* (from the series *Birds of Europe*), 1832–37 (440 × 290 mm., 17⅜ × 11⅜"). Milan, Il Mercante di Stampe.

Goya y Lucientes, Francisco, *The Famous American, Mariano Ceballos* (from the *Bulls of Bordeaux*), 1825 (400 × 305 mm., 15¾ × 12"). Washington, D.C., National Gallery of Art, Rosenwald Collection.
 Brave Bull (from the *Bulls of Bordeaux*), 1825 (410 × 305 mm., 16⅛ × 12"). New York, Metropolitan Museum of Art, Rogers Fund.
 The Divided Arena (from the *Bulls of Bordeaux*), 1825 (415 × 300 mm., 16⅜ × 11¾"). Washington, D.C., National Gallery of Art, Rosenwald Collection.
 The Entertainment of Spain (from the *Bulls of Bordeaux*), 1825 (415 × 300 mm., 16⅜ × 11¾"). Washington, D.C., National Gallery of Art, Rosenwald Collection.

Grasset, Eugène, *The Morphine Addict*, 1897 (355 × 470 mm., 14 × 18½"). Paris, Bibliothèque Nationale.

Gris, Juan, lithograph for *Denise* by Raymond Radiguet, 1926. Paris, Bibliothèque Nationale.

Grosz, Georg, *Veiled Lady*, 1914–15 (181 × 266 mm., 7⅛ × 10½"). New York, Museum of Modern Art.

Hayez, Francesco, *Magdalene*, 1822. Milan, Civica Raccolta di Stampe A. Bertarelli.

Heckel, Erich, *Handstand*, 1916 (196 × 279 mm., 7¾ × 11"). Munich, Staatliche Graphische Sammlung.

Heine, Thomas Theodor, *Simplicissimus*, 1897. Centro Documentazione Mondadori.

Hockney, David, *Celia Smoking*, 1973 (470 × 800 mm., 18½ × 31½"). Milan, Fabio Castelli Collection.

Hofer, Karl, *Two Girl Friends*, 1923 (173 × 271 mm., 6¾ × 10⅝"). Milan, Il Mercante di Stampe.

Hohenstein, Adolfo, *Esposizione d'igiene*, 1900. Centro Documentazione Mondadori.

Hohlwein, Ludwig, *Confection Kehl*. Centro Documentazione Mondadori.

Huet, Paul, *The Marshal's House*, 1829 (164 × 111 mm., 6½ × 4⅜"). Paris, Bibliothèque Nationale.

Isabey, Jean-Baptiste, *The Leaning Tower*, 1822. Paris, Bibliothèque Nationale.

Jawlensky, Alexei, *Head*, 1922 (124 × 177 mm., 4⅞ × 7"). Berlin, Bauhaus-Archiv Museum für Gestaltung.

Johns, Jasper, *Light Bulb*, 1976 (432 × 356 mm., 17 × 14"). Milan, Il Mercante di Stampe.

Jones, Allen, *Concerning Marriages*, Plate II, 1964 (560 × 760 mm., 22 × 29⅞"). Milan, Fabio Castelli Collection.

Jorn, Asger, *On the Golden Bridge (Intimacies)*, 1969 (560 × 785 mm., 22 × 30⅞"). Milan, Fabio Castelli Collection.

Kandinsky, Wassily, *Lithograph for the Fourth Bauhaus Portfolio*, 1922 (240 × 278 mm., 9⅜ × 11"). Print Collection (Art, Prints and Photographs Division), The New York Public Library, Astor, Lenox and Tilden Foundations.
 Orange, 1923 (405 × 382 mm., 16 × 15"). Print Collection (Art, Prints and Photographs Division), The New York Public Library, Astor, Lenox and Tilden Foundations.

Kauffer, E. McKnight, 1918 poster praising the dynamics of flight. Centro Documentazione Mondadori.

Kent, Rockwell, *Workmen Lowering Pipe Section into a Ditch*, 1941 (328 × 232 mm., 12⅞ × 9⅛"). Philadelphia Museum of Art: Lola Downin Peck Fund from the Carl and Laura Zigrosser Collection.

Kirchner, Ernst Ludwig, *Billiard Players*, 1915 (500 × 590 mm., 19⅝ × 23¼"). Frankfurt-am-Main, Städelsches Kunstinstitut, On loan from the Adolf and Louise Haeuser Foundation.

Klee, Paul, *Bird Comedy*, 1918 (215 × 425 mm., 8½ × 16¾"). New York, Museum of Modern Art.

Kokoschka, Oskar, *Pietà*, 1908 (795 × 1220 mm., 31¼ × 48"). Vienna, Albertina, Graphische Sammlung, © 1982 by Cosmopress, Geneva.

Kolbe, Georg, *Female Nude*, 1921 (445 × 350 mm., 17½ × 13¾"). Imperia, Neri-Valcado Collection.

Kollwitz, Käthe, *Self-portrait*, 1924. Munich, Staatliche Graphische Sammlung.
 Death on the Main Road, 1934 (535 × 645 mm., 21 × 25⅜"). Munich, Staatliche Graphische Sammlung.

Léger, Fernand, *The Vase*, 1927 (434 × 535 mm., 17⅛ × 21"). Milan, Fabio Castelli Collection.

Liebermann, Max, *Portrait of Theodor Fontane*, 1896 (220 × 266 mm., 8⅝ × 10½"). Milan, Il Mercante di Stampe.

Lissitzky, El, *Announcer*, 1923 (275 × 350 mm., 10⅞ × 13¾"). Milan, Fabio Castelli Collection.

Longhi, Giuseppe, *Susanna and the Elders*, 1821. Milan, Civica Raccolta di Stampe A. Bertarelli.
 Portrait of a Woman, 1808. Milan, Civica Raccolta di Stampe A. Bertarelli.

Lunois, Alexandre, *The Fancy-goods Store*, 1903 (540 × 460 mm., 21¼ × 18⅛"). Milan, Il Mercante di Stampe.

Magnelli, Alberto, *Composition with Red*, 1965. Milan, Galleria dell'Incisione.

Maillol, Aristide, lithograph for *Ars Amatoria* by Ovid, 1935. Paris, Bibliothèque Nationale.

Malevich, Kasimir, *Dinamonaturshshik*, 1911 (99 × 186 mm., 3⅞ × 7⅜"). Milan, Il Mercante di Stampe.

Manet, Edouard, *Punchinello*, 1876 (335 × 462 mm., 13⅛ × 18⅛"). Paris, Bibliothèque Nationale.
 The Races, 1864 (510 × 365 mm., 20⅛ × 14⅜"). Paris, Bibliothèque Nationale.
 The Barricade, 1871 (333 × 460 mm., 13⅛ × 18⅛"). Paris, Bibliothèque Nationale.
 Civil War, 1871 (505 × 394 mm., 19⅞ × 15½"). New York, Metropolitan Museum of Art, Rogers Fund.
 At the Window, lithograph for *The Raven* by Edgar Allan Poe, 1875 (300 × 385 mm., 11¾ × 15⅛"). Paris, Bibliothèque Nationale.

Manzù, Giacomo, *Woman Weeping*, 1954 (245 × 330 mm., 9⅝ × 13"). Milan, Private Collection.

Marini, Marino, *Acrobat*, 1956 (470 × 625 mm., 18½ × 24⅝"). Milan, Museo d'Arte Moderna.

Marsh, Reginald, *Switch Engines, Erie Yards, Jersey City* (Stone No. 3), 1948 (330 × 228 mm., 13 × 9"). Print Collection (Art, Prints and Photographs

Division), The New York Public Library, Astor, Lenox and Tilden Foundations.

Martini, Alberto, *The Kiss I*, 1915 (271 × 362 mm., 10⅝ × 14¼"). Milan, Il Mercante di Stampe.

Masson, André, *Fragment d'un féminaire*, 1955 (487 × 402 mm., 19⅛ × 15⅞"). Paris, Bibliothèque Nationale.

Matisse, Henri, *Nude on a Sofa, Her Arms Raised*, 1925 (480 × 630 mm., 18⅞ × 24¾"). Milan, Fabio Castelli Collection.
 Odalisque in Dancing Girl's Trousers, 1925 (440 × 545 mm., 17⅜ × 21½"). Paris, Bibliothèque Nationale.

Mazza, Aldo, *Corse a S. Siro*, 1909 (955 × 2060 mm., 37⅝ × 81⅛"). Milan, Civica Raccolta di Stampe A. Bertarelli.

Miró, Joan, *Palotin Giron*, 1955 (560 × 760 mm., 22 × 29⅞"). Milan, Fabio Castelli Collection.
 Barcelona, 1944. Milan, Il Mercante di Stampe.

Moholy-Nagy, László, *Construction* (from *The Kestner Portfolio*, VI), 1923 (220 × 422 mm., 8⅝ × 16⅝"). Berlin, Bauhaus-Archiv Museum für Gestaltung.

Monnier, Henri, *Burial of the People*. Paris, Bibliothèque Nationale.

Moore, Henry, *People of Clay*, 1950 (285 × 380 mm., 11¼ × 15"). Milan, Fabio Castelli Collection.

Moreau, Luc-Albert, *Cagibi de mannequins*, 1926 (278 × 393 mm., 11 × 15½"). Milan, Il Mercante di Stampe.
 Lithograph for *Physiologie de la boxe* by E. Des Courières and Henri de Montherlant, 1929 (290 × 410 mm., 11⅜ × 16½"—dimensions of book). Paris, Bibliothèque Nationale.

Mucha, Alphonse, *The Morning's Awakening, The Brightness of Day, The Evening's Reverie, The Night's Repose*, 1899 (365 × 1015 mm., 14⅜ × 40"—all four lithographs are of the same size). Paris, Bibliothèque Nationale.
 La Dame aux Camélias, Sarah Bernhardt, 1896 (762 × 2073 mm., 30 × 81⅝") Paris, Musée de l'Affiche.

Müller, Otto, *Two Girls in the Dunes, One Sitting and One Lying Down*, 1920 (392 × 297 mm., 15⅜ × 11⅝"). Milan, Fabio Castelli Collection.

Munch, Edvard, *The Sick Room*, 1896 (540 × 400 mm., 21¼ × 15¾"). Oslo, Munch-Museet.
 The Scream, 1895 (252 × 350 mm., 9⅞ × 13¾"). Oslo, Munch-Museet.
 The Lovers, 1896 (420 × 310 mm., 16½ × 12¼"). Oslo, Munch-Museet.
 Jealousy, 1896 (565 × 465 mm., 22¼ × 18¼"). Oslo, Munch-Museet.

Nash, Paul, *The Sluice*, 1920. Milan, Private Collection.

Nevinson, Christopher Richard Wynne, *Acetylene Welder*, 1917 (295 × 403 mm., 11⅝ × 15⅞"). Milan, Il Mercante di Stampe.

Nolde, Emil, *Gloomy Man's Head*, 1907. Berlin, Kupferstichkabinett, Staatliche Museen Preussischer Kulturbesitz.

Orazi, Manuel, *Théâtre de Loïe Fuller*, 1900 (650 × 1985 mm., 25⅝ × 78⅛"). Centro Documentazione Mondadori.

Orozco, José Clemente, *Rearguard*, 1929 (356 × 477 mm., 14 × 13¾"). New York, Museum of Modern Art, Gift of Abby Aldrich Rockefeller.

Il Pappagallo, How fear reduces people!, satirical cartoon from Issue I, 1 November 1848 (185 × 115 mm., 7¼ × 4½"). Milan, Museo del Risorgimento.

Pechstein, Max Hermann, *Bathers*, 1921 (240 × 320 mm., 9½ × 12⅝"). Milan, Private Collection.

Picasso, Pablo, *Table with Fish*, 1948 (700 × 545 mm., 27½ × 21½"). Milan, Fabio Castelli Collection.
 Lithograph for *Le Chant des morts* by Pierre Reverdy, 1948 (320 × 420 mm., 12⅝ × 16½"). Paris, Bibliothèque Nationale.

Pigal, Edme-Jean, *In everything one must consider the end*. Paris, Bibliothèque Nationale.

Pissarro, Camille, *Women Carrying Kindling Wood*, 1896 (300 × 229 mm., 11¾ × 9"). Berlin, Kupferstichkabinett, Staatliche Museen Preussischer Kulturbesitz.

Poliakoff, Serge, *Yellow Composition*, 1965 (475 × 630 mm., 18¾ × 24¾"). Milan, Il Mercante di Stampe.

Prampolini, Enrico, *Théâtre de la pantomine futuriste* (565 × 760 mm., 22¼ × 29⅞"). Milan, Civica Raccolta di Stampe A. Bertarelli.

Raffet, Auguste, *The Retreat of the Battalion Sacré at Waterloo*, 1835 (330 × 250 mm., 13 × 9⅞"). Paris, Bibliothèque Nationale.

Rauschenberg, Robert, *Test Stone 2 (Booster and 7 Studies)*, 1967 (630 × 800 mm., 24⅞ × 31½"). Milan, Fabio Castelli Collection.

Redon, Odilon, *Beatrice*, 1897 (295 × 335 mm., 11⅝ × 13⅛"). New York, Museum of Modern Art, Gift of Abby Aldrich Rockefeller.
 Anthony: What is the point of all that?—The Devil: There is no point (from *La Tentation de Saint Antoine*, III series), 1896 (250 × 311 mm., 9⅞ × 12¼"). New York, Museum of Modern Art.

Renoir, Auguste, *The Pinned Hat*, Plate II, 1898 (488 × 600 mm., 19 × 23"). New York, Museum of Modern Art, Lillie P. Bliss Collection.

Rivière, Henri, *In the Northwest Wind: The Old Men*, 1906–19 (500 × 376 mm., 19⅝ × 14¾"). Milan, Il Mercante di Stampe.

Rops, Félicien, *The New Year's Gift*, 1857 (243 × 325 mm., 9½ × 12¾"). Milan, Il Mercante di Stampe.

Rouault, Georges, *Autumn*, 1927–33 (570 × 430 mm., 22½ × 16¾"). New York, Museum of Modern Art.
 Portrait of Verlaine, 1926–33 (320 × 425 mm., 12⅝ × 16¾"). New York, Museum of Modern Art.

Roussel, Ker-Xavier, *Woman in Striped Dress*, c. 1900 (320 × 214 mm., 12⅝ × 8⅜"). New York, Museum of Modern Art, Abby Aldrich Rockefeller Fund.

Rysselberghe, Théo van, *On the Jetty*, 1899 (422 × 245 mm., 16⅝ × 9⅝"). Milan, Private Collection.

Savinio, Alberto, lithograph for *Clandestine Lottery*, 1948. Milan, Fabio Castelli Collection.

Schiele, Egon, *Male Nude*, 1912 (215 × 420 mm., 8½ × 16½"). Milan, Private Collection.

Schlemmer, Oskar, *Head in Profile with Black Outline*, 1920–21 (139 × 197 mm., 5½ × 7¾"). Berlin, Bauhaus-Archiv Museum für Gestaltung.

Schmidt-Rottluff, Karl, *Head*, 1921 (225 × 287 mm., 8⅞ × 11¼"). Munich, Galerie Michael Pabst.

Schnackenberg, Walter, *Odéon Casino*, c. 1925. Paris, Musée de l'Affiche.

Severini, Gino, *Spanish Dance*, 1960–61. Milan, Fabio Castelli Collection.

Sheeler, Charles, *Delmonico Building*, 1927 (176 × 246 mm., 6⅞ × 9⅝″). New York, Metropolitan Museum of Art, John B. Turner Fund 1968.

Signac, Paul, *Application of Mr. Ch. Henry's Chromatic Circle*, 1888 (180 × 155 mm., 7⅛ × 6⅛″). Milan, Il Mercante di Stampe.
Saint-Tropez: The Harbor, 1897–98 (330 × 435 mm., 13 × 17⅛″). Paris, Archives Paul Prouté S.A.
Demolition Workers, 1896 (305 × 470 mm., 12 × 18½″). Paris, Bibliothèque Nationale.

Siqueiros, David Alfaro, *Zapata*, 1930. New York, Metropolitan Museum of Art, Gift of Jean Charlot 1931.

Sironi, Mario, *Country*, Plate XV, 1930–31 (185 × 174 mm., 7¼ × 6⅞″). Milan, Il Mercante di Stampe.

Sisley, Alfred, *The Riverside*, or *The Geese*, 1897 (320 × 212 mm., 12⅝ × 8⅜″). Paris, Bibliothèque Nationale.

Sloan, John, *Saturday Afternoon on the Roof*, 1919 (326 × 268 mm., 12⅞ × 10½″). Print Collection (Art, Prints and Photographs Division), The New York Public Library, Astor, Lenox and Tilden Foundations.

Steinlen, Théophile-Alexandre, *Full-face Portrait of Maxim Gorky*, 1905 (505 × 602 mm., 19⅞ × 23¾″). Milan, Il Mercante di Stampe.
Tramway Interior, 1896 (345 × 265 mm., 13⅝ × 10⅜″). Milan, Il Mercante di Stampe.
Coming out of the mine, 1907 (430 × 253 mm., 16⅞ × 10″). Paris, Bibliothèque Nationale.

Strixner, Nepomuk, frontispiece and a plate from *Albrecht Dürers Christlich-Mythologische Handzeichnungen*, a lithographic album dedicated to Dürer (1808). Milan, Civica Raccolta di Stampe A. Bertarelli.

Sutherland, Graham, *Predatory Form*, 1953 (540 × 755 mm., 21¼ × 29¾″). London, British Museum.

Toorop, Jan Theodor, *The Lady of the Swans*, 1896 (334 × 220 mm., 13⅛ × 8⅝″). New York, Museum of Modern Art.

Toulouse-Lautrec, Henri de, *The Englishman Warener at the Moulin Rouge*, 1892 (372 × 470 mm., 14⅝ × 18½″). Paris, Bibliothèque Nationale, Lauros-Giraudon.
An Old Song (Yvette Guilbert, English Suite), 1898 (240 × 295 mm., 9½ ×

11⅝″). Milan, Il Mercante di Stampe.
Half-length Portrait of Lender Greeting an Acquaintance, 1895 (240 × 325 mm., 9½ × 12¾″). Milan, Private Collection.
La Goulue at the Moulin Rouge, 1891 (1220 × 1950 mm., 48 × 76¾″). Paris, Musée de l'Affiche, CFL-Giraudon.

Traviès de Villers, Charles-Joseph, *Face it!* Paris, Bibliothèque Nationale.

Vallotton, Félix, *The Downpour* (from *Paris intense, VII*), 1894 (313 × 227 mm., 12⅜ × 8⅞″). Geneva, Musée d'Art et d'Histoire, Cabinet des Estampes.
That one there?...He shouted Long Live Liberty!, 1901 (202 × 269 mm., 8 × 10⅝″). Milan, Il Mercante di Stampe.

Velde, Henry van de, *Tropon*, c. 1897. Centro Documentazione Mondadori.

Vertès, Marcel, *Houses...*, c. 1925 (305 × 235 mm., 12 × 9¼″). Milan, Il Mercante di Stampe.

Villon, Jacques, *Virgilius Maro*, 1953 (200 × 280 mm., 7⅞ × 11″). Paris, Bibliothèque Nationale.

Vlaminck, Maurice de, *Bowl of Fruit*, 1921 (640 × 475 mm., 25¼ × 18¾″). Milan, Il Mercante di Stampe.

Vuillard, Edouard, *The Avenue*, 1899 (410 × 310 mm., 16⅛ × 12¼″). Paris, Bibliothèque Nationale.
The Pâtisserie, 1899 (270 × 355 mm., 10⅝ × 14″). Paris, Bibliothèque Nationale.
Intimacy, c. 1895 (190 × 260 mm., 7½ × 10¼″). Paris, Bibliothèque Nationale.

Whistler, James Abbott McNeill, *Stéphane Mallarmé*, 1894 (70 × 95 mm., 2¾ × 3¾″). Paris, Bibliothèque Nationale.
The Steps, 1893 (157 × 205 mm., 6¼ × 8″). London, British Museum.
The Draped Figure—Seated, 1893 (160 × 180 mm., 6¼ × 7⅛″). London, British Museum.

Wildt, Adolfo, *Sudarium*, 1929 (260 × 347 mm., 10¼ × 13⅝″). Milan, Fabio Castelli Collection.

INDEX OF NAMES

The numbers in italics refer to captions.

SOURCES OF ILLUSTRATIONS

Collections

ADAGP, Paris : 204.
Adant, Hélène : 187 left.
Albertina, Graphische Sammlung, Vienna :
190.
Archives Paul Prouté S.A., Paris : 81, 132.
Atelier Mourlot : 182, 187 right.
Bauhaus-Archiv Museum für Gestaltung,
Berlin : 142, 143, 146.
Bayerische Staatsgemaeldesammlung,
Munich : 125.
Biblioteca Sormani, Milan : 236.
Bibliothèque Nationale, Paris : 2, 10, 11,
12, 14, 17, 18 left, 19, 20, 34 right, 36 top
left, 39, 52, 54, 55, 57, 58, 59, 60, 62, 63,
66, 67, 68, 78, 79, 82, 86 top, 88, 89, 92,
99, 100, 105, 108, 109, 135, 138, 159 top,
170 bottom, 206, 208, 210, 211, 212, 213
top and bottom left, 216 bottom, 222,
224, 225, 226, 230, 231, 232, 233, 235,
237.
Bibliothèque Royale Albert Ier, Cabinet
des Estampes, Brussels : 75.
British Museum, London : 18 right, 103,
173, 209.
Brooklyn Museum, New York : 48.
Centro Documentazione Mondadori : 34
left, 37, 192 right, 195, 196, 198 top left
and bottom, 199, 202 left.
Civica Raccolta di Stampe A. Bertarelli,
Milan : 22, 24, 25, 26, 27, 28, 29, 31, 41,
42, 45, 46, 180 bottom, 202 right, 203, 205
left, 240, 243, 247, 248, 249, 251, 256,
257.
Collezione Fabio Castelli, Milan : 6, 65, 71,
72, 123, 126, 129, 130, 133, 134, 139, 147,
149, 153, 155, 160, 162, 164 bottom left,
168, 170 top, 171, 172, 175, 176, 177 top,
179.
Collezione Ner-Valcado, Imperia : 122
bottom.

Collezione Ricordi, Milan : 200.
Galerie Patrick Cramer, Geneva : 156.
Galerie Michael Pabst, Munich : 119 bottom
right.
Galleria dell'Incisione, Milan : 169.
Hessisches Landesmuseum, Darmstadt :
198 bottom right.
Kupferstichkabinett, Staatliche Museen
Preussischer Kulturbesitz, Berlin : 98
bottom, 113, 124 right.
Library of Congress, Washington : 197.
Mercante di Stampe, Milan : 36 bottom left,
73, 76, 77, 80 top, 84, 91, 96, 98 top, 101,
104 bottom, 106, 107, 116, 118, 119 top
right, 122 top right, 128 bottom left, 129,
137 bottom, 140 right, 141, 142 bottom
right, 150, 151, 154, 161, 163, 164 bottom
right, 174, 177 bottom, 181 right, 214,
216 top, 217, 221, 233 right.
Metropolitan Museum of Art, New York :
128 bottom right, 218.
Munch-Museet, Oslo : 110, 111, 112.
Musée d'Art et d'Histoire, Cabinet des
Estampes, Geneva : 86 bottom.
Musée de l'Affiche, Paris : 192 top left,
193, 194, 195 left, 198 top right, 201, 204
right, 205.
Musée Toulouse-Lautrec, Albi (photograph
Lauros-Giraudon) : 2.
Museo d'Arte Moderna, Milan : 167.
Museo del Risorgimento, Milan : 213 bottom
right.
Museum of Modern Art, New York : 8, 69,
74, 80 bottom, 90, 94, 95, 97, 104 top, 124
left, 128 bottom right, 136, 137 top, 140
left, 157, 158, 159 bottom, 180 top, 218,
219.
National Gallery of Art, Washington, D.C. :
50 top, 51.
New York Public Library, Astor, Lenox

and Tilden Foundations : 93, 127, 131,
144, 145.
Philadephia Museum of Art : 128 top.
Private collection, Paris : 91, 138.
Private collections, Milan : 85, 102, 115,
122 top left, 164 top, 165, 166, 181 left.
Staatliche Graphische Sammlung, Munich :
117, 119 left and top right, 120, 220.
Staatliches Museum, Dresden (photograph
CFL-Giraudon) : 193.
Staatsgalerie, Stuttgart : 146, 198 bottom
left.
Städelsches Kunstinstitut, Frankfurt am
Main : 121.

Photography Credits

Adant, Hélène : 187 left.
Anders, J. P. : 98 bottom, 113, 124 right.
Atelier Grivel, Geneva : 156.
Blaudel, Munich : 125.
CFL-Giraudon, Paris : 193.
Cosmopress, Geneva : 190.
Lauros-Giraudon, Paris : 2.
Mali, Olatuni : 8, 80 bottom, 94, 95, 97.
Mori, Walter : 6, 36 bottom left, 65, 71, 72,
73, 76, 77, 80 top, 84, 85, 96, 98 top, 101,
102, 104 bottom, 106, 107, 115, 116, 118,
119 top right, 122, 123, 126, 128 bottom
left, 129, 130, 133, 134, 137 bottom, 139,
140 right, 141, 142 bottom right, 147,
149, 150, 151, 153, 154, 155, 160, 161,
162, 163, 164, 165, 166, 167, 168, 170 top,
171, 172, 174, 175, 176, 177, 179, 180, 181
right, 213 bottom right, 214, 216 top,
217, 221, 236.
Mossolova : 189.
Pillonel, Fred : 86 bottom.